Inside Nature's Giants

David Dugan, Mark Evans, Joy S. Reidenberg,
Simon Watt, Jamie Lochhead, Alex Tate,
Tom Mustill and Peter Fison

Foreword by Richard Dawkins

BAFTA Winner

Supported by
wellcometrust

windfalfilms

Collins

Commissioned by Julia Koppitz
Editor: Helen Griffin
Picture Coordinator: Eva Johnsson
Design and layout: Taylor Cope Wallace, Myfanwy Vernon-Hunt
Production: Stuart Masheter

Colour reproduction by Saxon Digital Services
Printed and bound in China by South China Printing

Foreword by Professor Richard Dawkins

When I was first approached to take part in *Inside Nature's Giants*, I immediately suggested that, if they ever had the opportunity to dissect a giraffe, they should try to hunt for an extraordinary bit of anatomy called the left recurrent laryngeal nerve. If you were designing a nerve connecting the brain to the voicebox, would you send it on a detour down into the chest to loop around one of the large arteries there, and then back up to its target organ at the top of the neck? Of course not. Yet that is exactly what the recurrent laryngeal nerve does, not because it has other business with branches in the chest – it doesn't. The detour makes perfect sense as a relic of evolutionary history and our fishy ancestry, but from a design point of view in a mammal it is a botched job, pure and simple: no self-respecting engineer would perpetrate such a thing. It's bad enough in humans, but in a giraffe . . . that I had to see!

Almost a year later I found myself in the Royal Veterinary College, blinking in amazement at a state-of-the-art dissecting theatre, one entire wall made of sheer plate glass, behind which, in near darkness, tiers of mesmerised students stared out of the gloom at an electrifying scene: a work of art that would leave Damien Hirst stranded drably in formaldehyde. Bright arc lights bore down on a young giraffe – which had unfortunately died in a zoo – on a huge dissecting table, one leg winched towards the ceiling in an attitude of stark hyperrealism. Its yellow and brown patchwork coat seemed to glow to match the bright orange overalls and white rubber boots of the dissecting team, a surreal uniform which I was also required to don when I joined them under the lights. Almost euphoric with the coincidence, I realised that it was Darwin Day 2009 – his 200th birthday – and I was privileged to spend it with the expert team of comparative anatomists and veterinary pathologists as they carefully traced that paragon of Darwinian paradox, the laryngeal nerve of the giraffe.

For me it was the start of a fascinating association with the *Inside Nature's Giants* team, as they unveiled the intricate internal complexity – a characteristically contrarian mixture of clumsy and elegant – inside some of the most amazing animals ever to evolve: elephant, lion, whale, cassowary, crocodile, python, polar bear, shark . . . and more. The overwhelming impression I get from surveying internal anatomy is that it is a beautifully honed mess! Every organ and structure has a function, but this has evolved gradually and sometimes imperfectly, with vestigial weaknesses reflecting the unimaginably long journey of the animal's DNA through geological deep time. From sea to land, from deserts to jungles, from shredding leaves to slaughtering wildebeest, the anatomies of animals tell us not only what they do now, but what their ancestors did in the past.

Inside Nature's Giants opens a bright window on each animal's life and also its evolutionary story. Each chapter of this book gives a unique anatomical insight into a different animal. The orange-suited explorers never cease to be surprised by what's under the skins of nature's giants. Engagingly, they not only demonstrate what we already know, but they also share with us the exhilarating experience of learning on the job. It has been my privilege to join them, and it is my pleasure to introduce this book.

Introduction

I've always enjoyed Rudyard Kipling's *Just So Stories*, but the evolutionary tales of how these creatures really got their trunks, spots and humps are just as enthralling and full of surprises. With the 200th anniversary of the birth of Charles Darwin approaching, Windfall Films was looking for new ways of tackling evolution. While doing some background research for a drama about Charles Darwin and Captain Robert Fitzroy we came across accounts of public dissections of large animals performed by one of Darwin's staunchest critics, the great Victorian anatomist Richard Owen.

Around the time of this background research, a team in New Zealand carried out a dissection on an extremely rare specimen of a colossal squid. The gigantic eye and huge hooked limbs of this deep sea monster looked utterly alien. At a Windfall ideas meeting we suddenly all got very excited about the prospect of dissecting large animals to reveal their underlying anatomy and evolutionary past. Channel Four was equally enthusiastic about this inside out approach to natural history. And so *Inside Nature's Giants* was born.

We started to explore possible presenters and experts, eventually settling on Mark Evans, Simon Watt and Joy Reidenberg. Richard Dawkins agreed to tell the real evolutionary 'Just So' story for each animal.

In the early days of the series we were concerned how the public might react to the sight of an elephant's guts cascading on to the floor. However, the audience became as absorbed as we were by the science as the anatomy was revealed. The series went on to receive critical acclaim and win numerous awards. By the time this book is published we will have completed 18 programmes filming animals in the Arctic, the rainforest and the African savannah.

Each of the chapters in this book is written by a producer or presenter of *Inside Nature's Giants*. Joy Reidenberg writes about her favourite anatomical feature in each animal. The book tries to convey the enormous enthusiasm, fascination and joy that we've all experienced making this series.

David Dugan
Series Producer
Inside Nature's Giants

Mark Evans

Mark Evans is a veterinary scientist who trained at the Royal Veterinary College and has wide experience of presenting television programmes about animals and wildlife.

Joy Reidenberg

Joy Reidenberg is a professor of Anatomy at Mount Sinai School of Medicine in New York. She studies whales and also teaches human anatomy to medical students. She came to Ireland to dissect a stranded fin whale, after which we decided to invite her to become a permanent member of the team.

Simon Watt

Simon Watt trained as an evolutionary biologist and regularly performs science shows at museums and science festivals.

Giant Squid

Architeuthis dux

Tom Mustill

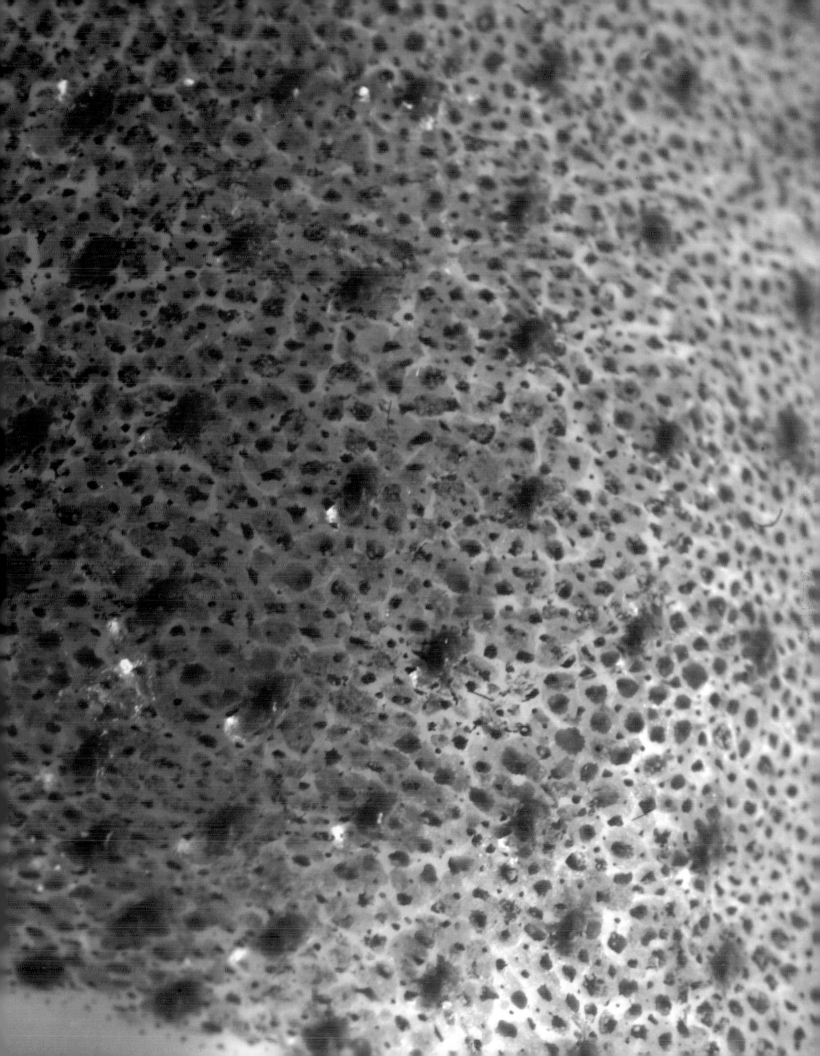

There was one creature that members of the *Inside Nature's Giants* team had set their hearts on from the start, a terrifying and mysterious alien. A predator that stalks the most inhospitable parts of our planet: the giant squid. These monsters of the deep can grow to 13m in length, yet we know almost nothing about them. Almost everything we know comes from studying the anatomy of the few rare specimens washed up on beaches or cut from the bellies of sperm whales. Sometimes research ships probing the sea's depths around New Zealand will return with freshly caught specimens which they freeze in their holds. After months of negotiation we'd been allowed access to one of these rare catches.

Getting access was only the first hurdle. This is an animal with no hard parts and with the colour and consistency of custard. To enable our audience to distinguish its bizarre features we decided to perform the dissection on a specially built light-box. The strong under-lighting would reveal the giant squid's inner secrets.

All the animals we planned to dissect, from elephants to whales to tigers, appear different, but are actually rather similar. They have four limbs and one heart, and once cut open their muscles and organs are recognisable as lungs, hearts and guts. But the giant squid is a 10-limbed, jet-propelled sac. Inside it has three hearts pumping blue blood, powering a beak attached to a gut, which runs through the middle of its brain. It is deeply strange.

Unlike our other giants, the giant squid has never been filmed alive in its natural habitat deep in the ocean. There are a few grainy photographs taken from a fishing line that show flailing red limbs and a short video showing the powerful death-throes of an animal hauled to the surface from the deep. Our expert Dr Steve O'Shea thought it would be a good idea for Joy to experience live squid, first-hand, to see how the basic anatomy works. Unlike the giants, we can catch and observe their smaller cousins from a boat in the calm waters of Russell, a quiet seaside town on the Pacific Coast of New Zealand's North Island.

At least that's the theory. We're onboard and everything is in place. The sonar

Opposite above: The giant squid is a 10-limbed, jet-propelled sac, with three hearts pumping blue blood, powering a beak attached to a gut, which runs through the middle of its brain.

Opposite left: The Japanese researcher Tsenemi Kubadera looks at images of the giant squid he captured at depth in 2004.

Opposite right: Spread out on the dissection table, the giant squid's mantle is as big as Joy and its arms stretch the full length of the table.

Previous page: Deepsea squid (Histioteuthis sp) close-up of mantle showing photopores in the Atlantic Ocean.

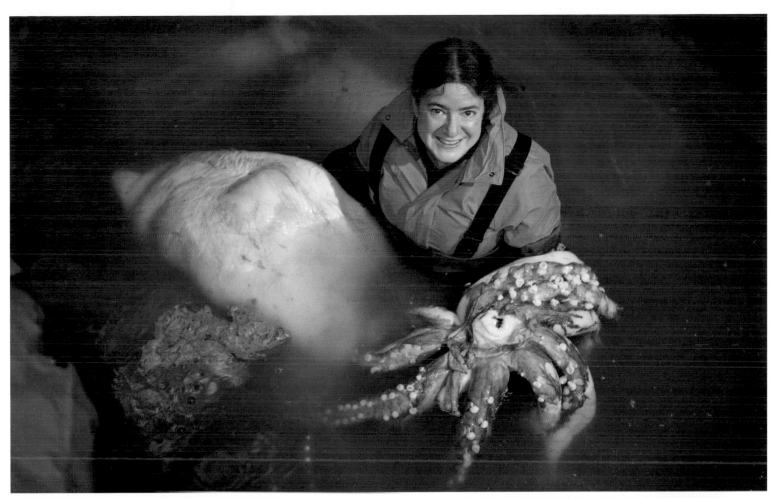

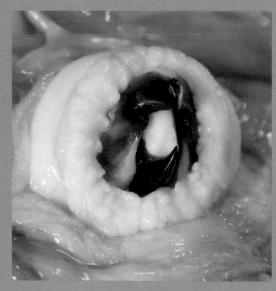

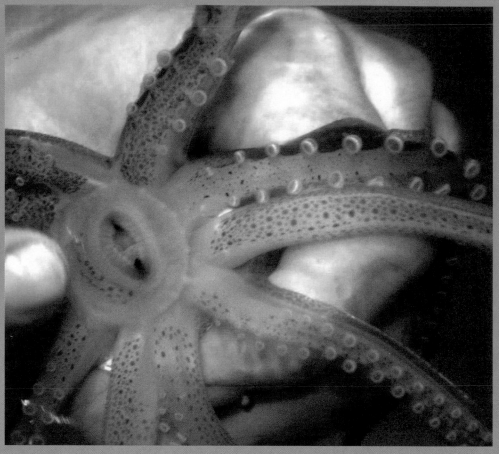

is showing a nice thick layer of krill that should tempt the squid. We can see hordes of these tiny shrimp-like animals swarming around. Suddenly a call goes up, 'Squid!' A bright white rocket shoots through the water as the jigging rod pulls a foot-long arrow squid aboard, where it is quickly transferred to the tank. It pulses around in tight circles, changing colour constantly from ferocious red to glaring silver. Steve thrusts his hand into the tank and deftly, but gently, points out the rows of suckers along each arm and at the centre of them the fiercely gnashing beak – two sharply interlocking points/folds of chitin.

He demonstrates how the main body of the squid is covered with a large muscular 'sock' called a mantle. The mantle, which contains the organs, contracts and relaxes, pulling water in to bathe the gills with oxygen, pushing it out through a funnel. This can be orientated in any direction, giving the squid a jet-propelled boost and incredible acceleration. Steve shows how the squid avoids blowing itself in half by joining the two parts of its body with a T-shaped locking mechanism. This neatly joins the mantle to the rest of the body. With a sucking noise he teases the two apart. The squid quickly re-engages the mechanism and jets away flashing murderous colours, its arms tucked up, holding the two feeding tentacles inside.

On the glowing dissection table the giant squid is laid out, its arms spanning the length of the table. Its two much longer feeding tentacles give it a total length of about 4m (13ft). It's the anatomy of these long tentacles that Steve thinks gives a clue to how the giant squid hunts. Each sucker is encircled by a hard ring of teeth, like a set of jaws. Each squid has thousands of these jaws, which can bite deep into whatever the tentacles and arms touch.

Above left: The giant squid's beak is nestled in the centre of its arms. It is one of the only hard parts of the animal and is surrounded by jellied tissue.

Above right: Dr Steve O'Shea demonstrates how even a small squid's beak is capable of quick and powerful bites on an arrow squid caught off the North Island of New Zealand.

Steve points out that when you place the two long tentacles side by side the strange knobs and suckers line up precisely. He thinks that these act like press-studs, zipping the two long tentacles together. He imagines the giant squid hanging 500m (1,640ft) deep in the water, with two tentacles dangling beneath. There it waits for its prey to pass between the two open clubs. When it does, the tentacles snap together to trap it.

But however the squid uses its tentacles, there are no bones to push and pull against. Joy thinks she can explain: she compares the tentacles to our tongue – it doesn't have bones either, but you can still stick it out and curl it into a U-shape.

Mark scans the skin surface with a digital microscope. The patches of intact skin appear naturally dark red, but as Joy looks more closely she sees that this colour comes from lots of tiny dots embedded across the surface, called chromatophores. They are tiny sacs of pigment, controlled by muscles. When the muscles contract, they stretch the sacs of pigment, so that the dark areas expand. When this happens the colour changes from the yellowy-white to dark red.

Hanging at great depth, where red light cannot penetrate, being dark red is good camouflage. But if it has the ability to rapidly contract and expand its chromatophores, perhaps the giant squid can flash bright white in the dark, to stun prey, or confuse its predators?

Nestling snugly in the centre of the giant squid's arms is its beak – a fearsome slicing tool – and one of the only hard parts of the animal. But it's surrounded by tissue the consistency of jelly like a knife with a butter handle. Only the beak's tip is really hard and it gets progressively softer where it attaches to the soft body of the squid. This stops the squid from carving itself when it opens its mouth.

Above: Each sucker is encircled by a hard ring of teeth, like a set of jaws. Each squid has thousands of these jaws, which can bite deep into whatever the tentacles and arms touch.

No bones about it
Joy Reidenberg

Ten long, wiggly extensions sprout from one head. Sounds like the mythical Gorgon, but this is no myth: it's the giant squid. Giant squids are cephalopods (literally 'head-feet'), a group characterized by a head with multiple appendages. This feature separates them from other molluscs, such as one-footed snails.

Cephalopod appendage movements are mesmerizing. I was fortunate to experience seeing this while scuba diving with a giant Pacific octopus. The octopus trailed its arms, flattening them like a stealth bomber's wings. It crawled over rocky surfaces by extending an arm, and then pulled the whole body towards that arm's tip. Its most peculiar locomotion was on the sandy sea floor: the arms coiled and uncoiled under the body, and appeared to roll like wheels with suckers for treads. It even held its body up and used two arms to 'walk'. But how does it do all this without a skeleton? The answer lies in its muscular anatomy.

A skeleton increases mechanical advantage through the arrangement of joints as levers or pulleys. Cephalopods, lacking bones, probably use more energy than vertebrates to generate movements through muscle contractions. However, their nearly weightless condition in water counteracts any energy debt. The lack of bones and joints provides exceptional flexibility and range of motion.

Bending occurs when muscles running along the arm's length contract on only one side and relax on the opposite. Retraction involves contracting all of these muscles at once. Extension, however, is paradoxical. Muscles girdling the perimeter shrink the arm's diameter. However, since there is no hollow core, there is no collapsible space to accommodate narrowing. Rather, compressing the outside propels fluids in the core – like squeezing a tube of toothpaste. Contractions begin near the base and progress peripherally, elongating and rigidifying the arm as fluids move to the tip. The uncurling and extending arms remind me of a New Year's party blower. The same mechanism shoots the tentacles forward towards prey.

Central Intelligence

The squid's narrow oesophagus passes through a doughnut-shaped brain. If there is a central intelligence in the squid, this tiny ring is where it lies. In the giant squid the brain is dispersed around the animal. The optic lobes process visual data and even the squid's arms have their own decentralized processing areas. If the arms are severed they can touch, react and manipulate the world around. Certain cephalopods are thought to be 'smart'. In captivity, octopuses can be trained to navigate mazes and to open jars: aquaria give their octopuses toys to keep them amused.

Arms

The giant squid has eight arms encircling the beak. It's thought that these are used to subdue struggling prey once captured by the two enormous feeding tentacles, holding them tightly with row upon row of jawed suckers against the beak as it chews them into pieces.

Protective Ink Sac

A dark chamber positioned above the anus of the squid is the ink-sac. It is the last resort when confronted by a threat. For the giant squid this would most likely be its nemesis, the sperm whale. Bits of skin around the anus – anal flaps – are muscular and can control how the ink is expelled, a great diversionary ploy.

Giant Squid (Estimates):

Weight male / female:
150kg (330lb) / 275kg (610lb)
Height: ..
N/A
Length male / female:
10m (33ft) / 13m (43ft)
Life Span: ..
3–5yrs
Top Speed: ..
Perhaps up to 32km/h (20mph)
Bite strength pound force:
N/A

A Tongue With Teeth

The beak of the giant squid might be fearsome, but lurking inside is a tongue glittering with rows of hooked teeth. These rasp across food particles, blending them into a soup thin enough to pass along the oesophagus and through the 'brain'.

Reproduction

Giant squid sex is an unusual affair. The nidamental gland – the reproductive organ of female squids – is a fluffy mass of tissue deep in the mantle of the squid. When squid sexually mature they stop feeding and plough all energy into reproducing. Once a female octopus is fertilized she will lay her eggs and guard them, keeping them fresh and oxygenated. When they hatch, she dies. The female giant squid will collect a number of sperm packages, which are embedded in her arms, perhaps from a number of different males. When her eggs are ready she'll extrude them through her funnel and nestle them in her arms, where they'll trigger the sperm packages to explode through her skin and onto the eggs. This moment of fertilization could take place long after the sexual encounter.

Eye

The lens of the giant squid is split into two hemispheres, joined together, and held in place by a sphincter around the outside. The eye itself is enormous, but the retina that the lens focuses the light onto has the highest acuity of any animal.

Huge Optic Lobe

The eye of the giant squid is actually similar to our own, but it has evolved this form and shape independently. It's a classic example of convergent evolution where the same basic layout evolves on a completely different branch of the tree of life. The huge optic lobe is where the squid processes visual information to respond with deadly precision.

Giant Squid

As Richard Dawkins says, 'The science fiction author Arthur C. Clarke, who obviously loved writing about space fiction, also made the point that we know less about the deep sea than we know about the moon. We can't unfortunately go to distant planets to see what alien life might be, so maybe the deep sea is the next best thing. Who knows what else we may find down there?'

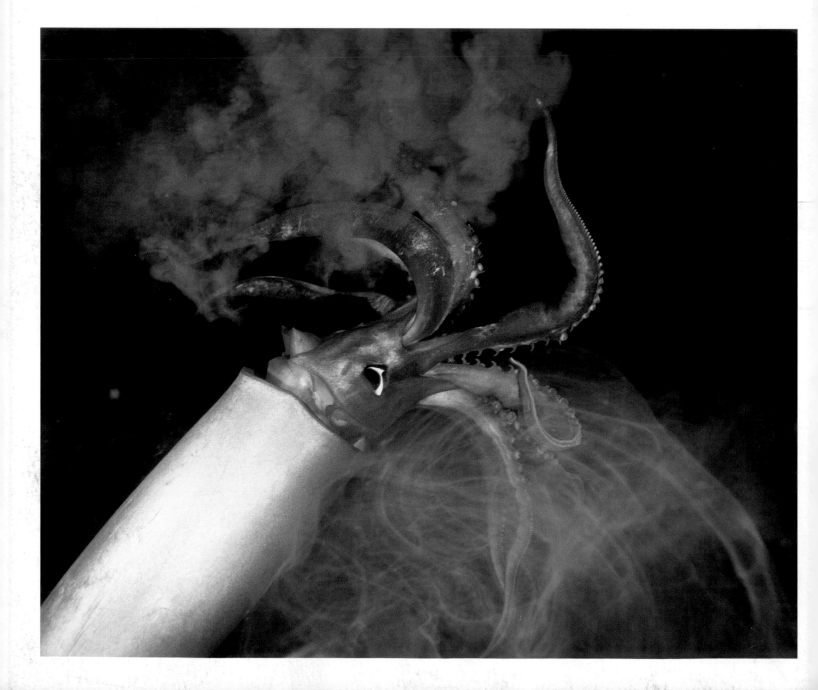

Inside the beak is the next extraordinary piece of the giant squid's feeding apparatus. It's a strange fleshy, tongue-like structure, covered in tiny teeth. This is called a radula, and is common to many molluscs; it's what snails use to rasp through lettuce. In the giant squid it rasps against the chunks carved off by the beak, turning them into a sludge that can pass safely down the thin oesophagus towards the digestive gland. This amorphous, brown sac full of enzymes breaks down the protein in its diet of smaller squid and turns it into giant squid. The giant squid grows extremely fast, from a 2mm (0.08in) infant to a 3m (10ft)-apex adult in five years. Joy inspects the oesophagus and finds it passes through a narrow ring of tissue like a Polo mint of white matter. This is the central brain of the giant squid.

The squid's internal organs are enclosed within its mantle. Inside, the anatomy is a confusing mass of delicate tubes and foul-looking sacs flanked by two large white feathery structures. These are the gills, where the giant squid pulls oxygen from the water and ditches carbon dioxide. The squid needs a great deal of oxygen to power its huge muscles, so these gills are very different from the gills of a fish. At the top of each one is a small round sac that's full of blood.

Joy injects ink into one of the sacs above the gills; from here the ink spreads delicately into and through the gills in fronds across the surface. Joy fills the central heart and other gill heart with ink and as it drains through the blood vessels this extraordinary anatomy is suddenly clear. Steve explains that the sac is actually a heart. Each of the two gills has its own heart, to pump the deoxygenated blood from the body into each gill. It then drains back to a third central heart, which pumps the oxygenated blood out to the rest of the body. But having three hearts is not quite so bizarre as it first sounds. Humans have a dual blood flow circuit for which we use not three but four bags of muscle – it's just that these four small hearts are enclosed within a single organ.

In the bright under-glow of the light-box it looks like a totally alien creature, but perhaps we're not as different as we'd like to think.

Opposite: With angry eye and a cloud of ink, a jumbo squid flees from a diver.

Whale

Balaenoptera physalus

David Dugan

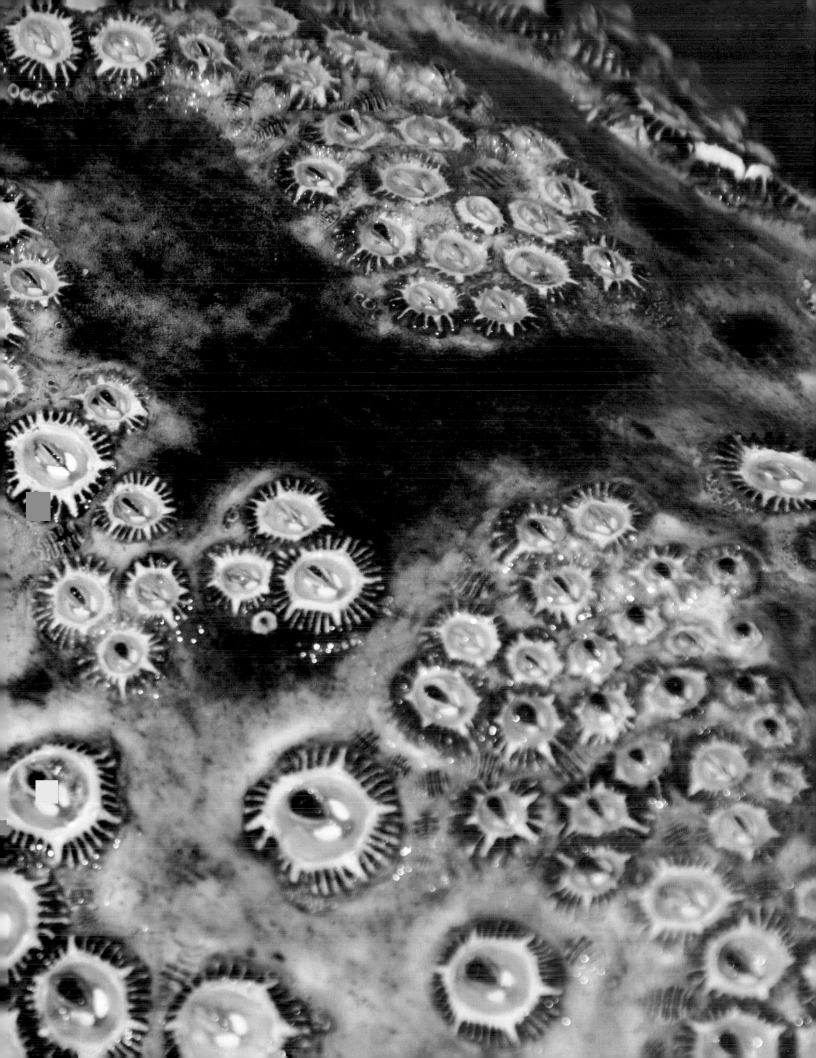

The car bumper sticker says it all: 'Courtmacsherry, a quiet drinking village with a fishing problem' – although what they have today is more of a marine mammal problem. As the car headlamps sweep across Courtmacsherry Bay in West Cork, we catch a glimpse of the half-submerged fin whale that has stranded on a falling tide. Despite the efforts of local fishermen to re-float her at high water, this 20m (66ft) giant was doomed. Her distant ancestor may once have walked on land, but when a whale this size beaches the full force of gravity crushes its internal organs. Sadly, she died, and the Irish authorities have a mountain of decomposing flesh on the beach. We are here to persuade them to let us carry out a full dissection.

The man in charge of this problem is Dan Crowley, the County Cork veterinarian, whose priority is to dispose of this whale as fast as possible. So far it has not been going well. County Council workers attempted to haul it up the beach away from the incoming tide. They put a big chain round the tail of the 50 tonne leviathan and attached it to a digger. In this unlikely tug of war between whale and machine, there was only ever going to be one winner. The digger sunk deeper into the sand until there was a resounding crack. The tail had come off. It was time to call in an expert.

Professor Joy Reidenberg teaches human anatomy to medical students at Mount Sinai School of Medecine in New York, but her research passion is marine mammals – particularly whales. As a comparative anatomist she's probably been inside the mouths and down the throats of more whales than anyone on the planet. Her toolbox full of knives is always on stand-by. So when she received the call, she jumped on the first plane to Ireland.

Dan Crowley knew enough about whales to realise he was sitting on an unexploded bomb, but he'd never disposed of a whale this size before. His plan was to bring in excavators, dig a deep trench and bury it. At least, that was his plan until he met Joy Reidenberg. The Irish Whale and Dolphin Group set up a temporary crisis headquarters in their camper van where the delicate negotiations about

Opposite top: Courtmacsherry Bay on the coast of West Cork, Ireland.

Opposite bottom: The fin whale is the second largest species of whale after the blue whale.

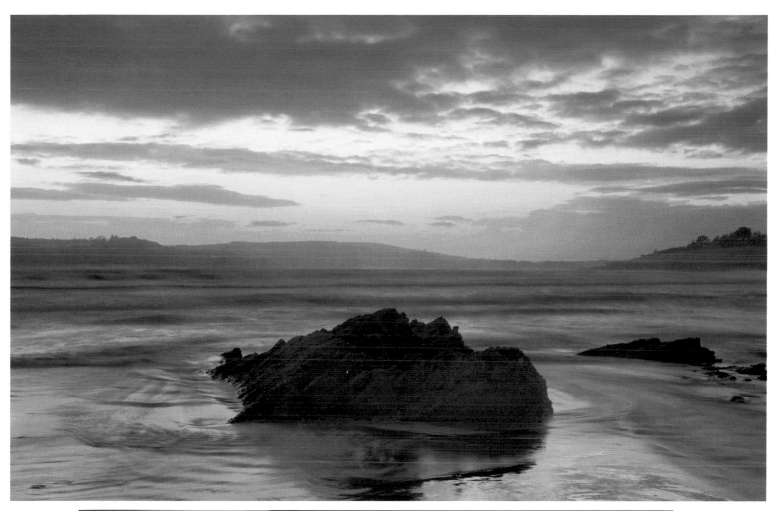

dissecting the whale take place. Dan is impatient. There's no time for dissection. He wants the carcass buried as soon as possible to avoid any public health risk. Joy shakes her head knowingly. She warns that his strategy will end in disaster. In a few days time the bloated carcass would re-surface no matter how many rocks were piled on top. The whale would come back to haunt them unless it was completely chopped up. Joy clearly knew what she was talking about. She sketches on a pad how the whale should be gently deflated and peeled open like a banana. Dan eventually relents and seals the deal with a spit-handshake. We have two days. Joy will help them get rid of the whale, if they let us carry out a dissection to explore its massive anatomy.

By now the tide has almost retreated, so we paddle across the last rivulets dividing the sand towards the whale which has now attracted a crowd of onlookers. After the blue whale, the fin whale is the second largest animal on the planet. To stand alongside such a colossal alien-looking organism makes you feel very small in the grand scheme of life.

While Joy prepares to make the first incision, Mark Evans, our veterinary scientist, inspects the bulging tissue that's forcing open the whale's mouth. The highly elastic tongue and floor of the mouth have inflated like a weather balloon. He prods it cautiously and marvels at how taut it's become.

The pressure inside this whale is building up and Joy is nervous that there are too many onlookers oblivious to the threat. She knows that if they don't act fast it could explode. Although it's cold outside, the whale's thick layer of blubber insulates the internal organs maintaining the heat inside. This accelerates the bacterial breakdown of the organs and releases more and more gas.

Above: The fin whale is a baleen whale. The baleen plates hanging from its jaws are used to filter krill and small fish which are eaten in vast quantities.

Above left: Joy Reidenberg briefs the team from the Irish Whale and Dolphin Group inside their temporary camper van HQ.

Top: The stranded fin whale draws a huge crowd of spectators. The fin whale's gigantic mouth occupies most of the front half of its body.

By now the whale is almost double its normal size.

Brandishing a large knife, and dressed in oil skins, pink wellies and goggles, Joy strides across the beach issuing orders: 'Everybody move please. Get out of the way. Or you're all going to be covered in whale goo.' Joy wants to be alone when she makes that first incision. Earlier, in the camper van, she had warned the volunteers of the dangers of making incisions that are too deep. In Denmark, when a team made the first cut on a sperm whale, its guts exploded, showering everyone with offal.

When the crowds eventually move back, Joy's knife is poised, ready for the first stab. She plunges it into a throat groove. There's an immediate hiss of gas. Slowly she works her way along the groove making a long line of small holes. The release of gas reaches a crescendo, creating mournful sounds loud enough to be heard above the noise of the howling wind. It is the 'opening' number (literally!) of what Joy describes as the 'Whale Fart Symphony'. Gradually the whale deflates, until it's safe for everyone to move in. Joy organizes volunteers to begin making a long cut along the side through the blubber.

The antics on the beach are starting to draw a large crowd. The whale stranding has been on the Irish news and despite appalling weather people are flocking to Courtmacsherry to enjoy the spectacle. Three fish and chip vans become so busy feeding the weekend hordes they completely sell out.

Joy and the volunteers eventually complete the two deep incisions along the length of the whale. Now it's time to call in the heavy machinery. They attach one end of a big rope to a corner of the blubber and the other to a digger. The digger moves away, slowly pulling off a huge slice of blubber like peeling a banana. The

Above: The ventral pleats on the whale's underbelly have expanded like an accordion stretched to bursting point – as its organs continue to rot they release gases that pump up the pressure inside. What we are witnessing is the massive capacity of the throat grooves to expand – a vital feature of its feeding anatomy.

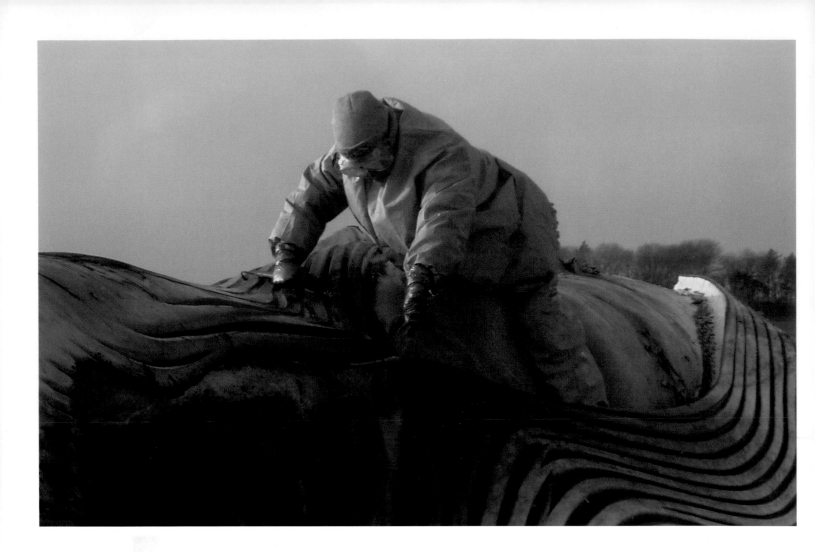

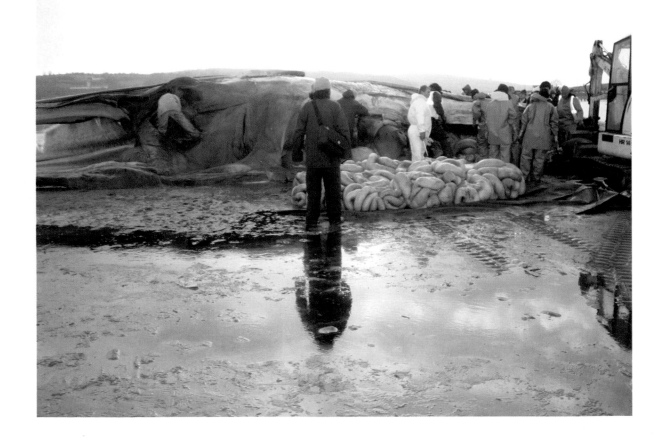

exposed guts underneath start bursting out on to the beach. They emerge steaming hot, wobbly and uncontrollable. For the next half hour the digger operators try to wrangle the squidgy mass of intestines into the dumper truck. They take several loads away for closer inspection on the next day.

By now it is 4pm; it's starting to get dark and the tide is turning. Joy has one more thing she wants to do before the tide comes in. For her the Holy Grail of whale anatomy is trying to understand how whales talk to each other. Despite the hailstones blasting into her face, she is determined to extract the larynx or voice box from the whale. This involves going inside its mouth. 'Just like Jonah,' Joy jokes; but Jonah did not handle a knife like Joy. After battling away for almost an hour she manages to release the huge chunk of tissue from the hyoid bone. She lifts it into the air using the shovel of a digger. Even though it's virtually dark, she's determined to give us an impromptu tour of her favourite organ. She spins the larynx round on a meat hook. Eventually, the strain is too much and the larynx drops on to the beach. That's it – it's a wrap – time to retreat to the hotel and to get cleaned up. Today has been an extraordinary experience – the stuff of surreal nightmares – but what a privilege to go inside such a giant.

Our spirits are high when we awake to sunshine the next morning, but the whale is back under water again. We will have to wait for the tide to go out before we can venture deeper into its body. We take the opportunity to explore the whale's digestive system. In a field just around the bay the veterinary team has laid out large polythene sheets. Overnight the guts have been kept in a lorry and now several tons of tangled guts are tipped on to the sheets. In their boots and

Above: Despite torrential rain and fading light, Joy manages to reach the larynx (or voicebox), which is part of the sound-producing apparatus.

Opposite top: Joy clambers on top of the whale to start a higher, parallel cut. The oily surface is incredibly slippery, so she uses a fisherman's gaff in one hand and a knife in the other to make the long incision.

Opposite bottom: The guts are laid out on a tarpaulin for collection by a dump truck.

protective aprons Dan, Mark and Joy try to sort out the mess. They walk up and down laying out 80m (263ft) of intestines – four times the length of the whale.

They want to examine the contents of the stomach and intestines in case it yields any clues about why this whale might have stranded. There's very little in the intestines. Joy scoops out some whale faeces that are much wetter than land mammals'. This is because they need to excrete fast when they swim along. They look inside the stomach to check its last meal, but there's only fluid. This lack of food suggests to Joy that the fin whale was probably sick.

When the tide is finally out again diggers, dumper trucks and knife-wielding volunteers converge on the whale. As we get closer, we notice a flipper is missing. There's also been a half-hearted attempt to remove the jawbone. Trophy hunters have come in the night to sabotage the whale. Had the flipper – or pectoral fin – not been removed, and the other one not been trapped under the whale, Joy was hoping to show us that its underlying anatomy is very similar to the front leg (or arm) of a land mammal. The bones have been changed to enable them to swim in water. The humerus – the bone that extends from the shoulder to the elbow – has become flattened and shortened. The radius and ulna – which make up the forearm – have fused at the elbow and are also much flatter. Hand bones form the end of the flipper; although in fin whales the first finger is missing. These flippers are not used for propulsion – they are used for steering, lift, braking and to maintain balance.

The powerful thrusts of the tail fluke are what propel a whale through water. The vertical muscles that power this movement have grown very long and large. When whales first took to the water, their swimming style was already set. Unlike fish, which have a spinal movement that goes from side to side, whales propel themselves with an up and down motion that extends through their entire body. Their ancestors had turned galloping over the land into galloping through the sea. This didn't just mean swapping legs for a tail – there are many other muscles involved. Joy thinks the hyoid bone, which she extracted from the whale's throat yesterday, plays a pivotal role. There are muscles that run from the chin to this bone and also muscles from the sternum at the beginning of the ribcage that extend to this bone. If the whale keeps its jaw closed and then contracts these muscles, it depresses the entire head. This is the beginning of a body wave that enables these whales to swim so well.

The fin whale is the fastest of all the whales and can swim for extended periods at 37km/h (23mph) with a top speed of 40km/h (25mph). Its streamlined body crosses back and forth across the oceans in its annual migrations. In spring it heads toward feeding grounds near the Poles and then in the autumn returns to subtropical waters for mating and calving.

The reproductive anatomy has also had to adapt for mating in the oceans. The larger whales have penises that can be up to 3m (10ft) long and very large testicles. Perhaps not surprisingly, the testes and penis are stored internally to minimise drag. The penis emerges through a genital slit between the belly and the anus. When it's withdrawn it folds into an S shape and is completely hidden. It's similar in shape to the penis of a bull and other even-toed ungulates – further evidence of the close evolutionary link to these species. The gestation period for a fin whale is 11–12 months. When a calf is born it will be over 6m (20ft) long. For six months it's nursed by its mother until it's ready for weaning by which

Opposite bottom: Joy examines a fin whale foetus from another postmortem. The bone around the mouth area is, in fact, cartilage, as it hasn't developed into bone quite yet. A fin whale foetus folds quite compactly into the womb.

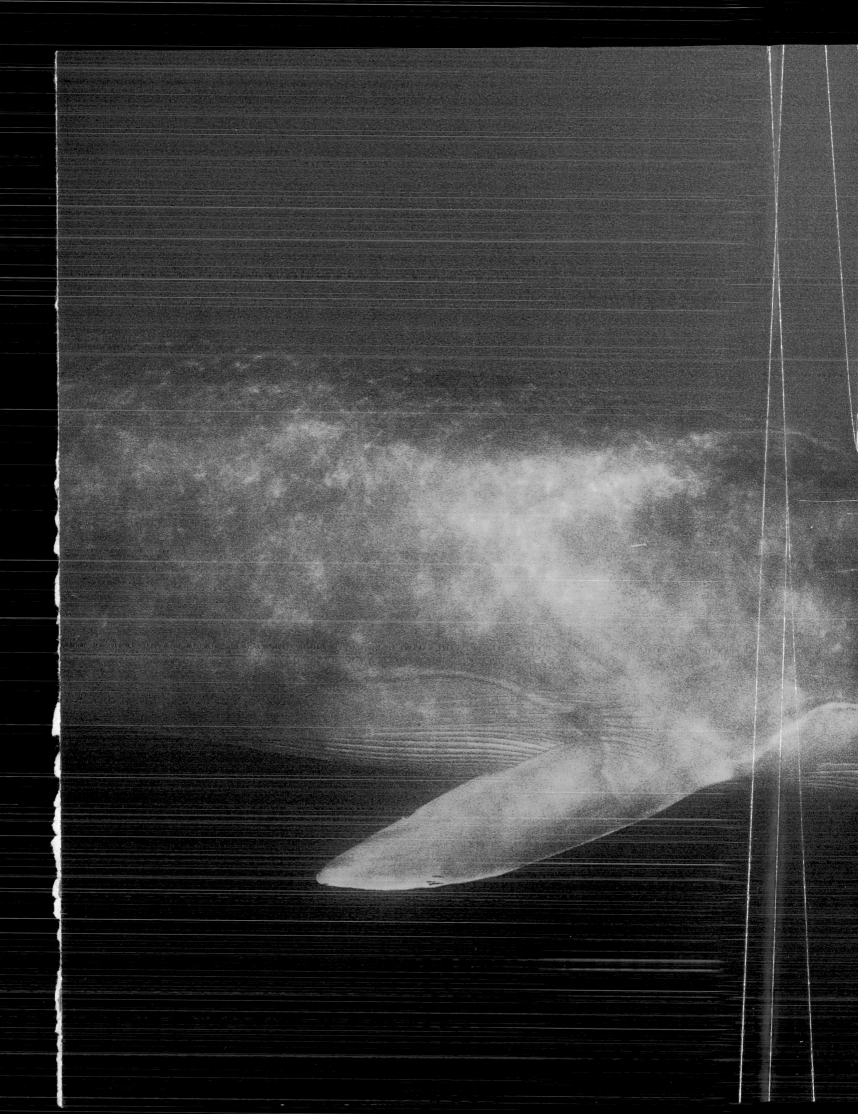

Tail

The powerful thrusts of the tail fluke are what propel a whale through water. The vertical muscles that power this movement have grown very long and large. When whales first took to the water, their swimming style was already set. Unlike fish, which have a spinal movement that goes from side to side, whales propel themselves with an up and down motion that extends through their entire body.

Legs

The vestigial hindlegs are embedded in the body. A tiny, stunted, hipbone was found. This bone had once been used to support walking on land, but is now withered away to almost nothing. Whales belong to a group of animals called the even-toed ungulates. These cloven-hoofed animals include cows and sheep. Recent DNA evidence shows that one of the closest living relatives of the whale is the hippopotamus. What's even more astonishing is that hippos are more closely related to whales than they are to pigs, cows or any other cloven-hoofed animals.

Whale Evolution

Whales may look like fish, but they breathe air and their ancestors walked on land, and had limbs and lungs. Then around 50 million years ago opportunities arose to return to the sea to hunt fish. From fossil evidence we know that one of the earliest 'old whales', Pakicetus, was similar to a wolf. It was semi-aquatic, probably only venturing into water to catch fish. We can deduce that its front limbs became flippers; its rear limbs shrivelled to almost nothing and a tail emerged to power it through the sea. From the size of a dog, how did they become so big? Once they no longer needed to walk, their large bones and muscles became unnecessary. Free from the constraints of gravity, whales could grow ever larger. No matter how big they got, they were weightless floating in water. Unfortunately this makes them very vulnerable if they become beached on a falling tide like the whale stranded in Courtmacsherry.

Sex and Birth

Their reproductive anatomy is adapted to mating at sea. Larger males have penises up to 3m (10ft) long and giant testicles, both stored internally to minimise drag. The penis emerges through a genital slit between the belly and the anus and withdraws into a folded S shape. The female's ovaries are also large and can weigh 15kg (33lb). The gestation period is 11–12 months and a new-born calf will be 6m long. The mother nurses for six months by which time the calf is 12m long. Babies come out tail first, and swim to the surface to take a first breath through nostrils on the top of their heads.

Intestines

The fin whale has 80m (263ft) of intestines – four times its length. Whale faeces are much wetter than land mammals' because they need to excrete fast when they swim along.

Lungs

After a single breath, a fin whale adult can submerge for 30 minutes. Its lungs can inhale 2,000 litres of fresh air in a single breath. Flexible chest walls allow the lungs to collapse under increasing pressure, forcing any remaining air away from the bloodstream, thus avoiding the bends which most mammals would suffer from diving to such great depths.

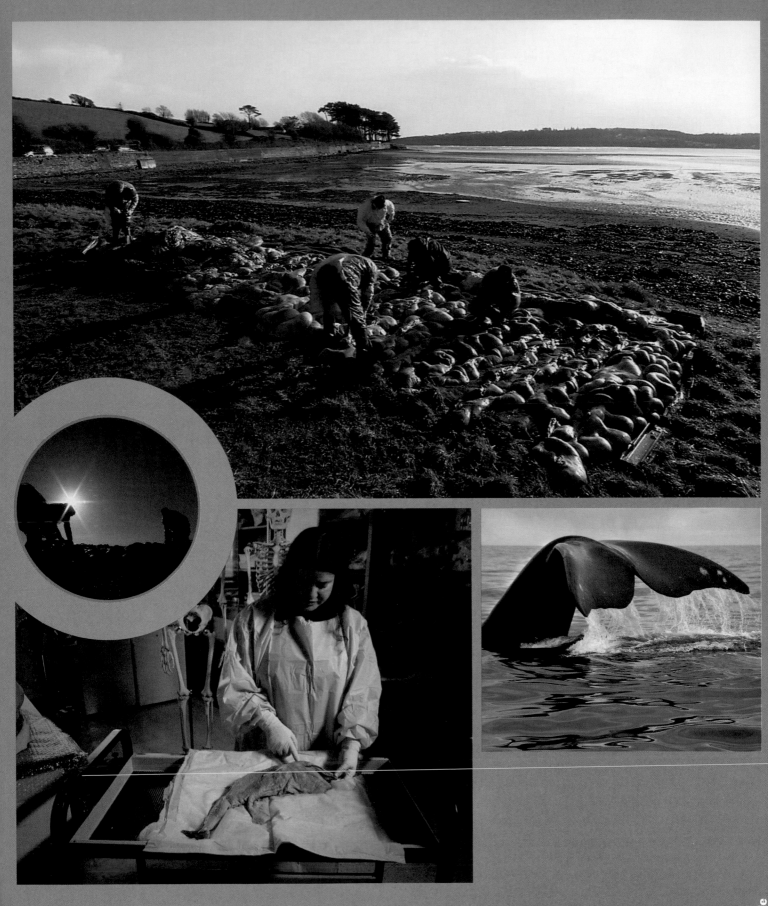

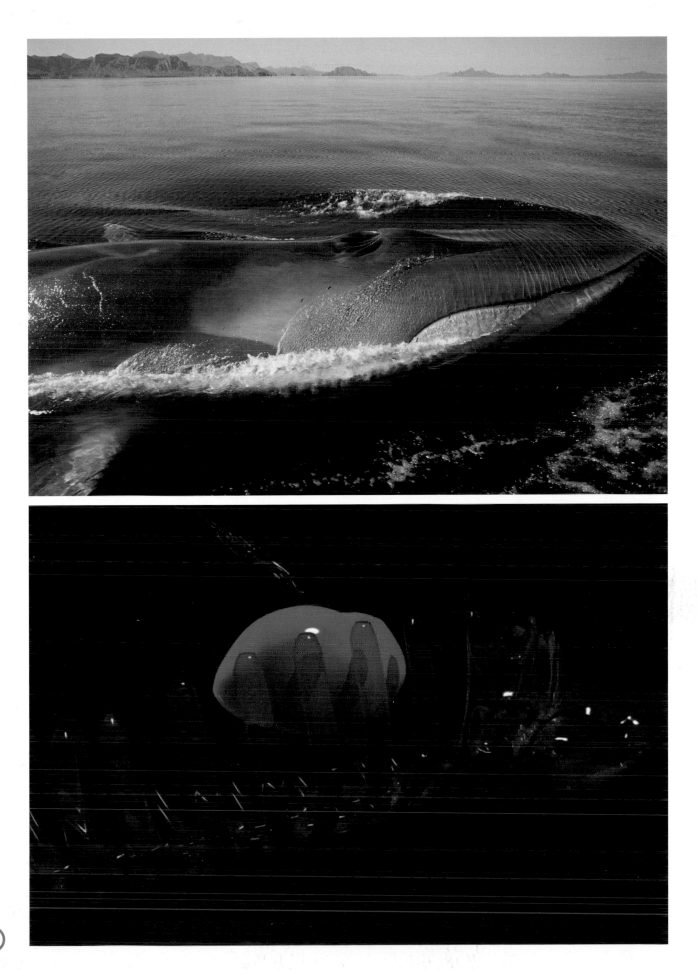

Stomach

Whales have multi-chambered stomachs similar to those in ruminants like cattle and sheep. First there's the forestomach where digestion begins. Then there's the main stomach where gastric glands release digestive enzymes. Then food passes into the connecting stomach and the pyloric stomach where solid food is broken down further before entering the duodenum. For a fish-eating carnivore to have a multi-chambered stomach – very similar to a ruminant's – might seem surprising, until you consider the ancient history of the whale.

Skin

For such a large animal the fin whale has incredibly thin black skin. Like all mammals, whales have four layers of skin: the epidermis, the dermis, the hypodermis and connective tissue. It's just that the outer layers, the epidermis and dermis are very thin and the next layer, the hypodermis is very thick. This blubber layer is composed of a mixture of fat cells and connective tissue. In a fin whale the blubber can be up to 35cm (14in) thick. It's one of many adaptations that occurred when this mammal became aquatic. Once upon a time most mammal skins were covered in fur to keep them warm, but fur is a poor insulator in deep water. Perhaps more importantly, it's not very easy swimming in a fur coat, so the whales' ancestors swapped it for blubber.

Flipper

The whale's flipper (or pectoral fin) is very similar to the front leg (or arm) of a land mammal, it's just the bones have changed so they can swim. The humerus is flattened and shortened, while the radius and ulna have fused at the elbow and are also much flatter. Hand bones form the end of the flipper - although in fin whales the third finger is missing. These flippers are not used for propulsion; they are used for steering and to maintain balance.

Feeding

The fin whale's gigantic mouth occupies most of the front half of its body. To feed it dives at speed towards a shoal of krill, opening its jaws so wide that each side disarticulates. Its throat pleats expand as a vast volume of water pours in. It raises an enormous tongue to force out the water, leaving krill trapped inside by the fibrous fringes of its baleen plates.

Whale:

Weight: ..
70,000–90,000kg (150,000–200,000lb)
Height: ...
N/A
Length male / female:
19–25m (62–82ft) / 20–27m (66–89ft)
Life Span:
100yrs
Top Speed:
40–45km/h (25–28mph)
Bite strength pound force:
N/A

Swim Bone

The hyoid bone in the whale's throat plays a pivotal role in its swimming action. Muscles extend from the chin to this bone and also from the sternum to this bone. If the whale keeps its jaw closed and then contracts these muscles, it depresses the entire head and begins a body wave that enables it to swim so well. The fin whale is the fastest of all whales and can swim continually at 37km/h (23mph) with a top speed of 40km/h (25mph).

Baleen

Instead of teeth, the fin whale has two racks of baleen growing from its upper gums. Fin whales have between 260–450 baleen plates, each 70–90cm (28–35in) in length. They perform a function as vital as teeth, but instead of grinding or cutting, they sieve out tiny fish and krill. An average mouthful will yield about 10kg (22lb) of food, but after many hours of lunging they can consume up to 1,800kg (3,970lb) a day. Baleen (or whalebone as whalers called it) is a horn-like substance made from keratin.

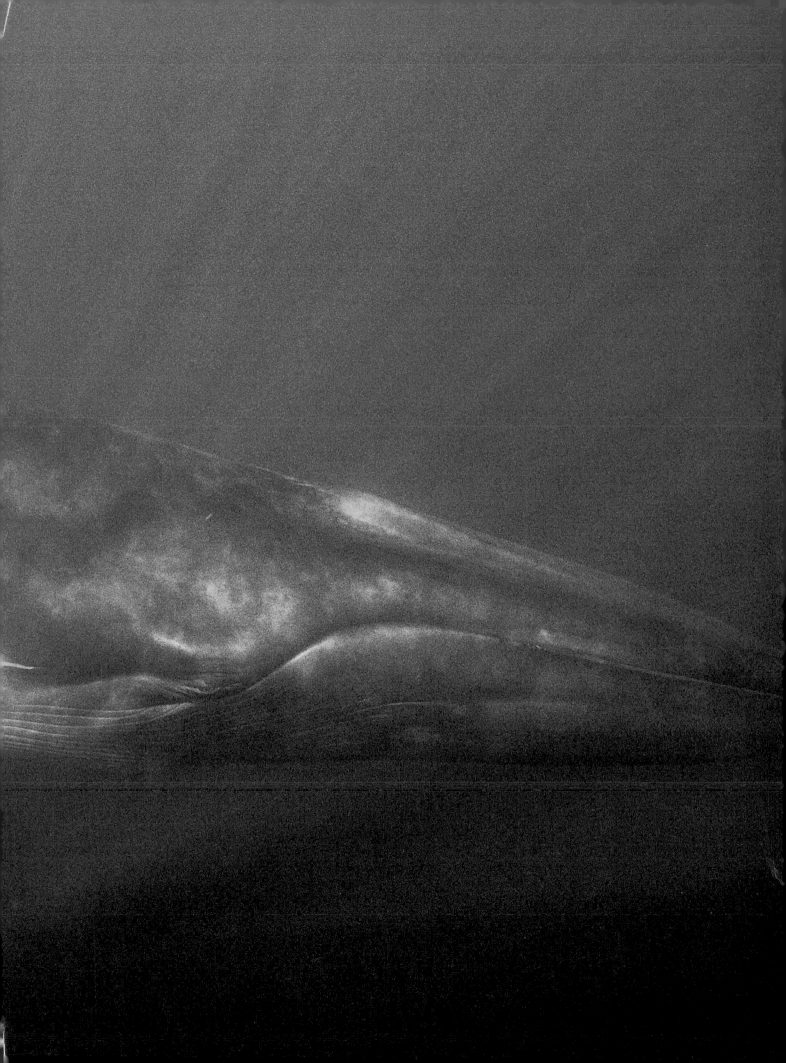

time the calf will have doubled in length. The life span of a fin whale is uncertain, but it's thought they can live for up to 100 years.

When the mother delivers the baby, they usually come out tail first, so that it doesn't take a breath until it's outside the mother. Then it swims to the surface to take its first breath through the nostrils on the top of its head. After a single breath many adult whales can stay under water for half an hour or more before returning to the surface.

In the remaining hours before the tide comes in Joy is desperate to gain access to the lungs and heart to show us how they have adapted to perform long deep dives. These organs are encased inside the whale's vast ribcage. Joy begins a heroic struggle to release the organs from the carcass by diving under the ribcage. Standing waist deep in blood and gore, her head disappears (quite literally) into the heart of the beast. She pulls out the aorta, but the other major blood vessels need to be cut through to release the heart. These are deep inside and hard to reach. After several attempts she admits defeat.

These are massive organs. A fin whale's heart weighs over 250kg (772lb), as much as four humans, and its lungs can inhale 2,000 litres of fresh air in a single breath. Although the heart is huge, its basic four-chambered anatomy is much like a human heart. And though whale lungs might seem big, proportionally they have only half the volume of terrestrial mammals. So with these organs how does a fin whale dive to 200m (656ft) and stay down for up to 30 minutes? It's one of the great wonders of the natural world.

The average human can hold their breath under water for not much more than 90 seconds. Anyone foolish enough to scuba dive down to 200m (656ft) and back in half an hour would not live to tell the tale. They'd suffer nitrogen narcosis (sometimes called raptures of the deep) once they dive past 40–50m (131–164ft). As more and more nitrogen dissolves in their neural membranes drunken disorientation would degenerate into unconsciousness. If they were still alive, then on the way back to the surface they'd suffer the bends or worse still, a pulmonary embolism, as the dissolved air in their blood turned into lethal gas bubbles. The whale has amassed an impressive set of adaptations to its breathing and circulation to enable it to survive long periods at great depth under water.

First of all its nostrils have moved from the front of the snout to become blowholes on the top of its head. Blowholes are familiar to whale watchers as the source of the geyser-like blast when whales surface to empty their lungs of carbon dioxide. This rapid exhalation is followed by a quick inhalation. Around 85–90 per cent of the air is exchanged in a single intake of breath. (Humans only exchange 15 per cent of air each time they breathe.)

Once its lungs are full the whale dips under the water again. To prevent its nasal passages flooding a pair of plugs seal the blowholes. These plugs require muscles to open them whenever the whale needs to breathe; otherwise the default position is to remain firmly shut. This energy-conserving adaptation avoids the need for continual muscle contraction and keeps water out of the lungs. On a fin whale the twin slits of the blowholes are also protected by a ridge of tissue to further prevent water flowing in when it inhales.

As the whale dives deeper, flexible chest walls allow the lungs to collapse under the increasing pressure, forcing any remaining air from the alveoli into the trachea and bronchi where it can no longer be absorbed into the bloodstream.

Opposite top: A fin whale adult at winter feeding grounds in Baja California, Mexico.

Opposite bottom: The fin whale's heart is encased inside the vast ribcage. It weighs over 250kg (772lb) and although huge, is much like a human heart with its four-chambered anatomy.

Leviathan's Larynx:
Loudest, Lowest, Longest, Largest
Joy Reidenberg

Sailors had long been familiar with the haunting and eerie sounds that reverberated along the ship's hull. These mysterious sounds became the inspiration for many ghost stories and underscored a fear of sea monsters. Singing sirens were believable and eventually attributed to seals, but singing leviathans were unheard of. Baleen whales were thought to be deaf and mute, supported by observations that they had no external ears and no sounds emanated from their mouths even when their heads were seen above water. Our own inability to hear well or speak clearly underwater probably fuelled the belief that no other animal could do so either. Early anatomists examined the whale's larynx ('voice box'), the structure responsible for generating sounds in other mammals. Unfortunately, they didn't find the classic vocal 'cords'. Whales, lacking essential vocalizing structures, were therefore dismissed as unable to vocalize. In fact, baleen whales, make the loudest and lowest sounds in nature. The amplitude of their calls can be as loud as a jet engine, and can be produced in frequencies that are lower than the human ear can detect. Scientists focused on the larynx, as it is the major organ of sound generation in most other mammals. Making loud and low sounds requires a thick and long set of vocal folds, which could only be accommodated in a very large larynx. Earlier published descriptions of the whale larynx, however, were troubling. They indicated that this organ was devoid of vocal folds. How could an animal possibly vocalize without vocal folds? Back in our lab at Mount Sinai School of Medicine in New York, my colleague Jeffrey Laitman and I looked for a homolog of the vocal folds. Homology tells us about evolution because shared features indicate origins from a common ancestor, while differences indicate evolutionary divergence over time. We discovered that the vocal folds homolog turns out to be a U-shaped fold in the larynx, which contains all 'the right stuff' of a proper set of vocal folds. The 'arms' of the fold are thick and long – a perfect recipe for generating loud, low frequency sounds. However, the whale's vocal folds were oriented parallel to airflow, rather than perpendicular to it as in all other mammals. How could the larynx act as a valve if air bypasses it? A closer examination shows that the vocal folds do in fact act as a valve – they guard a slit-shaped opening into a large and flexible sac located under the larynx. As air rushes past the vocal folds, the resulting vibrations propagate through the overlying soft tissues and transfer to the skin and then to the water. Amazingly, instead of losing air out of the nose or mouth, whales appear to capture the used air in this sac and then recycle it. This allows them to sing their songs over and over without having to take a break to come up for more air. Thus, whales certainly are one of nature's extraordinary giants, excelling in the 4 Ls: loudest (vocalization amplitude), lowest (vocalization frequency), largest (overall larynx size, and vocal fold thickness) and longest (vocal fold length, and song duration between breaths).

Silent Undersea World?

A new technology called hydrophones (underwater microphones) changed our perception of the ocean as a 'silent undersea world'. The United States Navy established underwater listening stations in the 1950s that were secretly poised to detect the sounds of Soviet submarines stealthily approaching the US coastline. This Cold War early warning system captured myriad other vessel-made noises, such as ship propellers and even natural sounds made by crustaceans such as snapping shrimp. However, there were several mysterious sounds that puzzled the military scientists that were quite loud and complex, but occurred only intermittently. The existence of the recordings was kept classified for around 15 years while expert acousticians and biologists were consulted to interpret them. Luckily, three whales were spotted in the vicinity of the hydrophones while their sounds were recorded. Bingo! The source had finally been identified.

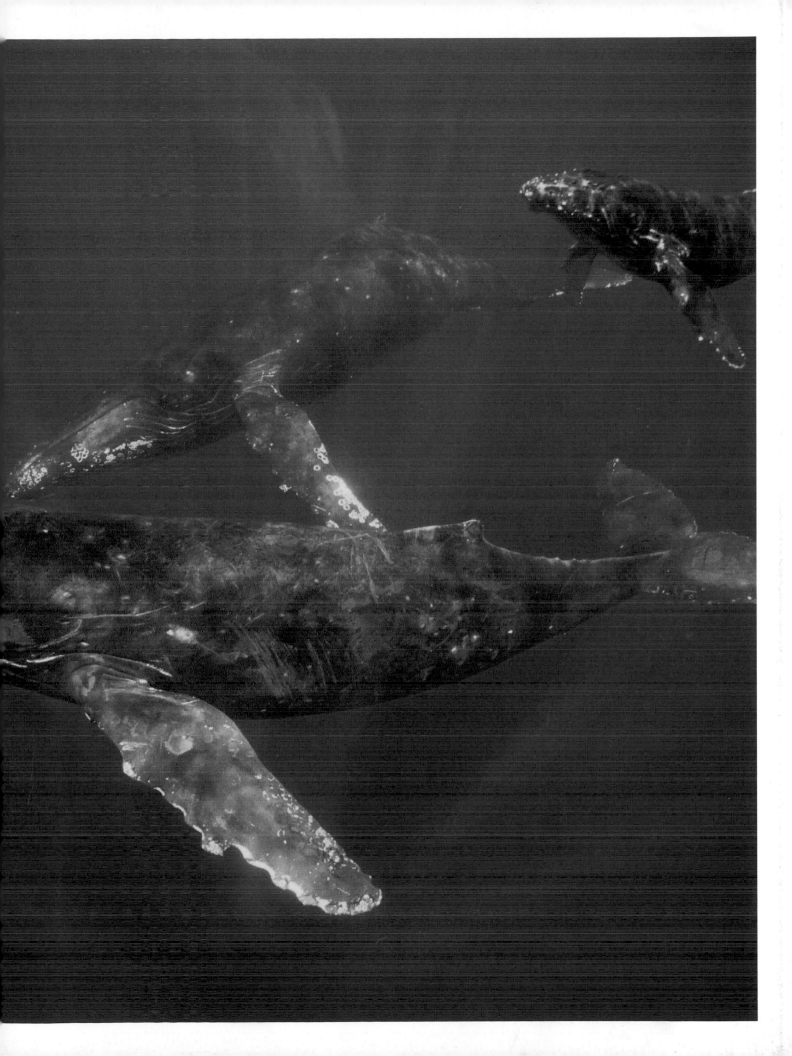

This is how whales manage to avoid the bends and nitrogen narcosis that can cause such serious problems for divers.

But if the whale has emptied its lungs of oxygen and continues to swim around as it lunges for food, how does it keep going? The whale has evolved lots of different ways of avoiding oxygen starvation. Its heart rate drops to as low as three beats a minute; some blood vessels shrink, diverting the flow of blood to the essential organs, and it also drops its body temperature. But the crucial advantage whales have is the ability to store more oxygen in their blood and muscle.

Whale blood has a higher density of red blood cells and their skeletal muscles are packed with myoglobin, the oxygen-binding molecule that gives whale muscle its dark colour. The deepest diving whales tend to have the darkest muscle. That's why sperm whales, which can dive down to 3,000 metres for over two hours, have muscle that is almost black.

As darkness falls on Courtmacsherry Bay, there was still one hidden piece of anatomy everyone was curious to see – a crucial link to its land-dwelling past. A cry goes up from a small group who have been searching the rear part of the whale. They have found one of the vestigial hindlegs embedded in the body. A tiny, stunted, thighbone that had once been used to walk on land, but had now withered away to almost nothing.

Looking back at this once mighty beast it was hard not to marvel at its ancestry. Here was an animal that had completely abandoned life on land. It was a sea creature that had accidentally returned to a place it could no longer survive. Yet as a mammal it is more closely related to you or me than the fish it used to swim alongside.

Above: The team are pleased to discover one of the vestigial hip bones embedded in the fin whale's body. The pelvic anatomy of whales exemplifies how evolution has transformed body parts that lost their importance as the animals changed their lifestyle.

Opposite: Fin whales are the fastest of all the whales. They can sustain speeds of 37km/h (23mph) and are often nicknamed the greyhounds of the sea.

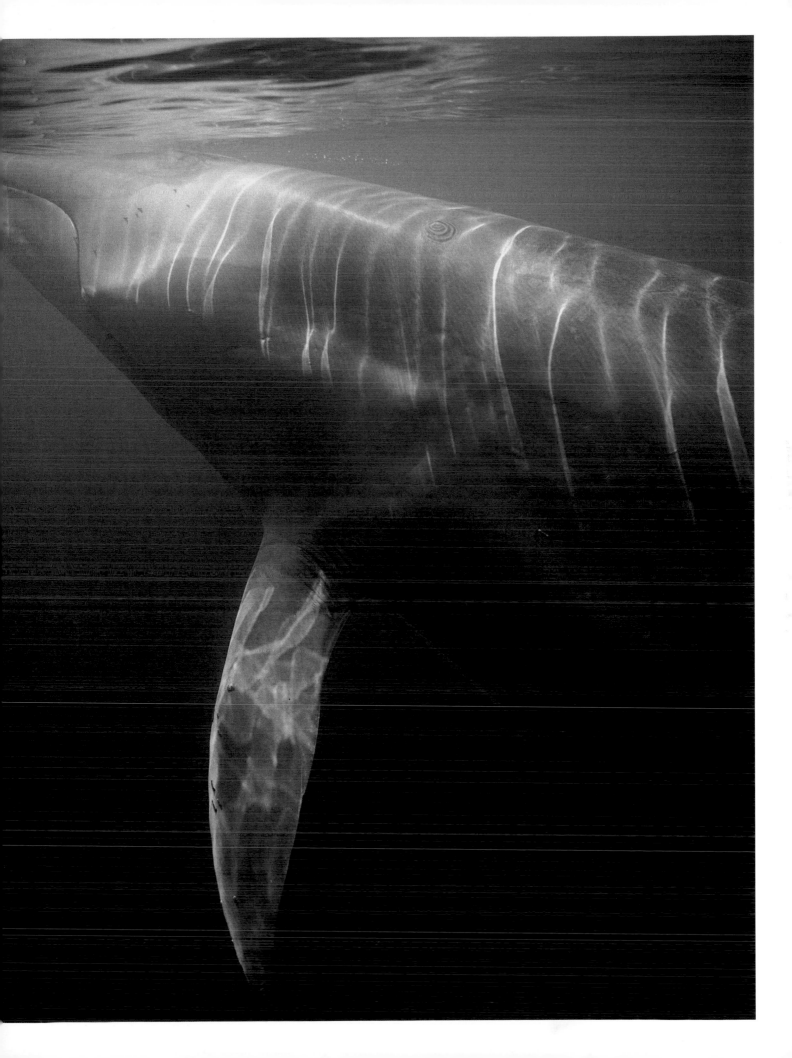

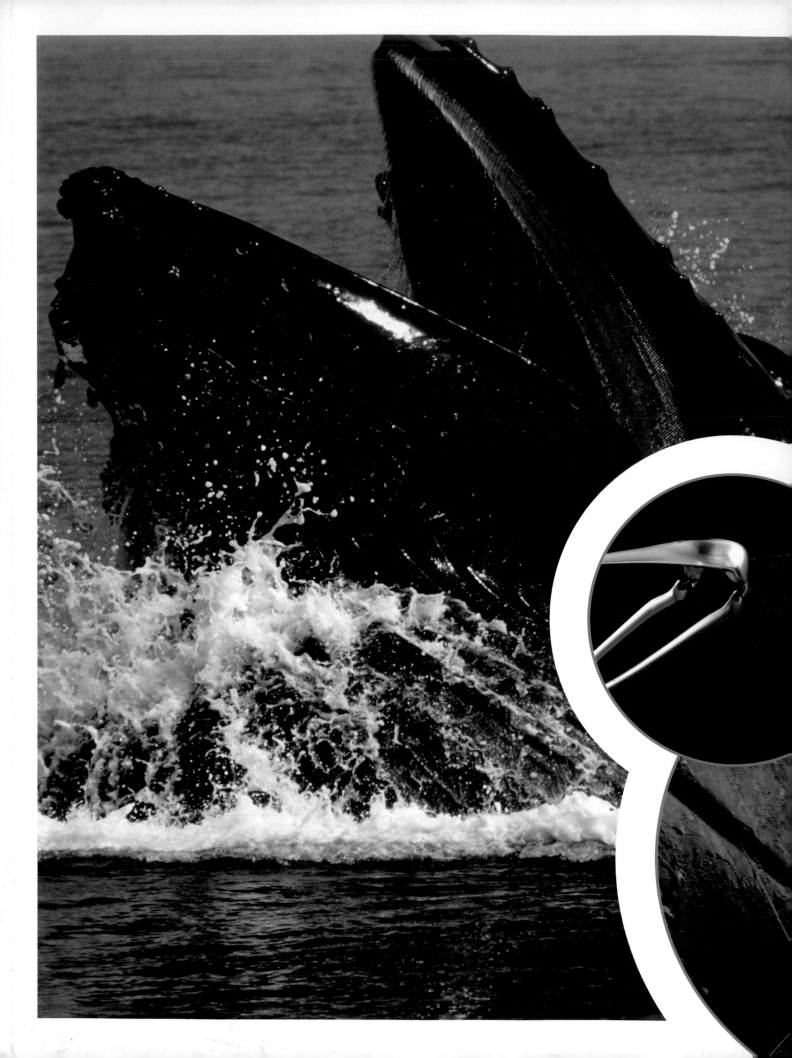

Open Wide: How The Fin Whale Feeds

When a fin whale wants to feed it dives at great speed towards a shoal of krill or small fish. It opens its jaws so wide each side disarticulates. Its throat pleats expand as a vast volume of water pours in. Its mouth becomes a swimming pool seething with tiny marine organisms; now it needs to filter them out. By contracting its throat muscles and raising its enormous tongue, it forces the water out, leaving the krill trapped inside by fibrous fringes hanging down from the roof of the mouth. These fringes are the frayed ends of its baleen plates. Instead of teeth, the fin whale has two racks of baleen growing from its upper gums. They perform a function just as vital as teeth. They act like a sieve, straining out the tiny fish and krill. The muscular tongue rises up to compact the prey against the inside of the baleen plates and then pushes the food on its way down the oesophagus to its multi-chambered stomach. An average mouthful will yield about 10kg (22lb) of food, but after many hours of lunging they can consume up to 1,800kg (3,970lb) a day. Baleen is a defining feature of a large group of whales – it is an adaptation that enables whales to survive on huge quantities of tiny sea creatures. Yet remarkably, if you look at the unborn foetus of a baleen whale, small teeth appear as its jaws develop. These then gradually dissolve away to be replaced by baleen plates. This strongly suggests an evolutionary pathway: that baleen whales are descended from toothed whales. Baleen, or whalebone, as the whalers used to call it, is not made of bone – it's a horn-like substance called keratin, the same material as fingernails and hoofs. It was highly prized in the 19th century because it was both strong and flexible, much like plastic is today. Its uses included whalebone corsets, collar stiffeners and parasol ribs.

Two Suborders

Whales divide into two Suborders: the toothed whales (these include killer whales, sperm whales and dolphins) and baleen whales (these include fin whales, blue whales and right whales). The number of baleen plates varies from around 150 to 450 on each side. Their length varies enormously, too. In the grey whale they are just under half a metre (20in) long; whereas in the bowhead they reach 4.5m (15ft). Fin whales have between 260–450 plates, each 70–90cm (2–3ft) in length.

Polar
Bear

··

Ursus maritimus

David Dugan

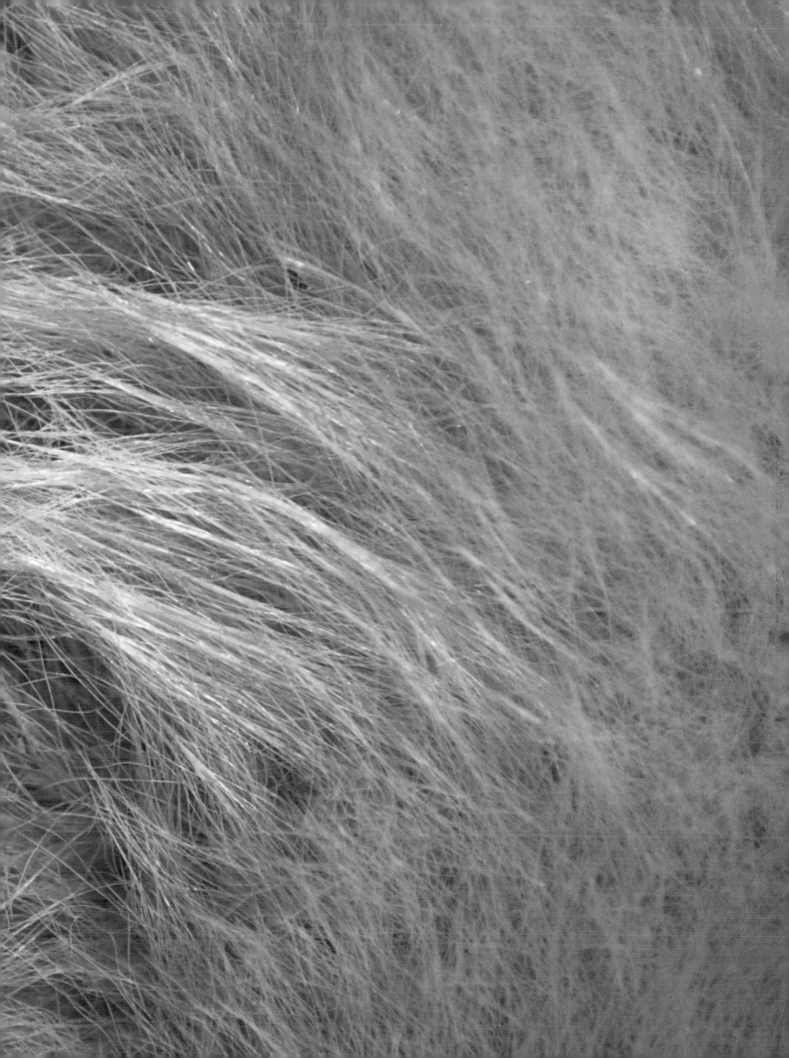

The helicopter skims low over Scoresby Sund, a semi-frozen fjord off the east coast of Greenland. We scan the deeply rutted sea ice in the hope of seeing a polar bear, even though we know the odds are small. We are about to join an international team of scientists led by Rune Dietz and Christian Sonne from the National Environmental Research Institute in Denmark. Scientists from USA, Canada, Norway and Denmark have gathered here to monitor the impact of pollutants in the Arctic – in one of the last places on Earth they can collect samples from freshly killed polar bears. We are sharing this chance to explore the anatomy and evolution of the largest living bear.

Rising above a headland we see the brightly covered roofs of the remote outpost where we are about to touch down, just above 70ºN. Ittoqqortoormiit (or Scoresbysund, as the Danes know it) is a small village of fewer than 500 people who live on hunting, fishing and adventure travel. All the houses are buried deep in snow and snowmobile and dog sledge are the only methods of transport.

As the dark winter gives way to longer days at the end of February, the sea ice starts to melt. For polar bears this is a prime time for hunting seals. One step up the food chain, Inuit hunters are ready to hunt the bears. Only professional hunters who live in Greenland and hunt in the traditional way using dogs and sledge are licensed to hunt polar bears, and the bear quota for this season is 35. For these families, eating polar-bear meat and drying the skins is their traditional way of life. The government's quota system ensures that hunting is sustainable.

Danish scientists have been monitoring bears since the 1980s and have recorded high levels of pollutants in their tissue, including mercury and organic compounds such as PCBs, contaminants blown north from industrialized parts of Europe and the USA. The more recent concerns are brominated flame-retardants used in plastics, which are fat-soluble and fool the body into confusing these compounds with their own biochemistry. These may be reducing polar bears' immunity and altering their reproductive biology, at a time when global warming is

Opposite above: The team flies to Greenland, located between the Arctic and Atlantic Oceans, east of the Canadian Arctic Archipelago. Physiogeographically it is part of the continent of North America.

Opposite below: The polar bear is largely native within the Arctic Circle encompassing the Arctic Ocean, its surrounding seas and land masses. It is the world's largest land carnivore and is classified as a vulnerable species.

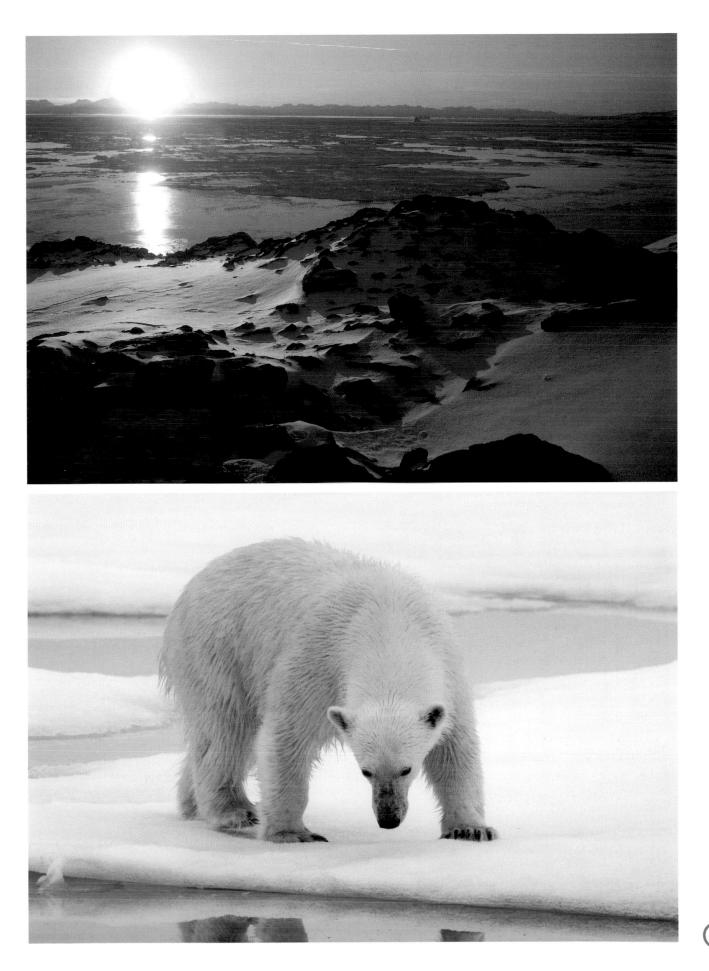

melting their habitat. If polar bears are also becoming more vulnerable to infectious disease and breeding problems, then it's important to find out urgently. Researchers have seen evidence of shrinking gonads, smaller penile bones and lesions in the testes. A strange form of pseudo-hermaphroditism has also been observed, where the clitoris of female bears has become enlarged like a penis. Is this hormonal confusion related to pollutants progressing through the Arctic food chain? This is one of many things they want to find out.

The scientists have set up their lab in an abandoned school on a remote peninsula called Kap Tobin, several miles from the village. Just before we are due to set off to join the scientists, Robin Scott, our cameraman, goes up the hill overlooking Scoresbysund to film distant ice flows on a telephoto lens. Suddenly he notices some dots on the edge of the sea ice several miles away. He quickly swings his camera around. There in the distance, he sees a team of dogs, with a hunter taking aim at a polar bear. The polar bear staggers. A lone dog runs across to the bear to block his retreat; the bear falls with the hunter's second shot. We call Rune to warn him we may have our first bear.

We race down through the town on our snowmobiles to the edge of the sea ice, but then stop. The hunter has crossed this ice on a dog sledge, which is much lighter than a snowmobile. We can see cracks in the ice and are wary of venturing out. Luckily, the head teacher from the school happened to be passing on his skidoo. After dropping his children off, he kindly agrees to lead us on to the ice. He travels slowly, carefully going round in a big arc towards the little figures in the distance by the water's edge. As we get closer we can see other dog teams have come out to the scene of the kill.

Above: A typical polar bear litter consists of a pair of cubs. Mothers are extremely protective and are constantly vigilant for roaming male bears who may try to kill and eat her cubs.

Above left: It was the polar bears that drew the first settlers to Scoresby Sund, a hunter's paradise. Almost a century later, the local people still rely on traditional hunting.

Above: The sad sight of a polar bear's head resting on its rolled up skin on a hunter's dog sledge.

There, surrounded by a closed circle of men in fur hats, lies the white bear. Dead. The young man who has shot it looks in his early 20s and he now starts sharpening his knife. I can't take my eyes off the bear's tongue. It's coated in red snow and hangs between its huge canines. The young hunter in his powder-blue fur hat crouches down to start skinning his bear. He doesn't speak English, so the teacher translates. We ask him if he is prepared to wait for the Danish scientists to arrive to collect samples, before skinning the animal. We call Rune on the phone again to see if he can persuade the hunter to collaborate, but this is his first bear of the season. All this proud young man wants to do is to skin the bear and take the meat home. He is not interested in science or money. This is a rite of passage that's been passed down from father to son over many generations. He's suspicious of any outside interference.

More hunters and elders from the community arrive on the ice to help butcher the animal. He distributes the meat in polythene bags; then rolls up the skin, still attached to the head, and places it on his sledge. It's an incongruous sight, as it slides past against the red sky. We watch as the last dog sledge disappears into the distance. All that's left is a red stain on the snow. Returning to the village, we feel an odd mixture of emotions: exhilaration for the hunters, frustration for the scientists and sadness for the bear.

The following evening the Danish team invite the local hunters to a meeting at the community centre. They want to convince them to phone immediately after they have shot a bear. Rune and Christian patiently explain with tables and graphs the point of their research and why they need fresh organ samples within 30 minutes of the animal dying. There's one set of numbers that catches the hunters' im-

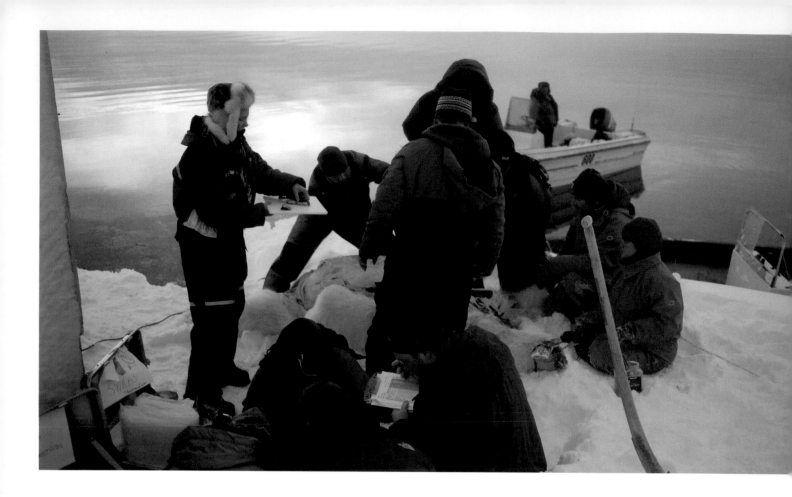

mediate attention: the reward for allowing the scientists to take samples, and the hunters agree to collaborate. Now all we have to do is wait for the call.

While we wait for them to find bears, we ask the young hunter who shot the bear the day before if we can borrow the skin to take a more detailed look. When you look closely at the fur and skin of a polar bear you realize that neither are white. The polar bear's nose and lips are black, and so is the area around its eyes. In fact the entire skin is black, an ideal colour for absorbing and radiating heat to warm the air in the insulating layer of fur. Bizarrely, polar bears are more likely to suffer from overheating if they have to run or exert themselves, than from being cold, such is the superb insulating properties of its fur.

Although the fur looks white, when you examine individual hairs under a microscope, you see that they are thin hollow tubes with no pigment. Through total internal reflection they reflect back sunlight in a similar way to crystals of snow. This is why the fur looks white. When the sun sets and casts a yellow light across the snow, the fur takes on a yellowish hue, too. This ability to reflect the same colour as the snow ensures the polar bear is perfectly camouflaged for its habitat. So it's a black animal, with colourless fur that ends up looking white.

When polar bears have been feeding well, the oils from their prey can make the fur look off white. The oils help the fur to retain its insulating properties when wet. Polar bears spend a lot of time swimming in these icy Arctic waters so they need to survive cold water. The fur works well in water, as any Greenland hunter, who has worn a pair of polar-bear fur trousers and fallen into the sea will confirm.

Because they are so well camouflaged, when polar bears wander in from the sea ice at the end of the winter they often take people by surprise. It's not uncommon

Above: As the dissection team assemble, the scientists are careful to follow the etiquette of the traditional hunters. Only the hunter who killed the bear is allowed to cut the precious skin.

Opposite: This electron micrograph of polar bear hairs shows that the hairs are hollow. This makes them look white and helps keep them warm.

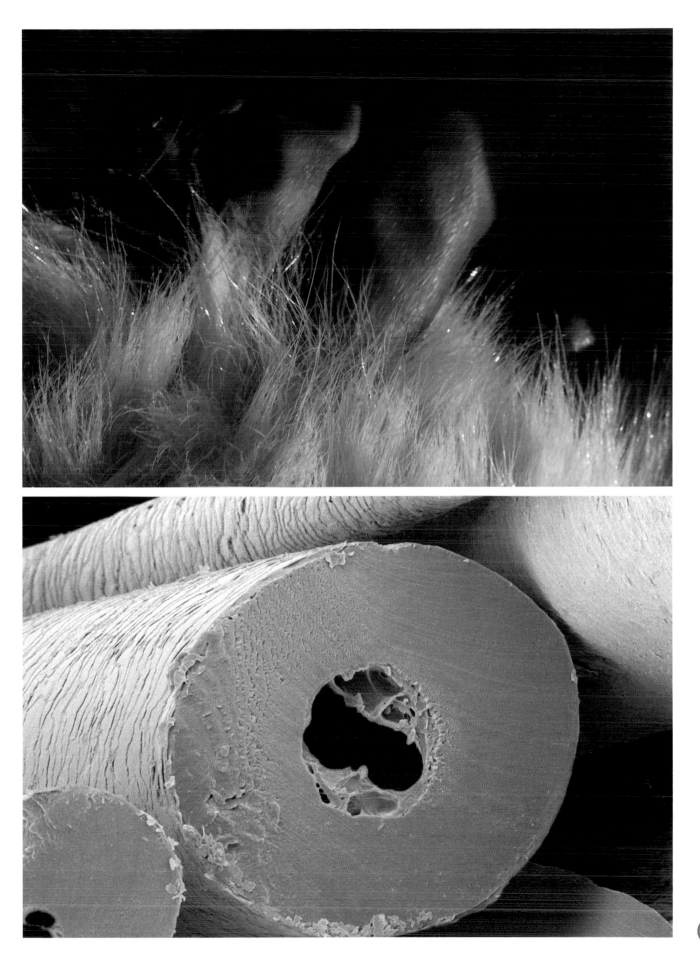

When female polar bears retreat to their dens to have cubs, they do not pee for months. Perhaps the kidneys have adapted to cope with this. There's another feature of the high-fat and low-protein diet that helps pregnant mothers survive without food for up to eight months (probably the longest period without food of any mammal). Digestion of protein requires water, whereas digestion of fat releases water, so they remain hydrated while they wait in their dens till their cubs are three months old.

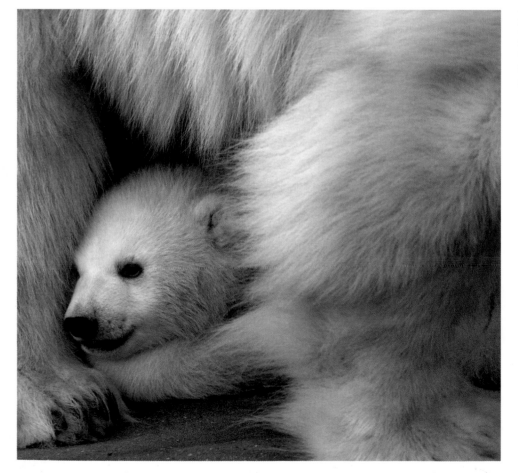

Left: Polar bears do not hibernate. Expecting mothers spend the winters in dens, but the others stay out on the pack ice and continue to eat, sleep and hunt.

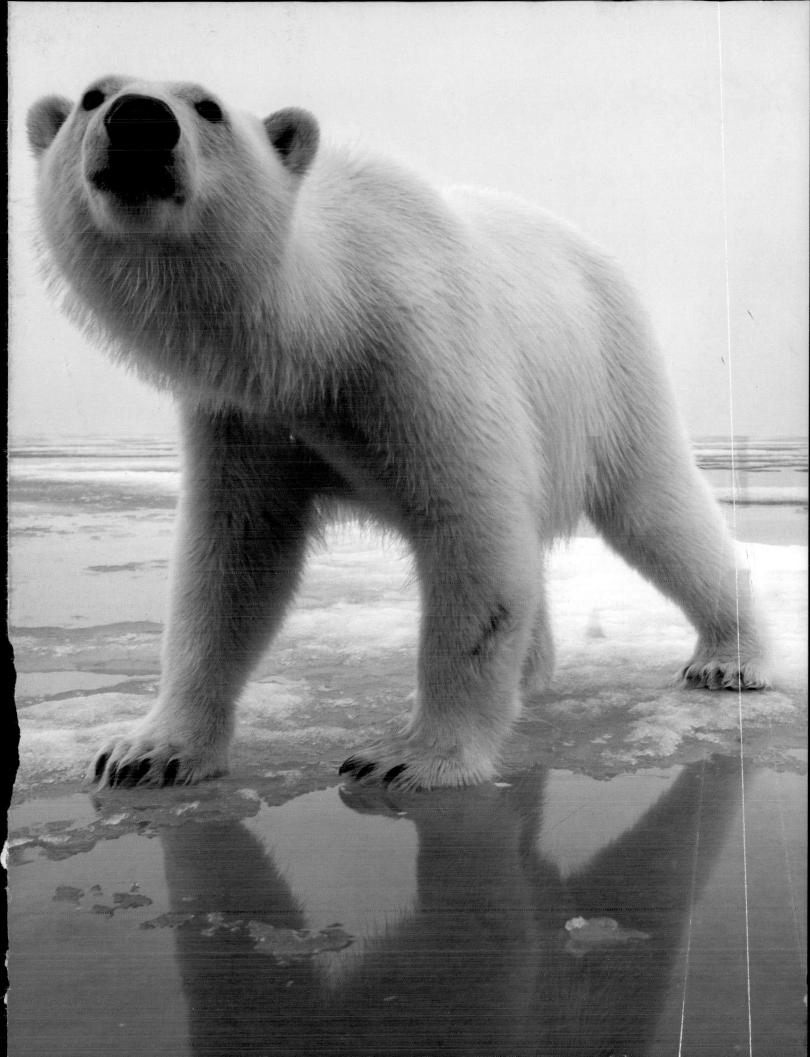

Head and Jaws

The long neck and streamlined head of the polar bear have probably adapted to reach into breathing holes that seals emerge from. A grizzly bear's massive head would get stuck. Close examination of the masticator muscles reveals that the muscles that close the jaw are much larger than those that open the jaw, providing the bear with a powerful grip to haul the seal out of the water.

Snow White Fur

The polar bear is a black animal, with colourless fur that ends up looking white. The polar bear's nose and lips are black, and so is the area around its eyes. In fact the entire skin is black – an ideal colour for absorbing and radiating heat. And although the fur looks white, under a microscope individual hairs are thin hollow tubes with no pigment. Through total internal reflection they reflect back sunlight. When the sun sets and casts a yellow light across the snow, the fur looks yellow. This ability to reflect the same colour as the snow ensures the polar bear is perfectly camouflaged for its habitat.

Liver

The polar bear's liver has exceptionally high levels of Vitamin A. This part of the polar bear is never eaten because it's lethal to humans (and to sledge dogs). Polar bears accumulate high levels of Vitamin A from ringed seals, which need so much Vitamin A for growth and pup development.

Gall Bladder

How has the polar bear adapted to cope with a high fat diet of blubber, sometimes as much as 50kg (110lb) in one sitting? Its blood lipid levels would be lethal for humans. The polar bear avoids problems by breaking down the fat using bile produced in its large gall bladder. Bile acts like soap, emulsifying fat and breaking it down into globules. Once broken down, the pancreas produces lipases that break it down further. Then the nutrients from the fats go back to the liver.

for polar bears to walk into the school play area at Scoresbysund. We were warned to carry a rifle or flare gun at all times, especially at night when they are very hard to see until they are just a few metres away.

When the sea ice melts, the hunters also use boats to hunt. One afternoon Simon Watt accompanies a hunter and his young apprentice on a foray through the icy sea. The water has a thin crust of ice easily broken by the metal boat, but there are also heavily frozen areas with much thicker ice. The watchful hunter, appropriately named Scoresby after the fjord, navigates his way through the treacherous slush. After an hour or so we see a couple of distant figures on an ice floe in the shadow of a huge iceberg. As he cuts the engine and we drift closer, we see chunks of blubber scattered across the ice floe. Christian Josefsen, the old hunter from Kap Tobin, has shot a walrus. The decapitated walrus head, with its moustache and tusks, sits forlornly on the ice with a rope tied around it. The head makes a convenient anchor for the hunter's boat.

Polar bears occasionally hunt walrus as well as seals. Christian knows the smell of walrus meat may lure polar bears towards Kap Tobin. Polar bears are complete carnivores. There's no opportunity to eat vegetation out here. Their diet is primarily ringed seal and the larger bearded seal. Polar bears gorge themselves on these fat-laden seals, particularly in spring and early summer when they put on a huge amount of weight to last them through the winter. Being large is an advantage for any marine mammal trying to stay warm in a cold climate; more importantly the fat provides a convenient portable energy store when there's no food available.

Returning from our boat trip as we approach the boat landing area, we can

Above: Polar bears feed mainly on ringed and bearded seals, and, depending on their location, they also eat harp and hooded seals, as well as the occasional walrus.

Above left: Polar bears are strong swimmers. They can swim for several hours at a time over long distances, swimming between land and sea ice floes to hunt seals.

Top: The team of researchers use a syringe with a large bore needle to draw blood samples from the bear's major blood vessels for analysis.

Polar Bear:

Weight: ...
410kg (900lb) (m)
Height: ...
2–3.7m (8–12ft)
Length male / female:
N/A
Life Span: ...
15–42yrs
Top Speed: ..
40km/h (25mph)
Bite strength pound force:
N/A

Fat Layer

Even though polar bears eat blubber, they don't have their own blubber layer, unlike many marine animals that have this insulating layer of fat. Instead, they depend upon their fur's air-trapping and water-shedding abilities. Waterproof fur allows polar bears the extraordinary ability to maintain insulation while swimming, and not to freeze when they come back out of the water.

Diet

Polar bears are total carnivores, occasionally hunting walrus but primarily ringed seal and larger bearded seal, and it has no chance of eating vegetation. Polar bears gorge themselves on fat-laden seals in spring and early summer to last them through winter. Being large is an advantage for any marine mammal trying to stay warm in a cold climate; more importantly the fat provides a convenient portable energy store when there's no food available.

Paws and Claws

The fur round a polar bear's paw is thick and extends on to the pad itself to help gain purchase on slippery ice and insulate the paws from the cold. The claws are shorter and more sharply curved than on grizzly bears. This is probably a crampon-like adaptation for clambering over snow and ice, as well as for grabbing hold of seals emerging from breathing holes.

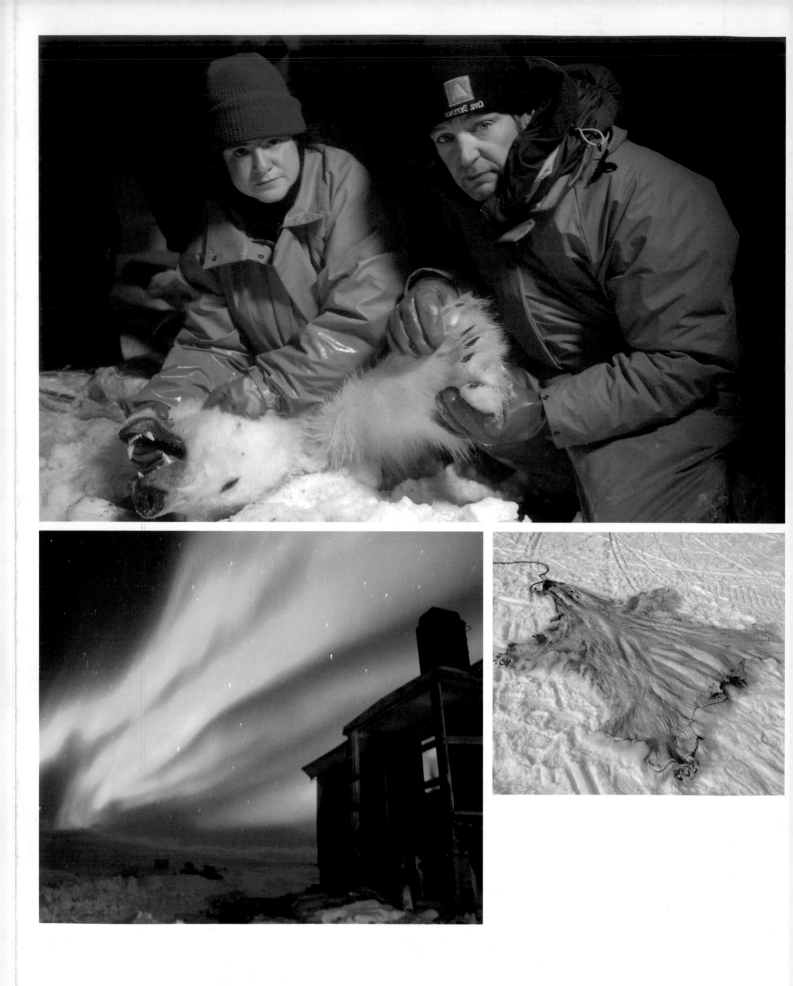

see there's a commotion. Another polar bear has been killed and it's been brought ashore. This time the hunter has alerted the scientific team. Rune and Christian have just arrived and are preparing their sample bottles and plastic pouches. This animal was killed two hours before, so the tissue will not be fresh enough for some of their tests, but they will still take samples. By torchlight the hunter starts to make the first incision. The scientists are careful to follow the etiquette of these traditional hunters. Only the hunter who shot the bear is allowed to remove the skin, which is the most valued part of the bear. After the mid-line cut, he peels back the skin to reveal the layers of fat underneath.

The female polar bear we are about to dissect is a relatively small animal, but males can weigh 600–700kg (1,323–1,543lb) and the biggest bears can reach 4m (13ft) standing on their hind legs. Females are smaller and rarely exceed 400kg (882lb). Once the skin has been carefully removed, the hunters and scientists take out the guts and internal organs. Using a syringe with a large bore needle, Christian draws blood samples from the major blood vessels entering the heart.

Rune and Christian return with the samples to the old school on Kap Tobin where a lab has been set up. Among the dozen scientists staying there are: Nil Basu from the University of Michigan who studies the impact of mercury on the brain of Arctic mammals; Milton Levin from the University of Connecticut who is investigating how pollutants affect the immune system; Tomasz Ciesielski from Trondheim, Norway who is looking at how pollutants affect the thyroid; Bjarne Strishave from the University of Copenhagen who is studying how organic pollutants affect the production of sex hormones in polar bears; and Robert Letcher a toxicologist from the National Wildlife Research Center in Canada, who has spent 20 years looking at the impact of pollutants on Arctic mammals.

In the evenings we are treated to spectacular displays of the Northern Lights. Ursa Major, the Great Bear constellation, shines brightly; but after several days there are still no reports of polar bears. Then suddenly Rune gets a call on his mobile phone. A hunter has shot a bear and will be bringing it to them by boat. It's a shocking sight to see such a mighty creature being dragged through the water, lashed to the side of a boat.

Once they've unloaded the bear on to level ground, the scientists turn it on its back and stand aside as the hunter cuts through the skin. Inside, the bear is still very warm. Rune and Christian start removing the vital organs as fast as possible. A team of researchers slice small tissue samples from the liver, testes, spleen and lymph nodes. They rush to drop them into liquid nitrogen Dewar flasks.

For scientist Milton Levin, trying to extract live cells from lymph nodes and other tissue is difficult. It's so cold his tissue culture media is freezing. He hopes to find proof that fat-soluble pollutants are compromising the immune system.

Joy and Mark want to find out how the polar bear has adapted its biology to cope with a high-fat diet. The lipid levels found in the blood of a polar bear would be lethal for humans, so how do they cope? They examine the contents of the stomach, finding seal fur and skin, a seal claw and a tail, but no bone or muscle. After killing a ringed seal, polar bears are selective in what they eat. They eat the blubber, as much as 50kg (110lb) in one sitting, and abandon the rest.

They start work untangling the digestive system. After laying out the stomach, small and large intestines, it measures 20m (66ft). The human digestive tract is about 8m (26ft) long, so the polar bear's guts are impressive. When humans eat

Opposite top: Mark and Joy examine the polar bear's short claws, which are both shorter and more sharply curved than on grizzly bears.

Opposite left: The team is treated to stunning displays of the Northern Lights in the evenings.

Opposite bottom: The hunters have skinned and dissected a relatively small female polar bear.

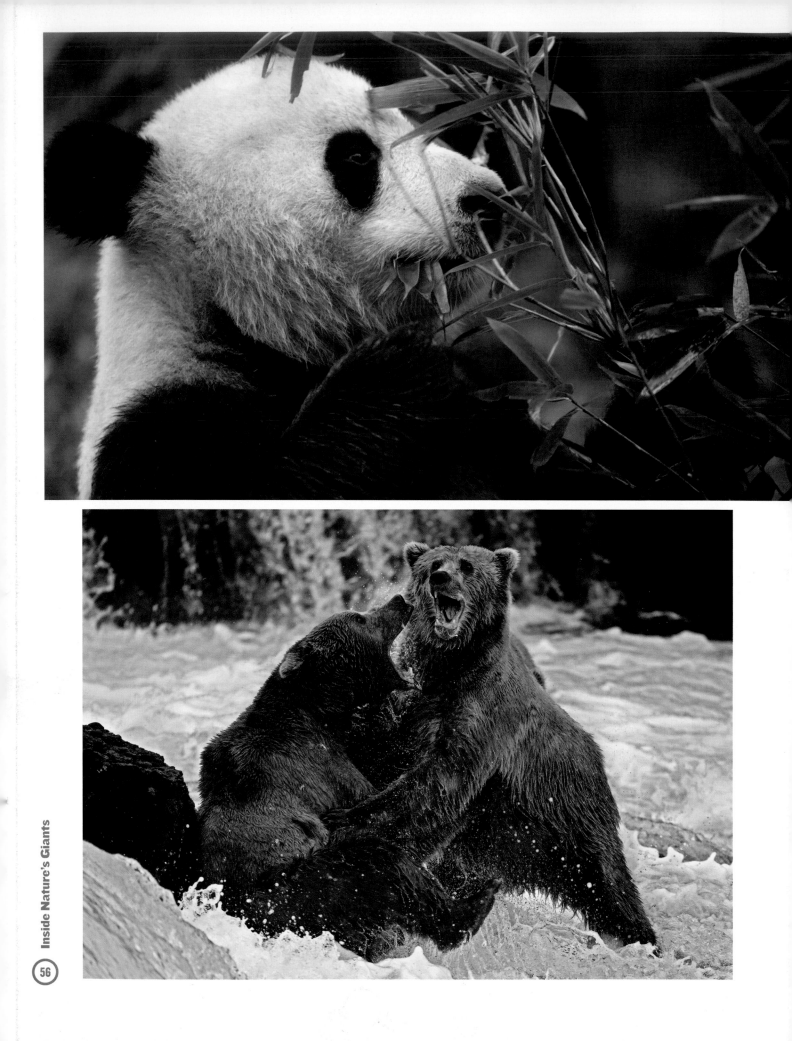

How the Polar Bear Evolved

There are eight species of bear left on Earth. The oldest is the giant panda; the youngest is the polar bear. Tracing the Tree of Life back 22 million years you reach a branch of small dog-like creatures that is sometimes called the dawn bear, *Ursavus elemenis*. It disappeared 10 million years ago, but another branch of larger bears emerged, *Ursus etruscus*, from which six of the eight surviving bear species arose. Around 1.5 million years ago, the brown bears split from the black bears and migrated from Europe to Asia and then finally to North America.

Nobody knows the precise details of how a berry-eating omnivore became the mighty meat-eating marine mammal we know today, but it's easy to imagine brown bears heading to the colder coastal regions half a million years ago and becoming isolated by giant glaciers and advancing sea ice. When they ventured out on to the ice, adaptations to survive the brutal conditions would have slowly emerged: a thicker fur coat, huge paws to improve swimming, smaller ears to avoid freezing, a long, thick neck and smaller skull to thrust their heads into holes in the ice looking for seals. And of course, the characteristic white fur, which provides excellent camouflage when approaching prey.

Around 200,000 years ago a new species was born from grizzlies that wandered on to the ice, Ursus maritimus. The literal translation from the Latin is 'sea bear', but a more accurate description would be 'ice bear'.

Recently analysis of mitochondrial DNA comparing polar bears to grizzly bears from Alaska's Alexandra Archipelago shows that it differs by only 1 per cent. It's estimated that around 6 per cent of bears' mitochondrial DNA genes change every million years, which is why scientists think polar bears split from their closest living relative 200,000–250,000 years ago.

The exact timing is uncertain, but there's no doubt that the polar bear is a very recent species that adapted to change in the climate. They did not exist in the last Ice Age and have only been around in the most recent glacial period. Now as the warmer climate melts their habitat, the adaptations that have made them such daunting and successful predators could become a disadvantage. Currently, there are 20 populations of polar bear around the world that add up to a combined total of 22,000–25,000.

The lack of sea ice has forced polar bears to spend more time on land exploring the shore. In some cases this has brought them into closer contact with grizzly bears; and being such closely related species, they've even successfully mated. The result is a strange looking hybrid, the 'grolar' bear, which is white with brown patches.

Polar Bear

57

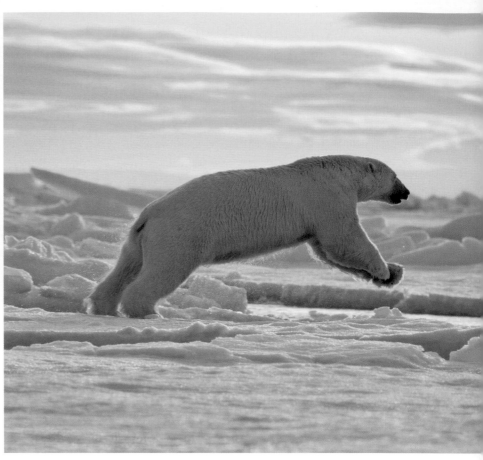

too much fat and cholesterol it leaves fatty deposits in blood vessels and stones in the gall bladder. Somehow the polar bear avoids these problems by breaking down the fat. The secret lies in its large gall bladder. When Joy slices into it, dark green-orange bile leaks out. This is produced in the liver, stored in the gall bladder and released into the small intestine. Bile acts like soap, emulsifying fat and breaking it down into tiny globules. Once it's broken down into these droplets, the pancreas produces lipases, fat-digesting enzymes, which break down the fat further. Then the nutrients from the fats go back to the liver.

By the end of the research expedition, the scientific team manages to obtain 1,500 samples from nine bears. This data will help scientists work out the impact of man-made pollutants on polar bears. And by collaborating with hunters they can see the extent to which global warming is forcing bears from ice onto land.

One of the scientists, Eline Lorenzen, a geneticist from the University of Copenhagen, is recovering ancient DNA sequences from polar-bear fossils and comparing them with modern DNA samples. This technique not only opens a window into the genetic history of the species, but also helps assess how bear populations have reacted to previous episodes of global warming.

The big question is whether polar bears can adapt to a terrestrial life as they are forced to move off the sea ice. Many fear that the loss of ice will have a similar effect to deforestation of tropical rainforests: loss of habitat usually results in loss of species. But if polar bears have survived climate change before, then hopefully they will do so again. As scientists have already observed with the 'grolar' bear, changes in environment can have a rapid effect on the evolution of a species.

Above left: The scientists slice into the internal organs in their search for clues to polar bears' extraordinary survival abilities.

Above: Scientists fear that polar bears may not be able to adapt to a terrestrial life as climate change is resulting in the loss of their habitat.

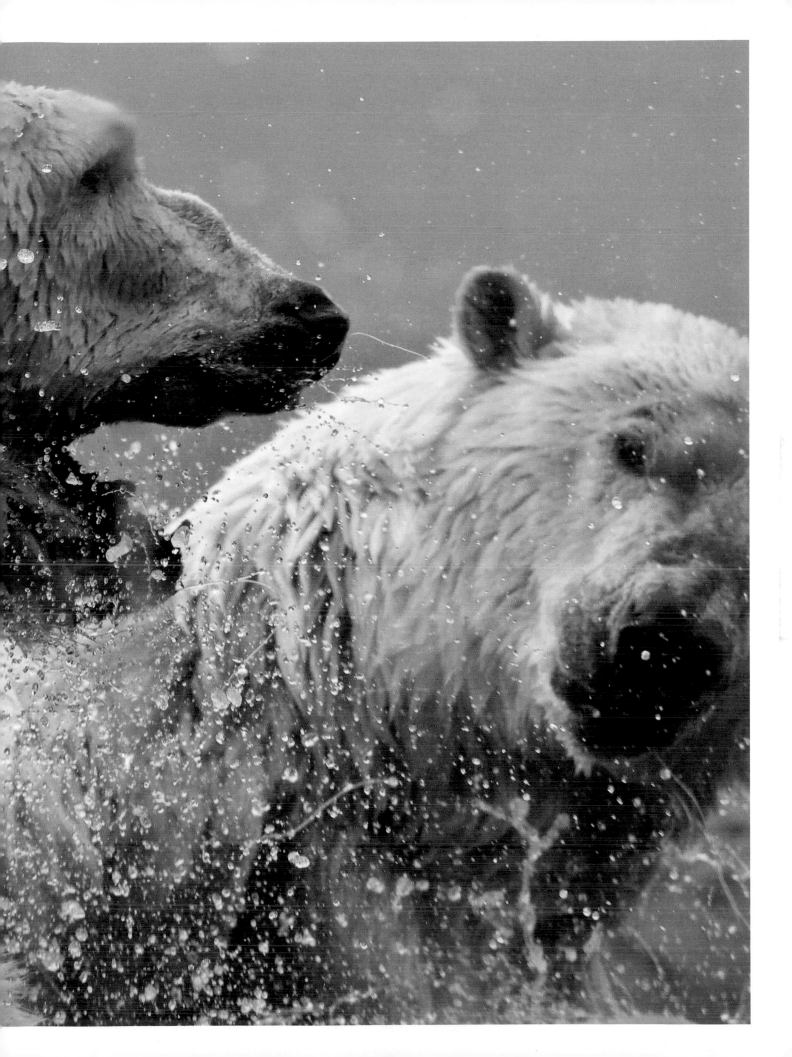

Fat is Fit but Fur is Fabulous
Joy Reidenberg

I spend so much effort trying to get rid of fat, that it's hard to imagine it has any benefits. Compared to all the thin and physically fit scientific colleagues and members of the Windfall Films crew, I was the only one who actually felt too warm in my seven layers of new super-high-tech-insulated clothing! Maybe that's because I was running to the dissection site, climbing over snowdrifts that were taller than me? However, as the dissection progressed, and I had to sit still on the frozen snowy ledge for hours as the sun sank below the horizon, I realized that my insulation was actually adequate for the dropping Arctic temperature. It was not my fat, but rather the layers of air trapped in my clothing, gloves, and boots that were saving my life. Even scarier was the looming thought that a misstep backward could plunge me into freezing water, where I'd die of cold exposure as my clothing's air-trapping abilities were extinguished. I began to appreciate not just the beauty, but the practicality of the polar bear's air-trapping, non-wetting fur coat.

Polar bears do have fat, and most of it is conveniently placed over the belly where it doesn't interfere with leg movements during locomotion. Heat generated during digestion or locomotion can be trapped and used to keep the bear's core warm. Also, it makes a convenient rug to shield out cold when the bear lies on its belly. However, I was surprised to learn that insulation is a very minor role for fat. Rather, its main function is to be the pantry – storage for energy that fuels the bear through lean times that can last several months when prey is scarce. The energy source is seal blubber, the main staple of a polar bear's diet.

Even though polar bears eat blubber, which is also fat, they don't have their own blubber layer for insulation like most other marine mammals. Whales, dolphins, porpoises, seals, fur seals, sea lions, walruses and even leatherback sea turtles have an insulating layer of fat associated with the skin called blubber. Fur coats are useless in these diving animals, as air is compressed at high pressures and squeezed out from the fur. The advantage of blubber is that it's incompressible, thereby retaining insulating abilities at depth. Non-diving marine mammals, such as sea otters and polar bears, never evolved blubber. Instead, they depend upon their fur's air-trapping and water-shedding abilities. I will never forget witnessing this amazing property up-close. When two bear carcasses were brought to us by boat and winched out of the water, I was stunned to see that the fur did not freeze to the ice ledge on which their bodies lay. I touched the fur to be sure it was not stiff. Incredibly, it was still dry, soft and flexible. Waterproof fur allows polar bears the extraordinary ability to maintain insulation while swimming, and not freeze when they come back out of the water.

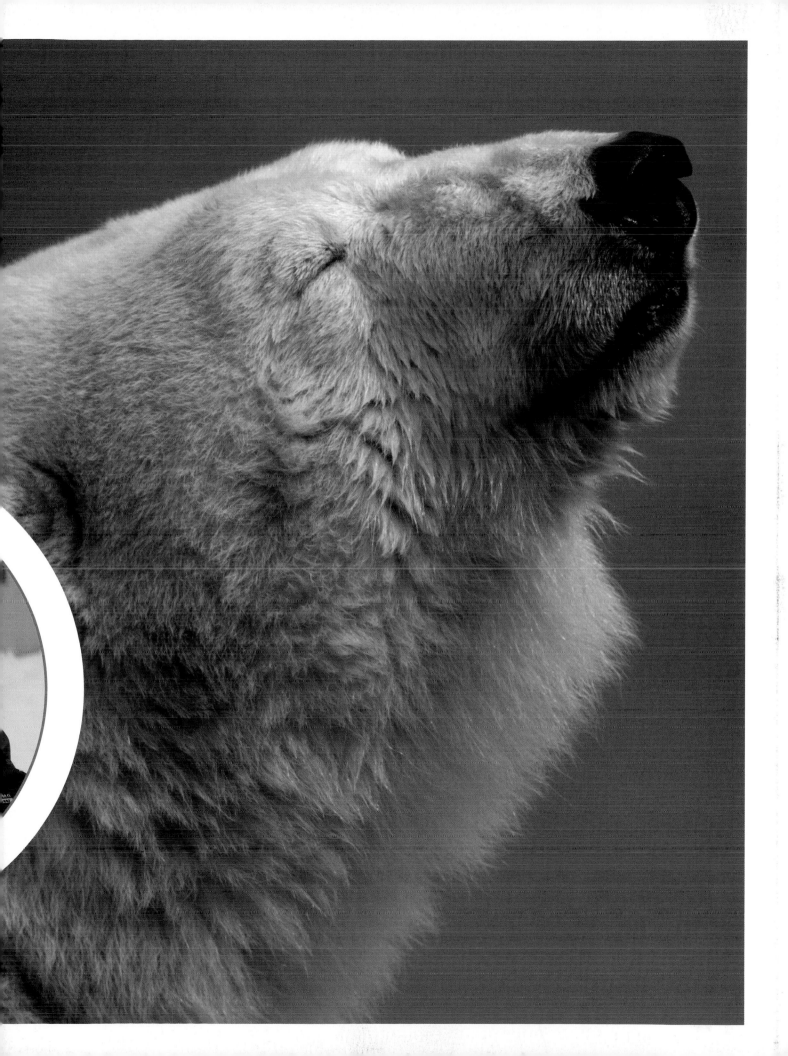

Crocodile

Crocodylus niloticus

Simon Watt

It is another hectic day at the Royal Veterinary College. Our team rushes around, checking equipment, sharpening knives, assembling cranes and camera tripods. Then, as the big back doors to the lab open, there is silence. Silhouetted in the sunlight, hanging vertically from a mechanised winch, is our Nile crocodile. It looks like a dinosaur, arcane and unnatural, yet so real. I am reminded of Tick-Tock, the crocodile that swallowed a clock and Hook's hand in the Peter Pan stories. It certainly appears like a monster, a worthy adversary for any pirate, a creature that, like Pan, time has forgotten. The evolutionary clock has been ticking for 100 million years now, and the crocodile has remained unchanged.

This particular Nile crocodile had died unexpectedly at a crocodile breeding and conservation centre in the South of France. Samuel Martin, the Director of the breeding centre, had noticed that the crocodile had been swimming strangely and lingering in the water, and was shocked to find it dead just days later. At only 17 years old, its death was a mystery. Normally crocodiles live as long as humans.

Samuel and the dissection team are joined by leading crocodile expert Greg Erickson. Together we hope to find out how this poor animal died and, on the way, uncover this awesome predator's truly ancient anatomy.

At first glance, Greg is impressed; this is a large male weighing 280kg (617lb) and measuring 4m (13ft). From the outside at least, the creature shows no signs of trauma. We start our dissection by looking at the mouth. Greg uses his knowledge, acquired from experiments involving crocodile jaws, to extrapolate and speculate on the workings of the jaws of dinosaurs like Tyrannosaurus rex. Under his supervision, the dissection team flips the animal onto its back, and starts cutting through and peeling back the thick skin of the jaw and throat.

The removal of the skin reveals two massive muscles on the lower side of the jaw, known as the pterygoid muscles. It is these huge muscles that give crocodilians the strongest bite on Earth.

To garner a better understanding of these jaws' lethal capabilities, I joined

Opposite top: The team prepare to dissect a large male Nile crocodile weighing an immense 280kg (617lb) and measuring 4m (13ft).

Opposite bottom left: Mark Evans and Greg Erickson show the extensive jaw of the crocodile.

Opposite bottom right: The crocodile's snout showing the enlarged 4th tooth on the lower jaw.

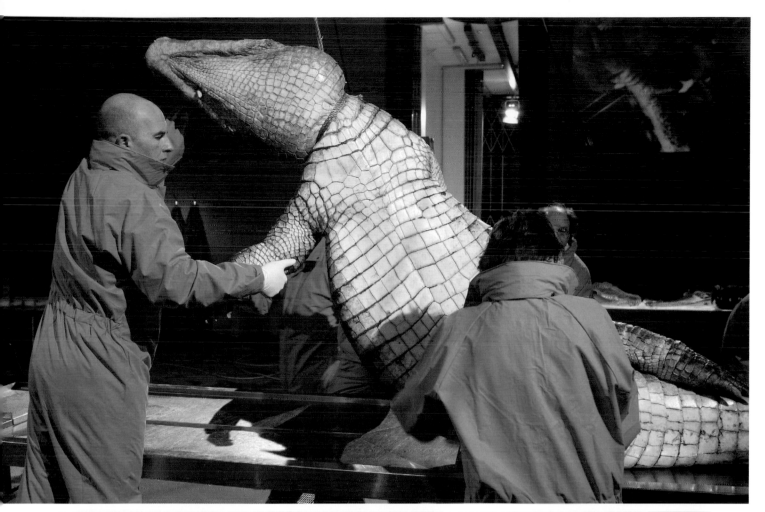

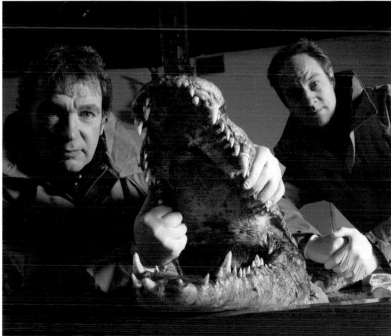

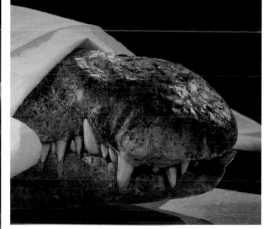

Greg back in his home state of Florida. There, we visited the St Augustine Alligator Farm Zoological Park to see some of his research in action. A large part of Greg's research involves measuring how strongly different types of crocodilian can bite. He had brought a force metre to deduce how powerful the bites of the park's alligators would be. To test it, I gripped it firmly between my teeth and squeezed as hard as I could, but still only managed a paltry 36kg (78.5lb), not even strong by human standards. No doubt a crocodilian would be able to smash my record easily. In anticipation, we padded the metre on either side with thick wads of leather to save it from being obliterated. Greg gathered our camera crew and the animal park staff together to discuss tactics. We singled out a large male in the alligator pit and sprang into action.

Wrangling an alligator into position is not an easy task. First we lassoed it around the neck and dragged it into the open. Next, we had to hold its mouth shut using a small noose before we could secure it in position with a few loops of electrical tape. From our dissection, I was aware of just how the weak the muscles that the crocodile uses to open its mouth are. I knew that the mouth could easily be kept closed with only a few turns of tape, but seeing it in reality, a few feet from the terrifying jaws, was a different matter. You doubt your convictions.

We negotiated the beast onto a strapped board where we could safely anchor its other deadly weapons: its tail and clawed limbs. One of the heavier members of staff jumped atop the gator's back and covered its eyes; instantly the beast calmed. This is one of the favoured techniques used by the park's staff to calm their animals. It seems to tap into the creatures' instincts and, somehow, pacify them. We were ready. We uncovered the eyes and as we unwound the tape from

Above: Joy and Mark examine the croc's immense mouth and jawbones, which are capable of a bite 20 times stronger than the bite of humans.

Above left: A force metre inserted into this alligator's mouth demonstrates the huge force of its bite.

Top: A crocodile can float with only eyes and nostrils exposed, enabling it to approach unwary prey without being detected.

the mouth it opened threateningly with a loud, low rasp. Greg tentatively inserted his force metre between the alligator's teeth which then clamped, viciously, closed. The metre read 641kg (1,413lb), nearly 20 times stronger than my bite. In fact, Greg's research has shown that the American alligator has the strongest bite yet recorded and, of course, the bigger the alligator the more forceful its bite.

Having taken our readings we were now faced with a new problem: how to get our force metre back. Tugging on it, the alligator firmly reasserted its grasp, using about 90 per cent of the initial force. Greg gave a sharp tug and it finally slipped from the gator's mouth leaving chunks of leather trailing behind.

In spite of the awesome, bone-crushing strength of the crocodile's jaws, it is not the bite itself that kills the prey. Though the Nile crocodile spends much of its life in the water, it feeds almost exclusively on land mammals. It cunningly waits, largely submerged in the shallow waters of a river, knowing that its prey will have to brave a trip to the water's edge for a drink. It is a clever tactic and when food does arrive, the crocodile launches itself from the water, with incredible force, and embeds its teeth in the flesh of its prey. Using these anchors, it pulls its victim into the river, dragging it under until it drowns. Its teeth are not sharp; in fact tearing flesh might allow its prey, albeit missing a chunk, to flee. Its teeth are dull and cone-shaped. They are strong, built for grip, intended to be able to sustain stress from any angle and so resist the struggles of flailing prey.

To finish off its victim, the crocodile often employs the aptly named death roll. Firmly gripping its prey, it rolls over and over in the water, submerging it until its struggles subside. While at St Augustine's, our team tried to get a closer look at the death roll. We ventured into a nursery area at the back of the park

Above: Despite its strong bite, the crocodile's individual teeth are dull and cone-shaped. They are built for grip and are unsuited for tearing flesh. They don't need to be sharp with such an explosive force behind them.

where a small lagoon was filled with a large congregation of crocodilians. Resistance is required to induce a death roll. The crocodile won't waste its energy thrashing when scavenging or munching on some of the park's prepared food; it will only fight food that fights back. Greg tied a rope around a large, dead rat and threw it into the water. Slowly he drew it through the water, fishing for crocodiles. The hidden crocodiles subtly coalesced around the lure, doing their best to stay inconspicuous and appear like harmless driftwood. One abruptly lunged forward and, with a quick snap, grabbed the rat. Greg pulled on the rope, entering into a tug of war. The crocodile's instinct kicked in, and it started revolving quickly and violently in the water, thrashing round and round. It was easy to see how swiftly this technique could drown something like a wildebeest. Suddenly, the crocodile won the tug of war and the rat was sheared in half by the twists of the death roll. Greg stumbled backwards as, with elastic recoil, the rat and rope came flying through the air, only to smack me right across the face. Now, being hit in the face with a rat is far from pleasant. Being hit in the face with half a rat is so much worse.

One might think that something as effective as the death roll would put the crocodile at risk of drowning too, particularly when one considers its mouth is held open by its victim's floundering body. But the crocodile's anatomy features some crucial adaptations to prevent this. Its snorkel-like nostrils are fitted with valves that can close its airway and so prevent it flooding with water. Even more ingenious is the way it uses a ridge at the back of its tongue to block off its airway when water enters its mouth. Locking this into position saves it from drowning.

The crocodilian family has evolved a wide variety of different shaped jaws to

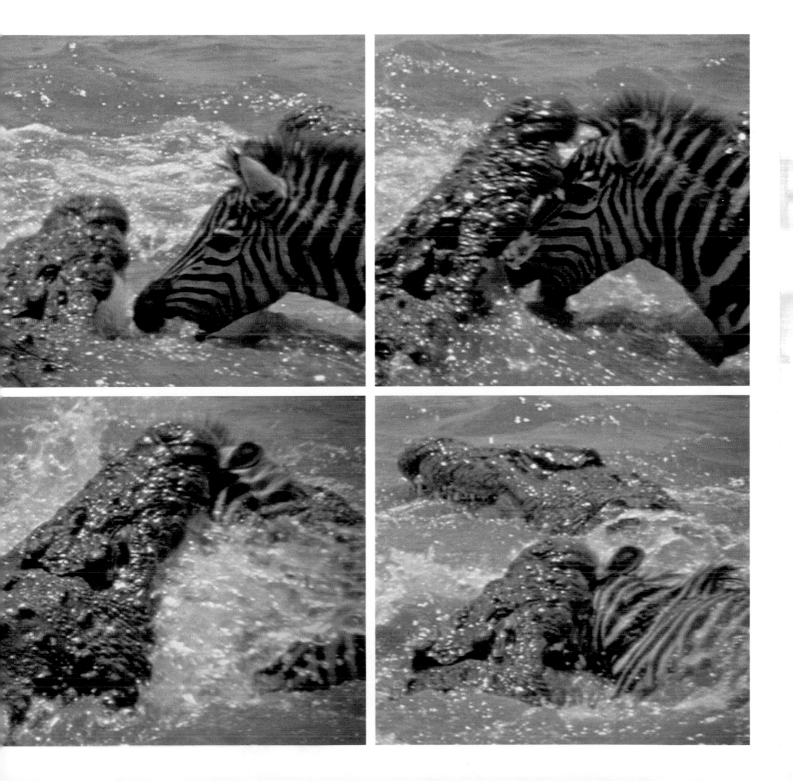

Crocodilians have the strongest bite on Earth – so strong that they can crush the skulls of their prey or the shells of turtles in a single swift motion. While most big biters, like hyenas and lions, have their muscles anchored high on their heads for leverage, the crocodile has its biggest and strongest muscles on the lower side of its jaws. This helps it to keep a low profile in the water.

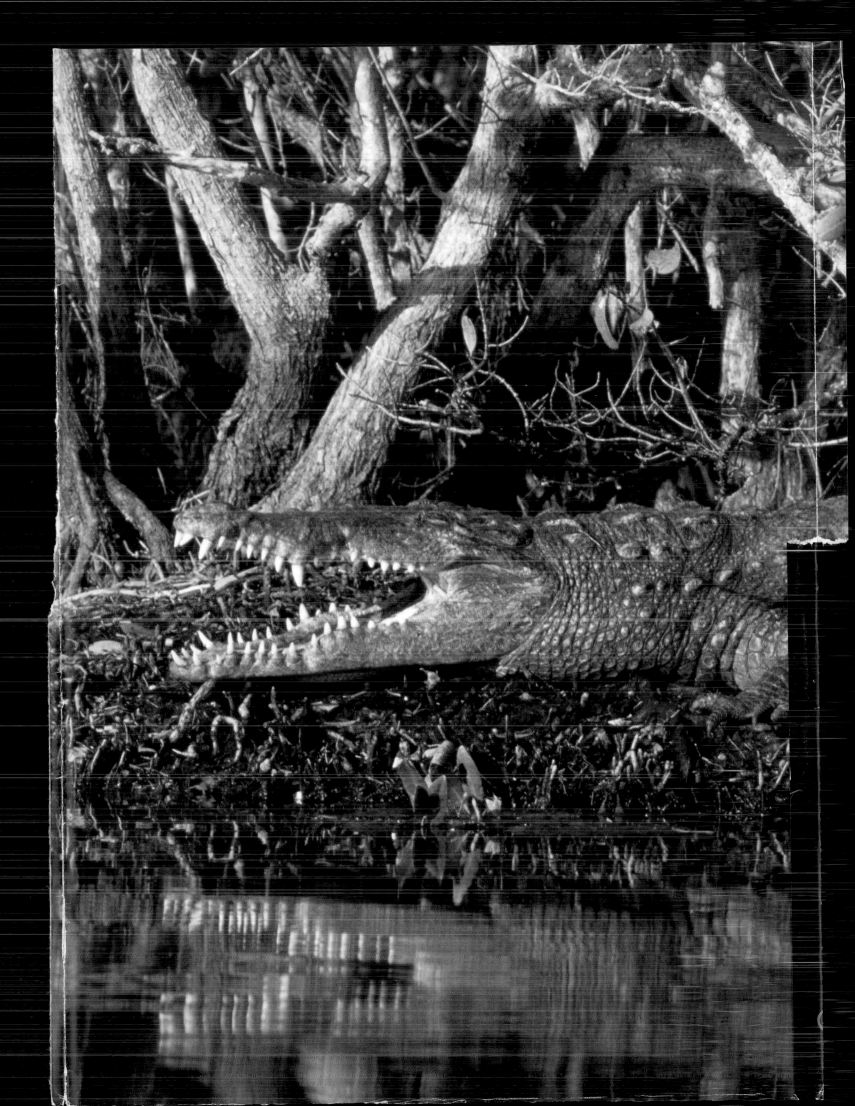

Jaws

The crocodilian family has evolved a wide variety of different shaped jaws to suit the prey they hunt. Nile crocodiles have powerfully strong, low-slung jaw muscles which enable them to keep a low profile. Their ability to lie concealed underwater, combined with their speed over short distances, makes them effective hunters of larger prey on land, including gazelles, zebras, wildebeests and even leopards and lions. They grab their prey in their powerful jaws and drag it into the water, applying the aptly named death roll, until they drown.

Palatal Valve

To avoid drowning when submerged under water – either while lurking on or drowning their prey – crocodilians have evolved a secondary bony palate that enables them to breathe. A tall ridge behind the tongue forms a flap-like 'palatal valve' that seals the mouth from the throat. This protects the airway from water in the open mouth, thus preventing drowning when submerged.

Jaw Muscles

The secret of the crocodile's famously strong bite lies in the two massive oval muscles on the lower side of the jaw, known as pterygoid muscles. Surprisingly, the antagonistic muscles that open the mouth are comparatively tiny. In fact they are so weak that crocodile wranglers sometimes use an elastic band to keep a crocodile's jaw shut.

Trachea

The airway leading to the lungs – the trachea – is longer in crocodilians than in most animals. This extra length allows flexibility to be pulled to the side, thereby allowing the oesophagus, running parallel to the trachea, to undergo immense alterations in size as it fills with irregularly shaped, unchewed lumps of food on their way to the stomach. The trachea also has rings of cartilage reinforcing it, to prevent it being crushed by the pressure from the expanding oesophagus.

Sophisticated Heart

The heart plays a key role in digestion. The compact digestive system of the crocodile has to be effective enough not only to digest flesh, bone and hoof, but to do it quickly, before it starts to rot and produce a toxic brew within the stomach. The crocodile manages this by secreting ten times as much stomach acid as we do, and the secret to this surprisingly lies in its heart. The artery that takes blood from the heart to the rest of the body is called the aorta, and crocodiles have an 'extra aorta' which goes directly to the gut, where the oxygen-depleted blood – which is high in carbon dioxide – may help in creating excessive amounts of gastric acid to assist in digesting the massive prey that they hunt.

Evolution Of The Crocs' Feet

Crocodilians have a flexible, semi-erect posture. They can walk in low, sprawled 'belly walk', or hold their legs more directly underneath them to perform the 'high walk'. To understand the success of the crocodile, we have to go all the way back to the earliest reptiles some 320 million years ago. While the dinosaurs died out, the crocodile remained; its anatomy virtually unchanged for the past 100 million years, surviving repeated mass extinctions. The earliest crocodilians lived on land, chasing down their prey, like the long-legged Terrestrisuchus, a fast runner not much bigger than a rabbit. Today, young, small crocodiles are still capable of galloping in the same manner that we think was adopted by Terrestrisuchus. They may look primitive but, in fact, their bodies are brilliantly adapted to the way they live.

suit the prey they hunt. Not all crocodilians favour brute force. The gharial is a type of crocodile that lives in India and feeds mainly on fish. Compared to the blunt cones of the Nile crocodile, its teeth are more like small needles. Though all the crocodilians share the same bone structure, they develop in different ways. The gharial's jaws are streamlined, built for speed rather than force, intended to snatch fish under the water before they can dart away to safety. Its jaws are not thick and robust but instead are long, thin and more delicate. For the gharial to become faster it had to lose some of its strength; this was a trade-off it had to make. It was a choice between speed and power. A compromise would be ineffective, leaving it too slow to catch fish and too weak to take down large mammalian prey like antelopes or wildebeest.

The crocodile's mouth might be an incredible instrument, but it is not built for chewing. Although the death roll can help by tearing prey into more manageable chunks, most of its food is swallowed in enormous gulps. It can consume a third of a wildebeest, the equivalent of more than 500 hamburgers, or 20 per cent of its own body weight, in a single sitting.

Looking at the stomach contents of our Nile crocodile, we could quickly see that something is wrong. It is filled with a bile green soup in which croutons of a white, waxy, cheese-like substance are floating. There is a single pebble among the gunge, but this is nothing alarming. Crocodiles, like chickens and many other animals that can't chew, are known to swallow small stones that rattle around in their stomach and can help to break down food mechanically, as a substitute for masticating. The stones can also act as ballast, helping the predator to disappear beneath the water.

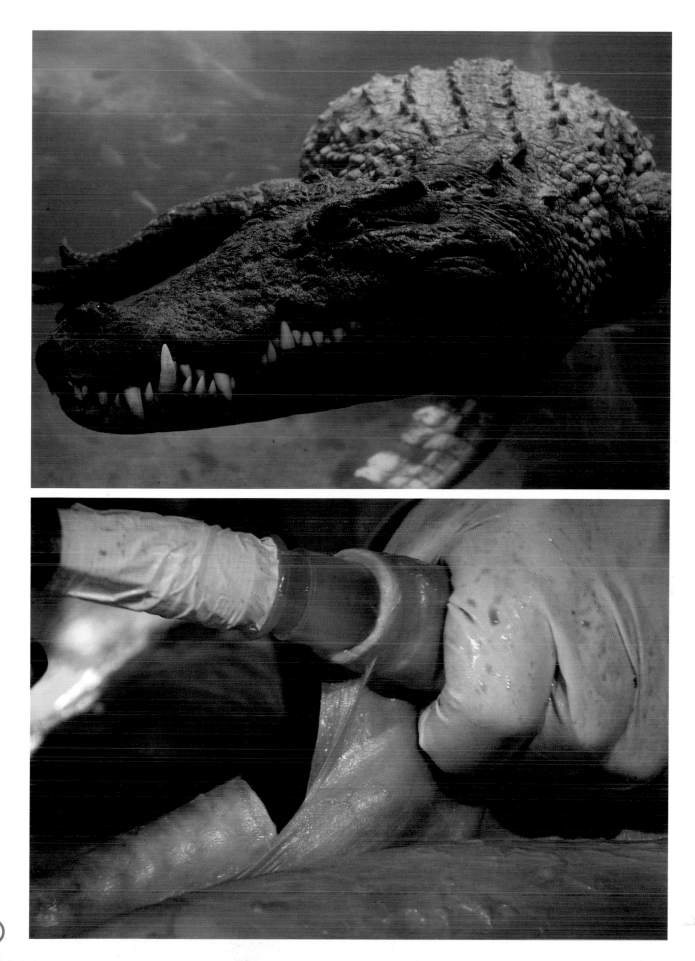

Thick Skin

The skin on a crocodile's topside is coarse and bumpy. Each bony bump is known as a scute and is covered with a dense layer of keratin, the main protein we find in our nails and hair. Crocodiles need this thick skin to protect them in their fight for survival, but these plate-like bones have another purpose which helps explain why crocodiles have survived for so long. Tiny blood vessels weave their way through the skin to form a lattice below the skin to act like solar panels all along the back of the crocodile, absorbing heat. Warming up allows their metabolism to speed up, and their bodies to keep active. When the temperature drops, they can shut off the blood supply to any inessential organs. Crocodiles are living proof that, because they are cold-blooded, they can slow down their metabolism and survive on a minimum of food and warmth.

Liver

When inhaling, the crocodile uses the intercostal muscles on its ribs to expand its chest, just as we do; but it also has another, unique mechanism. Its diaphragmatic muscles attach to the pubic bone and when these contract, they pull back on the liver and expand the pleural (chest) cavity. The liver acts like a piston, allowing the lungs to suck in more air. Incredibly, when holding its breath, it can also use the diaphragmatic muscles and liver to shift the physical position of the lungs and so alter the crocodile's centre of buoyancy, adjusting its location in the water like a submarine. This superb adaptation allows it to sink below the surface of the water without a ripple or splash.

Crocodile:

Weight: ...
227kg (500lb)
Height: ...
N/A
Legnth male / female:
5–6m (16–19ft) / 3m (11ft)
Life Span: ..
55yrs
Top Speed: ...
13–16km/h (8–10mph)
Bite strength pound force:
4,000lbf

Tail

Amazingly, most of a crocodile's body is made up of muscle, with the organs positioned quite compactly – only a small proportion of its body holds its vital organs. The crocodile's tail is one of its most impressive features, spanning about half the length of its body. It has the capacity to propel itself forward in water at enormous speed and with great strength. Slow and tiny contractions move the crocodile silently forward, while fast muscle contractions can accelerate it to swim speeds up to 10–15km/h (6–9mph).

By looking through the intestines and the rest of its digestive system, we could tell that this crocodile has not eaten for a long time. Samuel speculates that the dark green mulch in the stomach might be a result of having consumed some leaves or vegetable matter. Mark suggests pica, a condition characterised by a deranged appetite to consume non-food items. Such a symptom in animals could suggest an underlying illness. In itself, this would not have been the cause of death; it looked unlikely that there had been some form of toxic reaction. Our search continued.

The dissectors delve deeper into the chest cavity, this time looking at the lungs. When inhaling, the crocodile uses the intercostal muscles on its ribs to expand its chest, just as we do; but it also has another, unique mechanism. Its diaphragmatic muscles attach to the pubic bone and when these contract, they pull back on the liver and expand the pleural (chest) cavity.

During the dissection, Joy points out that the trachea, the airway leading to the lungs, is longer than in most animals. Perhaps this is to allow leeway for the additional movement of the lungs within the chest. Or maybe it enables the trachea to move aside and allow additional room in the throat area. The oesophagus, running parallel to the trachea, can undergo immense alterations in size as it fills with irregularly shaped lumps of food on their way to the stomach. The trachea even has rings of cartilage reinforcing it, to prevent it being crushed by the pressure from the expanding oesophagus.

To get a better picture of the size of the lungs, Joy slits open the trachea, so that compressed air can be blown into the lungs to inflate them. As the organs balloon out, Professor Alun Williams, the RVC veterinary pathologist, notices that the right lung is not inflating fully due to some strong adhesions between the tissue and the chest wall. Crocodiles can normally inhale four times the volume of air that we can, allowing them to hold their breath and stay submerged for up to half an hour. Our crocodile seemed to have incurred some serious damage and was definitely suffering from a respiratory problem. A closer look at the lungs reveals many large abscesses. When Alun cuts into one of these, he finds that it is thickly encapsulated, evidence that the initial damage had occurred at least weeks before. Perhaps an infection of the lungs is what caused the croc's death.

With the trachea already cut open, Joy could not resist using the compressed air in the other direction and forcing it through the vocal apparatus. The larynx is Joy's specialist area. Her research focuses on this organ in whales, but she is always keen to examine it more closely in any animal she has a chance to study. She re-attaches the air pump to the trachea and forces air through the voice box in a sharp burst. The crocodile lets rip with a deep, husky bark. This roar is the call that males use during the mating season. At this time of year crocodiles are meant to be at their noisiest, yelling loudly to attract mates or to scare other males away from the best basking sites. These are where males sun themselves and are prime real estate for seducing females. For crocodiles, a strong voice is one of the best ways to show off its masculinity. But Samuel tells us that our crocodile had become quiet and withdrawn – the first sign that he was not well.

Male crocodiles are typically much bigger than females and can grow up to 5.5m (18ft) long compared with 3m (10ft) for females. Size is the easiest way to tell the sex of a crocodile as their sexual organs are internalized most of the time, completely hidden in the cloaca. The testes and ovaries are positioned dorsally,

Why the Crocodile Wears Body Armour

As a cold-blooded reptile, basking is an important pasttime for a crocodile, and its skin is adapted to make the most of its sunbathing. The skin on the crocodile's belly is smooth and leathery, perfect for tobogganing along mud flats. On its topside it is quite a different story. The skin here is coarse and bumpy and on the tail it even forms spines worthy of a dragon. Each bump is known as a scute and is covered with a dense layer of keratin, the main protein we find in our nails and hair. Crocodiles need a thick skin. The battles they fight for territory, food and mates can be ferocious. In skirmishes for food they even have to take on other large and deadly animals like lions and hyenas. The ancient Egyptians and Romans are known to have worn this skin as armour. Greg told us that, back in Florida, he had on occasion picked bullets from the backs of unharmed alligators. It was no wonder that Joy was having trouble cutting into it. Working her way through the thick connective tissues, she removed one of the scutes to show how some contained a small plate-like bone. These plates overlap, leaving no chinks in the animal's armour.

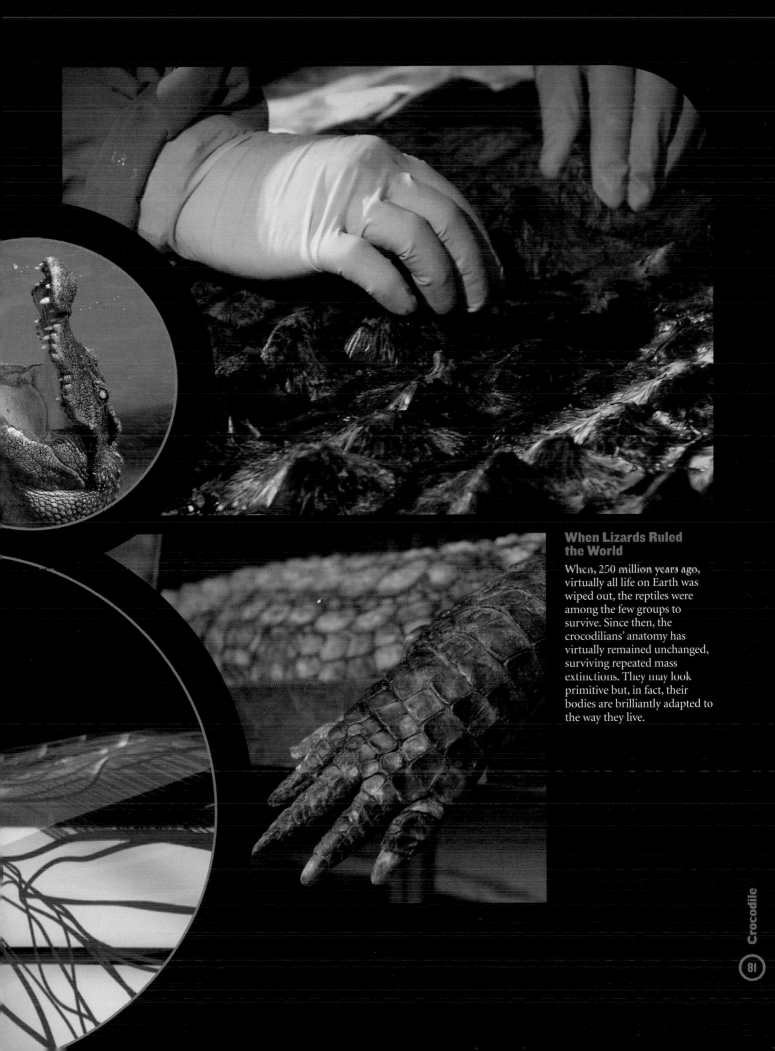

When Lizards Ruled the World

When, 250 million years ago, virtually all life on Earth was wiped out, the reptiles were among the few groups to survive. Since then, the crocodilians' anatomy has virtually remained unchanged, surviving repeated mass extinctions. They may look primitive but, in fact, their bodies are brilliantly adapted to the way they live.

within the abdominal cavity. Sperm are conveyed forward to the penis, which is normally hidden within the cloaca, but can be projected out during mating. In our male, the testes were surprisingly small. At the height of the mating season they should have been bigger, indicating that our male was probably being bullied by rivals. It was unlikely to have been breeding and, worse still, couldn't gain access to the basking sites and so could not sun itself and control its body temperature. Falling ill would have been the start of a vicious cycle, weakening the crocodile, limiting its ability to acquire the best basking sites which would, in turn, exacerbate its illness. Perhaps this is how its stomach came to be filled with such foul green gunk; it resorted to chewing on leaves rather than jousting with its more dominant rivals for food and basking sites.

The plate-like bones on a croc's back have a secondary purpose other than defensive. On closer scrutiny we notice they are riddled with fine channels. Tiny blood vessels worm their way through these channels to form a lattice below the skin. Here they act like solar panels – warming up allows their metabolism to speed up, and their bodies to keep active. However, crocodiles aren't obliged to employ these vessels near the surface of the skin and when the temperature drops, they can shut off the blood supply to any inessential organs. They prefer to maintain their body at about 33ºC (91ºF), but some have recently been found surviving in cool caves in Madagascar. Scientists now think that these animals could be living proof that, because crocodiles are cold-blooded, they can slow down their metabolism and survive on a minimum of food and warmth. This ability to weather temperature extremes might be what has allowed crocodiles to survive so long.

Above left: The bumps on the back of a crocodile are called scutes. They are covered with a dense layer of keratin, the protein that we find in our nails and hair.

Above right: Tiny blood vessels act like solar panels all along the back of the crocodile, absorbing heat from the surrounding world.

Opposite: Crocodiles have a thin layer of guanine crystals behind their retina. This intensifies images, allowing crocodiles to see better at low light levels.

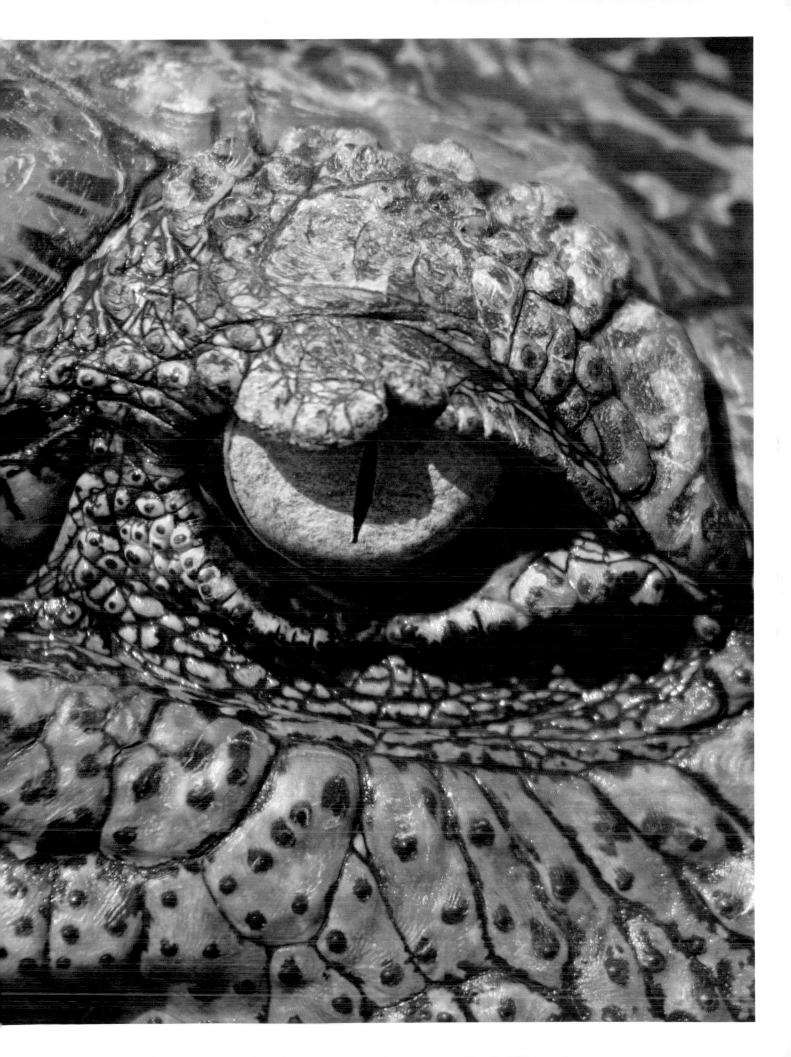

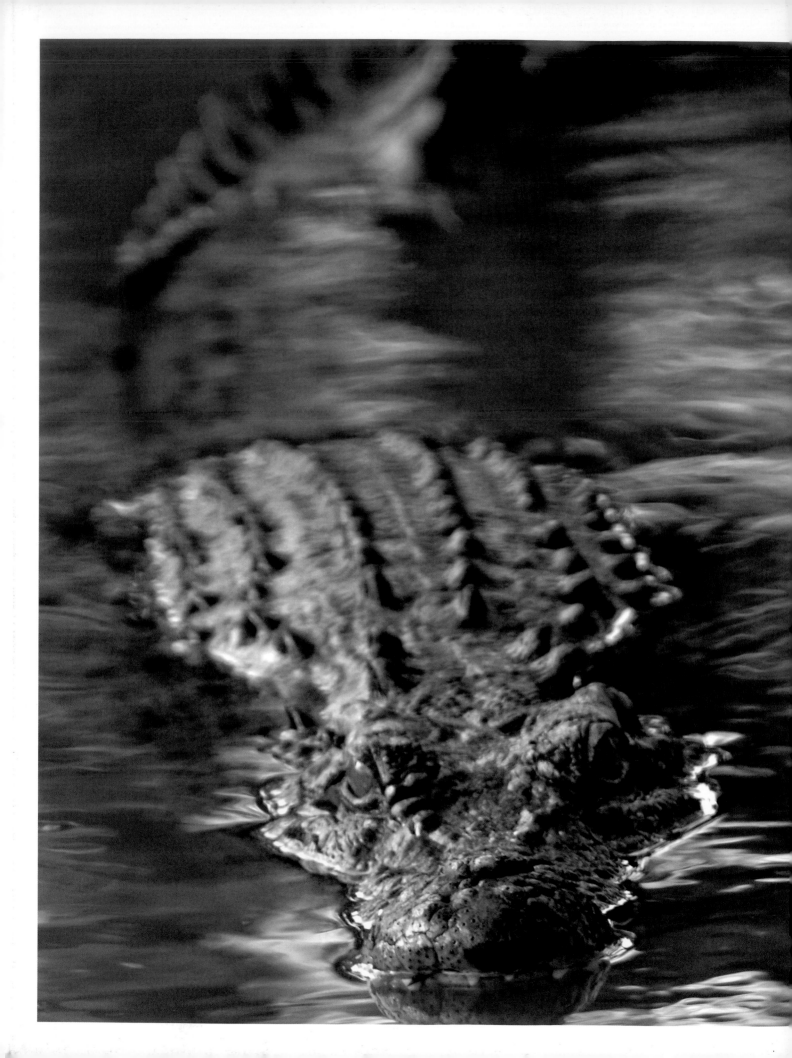

Turbo Tail
Joy Reidenberg

The crocodile's tail is one of its most impressive features, spanning about half the length of its body. At its core is a long string of tail bones (caudal vertebrae). Their numerous joints provide many bending points, thus giving the tail extreme flexibility. This helps propel the body forward as it undulates in graceful sinusoidal (S-shaped) curves, or twist like a propeller to roll the whole body in a 'death roll'. Attached to the vertebrae are the many tendons of the muscles that move the tail. Most of the tail's bulk and weight is from these muscles, indicating that it is a very powerful motor. Slow and tiny contractions move the crocodile silently forward, while fast muscle contractions can accelerate it to swim speeds up to 10–15km/h (6–9mph). While this might be slower than an animal galloping on land, it requires less energy to maintain and can therefore be sustained for longer periods. The whole body can become involved in the fish-like side-to-side motion, making the crocodile appear very snake-like in its swimming motion. The legs are pressed against the body to reduce drag at faster speeds, but at slower speeds they can assist in steering, balance, or braking. The tail is flattened on each side, providing large surfaces for pushing against water during propulsion. Like a fan or propeller, the larger the blade, the stronger the push. The tail tapers to a point – a streamlined shape that helps reduce drag (similar to the 'fast-back' on a race car). The top of the tail is crowned with projecting scales, that probably inspired artistic renderings of spines on dragons. The 'spines' near the beginning of the tail form two rows that are an extension of the dermal ridges on the crocodile's back. These modified scales project at a 45 degree angle from the midline and thus may serve as stabilizers, preventing the body from tilting to one side or the other. They may even work like little wings to provide lift for the heavy tail while swimming forward. Around halfway along the tail, the two rows of 'spines' fuse into one row and become nearly twice as large. These projections point straight up and add more surface area for propulsion. They serve as keels to prevent rolling (tipping over) or yaw (turning left or right) when the animal is gliding straight forward. These spines (scutes) are taller than the biggest crocodile teeth, which means they may help stop punctures from rivals' teeth and may even advertise size.

Kangaroo

Macropus rufus

Simon Watt

On 12 January 1836, a Royal Navy ship docked into the Australian port city of Sydney. On board HMS *Beagle* was an inspired young scientist by the name of Charles Darwin. He was yet to fathom the theory that would make him famous, the theory that unites all of biology and is one of the most significant scientific discoveries: the theory of evolution through natural selection. Darwin visited Australia for only two months, but his experiences there influenced his thinking for life. He once wrote, 'I am like a gambler, and love a wild experiment'. As my plane touched down in Sydney I thought of Charles's great voyage of discovery and his words rang in my ears: 'a wild experiment'. This phrase seemed to sum up Australia perfectly.

Even now, Australia has the air of a frontier. An island that is a continent, second only to Antarctica in size, it has a landmass nearly as large as the USA. Its vast interior feels like a wilderness, as most human life seems to cling to the coastline. The huge island first went its own way around 50 million years ago after it separated from Antarctica and drifted north.

Now isolated, life went its own way. New species emerged as animals diversified to fill empty niches, evolving novel solutions to the challenges of the environment. The earliest fossil remains of marsupials have been found in China and their fossils have been found on every continent, but it is in Australia that they flourished. No one knows why the placental mammals died out there, or why the marsupials didn't come to dominate the other continents to the same degree. Maybe the dice just rolled differently down under. Perhaps Australia's climate suited the low energy requirements of marsupials. Whatever the case, life shot off in very different directions.

As I traced Charles Darwin's footsteps I was accompanied by his great, great grandson, Chris; a charming man with a face vaguely reminiscent of his biologist ancestor. Though Charles was profligate and greatly contributed to the gene pool (he has more than 100 descendants alive today) Chris and his children are the only ones living in Australia. Together we travelled along a billabong in the Blue

Opposite: The team drive hundreds of miles into the outback from Alice Springs to a remote farm to meet kangaroo expert Adam Munn, in search of the kangaroo's evolutionary secrets.

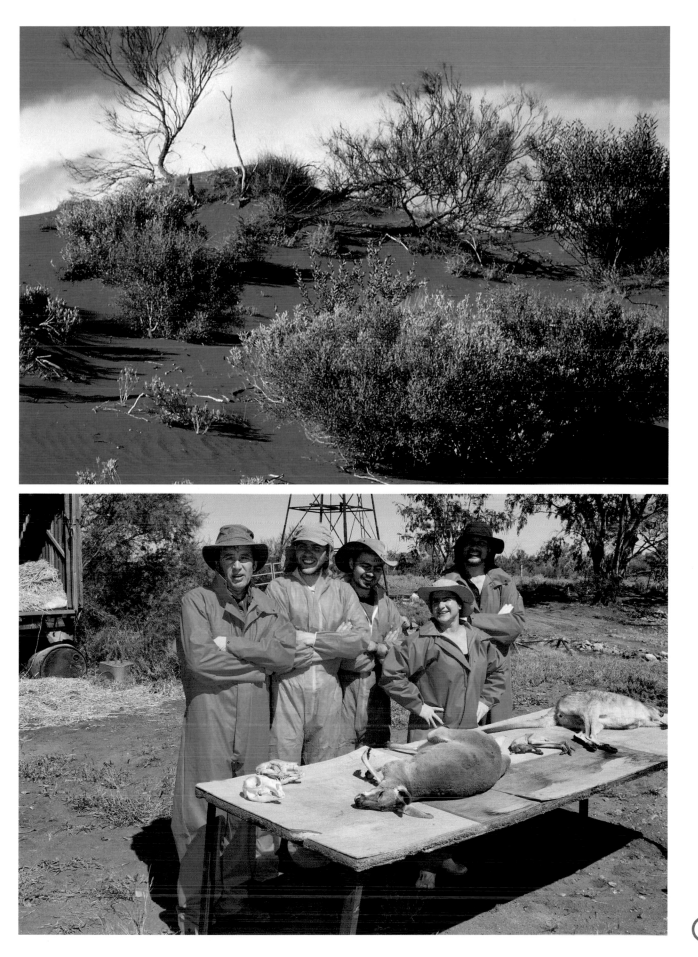

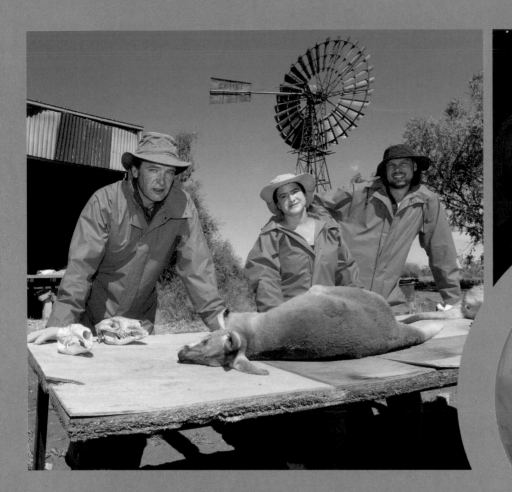

Above: The team's dissection will be of the corpses of a female kangaroo and a young joey.

Mountains looking for some of the area's iconic wildlife. On the way Chris told me tales of Charles's experiences that had shaped his thinking. Charles's research, as was the tradition for enterprising Victorian science, involved shooting his samples to prove that they were alive. I honestly can't say if the irony ever dawned on them. Darwin also tended to dine on as many species as he could find, treating his trip, at least in part, as a gastronomic tour of the world. He is reputed to have eaten, among other things, a lesser rhea, many types of turtle and an owl. At that time, taste was as much a factor in the cataloguing of a species as describing its behaviour or appearance.

Even though Darwin had heard about kangaroos, he never managed to see one, but he did shoot a kangaroo rat and a platypus. Darwin knew that the habitat and habits of the platypus were remarkably similar to those of the water rat in Europe, and yet the two creatures were astonishingly different. It prompted him to write in his diary that 'an unbeliever . . . might exclaim "surely two distinct creators must have been at work"'.

Darwin was onto something. The origins of the mammals had been a puzzle to science but we now know that there are three main branches to the mammal family tree. The protherians consist of only the platypus and echidnas; the metatherians contain the marsupials and the eutharians, feature the vast majority of mammal species, including humans. The eutharians use a placenta as they develop in the womb and so are known as placental mammals. The protherians are the most ancestral, and certainly the weirdest. The platypus even lays eggs.

The first reports of kangaroos were greeted with scepticism. Early explorers described them as creatures with heads like deer but without antlers, that could

stand up like men but that hopped like frogs. When they saw female kangaroos, with a joey's head in the pouch, they mistook them for two-headed animals.

The iconic red kangaroo is the largest mammal in Australia. They are far from rare and can even be seen in groups of over 1,000 individuals. Sadly, though, if visiting, the first you would encounter would probably be dead by the roadside.

Joy Reidenberg, Mark Evans and the dissection team were driving hundreds of miles into the outback from Alice Springs to a remote farm to meet kangaroo expert Adam Munn. On the way, they passed the fresh carcass of a young male lying on the road. They tied it to the car roof, claiming it as another sample.

Adam greets them with the corpses of a female kangaroo (of a variety known as a wallaroo or euro) and a young joey. The team layer up with sunscreen and the dissection is soon under way. As they look into the red kangaroo's mouth with its two front incisors, Mark is struck by how similar it appears to that of a rodent. On closer inspection they could see that there's a gap between the two lengthy front teeth and that this gap is a result of the jaw bones not being fused at the front as it is in humans.

The jaws and head bear a great resemblance to those of a deer or an antelope, probably because they feed on much the same food. Though the inventiveness of the natural world is incredible, when faced with similar challenges from an environment, evolution sometimes comes up with similar answers. Perhaps these same patterns occur in many different places because they are the best response available. Biologists call this independent innovation of the same solution more than once 'convergent evolution'. Richard Dawkins summed it up well by stating that kangaroos are basically hopping antelopes.

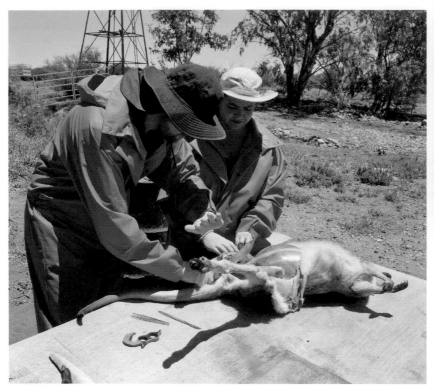

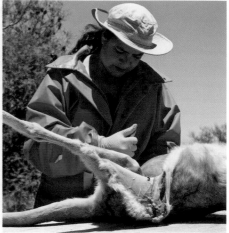

Our dissection moves on to the next stage of digestion. Laying the digestive system out on the dissection table, Mark remarks that it appears back to front when compared to that of a placental mammal. Though it is digesting food very similar to that eaten by animals like sheep, its stomach is a very different shape. The kangaroo's gut is a long tube with many balloon-like outcroppings, where bacteria can hang out and mix with the bolus of food. It looks like a cross between a sausage and an accordion. After mixing with the bacteria, the smaller chunks of food are moved along the digestive tract and dunked in an acid bath. From here they move on to a small intestine where nutrients start to be absorbed. Following this, the bacteria have a second opportunity to break down some of the larger molecules in a long blind pocket of the gut called a caecum. This is followed by a long colon, which not only absorbs more nutrients but collects as much water as possible. In an arid environment like the outback, this is an exceedingly important process. In the incredible heat, a 45kg (99lb) kangaroo can survive on as little as two or three litres of water a day, while a sheep of similar size would need about 12 litres.

The need to conserve and acquire water has been a dominant influence in the evolution of the kangaroo. A kangaroo has to be able to cover large distances at speed, from one area with food and water to another, especially during the frequent periods of drought. The dissection team moves on to look at the animal's legs and unveil the secrets of its hop. The red kangaroo is the largest hopping animal on earth, and though such an approach to locomotion might appear ungainly, it is ideal for the expansive arid environment that is the outback. In short bursts it can sprint at more than 50km/h (31mph). More impressive still, though, is that it can cruise at a pace

Above: Joy and Adam pull back the skin of the kangaroo's stomach to begin dissection of the gut.

Opposite: A pair of kangaroos demonstrate their jumping prowess.

Hopping is not only a highly efficient way of moving around, but it may also help with breathing. As the kangaroo jumps forward and upward, the internal organs within its abdomen lag behind. The diaphragm is flattened and the volume of the thorax is increased, helping suck air into the lungs. When it lands, the impact of the organs against the diaphragm has the opposite effect and causes the lungs to breathe out. The result of this is that the kangaroo uses less energy to breathe while moving than it does at rest.

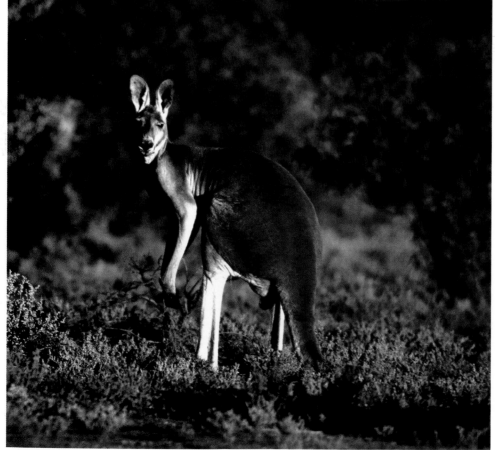

Above: When a kangaroo's leg is extended, as it is when the animal is airborne in mid-stride, the long Achilles tendon is loose. When it lands, it is stretched and held taut. Much of the energy produced by the kangaroo's movement is stored in the tension of the tendon, enabling it to easily cruise at a pace of 30–40km/h (19–25mph).

Left: A lone kangaroo standing on its strong hind legs.

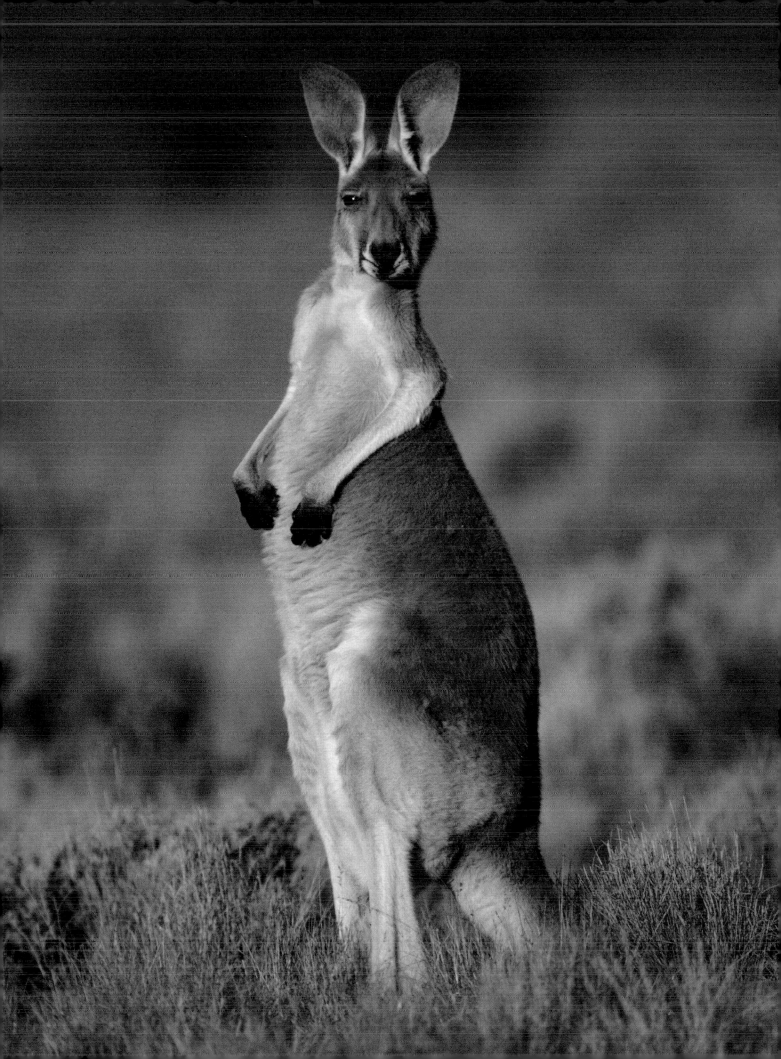

Breathing

Hopping also helps with breathing. As the kangaroo jumps, the internal organs within its abdomen lag behind. The diaphragm is flattened and the volume of the thorax is increased, helping suck air into the lungs. When it lands, the impact of the organs on the diaphragm causes the lungs to breathe out. The result of is that the kangaroo uses less energy to breathe while moving than it does at rest.

Teeth

Inside the red kangaroo's mouth are two rodent-like front incisors. Behind these there's a gap between the two lengthy front teeth as a result of the jawbones not being fused. The jawbones are held together by a ligament giving flexibility to rock back and forth and make large circular motions, grinding at tough grass. Chewing is particularly important for the kangaroo as they cannot chew the cud like ruminants, re-chewing partly digested food.

Pouch

The pouch is the iconic organ of a marsupial. A baby roo spends 190 days in her mother's pouch. It will emerge from the pouch to become a 'young at foot', eating vegetation but still supplementing its diet with drinks from its mother. The mother roo will tailor her milk to suit the changing nutritional needs of her offspring. While the joey is in the pouch, the milk it drinks is richer in carbohydrates. When it is out and about, getting most of its carbohydrates from plants, the milk becomes more fat-rich. As each young has a teat of its own, each teat produces a differn variety of milk specific to the dietary needs of that joey.

Joeys

Their lanky bodies mean they have a large surface area for their volume and so lose heat rapidly. Secondly, they have a desire to be confined near the comfort of a heartbeat. Thirdly, they find solace in darkness.

Legs

At the top of the femur are huge thigh muscles, but the secret lies in its calf muscle and long Achilles tendon. When the leg is extended, as it is when the animal is airborne in mid-stride, the tendon is loose, flapping under the skin. When it lands, the tendon is stretched and taut. Rather than all the kinetic (moving) energy being lost into the ground, much of it is stored in the tension of the tendon. It's this elastic recoil that puts the spring in the next step.

Foot

Its foot and calf are each very long and can articulate around the ankle joint nearly 180 degrees, an angle well beyond the ambitions of any ballet dancer. It is not surprising then, that it could cross a basketball court in three strides.

Digestive System

Though it is digesting food very similar to that eaten by animals like sheep, its stomach is a very different shape. It is a long tube with many balloon-like outcroppings, where bacteria can hang out and mix with the bolus of food. After mixing with the bacteria, the smaller chunks of food are moved along the digestive tract and dunked in an acid bath. From here they move on to a small intestine where nutrients start to be absorbed. This is followed by a long colon, which not only absorbs more nutrients but also collects as much water as possible. In the incredible heat of the outback a 45kg (99lb) kangaroo can survive on as little as 2–3 litres of water a day, while a sheep would need about 12 litres.

of 30–40km/h (19–25mph) with ease. It bobs along with its tail outstretched, moving like a pendulum, acting as a counterweight for balance.

At the top of the leg, on the femur, are the huge thigh muscles. These power propulsion, launching the kangaroo forward with tremendous force. However, the real secret lies in the calf muscle and the long Achilles tendon that attaches it to the heel. When the leg is extended, as it would be when the animal is airborne in mid-stride, the tendon is loose, flapping around under the skin. When it lands, the tendon is stretched and held taut. Rather than all the kinetic energy being dissipated into the ground, much of it is stored in the tension of the tendon. It is this elastic recoil that puts the spring in the kangaroo's next step and makes it so efficient. Mark compares loading energy into the leg to cocking a crossbow. To put his analogy to the test he watches the effect on the calf muscle as he pulls hard on the long lever that is the foot and it pivots around the ankle. He runs his fingers over the tendon and under tension it makes a sound like an out-of-tune guitar string. When he releases the foot, it shoots downward with explosive speed.

To increase pace, unlike most quadrupeds, the kangaroo increases the length of its stride. Its foot and calf are each very long and can articulate around the ankle joint nearly 180 degrees, an angle beyond the ambitions of any ballet dancer. It is not surprising then, that a large kangaroo can jump over seven metres in a single bound. It could cross a basketball court in three strides. This may be why the kangaroo is at risk from traffic. It can appear on the road in an instant.

Adam draws our attention to the kangaroo's massive biceps that would make a gym junky jealous. Rival male roos use these to grapple with each other, trying to topple their opponents. Although the back legs have the most power, which they occasionally use to strike their rival, most wrestling involves the forelimbs. The

Above: The underside of the kangaroo's paw, as the dissection on the legs continues.

Plumbing

The bladder is small – not surprising given that the kangaroo urinates as little as possible. It is the complicated plumbing of the reproductive tract that is surprising. A female kangaroo has three vaginas, looking like a trident leading into the uterus. After intercourse, sperm travel up each of the outer two vaginas to meet with a descending egg and fertilise it. The egg starts to divide as normal but when it reaches the blastocyst stage, at 100 cells, its development pauses, allowing the mother to control and plan the time of birth. She will not allow the embryo to develop any further until the conditions are right and her eldest offspring has become fully independent.

Hopping

The red kangaroo is the largest mammal in Australia and the largest hopping animal on earth - its sprinting hop ideal for the expansive arid environment. It can sprint at more than 50km/h (31mph), and cruise at 30–40km/h (19–25mph) with ease. It bobs along with its tail outstretched, moving like a pendulum, acting as a counterweight for balance. To increase pace, the kangaroo lengthens its stride. And a large kangaroo can jump over seven metres in one bound.

Kangaroo:

Weight: ..
30–90kg (65–200lb)
Height: ..
1.5m (5ft) (m) / 1m (3ft) (f)
Length male / female:
N/A
Life Span: ...
18–23yrs
Top Speed: ...
65km/h (10mph)
Bite strength pound force:
N/A

Tail and Forearm Cooling

Exercising under the blazing sun of the outback puts kangaroos at risk of overheating, so, when hopping, they sweat mainly around the tail area. When not hopping they use a very different technique to keep cool. An extensive network of blood vessels, just beneath the skin of their forelimbs, takes warm blood to the surface to be cooled. When warm, these vessels flood with blood. For enhanced cooling, the kangaroo licks its forearms so that as the saliva evaporates, it takes heat energy from the wrists, cooling the blood down.

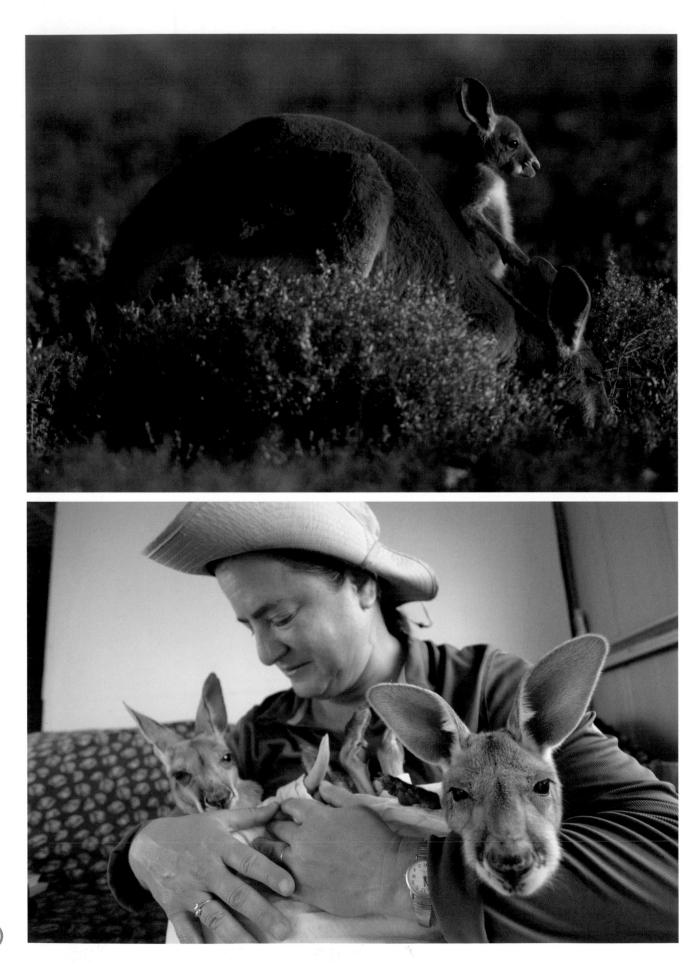

males can become rough when vying for females. They can even be dangerous to humans. The claw on the hind leg can be a formidable weapon.

Doing her best to ignore the flies that have started to festoon the carcass, Joy carefully dissects the cloaca, the common opening for the urinary, reproductive and excretory systems. The bladder is small. This is not surprising given that the kangaroo urinates as little as possible to conserve water. It is the complicated plumbing of the reproductive tract that takes Joy's breath away. A female kangaroo has three vaginas, looking like a trident leading into the uterus. After intercourse, sperm travel up each of the outer two vaginas to meet with a descending egg and fertilise it. The egg starts to divide as normal but when it reaches the blastocyst stage, at 100 cells, its development pauses, allowing the mother to control and plan the time of birth. She will not allow the embryo to develop any further until the conditions are right and her eldest offspring has become independent. This is extreme family planning. When the time comes to give birth, the mother pushes her tiny, undeveloped baby out through the hitherto unused central vagina to the pouch, where it will continue to grow.

In the male, the penis has to be surprisingly long to reach around the testes, which sit in front of it. The male can control the level of the testes' descent into the scrotum and so maintain them at a cool temperature. However, if the kangaroo engages in a fight with another male, it pulls them close and safe to the body.

In good conditions, a mother will be rearing three offspring at a time, each at a different stage of development. She will have a young at foot, another in the pouch suckling and an embryo in suspended animation within the uterus at the 100 cell stage, poised to develop as soon as the young at foot goes its own way. It is this assembly line approach which makes the kangaroo so superbly adapted to its environment. When the conditions are right, it can churn out young at a tremendous rate. If conditions are poor they can halt development at the blastocyst (100 cell) stage and wait for conditions to improve. In the worst case scenario, if the joey dies, the investment of time and energy has been low compared to placental mammals and the mother can begin to incubate another embryo straight away.

Having seen the damage that a car can do to a kangaroo, Mark and Joy went to the home of Cynthia Lynch, a lady doing her best to look after roos orphaned on the roads. Her house is cluttered with the paraphernalia of child-rearing: baby bottles, blankets and embroidered bags. As Mark walked into the house a small kangaroo lolloped up beside him peering up inquisitively. Cynthia pulled back the flap on one of the bags to reveal a young joey swaddled in blankets. Its head poked out and Cynthia gave it an affectionate pat. Its face was elongate; at that young age a joey's limbs, tail and face seem to lengthen at an explosive rate, before its muscles and other organs catch up. They look comically gangly and endearing. Cynthia has been raising orphan joeys like this for over 20 years. She first became a 'roo carer' after becoming fascinated with the local wildlife while working as a nurse in the outback. When indigenous people in the area were hunting kangaroos for meat they would often leave the young untouched, and she would take them in. Nowadays she adopts the forlorn joeys from the roadside, loitering near the carcasses of their mothers.

Living over six hours from the nearest doctor and vet, she was forced to improvise. Cynthia gave Mark a crash course in rearing a roo. First they need warmth, which is why Cynthia keeps each of her joeys cosseted in blankets. Their lanky

Opposite top: A mother kangaroo feeding with her young joey nearby.

Opposite bottom: Joy cuddles two joeys, wrapped up in blankets to simulate the feeling of their mother's pouch.

Distinctive Dentition
Joy Reidenberg

While cradling two orphaned baby kangaroos in my arms, I noticed that their cute little faces looked like a cross between a rabbit and a deer. When one yawned, I could see two lower teeth poking forward from the little mouth, the classic trademark of Diprotodontia (literally 'two front teeth'), the marsupial order that includes kangaroos. Since the kangaroo is an herbivore, I wondered whether its teeth would resemble those of other herbivores such as rabbits or deer. A quick inspection of the kangaroo skull shows some similarities in tooth pattern: front incisors for cropping, side molars for grinding, and a large space where canines have been lost. This toothless gap allows food to be pushed into the cheek for storage, and provides room for manipulating food without accidentally biting the tongue. In horses, this space accommodates the bridle's bit without damaging any teeth. Unlike deer and other cloven-hooved ruminants, kangaroos have opposing sharp-edged incisors that shear against each other like a pair of scissors. Paired lower incisors nest into a U-shaped pocket formed by six upper incisors. The lower jaw has large pockets that provide extra surface area for muscle attachments, indicating powerful forces are needed to cut and grind tough desert grasses. This is a different pattern from rabbits and hares that have four upper and two lower incisors, or rodents that have only two upper and two lower incisors. Unlike kangaroos, their incisors are continuously growing, and must grind against each other to regulate overgrowth and stay honed. Kangaroos, like other herbivores, chew on only one side at a time. This reduces tooth-wear and increases chewing efficiency by limiting compression to one side of the mouth.

Since the lower jaw is narrower than the upper jaw, the teeth only line up when shifted laterally. The split lower jaw allows the flexibility to lean both halves towards the side that's chewing. The split centre may also dampen transmission of chewing forces cross the midline. The molar teeth in kangaroos have a very rough top surface that extends their wear-time. The lower molars are not arranged horizontally as in other herbivores but, rather, rise up in an arch so that only the front teeth are engaged with the upper molars. As they wear out, the front molars are shed and replaced by advancing molars from behind in a similar way to elephants.

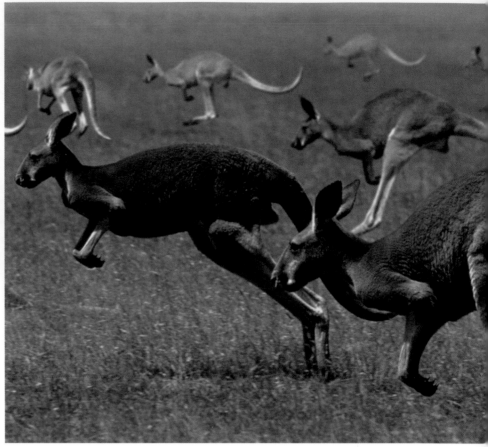

bodies mean they have a large surface area for their volume and so lose heat rapidly. This is ideal when in the warmth of the sun, or being heated by their mother's body heat, but when inside an air-conditioned home they need a great deal of insulation. Secondly, they have a desire to be confined and it seems that pillowcases make good surrogate pouches. Cynthia has noticed that they prefer the bag to be on her lap for her body heat and also to be near a heartbeat. During their time in the pouch the percussive pumping of their mother's heart would be their constant companion. They even seem to find solace in darkness. They dive head first into Cynthia's makeshift pouches and acrobatically somersault around to face out again. Some older roos shove their heads into darkened corners and crevices to find comfort when stressed.

Mark knew of this calming effect of darkness from first-hand experience. As a veterinary student, he had briefly worked in Sydney Zoo. One day they had to move a feisty and boisterous adult male red kangaroo into a different enclosure. This male was infamous amongst the zoo staff for its cranky temperament. It was over six feet tall and posed a serious risk to the vets working with it. Yet as soon as they had managed to wrestle a Hessian sack over its head, its struggles subsided and it became completely docile. One of the best ways to keep a joey warm and reassure it with the comforting sound of a heart beat is to curl up in bed with it. 'You need a good marriage for these sorts of things,' Cynthia chuckled.

In spite of the large numbers that are dying on the roads, kangaroos continue to thrive. Unfortunately, the same cannot be said of the rest of the continent's indigenous wildlife. Australia is no longer isolated. With James Cook there came a raft of invasive species that have upset the delicate balance of many ecosystems. Who knows how they will respond? The wild experiment continues.

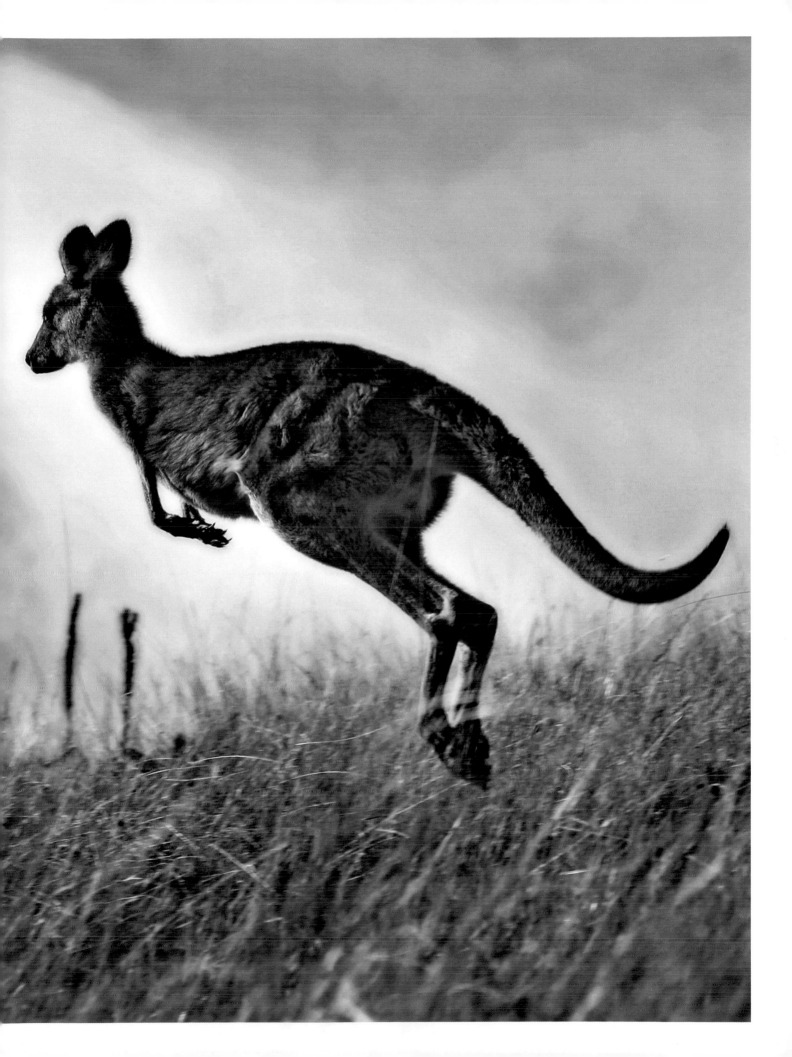

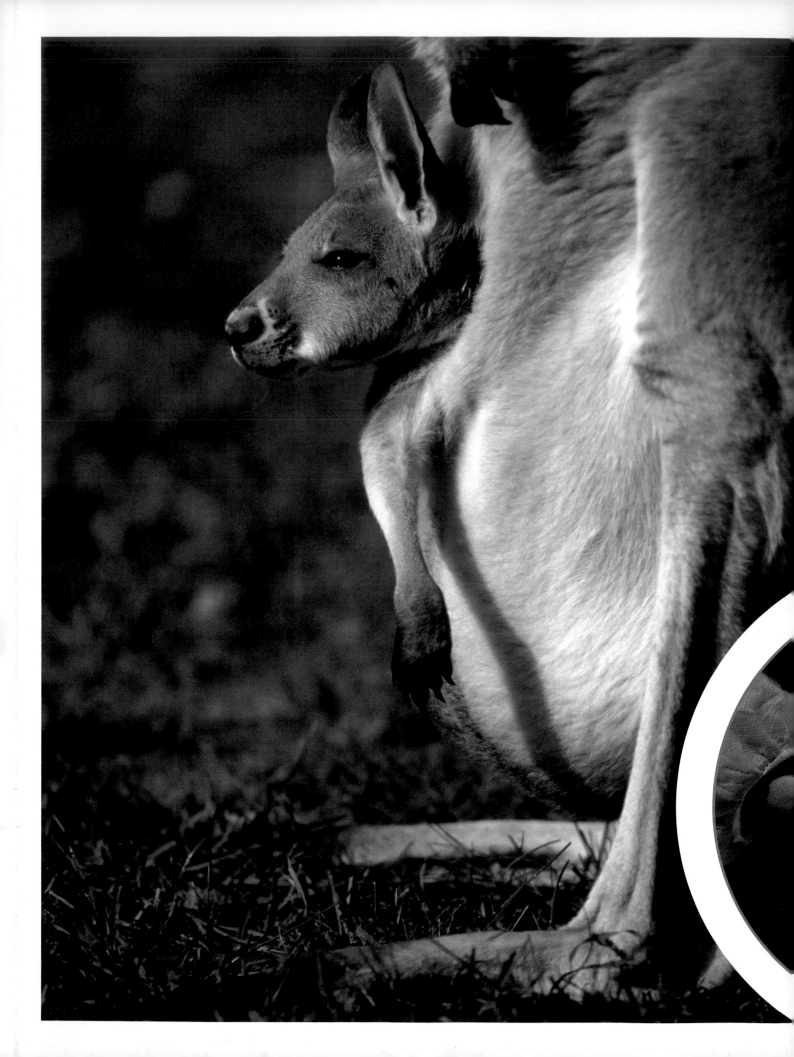

The Secrets of the Kangaroo's Pouch

The pouch is surely the organ for which marsupials are most famous. Pouches come in a variety of shapes and sizes. Many burrowing animals have theirs facing backwards and down to avoid the pocket filling up with soil. The red kangaroo has the deepest pouch and its opening faces up and forward. Pouches are found only on females, and unlike in humans, the males don't carry any redundant nipples. Slicing open the pouch on our female kangaroo, Joy is amazed to see just how muscular it is. When bounding along in the bush, the joeys need a seatbelt and these muscles are used to hold them safe and tight. Inside the pouch there is a line of four teats. A roo baby is born blind and bald. The Australians at the dissection affectionately referred to them as 'jellybeans' and the description seems apt. It is born largely undeveloped so it must quickly make its way to the pouch or it will die. The only help its mother can provide is licking a path through her fur to the pouch. If the baby is unfortunate enough to fall off, there is nothing she can do to help it. The journey is 30cm (12in), a gargantuan task for such a small creature, and the equivalent of a human baby crawling 2km (1.2 miles) at birth. Though largely undeveloped, the neonate kangaroo has a few features that help it survive the journey to the pouch. It has a large mouth, ready to grasp a teat, and big forelimbs and claws for crawling. The largest and most developed area of the brain at this stage is the olfactory bulb, the region responsible for deciphering smells, and it is this sense that orientates the jellybean and helps it head straight for the safety of the pouch. When it arrives there, it latches onto a teat claiming it as its own. It will suckle from this one, and no other, until it is completely weaned. The joey grows quickly and the nipple grows with it to accommodate the changing shape of the mouth.

Bottom left: Joy reveals the four teats in the female's pouch.

Giraffe

Giraffa camelopardalis

Jamie Lochhead

'Any closer and he'll be too big to fit in the shot,' Sean whispers, looking into the viewfinder. 'Did you bring the wide-angle lens?' I respond softly. Our hushed voices are unnecessary; clearly the approaching giraffe is fearless. With a few slow-motion strides the giant is on top of us. Sean jumps to one side, saving his camera, while I am transfixed as the towering animal stops in front of me. We are in Johannesburg on the final day of filming the giraffe episode. We had come to this safari park to film Gambit, a famously friendly giraffe. We want to get close enough to film Gambit with a thermal-imaging camera, but this is too close. Every time we back off far enough to get his body in shot Gambit simply follows us.

That dusty afternoon in South Africa couldn't have contrasted more with our first day of filming at the Royal Veterinary College just a few weeks earlier. On the train to the college's Potter's Bar campus I prepare myself to see a dead giraffe, but as we open the doors of the cavernous post-mortem room fridge we are hit with a blast of cold air and a sight I had not expected: the giraffe in front of us is upside down. Its feet are attached to a winch high above us. Its body and neck hang limply beneath.

The animal is a young male Rothschild giraffe. It had died at the age of two and a half – adolescent for a giraffe. Its keepers had been unable to save its life after it had been found paralysed on the ground in its enclosure. The body had been brought to the Royal Veterinary College to allow experts to investigate the animal's death and to present the extraordinary anatomy of the world's tallest animal to an audience of vet students and television viewers.

We watch as the winch rolls along rails on the post-mortem room ceiling carrying the upside-down giraffe from the fridge out into the dissection area. Richard Prior, the post mortem room technician, lowers the giraffe onto a frame normally used for examining horses, and wheels in a second table to support the oversized neck. Word has spread around the college that a giraffe dissection is about to take place, which is a far more spectacular proposition than the usual

Opposite: A giraffe in the savannah at dawn. The Rothschild giraffe that the team have the opportunity to examine is among the most endangered subspecies, with only a few hundred members in the wild. It is named after the famous family of the Tring Museum's founder, Lord Walter Rothschild.

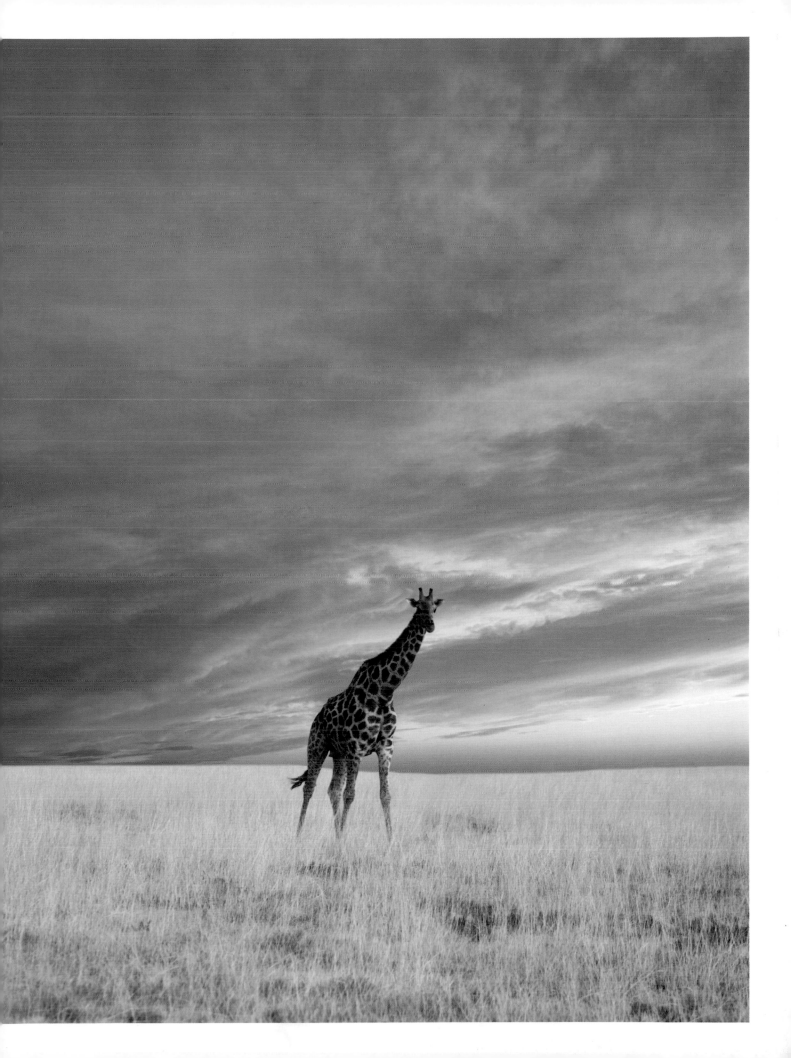

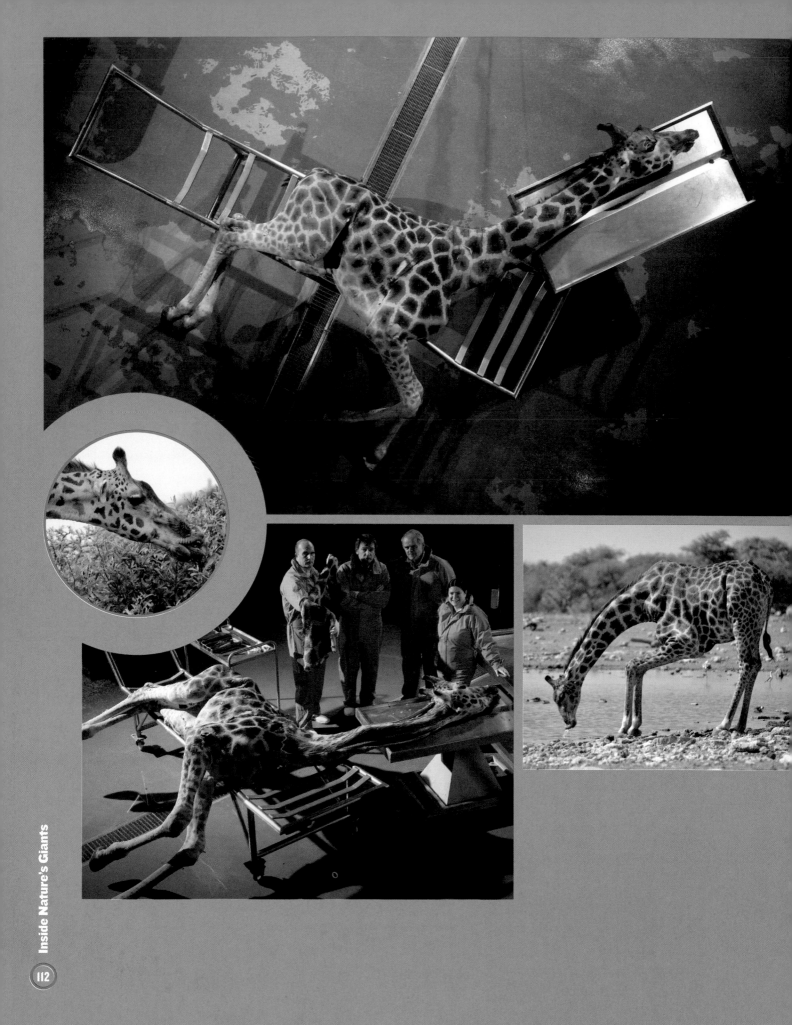

fare of cats and dogs. Here is a rare opportunity to peer inside an exotic species.

Leading our dissection is Professor Graham Mitchell, a physiologist and leading giraffe expert. Throughout his career Graham has been fascinated by how giraffe survive such an extreme body shape. Top of his list is the neck. How do giraffe cope with such a long and heavy neck? To begin revealing the answers Graham asks Richard Prior and Professor Joy Reidenberg to remove a large section of skin from beneath the animal's ear down to its shoulder.

Layers of muscles are exposed as the skin is peeled away and at the back of the neck, a line of thick yellow tissue begins to emerge – the nuchal ligament. This tough elastic ligament is perhaps the most important in the giraffe. Its role is to hold the neck upright. The natural position for a giraffe's neck is at an angle of 55 degrees to the vertical. That's the angle at which the weight of the neck and the elastic tissue of the ligament balance out. Holding the neck in this position requires no effort. What does require muscle is lowering the neck to drink.

To prove the point Graham asks Mark and Joy to move the giraffe's head down towards its feet. They struggle to bend the neck as they fight against the tension of the ligament. When they can't lower the head any further Graham tells them to let go . . . Whap! The elastic ligament springs the neck back to its default position. In the wild, when a giraffe stops drinking, its head can swing like this through a 4m arc back to its upright position in as little as two seconds.

But why such an unwieldy neck in the first place? The most famous author to have tackled this question is Charles Darwin. In the 1872 edition of his seminal book *Origin of Species*, Darwin wrote about giraffe:

'Individuals which were the highest browsers, and were able during dearth to

Above: Richard Dawkins joins the dissection team as they investigate the anatomy of the giraffe. The recurrent laryngeal nerve carries signals from the brain to the larynx.

Opposite: The default position for a giraffe's neck is at an angle of 55 degrees to the vertical, so getting a drink of water is more of an effort than reaching up to eat leaves from the trees. The team find the muscles and tendons in the giraffe's long neck to explore the mechanisms behind this.

Giraffe

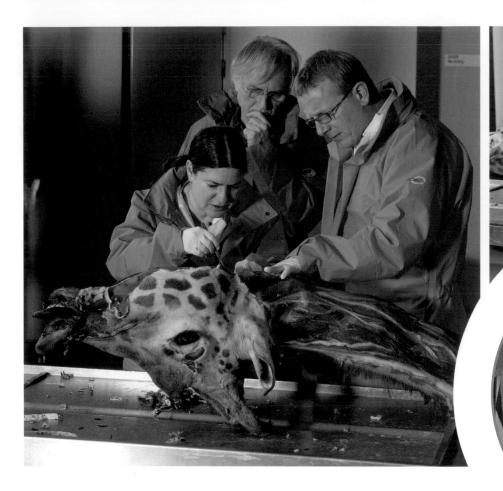

reach even an inch or two above the others, will often have been preserved
. . . whilst the individuals, less favoured in the same respects will have been the
most liable to perish . . . By this process long-continued . . . it seems to me almost
certain that an ordinary hoofed quadruped might be converted into a giraffe.'

Remarkably, the idea that the neck evolved for feeding was first scientifically
tested in 2007. Ecologist Elissa Cameron showed that giraffe do enjoy more leaves
per mouthful by eating above the heads of competing animals. However giraffe
don't just feed up high, they also use their necks to reach low bushes and deep
inside trees. This ability to access food at all heights is likely to be a major factor in
the evolution of the neck.

But getting to food is only half the story. Graham tilts the giraffe's head on the
dissection table to give our cameras a better view of the giraffe's second piece of
specialised feeding anatomy – its tongue. Even in our young giraffe the tongue is
40cm (16in) long. To get to their favourite acacia leaves, giraffe are able to slide
their narrow heads in between branches and stick out this long, thin tongue to
pull leaves into the mouth. Sharp ridges on the back teeth then cut and grind the
leaves before they are swallowed and passed through the four-stage digestive sys-
tem to extract every last bit of nutrition.

As Joy and Richard remove the guts from the giraffe's body cavity Mark is sur-
prised to see how little space there is for the heart and lungs of this vast creature.
To illustrate just how tight a space it is Graham asks Joy to insert a plastic tube into
the giraffe's windpipe and to inflate the lungs with compressed air.

Mark looks on in amazement as the lungs balloon in size. Humans take in
about half a litre of air with each breath; this animal needs to take about 30 times

Above: The team dissect the long neck of the world's tallest animal, exploring its complex circulation system.

that. In order to do so its lungs fill every available space inside its chest with each and every breath. How giraffe increase their breathing capacity when running is somewhat mysterious. Graham suspects it could be related to the movement of their intestines against the diaphragm.

When the front feet of a galloping giraffe hit the ground the jarring impact causes the intestines to hit the diaphragm and push the air out. As the gallop continues, and the animal rocks onto its back legs, the intestines move backwards helping the diaphragm to contract as the animal inhales. 'It's a piston,' explains Graham. 'It couldn't be more beautifully designed . . .' Graham corrects himself quickly, 'Evolved!' It's a slip of the tongue that's easily made. Evolution produces such elegant solutions it's hard not to use words like 'design'. But animals are not designed and their imperfections offer clues to their evolutionary past.

The history of the giraffe family can be traced back around seven million years to an animal named Bohlinia. Bohlinia was about 1.8m (6ft) tall and had a typical giraffe-like shape. Its fossilized bones were found in modern-day Greece, and from there this animal spread across Asia, China and Africa. It diversified into at least 10 different giraffe species with a variety of shapes and sizes. Those in Asia and China became extinct when massive earthquakes in the Himalayas triggered a change in climate that transformed the vegetation from trees and shrubs to grassland. Of the five species known to have lived in Africa just one survived, growing gradually over three million years until we arrive at one-million-year-old skeletons indistinguishable from the giraffe we know today.

While in South Africa we meet Dr Julian Fennessy, an ecologist who is collecting giraffe DNA samples to piece together the recent history. We arrange to follow

Above: Giraffe have two ways of moving, a loping walk and a gallop. While running, the neck of a giraffe moves backward and forward to keep the animal balanced.

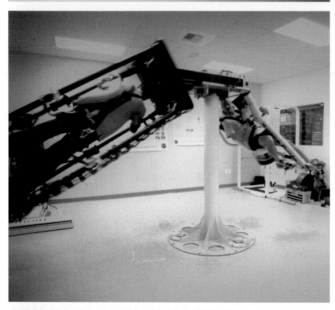
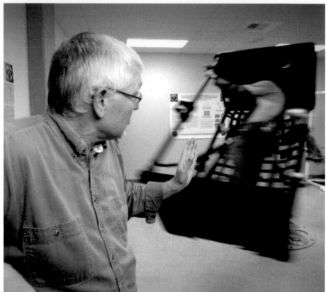

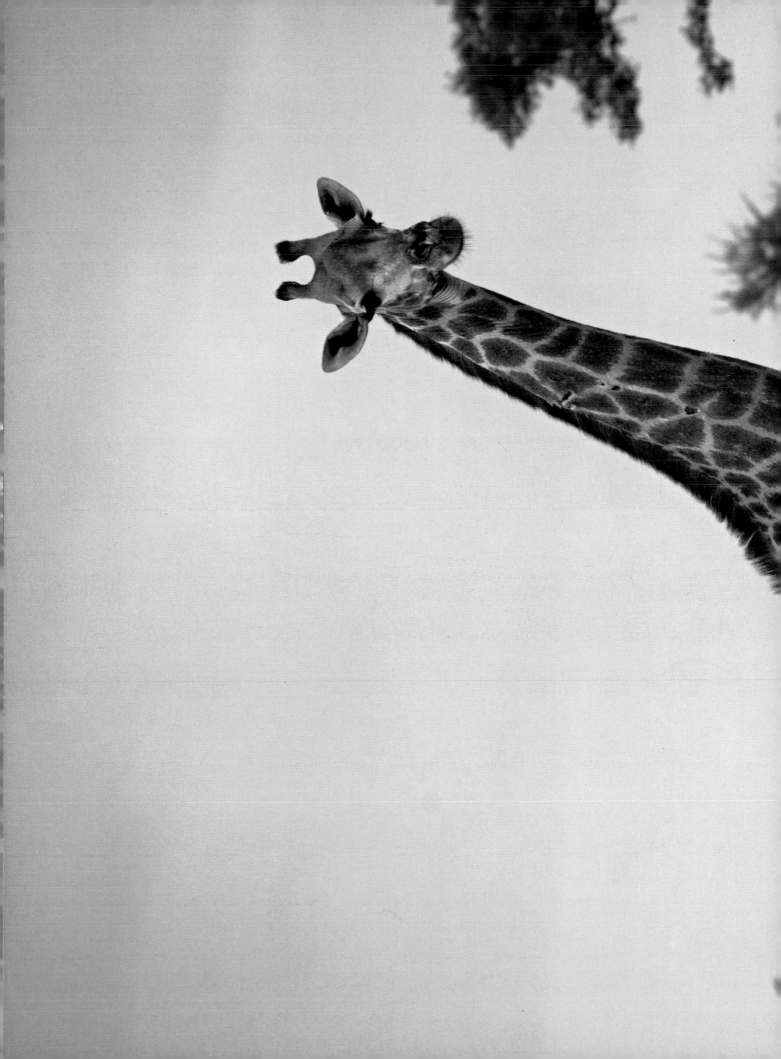

Skull

Small-brained and empty-headed, the large head of this young male Rothschild giraffe is surprisingly lightweight. In the animal we dissected the brain weighed less half a kilo, about one-thousandth of its 500kg (1,100lb) bodyweight. Dissection reveals a series of large empty spaces in the top of the skull. These cavities are the giraffe's sinuses. But lightness doesn't make aggressive head swings any less dangerous. When fighting, giraffe often hit their opponents with their horns. The entire force of the neck is transmitted onto a small area at the very tip of the horn ensuring a powerful blow from such a light head. The giraffe's eyes are relatively forward-facing providing excellent forward vision with strong depth perception that allows them to spot predators at a distance.

Neck

Far from being a problem, the long neck of the world's tallest animal offers several advantages: it provides a unique early warning system offering a vantage point for the forward-facing eyes, and it allows access to food at all heights, and it provides a greater surface area from which to lose heat. There are other, less obvious advantages to having a long neck. Male giraffe often fight for dominance. Standing side-by-side, duelling giraffe swing their necks and heads to club their opponents. In head to head battles males with the largest necks win access to the most females and are likely to pass their 'big neck' genes to the next generation. Remarkably, the long neck of a giraffe doesn't contain a large number of bones. They have the same seven neck vertebrae found in humans and other mammals. The difference in the giraffe is that each of these bones has evolved to become extremely elongated. The tough elastic nuchal ligament is perhaps the most important ligament in the giraffe. Its role is to hold the neck upright. In the wild, when a giraffe stops drinking, its head can swing like this through a 4m arc back to its upright position in as little as two seconds.

Heart

The heart and lungs – the vital organs needed to power this giant animal – occupy a small space inside the ribcage. The heart is smaller than you might expect for an organ that must pump blood all the way up such a tall neck, but the left ventricle, the chamber responsible for sending blood around the body, is much narrower than in other animals and is surrounded by an extremely thick muscle wall. It is this muscle that squeezes the blood out of the chamber at pressures high enough to reach the head. The longer the neck, the thicker the muscle needs to be. Every 30cm (12in) of neck length requires an extra 1cm of muscle around the ventricle. A large giraffe's heart produces the highest blood pressure of any animal on the planet.

Julian on a sampling expedition to hunt giraffe in Pilanesberg National Park. In the back seat of his jeep I spot Julian's rifle. Collecting a DNA sample involves shooting an unwitting giraffe with a dart that pricks its skin and then falls out, ready for collection.

But by the second long day of hopelessly scanning the landscape through binoculars I begin to realize that perhaps the patchwork skin pattern of a giraffe isn't as bizarre as I had first thought. A giraffe could be standing in a group of trees just yards from the road and we'd never know. It would be impossible to pick out its shape from the light and dark patterns of the leaves and branches.

Eventually, from the top of a hill in the centre of the park, we spot a head sticking up from a patch of trees . . . and then another . . . and another. We race down the hill, leap out of the jeep and begin to creep into the undergrowth. Suddenly a group of five giraffe seem to simultaneously step out of the trees and look straight at us. As they begin to move away Julian lifts his rifle and fires. We see the bright orange dart stick into the giraffe's rump and then fall to the ground.

In recent years data from Julian's darts is suggesting that new branches may be beginning to emerge in the giraffe family tree. There are nine different groups of giraffe across Africa. Each can be identified by a particular skin pattern. What Julian's research indicates is that many of these groups have been reproductively isolated for so long they could now be considered individual species of giraffe.

In such a tall animal the effects of gravity on blood flow are extreme. Blood rushes down into the legs with ease, but to prevent a severe case of swollen ankles the circulation system faces an uphill struggle. To give Simon Watt a sense of the problem we take him for a ride on a contraption called the Space Cycle. It was designed by physiologist Jim Hicks to simulate gravity in the bodies of astronauts exercising in space. When used on earth the Space Cycle subjects the circulation system to around three times the force of gravity. Perfect for sending Simon's blood rushing down into his legs in a very giraffe-like manner.

As we watch Simon being accelerated up to speed I wonder how much of this he can take. He certainly seems be enjoying himself. 'It's great, I love it!' He shouts from the spinning platform and then promptly passes out.

The cycle is slowed to a stop and a ghostly pale Simon lifted out. Jim slides a vomit bucket in front of him and begins to explain what has happened. The G-force created by the spinning had caused Simon's blood to collect in his legs. His circulation system couldn't cope and the resulting lack of blood to the brain caused him to faint. A G-suit that squeezed his legs would have helped him retain more blood in the upper body and kept him conscious.

In the post-mortem room they run a sharp scalpel down the giraffe's lower leg. Lifting up the flap of skin, Graham shows just how thick it is. This skin is the giraffe's built in G-suit. It is so stiff and strong blood vessels that would otherwise swell under the weight of blood rushing down the long body are held firmly in place as the beast feeds, walks and runs.

Flying over the South African bush in a helicopter Mark gets a bird's-eye view of a group of giraffe on the move. Looking down from above he watches their 'pacing' walking pattern. First the left legs move forwards together, then the right legs, like two people marching in step. As the group starts to run Mark watches the pattern change – the front limbs now moving together followed by their hind limbs. A galloping giraffe may look ungainly but it can reach speeds of 30mph, fast

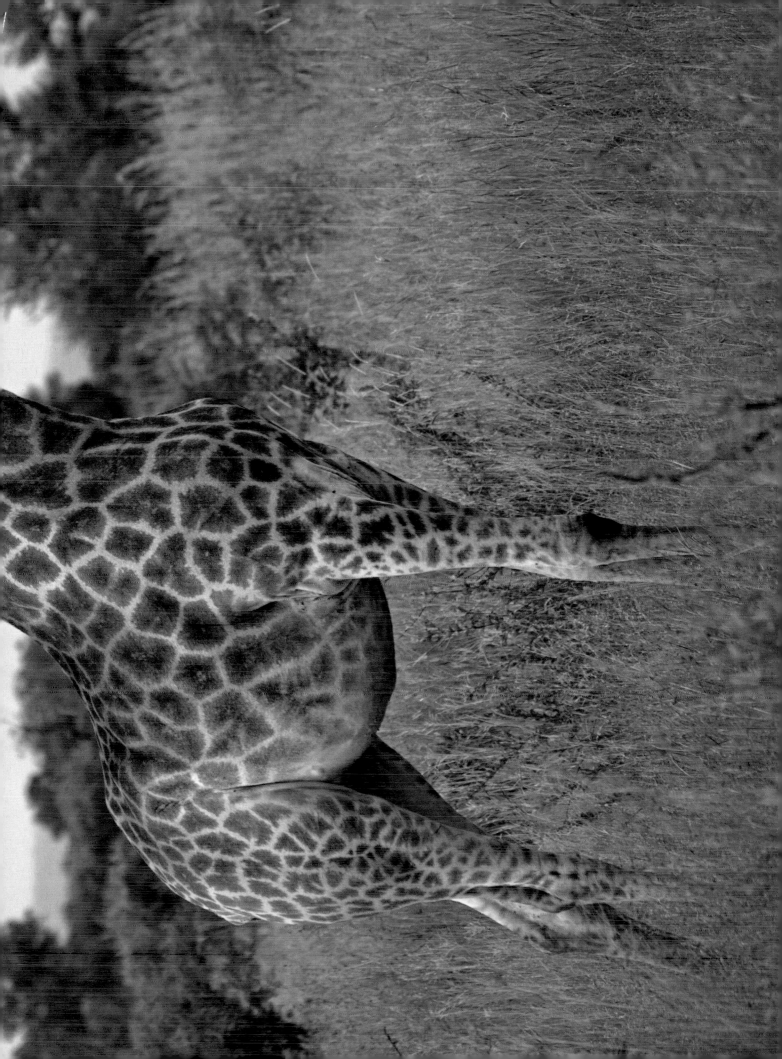

'This is a creature that is living right on the edge. It won't take much for the disadvantages to outweigh the advantages and then the species will crash. Just like all species do when they've come to the end of a suitable environment. And that's what I think this animal is doing right now. It is right on the edge of what an animal can do.'

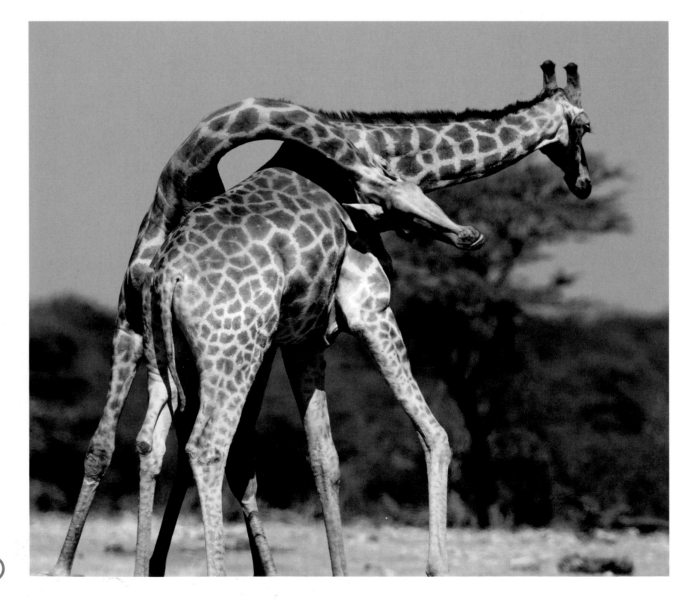

enough to outrun a lion. At the back of the group Mark spots a young giraffe. It is comparatively small but its enormously long legs allow it to keep up.

Giraffe mothers don't lie down to give birth or to feed their young. The precarious procedure of lowering their body to the ground and standing up again would make them vulnerable to attack. Lying down to sleep is equally risky so giraffe have adapted to get by on as little as 10 minutes of sleep a day.

The giraffe's extreme body shape seems to bring more problems than it solves. Drinking, breathing, pumping blood to the head, simply standing up – all are difficult. The benefit of reaching a few extra leaves doesn't seem to outweigh all the costs. But there are other, less obvious advantages to having a long neck.

Male giraffe often fight for dominance. Standing side-by-side, duelling giraffe swing their necks and heads to club their opponents. The neck cracking blows can be fatal, but in most cases the loser simply backs away. In head-to-head battles males with the largest necks win access to the most females and are likely to pass their 'big neck' genes to the next generation. This could well be a factor in the evolution of the neck.

To explore how its skull may have adapted as a weapon Richard removes the giraffe's head and powers up the post-mortem room band saw. Sliding the skull nose first into the saw he bisects the head perfectly. As the two halves of the head are laid out on the dissection table Mark is amazed to see just how small the giraffe's brain is. Graham explains that in this animal it probably weighs less half a kilo, a tiny proportion in a body of around 500kg (1,100lb).

The cross-section also reveals a series of large empty spaces in the top of the skull. These cavities, the giraffe's sinuses, mean that the large head is surprisingly lightweight. But this doesn't make aggressive head swings any less dangerous.

When fighting, giraffe often hit their opponents with their horns. The entire force of the neck is transmitted onto a small area at the very tip of the horn ensuring a powerful blow from a relatively light head.

Graham then points out that the giraffe's eyes are directed in a more forward-facing orientation than you would see in a horse or cow. This gives giraffe excellent forward vision with strong depth perception that allows them to spot predators at great distance. This system at the top of a long neck gives the giraffe a unique early warning system for survival.

With the giraffe now completely dissected Graham has one last explanation for the giraffe's elongated shape. Reaching for the section of neck skin that was removed at the very beginning of the dissection, he explains that the giraffe's distinctive skin pattern holds hidden properties. The dark patches on the skin contain clusters of large sweat glands and deeper still, a network of small blood vessels. When a giraffe needs to lose heat it sends warm blood to these vessels and, with help from the sweat glands, the heat radiates from dark areas of skin.

As we spend our final filming day backing away from a giraffe called Gambit I begin to wonder whether I just take Graham's word for the thermal abilities of the skin pattern. Finally, Gambit decides to stop following us around and we get some clear shots of his body with the thermal-imaging camera. Dark patches of his skin are glowing hot and not just in areas hit by the sun. The patches are acting as thermal windows radiating heat. In this context the long neck offers another advantage: it provides a greater surface area from which to lose heat.

If you want to keep cool in the African bush, having a long thin body is a

Opposite: Giraffe duels are among the most extraordinary in the animal kingdom. Behaviour known as 'necking' sees two males engaging in rubbing and intertwining of their necks, allowing them to assess each other's size and strength.

The Curious Case of the Laryngeal Nerve

Richard Dawkins came to the giraffe dissection eager to follow the strange route of a nerve deep inside the giraffe's neck, offering clues to its evolutionary past. In humans the left recurrent laryngeal nerve carries signals from the brain to the larynx. But rather than linking the two organs with a direct connection, the nerve takes a circuitous route from the brain down into the chest then back up the neck to the larynx. With the help of Justin Perkins, an equine anatomy expert at the RVC, Joy begins to investigate what this nerve does inside the giraffe. It's a dissection that hasn't been done since 1838. Making minute incisions with her scalpel, Joy slowly reveals the tiny nerve and traces its route from the base of the brain down into the neck. Centimetre by centimetre, inch by inch, she follows the nerve down the neck into the chest of the animal where it loops around one of the major blood vessels near the heart before travelling all the way back up the neck to the larynx. A nerve that only needs to carry signals between organs a few centimetres apart takes a detour of more than 2m (7ft). The reason for this seemingly bizarre piece of anatomical wiring is that the laryngeal nerve first evolved in early fish-like creatures. In these ancient ancestors the nerve served as a direct link from the brain to gills near the heart. Over millions of generations, as the mammalian neck evolved, this nerve lengthened by a fraction of a millimetre at a time, each small step always simpler than a major rewiring to a more direct route. As Richard Dawkins explains, the path of this nerve is a beautiful example of historical legacy as opposed to design. Where a designer can throw away a bad design and start again with something more suitable, evolution can't go back to the drawing board. Evolution has no foresight.

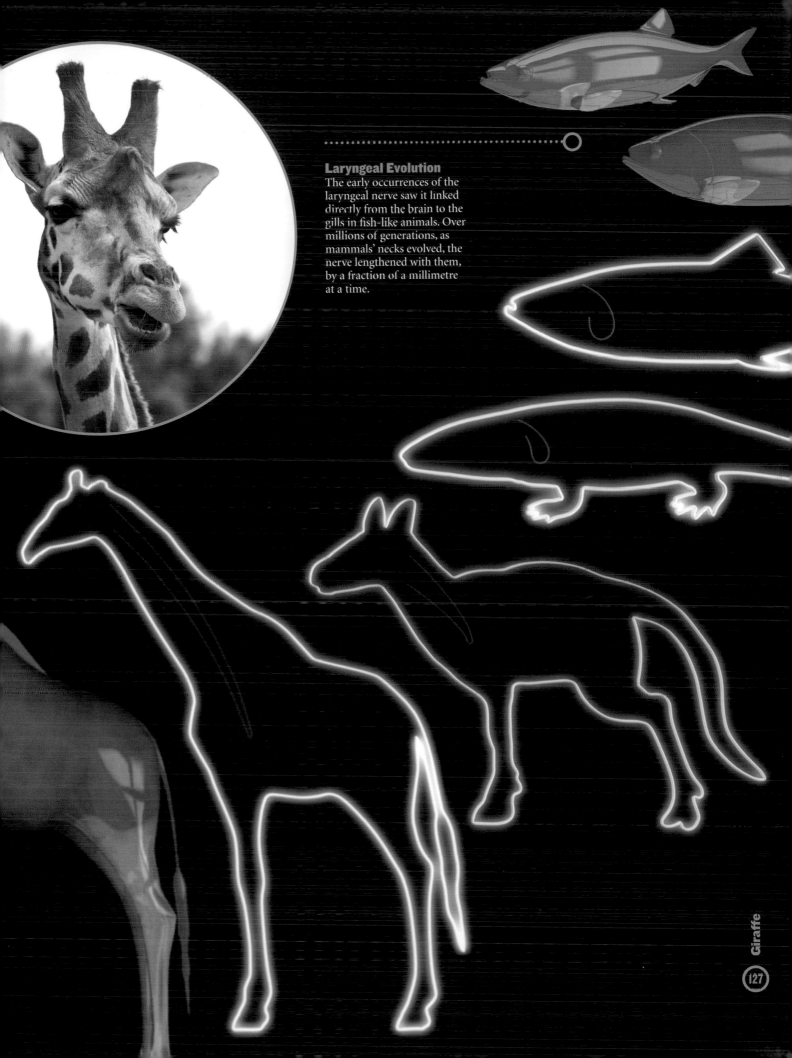

Laryngeal Evolution

The early occurrences of the laryngeal nerve saw it linked directly from the brain to the gills in fish-like animals. Over millions of generations, as mammals' necks evolved, the nerve lengthened with them, by a fraction of a millimetre at a time.

good start. It means you can spend more time feeding and less time seeking shade. Thermoregulation could be another force in the evolution of the neck.

Examining the inside of the neck, veterinary pathologist Professor Alun Williams hunts for clues that might reveal the cause of our giraffe's death. Under the jaw he notes areas of bruising that suggest an impact onto the lower part of the head, as if the head had hit the floor. His next step is to examine the vertebrae in the neck. Remarkably, the long neck of a giraffe doesn't contain many bones. They have the same seven neck vertebrae found in humans and mammals. The difference is that each of these bones has evolved to become extremely elongated.

Alun and Richard examine the spinal cord inside and discover signs of further bleeding. Alun then makes a cut across the cord to examine its cross-section. Tiny pink spots are visible inside the creamy white spinal cord. The giraffe must have somehow lost its footing and its head and neck hit the ground. Bleeding in and around the spinal cord had stopped nerves that carry signals from the brain to the body from functioning properly and the result was a paralysis witnessed by the zookeepers who found the dying giraffe.

This fatal fall highlights just how costly a giraffe's elongated body and neck can be. The giraffe is an iconic example of evolution by natural selection yet it has become so specialized it is now, in every sense, a delicately balanced beast. In Graham's view, it is an animal that has pushed its body to the very limit in the struggle for survival.

Above: The dark patches on the skin of a giraffe have unique, hidden capabilities that help to regulate its temperature in the hot climate it lives in. Clusters of large sweat glands as well as a deeper set network of small blood vessels allows it to lose heat by radiating it from the dark areas of the skin. Within this context, the long neck offers another advantage by providing a greater surface area from which heat can be radiated and lost, thus allowing the giraffe to keep cool.

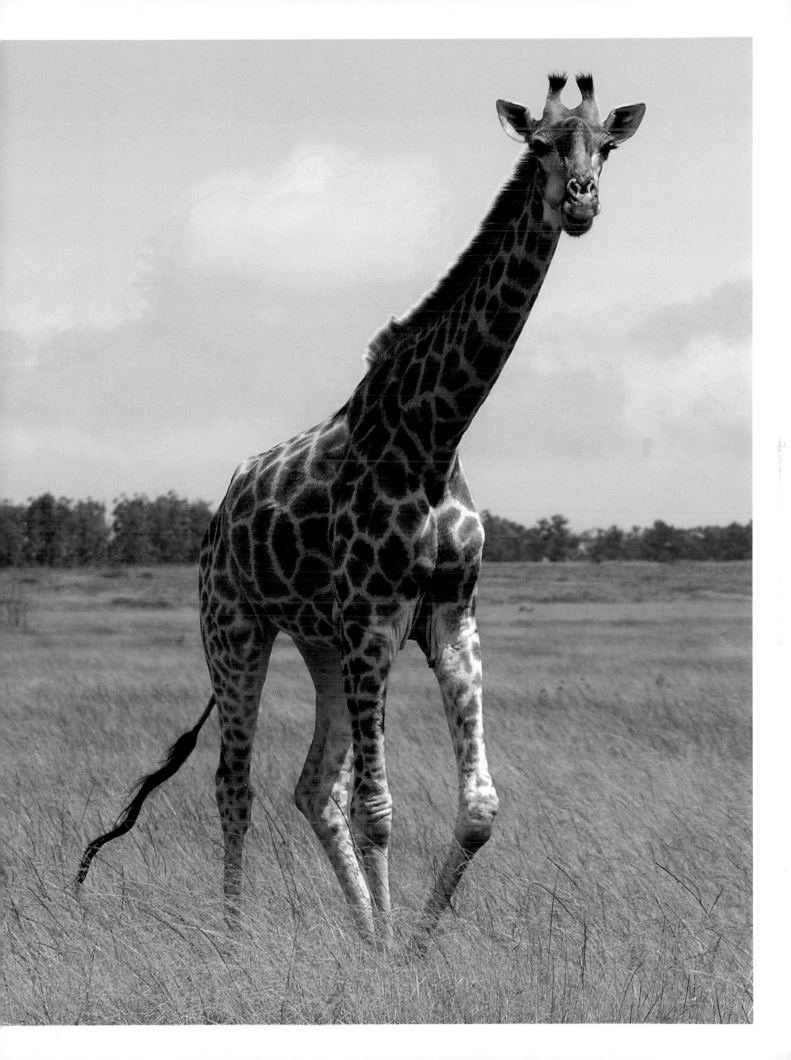

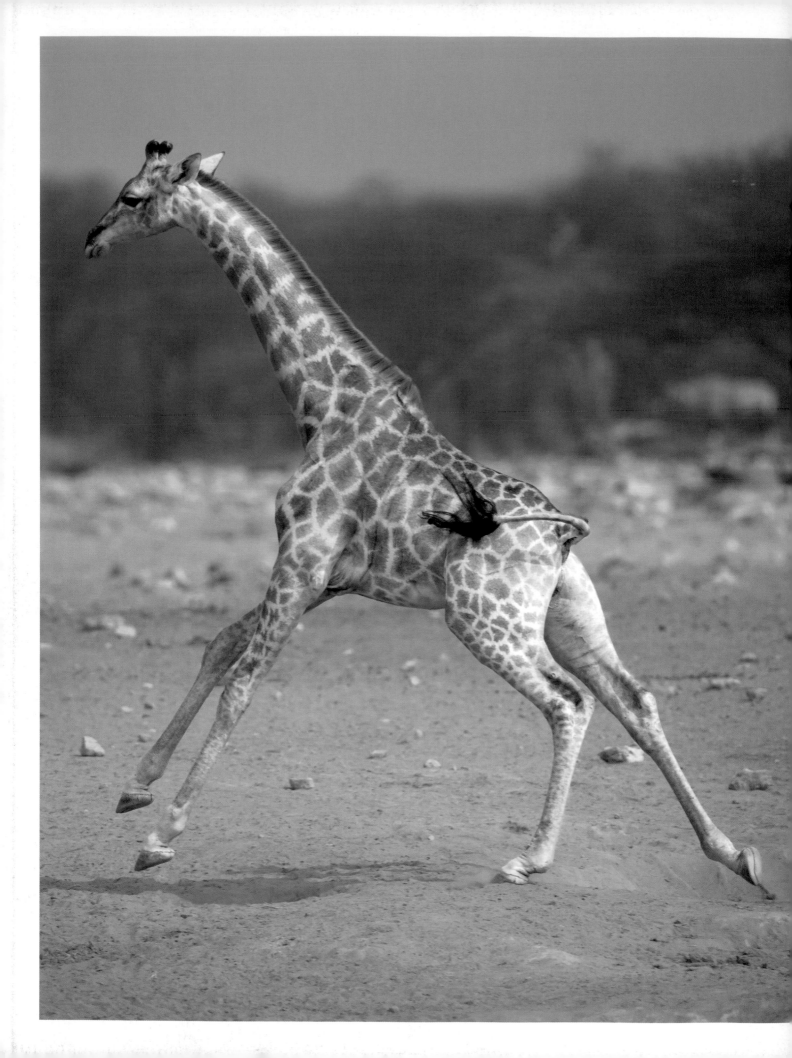

Tell-Tale Toes
Joy Reidenberg

Is a giraffe kosher? I had often wondered this as a child. Its stomach anatomy revealed that it is a ruminant, which means that it chews its cud. OK, one criterion checked off. What about the hooves? A close examination of the giraffe's feet reveals that they are, in fact, 'cloven-hoofed' (and therefore kosher). This means that their hoof looks like it has been split into two parts, rather than the single hoof of a horse's foot. The story of the hoof takes us back in time to an ancestor with five toes. While toes work well for climbing and grasping, they are probably not the best material for running on a hard surface. The soft skin would eventually tear when exposed to rougher substrates, especially sharp rocks. A hard nail for each toe certainly gave an advantage here, as the keratin took much longer to wear down that the calloused pad of a paw. Carnivores, which only run for short periods of time, kept the paw arrangement that had the flexibility needed to grasp prey. Big cats and bears elongated the claws as weapons. Moles and badgers accentuated the claws during their evolution, which improved their digging abilities. Some groups of mammals, such as rodents and raccoons, retained a flexible paw for manipulating food items. Primates accentuated the paw into long fingers for added dexterity (e.g. tree climbing, knuckle-walking, fruit grasping). Multiple, long fingers were a liability for the large grazing herbivores, as they were less stable at high speeds. Larger degrees of freedom of movement only increased the chances of twisting and injuring toes while galloping and making tight turns to evade pursuing predators. The solution was a more rigid end to the extremity. Elephants kept all five toes, but embedded them into a trunk-like foot. The lack of finger-like extensions increased stability, while the large surface area had an increased weight-bearing capability. The modified foot of ungulates gave them the advantage of speed in the literal race for survival. A reduction in the number of fingers during evolution split the ungulates into two groups: odd-toed perissodactyls (e.g. horse, zebra, rhinoceros, tapir) and even-toed artiodactyls (e.g. swine, hippopotamus, cattle, deer, camel).

Below and opposite:
The first toes to be lost through evolution were the ones on the outside, as they were the most prone to injury. Giraffe have lost digits 1, 4 and 5 – which include the 'thumb' and 'pinky' toes. The nails were enlarged to become pointed 'cloven-hooves', which they use like football cleats to dig into the dirt and get a better grip on hard ground while running. The split hoof is also more stable on uneven surfaces. This allows two-toed ruminants to run and jump on rocky outcrops or gracefully exist on jagged cliff ledges.

Turtle

Dermochelys coriacea

Alex Tate

'Hippo, camel, kangaroo, polar bear ... what else?' As I sit at my desk at Windfall Films in London, drawing up a list of animals for future *Inside Nature's Giants* episodes, the phone rings. My colleague, Jamie, picks it up. Although I can only hear half the conversation, my ears immediately prick up. 'A what?... How big?... Is it in a freezer?' Jamie finishes the call. 'Do you recall Jeanette from the snake film?' he asks me. 'She's just picked up a leatherback sea turtle – it's the biggest turtle in the world.' This animal weighs as much as a horse, has salt glands where its brain should be, and a bizarre shield – the shell. Ideal for our series. 'One more thing', Jamie says. 'She's dissecting it on Monday – in Florida.'

Florida is a Mecca for sea turtles – its golden sands provide perfect nesting sites for them to come ashore and lay their eggs. Of the seven species in the world, five of them come here; the loggerhead, the green, the Kemp's ridley, the hawksbill and the mighty leatherback. But these same beaches have also turned the state into a bustling tourist destination, and the turtles are paying the price. Artificial lighting streaming from beachfront properties disorientates baby turtles when they emerge from their eggs. Instead of heading out to sea the bright lights can send them in the wrong direction. Once in the sea, other man-made threats await: from being trapped in shrimp nets to being caught up in oil slicks. In Florida, the most common cause of turtle trauma is boat strikes, which have tripled since 1980. The turtle we've come to dissect suffered this fate. A boat propeller sliced off his entire right flipper and he died a day later.

When turtles die, many undergo a post mortem on the dissection table of Jeanette Wyneken, from the Florida Atlantic University. When we arrive she and her students are taking it out of the freezer where it's been stored since its death. The giant leatherback weighs around 300kg (660lb) and is nearly 2m (7ft) long. Its head is reminiscent of a dinosaur, but the standout feature is a colossal shell. This ultimate defence shield of turtles and tortoises is one of nature's great masterpieces. Impenetrable even to the most sharp-toothed predator, it's helped

Opposite top: Leatherback turtles prefer open access beaches to avoid damage to their soft plastron and flippers.

Opposite bottom: A female leatherback turtle may lay as many as nine clutches in one breeding season, with the average clutch size comprisig around 100 eggs. About 85 per cent of the eggs are viable, and they hatch after about 60–70 days.

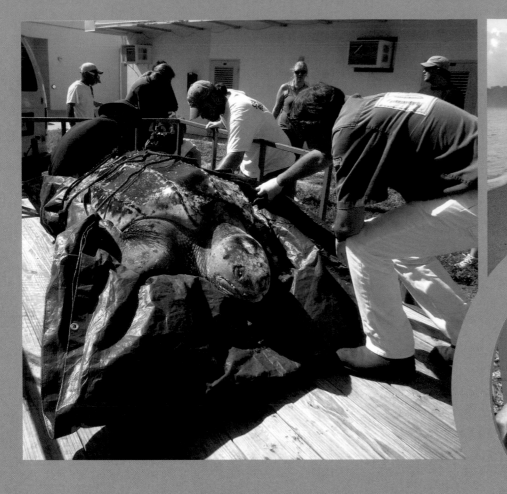

these animals survive for more than 200 million years, right through the dinosaur age.

But as we look more closely at this shell we see there's something peculiar about it. Although it is hard to the touch, it doesn't look like the smooth armour you associate with turtles. Instead, it's covered in a black, leathery skin and has ridges running down its length. How strange. Why is this shell so different, and how did it evolve in the first place? It will take two days for the carcass to thaw.

We leave the aroma of death and head to the beach to film a ritual that has been performed for over 200 million years – a sea creature coming on to land to lay its eggs. We join Doctor Llew Ehrhart and his team at the Archie Carr National Wildlife Refuge. This 32-km (20-mile) stretch of sand receives virtually no artificial light and is the most important nesting site in North America. Every year, 10,000 nests are dug here. Even so, Llew, who has monitored egg-laying on this beach for 30 years, has seen this figure halve since 1998.

Leatherbacks have already laid their eggs by this time of year, so we've come to look out for the second largest species of turtle, the loggerhead. Using torches beaming red light, a colour which turtles are apparently oblivious to, we spread out across the beach, keeping in radio contact. It doesn't take long before the air-waves began to buzz with excitement. 'We've spotted a loggerhead, five minutes up the beach from you.' We scramble up the coast eager not to miss this oppor-tunity. Once sea turtles come onto land they don't stick around for long. Fortu-nately when we arrive she has just started laying, and once she starts, she doesn't stop. For 20 minutes, 118 ping-pong ball-sized eggs are deposited into a hole she has dug into the sand, and she may repeat the process up to seven times in a sea-

Above: Simon has discovered a loggerhead turtle hatchling on Fort Myers Beach. It is barely 5cm (2in) long.

Above left: As the team examine the dead turtle's skin, they notice that instead of the expected smooth armour associated with turtles, this one is covered in black, leathery skin, with ridges running across its back. They set out to find out why it has evolved in this particular way.

Top: The female leatherback leaves the sea to dig burrows in the sand to lay her eggs.

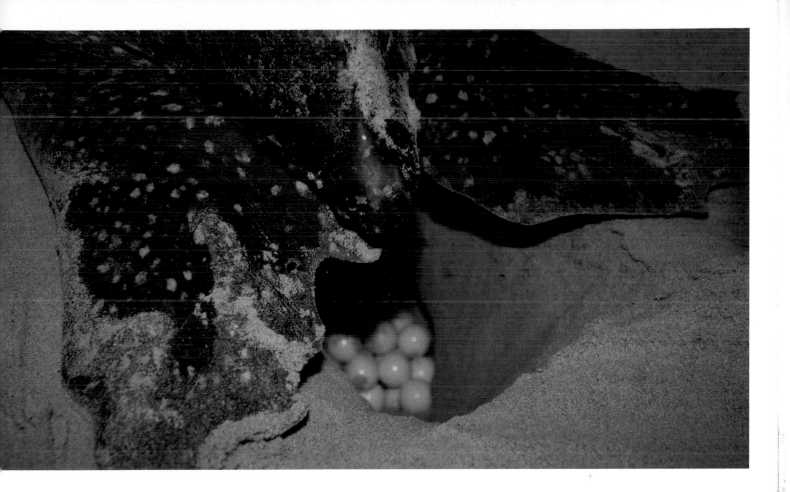

son. Sea turtles lay more eggs than any other reptile, and with good reason. Their life cycle is so perilous that only one in 10,000 eggs may make it to adulthood.

Back at the dissection room, our leatherback has thawed. Joining Jeanette, Mark Evans and Joy Reidenberg is marine veterinarian Nancy Mettee, who is looking for any signs of ill-health which might have dulled the reactions of a turtle which would normally avoid boats. According to Jeanette, the easiest way to dissect a turtle is to turn it onto its back and then remove the internal anatomy layer by layer, eventually leaving nothing but an empty turtle soup bowl. Only then would we be able to understand how the shell evolved.

Once the team get the creature onto its back, which takes a Herculean amount of effort, Jeanette begins to cut into the armoured shield with an industrial circular saw. The turtle shell is actually made of two parts: the upper shell, called the carapace, and the lower shell, called the plastron. Jeanette slowly makes her way around the animal's circumference, centimetre by centimetre before she begins to peel off the plastron.

Rather than being a hard bony plate, the leatherback's plastron is quite flexible. A closer examination reveals that a few small bones are dotted around the edges of the plastron, but it is mainly composed of a layer of fat at least an inch thick. In fact, this fat completely encircles the body. Joy has seen this blubber layer many times before in whales she has dissected. By trapping body heat it enables them to keep warm in cold water. But turtles are reptiles and are therefore cold-blooded. They can't adjust their body temperatures, so if the water temperature is cold, then their body temperature is cold, too. That's why they tend to be restricted to warm waters. When in January 2010 Florida was exposed

Above: A female lays her eggs in deeply dug burrows in the sand. Leatherback turtles prefer gradually-sloped beaches without vegetation to avoid injury to their flippers.

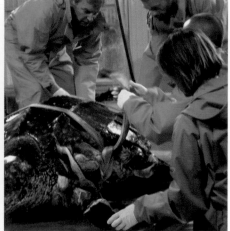

to an unusually cold snap, plummeting water temperatures sent sea turtles into shock – they were found either floating listless on the surface of the ocean or washing on to shore. Although they were still alive, their cold bodies ceased to function. It was almost as if they had been cryogenically frozen.

So why then does a cold-blooded turtle have blubber like a marine mammal? It turns out that the large size of leatherbacks gives them some unusual heat-generating properties.

Lying directly beneath the fat-filled lower shell are the pectoralis muscles. We have the same chest muscles, but in a leatherback they are so huge that they extend almost half the length of the body. It would be like having pecs that went down to your waist. They need these giant pecs to power their equally impressive flippers. In water these giant wings arc up and down in great purposeful strokes. These animals are born to swim; unlike other sea turtles, they rarely stop moving and on average will cover 65km (40 miles) in a day. As their giant chest muscles are forever contracting and relaxing, with each stroke, they generate vast amount of heat – far more than their smaller cousins. But rather than allow this heat to escape, the ever-efficient leatherback traps it with its blubber layer, allowing it to keep a high body temperature even in cold water.

Smaller cousins are restricted to temperate waters, but the leatherback has been able to spread throughout the world's oceans – reaching as far north as Alaska and Norway and as far south as the tip of South Africa. These turtles travel further than any other sea vertebrate. They treat the ocean as their pond – one female was recorded swimming nearly 21,000km (13,000 miles) in 647 days. Leatherbacks travel to these cold waters because they are great places to feed on

Above: The team begins to dissect the turtle. The easiest way to dissect a turtle is to turn it on its back and then remove the internal anatomy layer by layer.

Above left: The throat of the leatherback turtle is lined with backward-pointing spines called papillae, which snare the jellyfish it eats all the way down the food pipe every time it gulps a mouthful.

Opposite: The biggest, deepest-diving, widest-ranging of all turtles, the leatherback has endured for 100 million years.

These animals are born to swim; unlike other sea turtles, they rarely stop moving and on average will cover 65km (40 miles) in a day. As their giant chest muscles are forever contracting and relaxing, with each stroke, they generate vast amount of heat – far more than their smaller cousins. But rather than allow this heat to escape, the ever-efficient leatherback traps it with its blubber layer, allowing it to keep a high body temperature even in cold water.

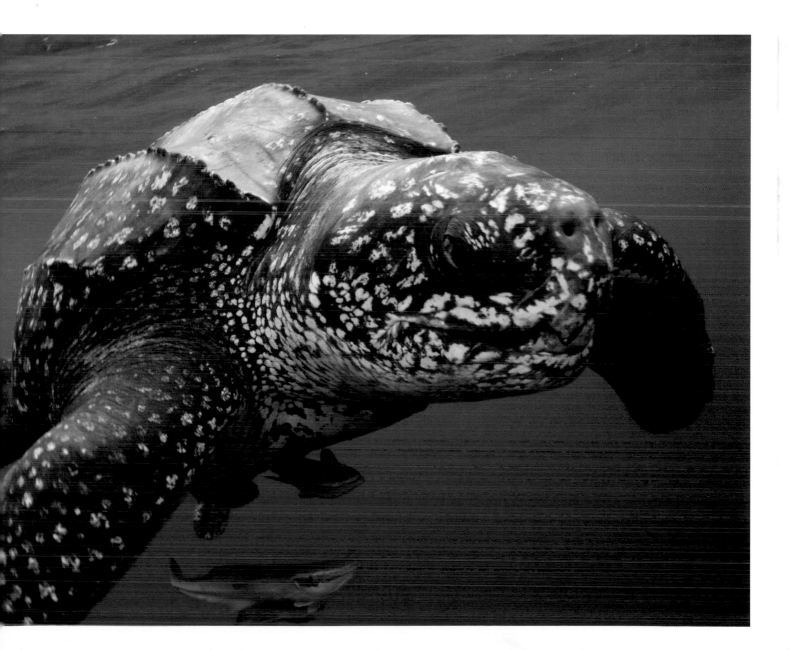

Above: A turtle's early life is incredibly hazardous, with predators far and wide lurking to kill the young hatchlings unable to fend for themselves. Less than I per cent tend to make it through their first year.

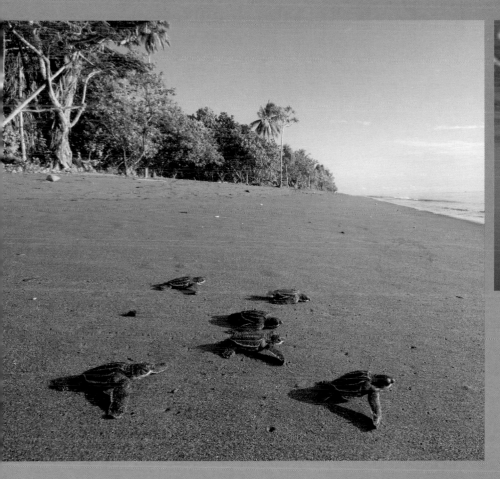

jellyfish, but when it's time to lay their eggs they need to return to warm waters. The small hatchlings that emerge from their nests do not have the ability to survive in the cold until they are much larger.

Early life for a turtle is hazardous. It's thought that less than 1 per cent make it to their first year. To find out why, Simon Watt met up with conservationist Eve Haverfield on Fort Myers beach. Eve is one of Florida's many 'nest guardians'. She marks each clutch of eggs when they are first laid and watches over them for the entire incubation period, which can last up to two months. The morning after they eventually hatch she digs up the nest and counts how many hatchlings made it out. She also rescues any stragglers that don't make it.

Like some other reptiles, the temperature inside the nest determines whether a turtle is born male or a female. Warmer eggs are more likely to be female, and colder eggs male. Hot babes. Cool guys. So nests laid at the southern end of the Florida coast are predominantly female, whilst those further north are male.

As Eve and Simon pull out handful after handful of sand, it soon becomes apparent that this nest had not had it easy. Fire ants, known to pierce their way through an egg and devour the developing embryo, scamper about. And a hole made by a ghost crab indicates that even larger predators have been feeding here. They continue to dig deeper, searching for the eggs. Suddenly, Eve jumps with fright, before bursting into a fit of giggles – she has been bitten by the ghost crab lurking in the nest. Clearly Eve's finger looks like a tempting snack. The duo gets back to work, but before long the smiles and laughter dampens. Simon pulls out an unhatched egg with three distinctive fire ant holes in it, and then Eve discovers the lifeless body of a dead hatchling. Several siblings shared the same fate – they had been victims of a recent storm that had flooded the nest and drowned them.

Above: The hatchlings make for the sea after emerging from the nest and are not seen again until many years later, when the adult female turtles that have survived the countless predators, return to the same beach that they were born to lay their eggs and the cycle begins again.

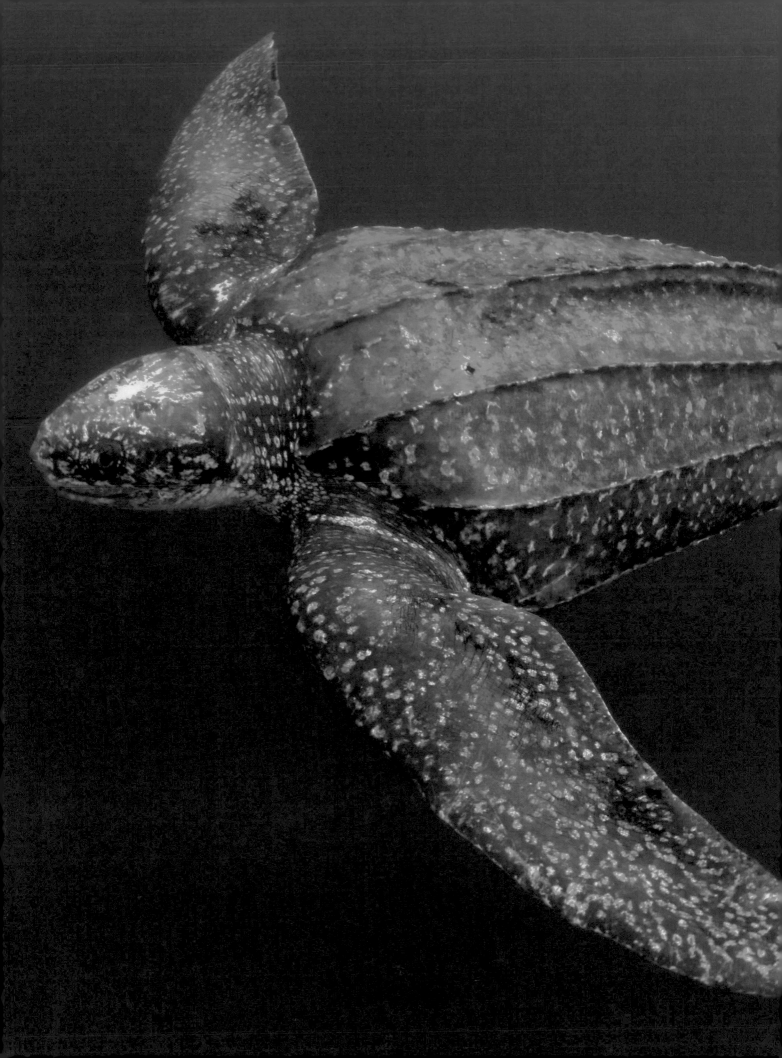

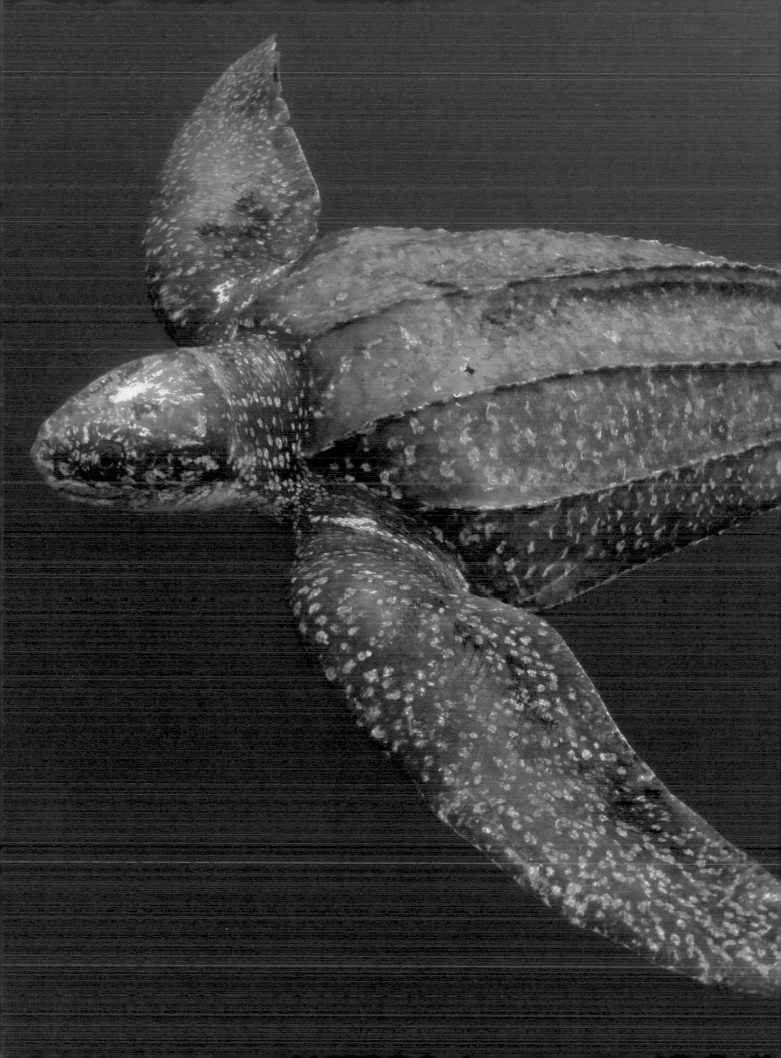

Eyes

Leatherbacks are known to be the deepest divers of all the sea turtles with dives of 1,270m recorded. But how do their eyes cope with the pressure at that depth? The ping-pong ball-size eye is harder than a human eye, its back thickened with a layer of cartilage that prevents crushing.

Salt Glands

All animals need freshwater to survive, but the leatherback's jellyfish diet is rich in salt, so it has evolved huge salt glands in its skull which act like kidneys, to remove excess salt from the seawater. The salt leaves the body via the tear ducts in the form of continuous, viscous, salty tears. The process is happening all the time, but when turtles come on to dry land it looks like they're crying.

Breathing

Despite their benign image, when it comes to sex, sea turtles can be nasty. A testosterone-charged male will bite into the exposed limbs of a rival to force him off the female. Several males will even gang together to try to block a mating pair reaching the surface, attacking their need to breathe. Its lungs aren't actually that big, but leatherbacks have been known to hold their breath for nearly 90 minutes when foraging, the longest active dive time of any turtle. It survives by storing oxygen in its bloodstream and muscles.

Shell

The giant leatherback can weigh up to 900kg (1,984lb) and is around 2m (6.6ft) long. Its impenetrable and colossal shell is covered in a black, leathery skin with ridges down its length. The shell is actually made up of two parts: the upper shell (carapace) and the lower shell (plastron). The leatherback's shell is the key to its extraordinary deep diving capabilities, because unlike other turtles, the ribs that make up the carapace aren't fused together. This allows the shell to compress when the leatherback dives.

Keeping Warm

Turtles are cold-blooded reptiles and unable to adjust their body temperatures, which is why they prefer warm waters. But leatherbacks are different; they can survive even in Arctic waters because their large bodies generate and trap excessive heat. The heat is produced by the leatherback's pectoralis muscles, which extend almost half the length of the body. They power their impressive flippers in long, purposeful strokes. Leatherbacks rarely stop moving and on average cover 65km (40 miles) per day.

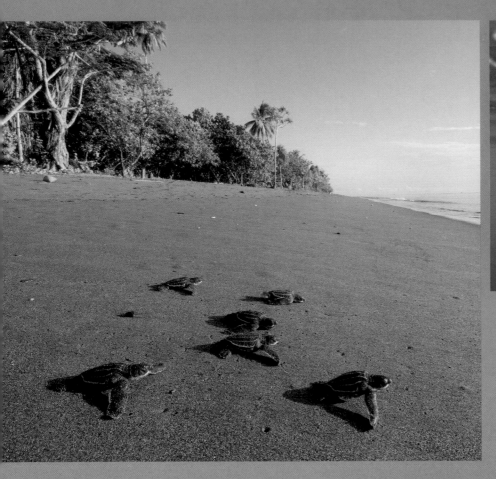

Above: The hatchlings make for the sea after emerging from the nest and are not seen again until many years later, when the adult female turtles that have survived the countless predators, return to the same beach that they were born to lay their eggs and the cycle begins again.

jellyfish, but when it's time to lay their eggs they need to return to warm waters. The small hatchlings that emerge from their nests do not have the ability to survive in the cold until they are much larger.

Early life for a turtle is hazardous. It's thought that less than 1 per cent make it to their first year. To find out why, Simon Watt met up with conservationist Eve Haverfield on Fort Myers beach. Eve is one of Florida's many 'nest guardians'. She marks each clutch of eggs when they are first laid and watches over them for the entire incubation period, which can last up to two months. The morning after they eventually hatch she digs up the nest and counts how many hatchlings made it out. She also rescues any stragglers that don't make it.

Like some other reptiles, the temperature inside the nest determines whether a turtle is born male or a female. Warmer eggs are more likely to be female, and colder eggs male. Hot babes. Cool guys. So nests laid at the southern end of the Florida coast are predominantly female, whilst those further north are male.

As Eve and Simon pull out handful after handful of sand, it soon becomes apparent that this nest had not had it easy. Fire ants, known to pierce their way through an egg and devour the developing embryo, scamper about. And a hole made by a ghost crab indicates that even larger predators have been feeding here. They continue to dig deeper, searching for the eggs. Suddenly, Eve jumps with fright, before bursting into a fit of giggles – she has been bitten by the ghost crab lurking in the nest. Clearly Eve's finger looks like a tempting snack. The duo gets back to work, but before long the smiles and laughter dampens. Simon pulls out an unhatched egg with three distinctive fire ant holes in it, and then Eve discovers the lifeless body of a dead hatchling. Several siblings shared the same fate – they had been victims of a recent storm that had flooded the nest and drowned them.

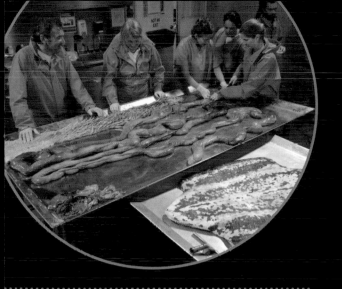

Turtle:

Weight:
900kg (1,984lb)
Height:
N/A
Length:
2m (7ft)
Life Span:
45yrs
Top Speed:
35km/h (22mph)
Bite strength pound force:
N/A

Digestion

Leatherbacks feed exclusively on jellyfish, which at 95 per cent salt water is one of the least nutritious foods in the sea. Like birds, they have swapped their teeth for a sharp beak. The food pipe is six times longer than it is in other turtles and it is lined with backward-pointing spines, called papillae, which snare jellyfish when seawater is squeezed out of their mouths. These adaptations help the leatherback to eat its entire body weight in jellyfish every day.

Egg Laying

Leatherbacks travel far to cold waters to feed on jellyfish, but they lay their eggs in warmer climates. The small hatchlings that emerge cannot survive the cold until they are much larger. Early life is hazardous, and fewer than 1 per cent will survive for a year. Incubation can last two months, and the temperature inside the nest determines whether a turtle is born male or a female. Warmer eggs are more likely to be female. Hatchlings must overcome many obstacles: they leave the nest; make a desperate dash to the sea; and begin an epic 48-hour swim towards the sargassum seaweed 60 miles offshore. In this floating nursery they hide from predators, find food and learn to fend for themselves.

Turtle

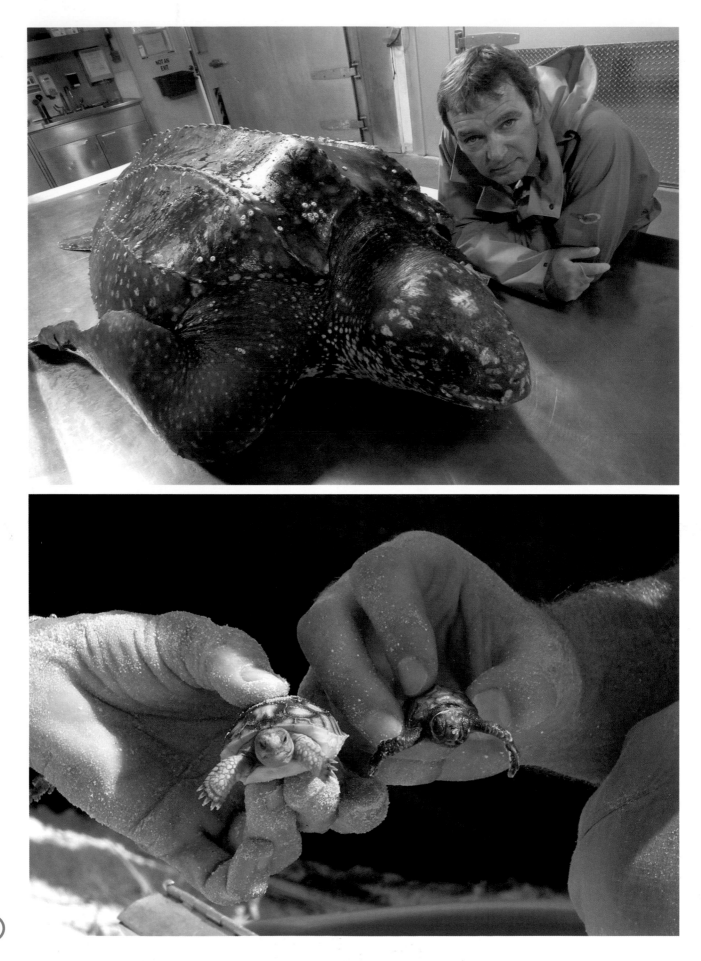

Getting out of the nest is just the first hurdle that hatchlings must overcome if they are to survive. They then make a desperate dash to the sea, running the gauntlet of hungry predators. Birds lurk outside the nest waiting for the hatchling hors d'oeuvres to present themselves. The hatchlings tend to make a run for it at night when they are harder to spot, but even so they are easily picked off, one by one. The few that make it to the water's edge then begin an epic 48-hour marathon swim. Dodging the jaws of sharks, fish and even other turtles, they instinctively head towards the sargassum seaweed 97km (60 miles) offshore. In this floating nursery they hide from predators, find food and grow big enough to fend for themselves.

Back in the dissection room, the team is examining the anatomy of the turtle's head. Leatherbacks are known to be the deepest divers of all the sea turtles – satellite tagging of one nesting female recorded a descent of 1,270m (4,167ft), which is the depth sperm whales go. Joy is intrigued to find out if their eyes have similar adaptations to coping with the immense pressure at that depth.

Mark and Joy each use a metallic implement to pull back the turtle's eyelid, while Nancy delicately uses her scalpel to etch into the muscles that hold the eye in place. As she proceeds, it becomes obvious that the eye is not as small as it looks. Much of it is hidden in its orbit. So instead of the small marble-sized eye we are expecting, out pops an eye the size of a ping-pong ball.

Joy picks up the eye and presses it between forefinger and thumb. It's much harder than a squidgy human eye. This makes sense to her – a soft eye would crush under pressure. Just like a whale's eye this eye is hard. But what makes the eye so resistant? Taking a knife, she slices through it and peers inside. The back of the eye is thickened with a layer of cartilage that prevents it being crushed under pressure. Deep diving whales have a similar adaptation, but they've strengthened their eyes with connective tissue rather than cartilage. Two completely unrelated groups of animals solve a similar problem in different ways. It's a classic example of convergent evolution.

Back on Fort Myers Beach, Simon Watt continues to help Eve Haverfield in checking her nests. 'Got one, got one', Eve exclaims. Reaching beneath the sand she pulls out a loggerhead turtle hatchling. This miniaturized version of an adult is barely 5cm (2in) long. With its brothers and sisters long gone, this little guy would never have made it out of the nest if it weren't for Eve's intervention. It may not be as nature intended, but in a modern world where turtle numbers are falling due to human activity, she does everything she can to improve their odds of survival. After dousing it down with water and washing off the sand, she hands it to Simon. The hatchling displays its camouflage technique, by pulling in its limbs so it resembles a leaf. Out at sea this might be enough to evade the watchful eyes of a hungry bird. Eve then shows Simon another hard-shelled hatchling that was also rescued from its beach nest – a gopher tortoise. Side by side, the two look quite similar, but there's a vital difference: one has flippers and the other feet. So what is the evolutionary relationship between the two? Did the tortoise walk into the sea to become a turtle, or did the turtle swim on to dry land to become a tortoise? It's a question that has intrigued biologists for centuries.

Richard Dawkins relishes the surprising twist to this evolutionary tale. There are two kinds of land tortoises: ancient and modern. Modern sea turtles are descended from ancient land tortoises that lived on land and went back to the wa-

Opposite top: Mark carefully examines the anatomy of the leatherback turtle's head in the dissection room.

Opposite bottom: Simon and Eve find two small hatchlings on Fort Myers Beach – a loggerhead turtle and a gopher tortoise.

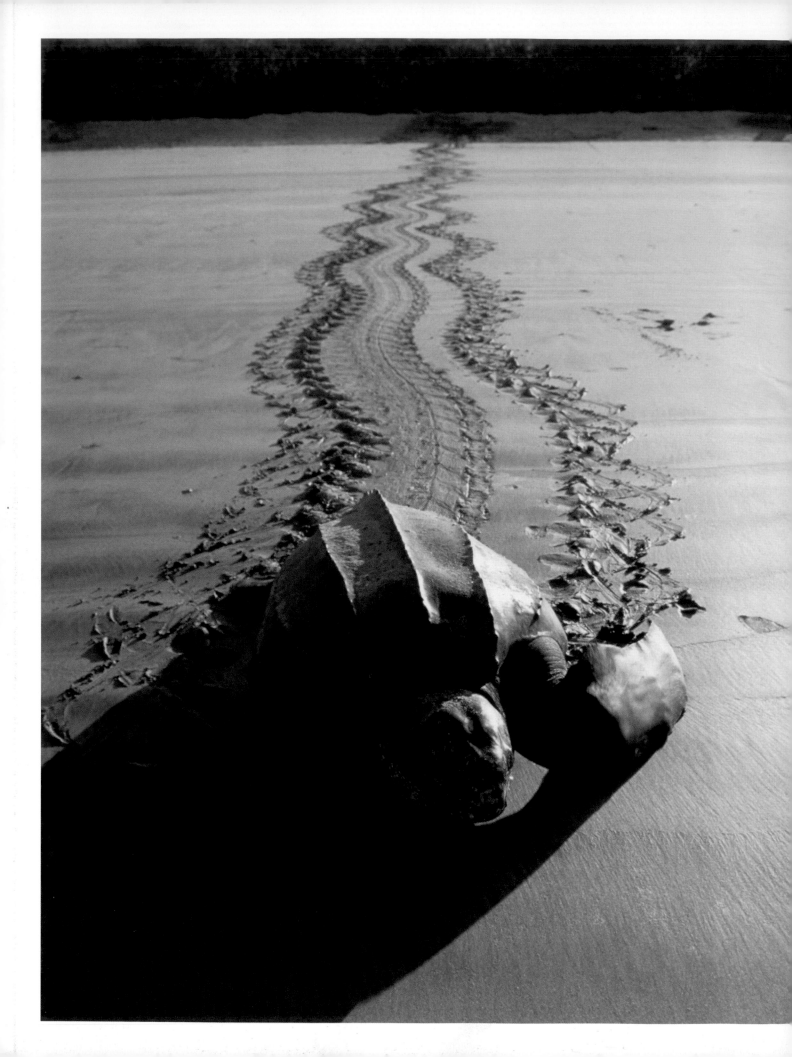

How the Turtle Got Its Shell

At the end of the dissection, we return to the question we began with: how did the turtle's armoured covering evolve? With all its internal organs removed, we stare into the empty turtle soup bowl. The revelation is striking and obvious: the shell is made of ribs. It's a modified ribcage. Countless times in the history of life, evolution has developed new uses for pre-existing body parts. The elephant's trunk came from an elongated nose; the bat's wing from lengthened fingers, and now, here before us, the turtle shell from an expanded ribcage. But this elegant adaptation only prompts further questioning. The ribcage completely encircles the arms and legs, so how did the shoulders and hips get inside the shell as well?

Until recently this was a perplexing puzzle because fossils depicting this transition have never been found; but a recent study focusing on the development of turtle embryos may have the answer. As the ribs grow outwards from the vertebral column, there comes a point where they should begin to bend and tuck inside the shoulder blades – that's what happens in mice, whales and humans. But in turtles and tortoises this doesn't happen. Instead, the ribs keep growing outwards, passing over the shoulder blades (and hips) before connecting to the lower shell, and so enveloping the turtle with an armoured shield.

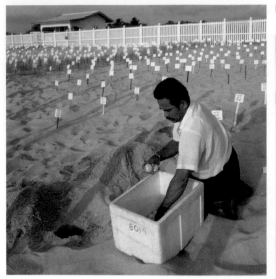

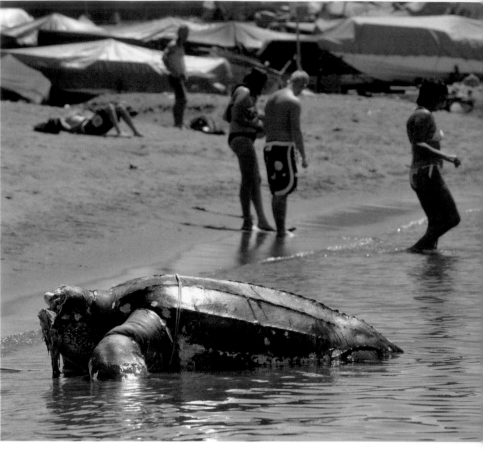

ter. Now you might think that modern land tortoises would have come straight from the ancient land tortoises that gave rise to the turtles, but they didn't. Instead turtles re-emerged out of the water, back on to the land, as modern land tortoises.For the seven species of turtle that remain in the sea today, the leatherback has one particular distinctive feature that sets it apart from its smaller cousins – its shell. The armoured shields of other sea turtles are more like bony boxes, as their ribs have expanded and fused together to form an impenetrable seal. But the extraordinary deep dives that the leatherback regularly undertakes would cause a shell like that to crack and break when exposed to the enormous pressures at 1,000m (3,300ft) deep. So just as the eye had to adapt to avoid crushing, so did the leatherback's shell.

Stretching across the empty soup bowl, Jeanette pulls out the leatherback's secret. It's a small bone, no larger than a 10 pence piece. This bone and thousands of others just like it are what make up the leatherback's upper shell, which sits above the ribs and whose surface is covered in a black, leathery skin. The bones fit neatly together like puzzle pieces with tiny gaps in between, filled in by a thin layer of connective tissue. The gaps are vital, because they allow the shell to compress when the leatherback dives, instead of cracking. So it's not a hard shell, but a firm, flexible shell, and it is the key to the leatherback's diving capabilities.

There used to be many other flexible-shelled sea turtles; one of them, archelon, a beast measuring over 4m long, was the largest turtle to ever swim the seas. But only the leatherback remains from this offshoot group of sea turtles. Today the leatherback struggles to survive with so many man-made threats. Let's hope it does not join archelon as an extinct animal confined to the history books.

Above: The carcass of a giant leatherback turtle was found on a beach in Genoa in June 2011. The animal is thought to have been killed during a heavy storm.

Above left: The Deepwater Horizon oil disaster became the single-largest threat that turtle hatchlings had ever faced in the Gulf of Mexico. A massive operation endeavoured to rescue every single egg laid over the entire nesting season, carefully transporting them to the oil-free Atlantic coast.

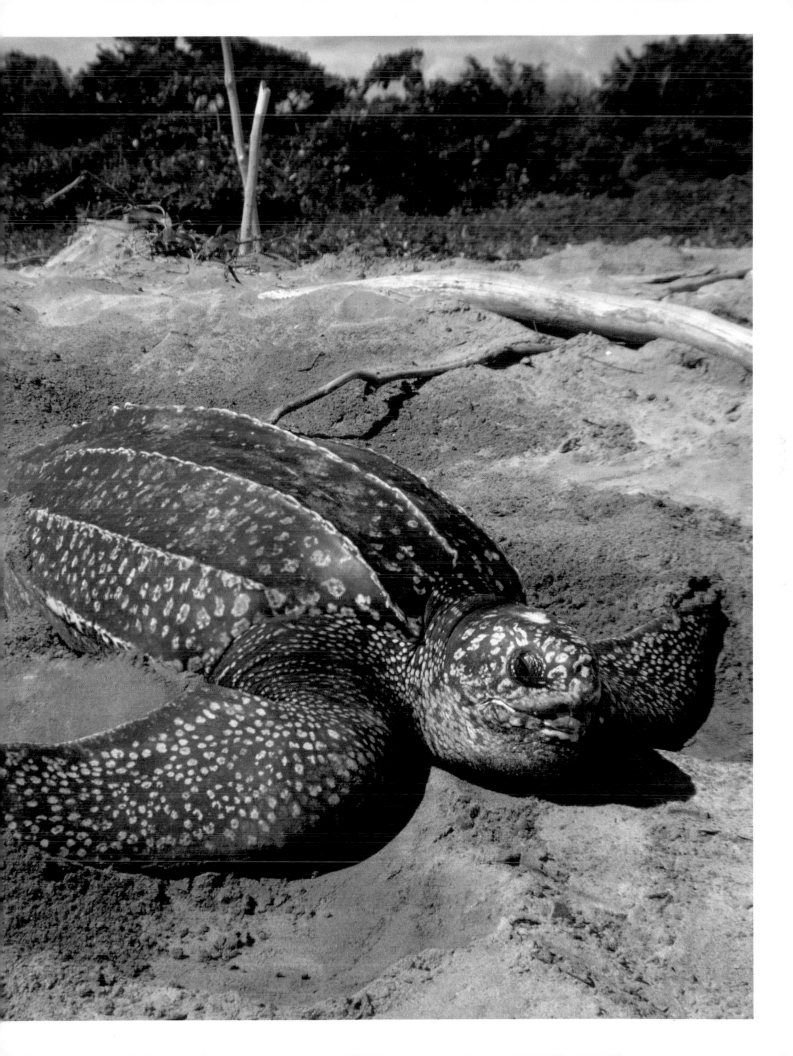

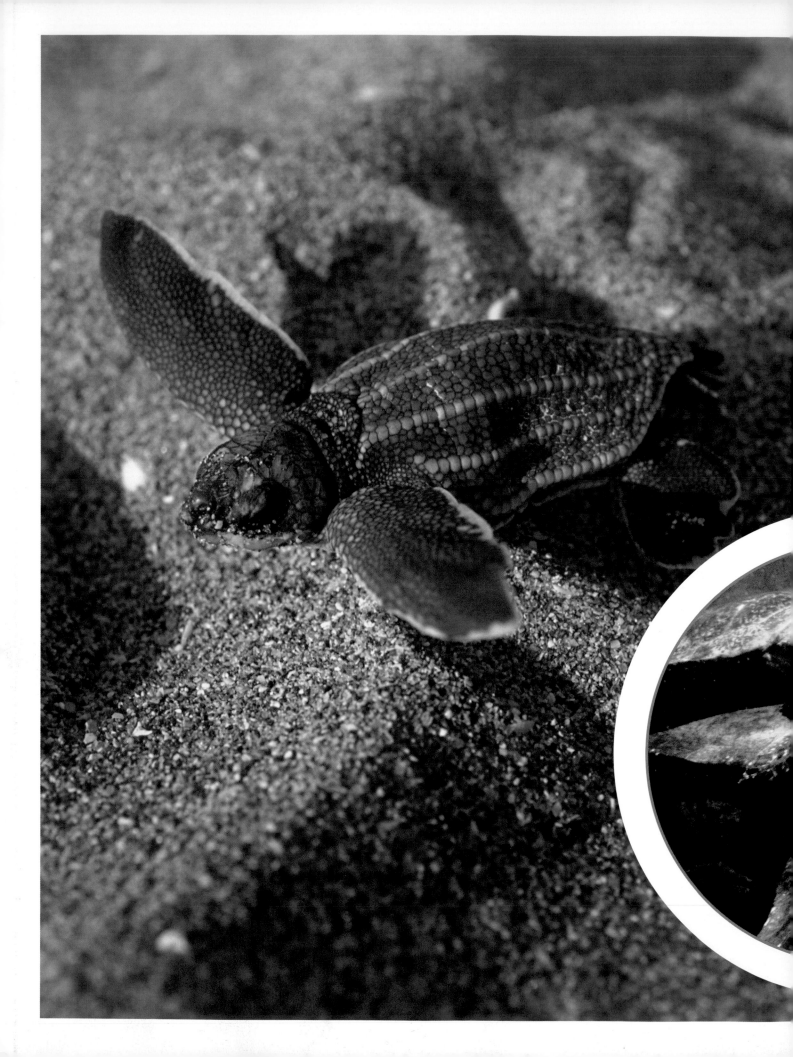

The Leatherback Penis
Joy Reidenberg

Leatherback sea turtles cannot possibly hip thrust when they mate. The protection provided by a rigid shell means a loss of spine flexibility, and they cannot achieve the close jig-saw fit that other animals have when they mate. Leatherback sea turtles solved this problem through the evolution of a better method to stay in touch, literally. It's a very simple idea: if you can't get the bodies close enough together, make a longer bridge. This is not a unique solution. We see long penises in other animals that can't cradle their hips against their mates, such as whales and walruses. Even the long claspers of the shark help make a bridge for channelling semen (sperm and seminal fluids). The leatherback sea turtle's penis is indeed a very long bridge. Although it is not as absolutely long as a whale's, it is relatively much longer given the smaller size of the turtle.

The leatherback sea-turtle penis is an extension of the ventral (bottom) part of the cloaca (the common opening for urinary, digestive and reproductive tracts). When the penis is flaccid, it is hidden within the cloaca at the base of the tail (males thus have much longer tails than females). When it is erect, muscles from the tail region can help adjust penile position. It is an enviable ability to be able to direct the penis independently of the torso! Whales also use muscles to control penile position. It's an evolutionary convergence of a similar solution to the problem of mating two wide-bodies in open water without pelvic thrusting.

Male sea turtles need more than just a long bridge to reach their mate's cloaca. The penis must also be stiff enough to penetrate without bending. In mammals, both length and stiffness are achieved by filling three separate vascular spaces (called erectile bodies) with blood. Turtles also use blood to fill the penis, but it is contained within only one erectile body. The turtle's erectile body is divided into two components: an expandable erectile portion, and a dense collagen portion that provides additional strength. Even though the turtle penis we were dissecting was not erect, the dense collagen rendered it much stiffer than a flaccid mammalian penis.

The erectile body is trough shaped in leatherbacks, resembling the letter 'U' in cross-section. This shape gives strength at the bottom and sides of the 'U' but is weaker at the 'U's' opening. This opening, which runs the length of the penis, may make that side more bendable and thus easier to retract into the cloaca and tail region. During erection, engorgement of the surrounding erectile tissue closes the 'U'. This is crucial to proper functioning, or else precious semen would leak out of the cleft and be left floating in the ocean.

Shark

Carcharodon carcharias

David Dugan

A strange squelching sound can be heard as our boat rolls in the gentle swell off Mossel Bay. We are in South Africa with shark biologist Enrico Gennari, who is extracting the oily innards from sardines and fish heads to produce 'chum'. In his Wellington boots, he rocks back and forth in his homemade bisque, savouring the aroma of his disgusting brew with as much pride as an olive grower squeezing out the finest extra-virgin olive oil. Using a bucket on a stick, he casts the pungent liquid into the sea every few minutes. For Enrico 'chumming' is a familiar ritual – the first stage in attracting great white sharks to his boat.

Mossel Bay is a town with two fronts. On one side, the big Indian Ocean rollers attract surfers. On the other, Seal Island attracts great white sharks. For decades the two have ignored each other, but a couple of months before we arrived, there was a fatal shark attack. Unwittingly, one species had strayed into the other's territory. A surfer with wet-suited legs could easily be mistaken for a seal.

We have been at anchor for several hours and the current has carried the oily chum film several miles, but so far there's no sign of sharks. Joy Reidenberg is in her wetsuit ready to go into the shark cage, while Enrico scans the horizon.

'Shark!' the cry rings out. In the distance a strangely familiar dorsal fin cuts through the water towards us. Immediately our heartbeats quicken. Steven Spielberg has got a lot to answer for. His film *Jaws* has given great whites their fearsome reputation. Yet as it accelerates towards us, there is no denying the power of this animal. Suddenly, it rams the stern with great force, a very uncharacteristic behaviour, that rocks the boat. Everyone, including Enrico, gasps. Our first brief encounter with a great white was over. It dived down and we never saw it again, but it left me with a healthy respect for these powerful predators.

The *Inside Nature's Giants* team had come to Mossel Bay to film great whites and to carry out a dissection on a huge 4m (14ft) specimen caught in beach protection nets off Zinkwazi Beach north of Durban. This was the biggest great

Opposite: The team assemble in Mossel Bay, South Africa to carry out a dissection on an adolescent female great white shark that had been caught in beach protection nets off Zinkwazi Beach.

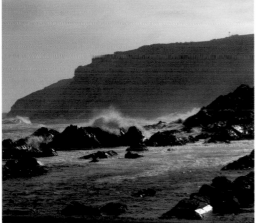

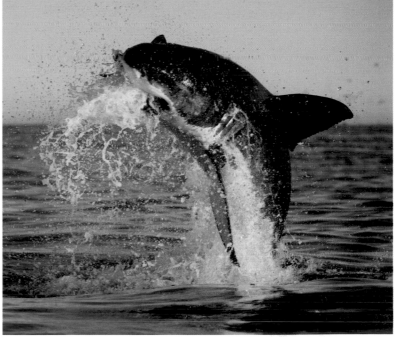

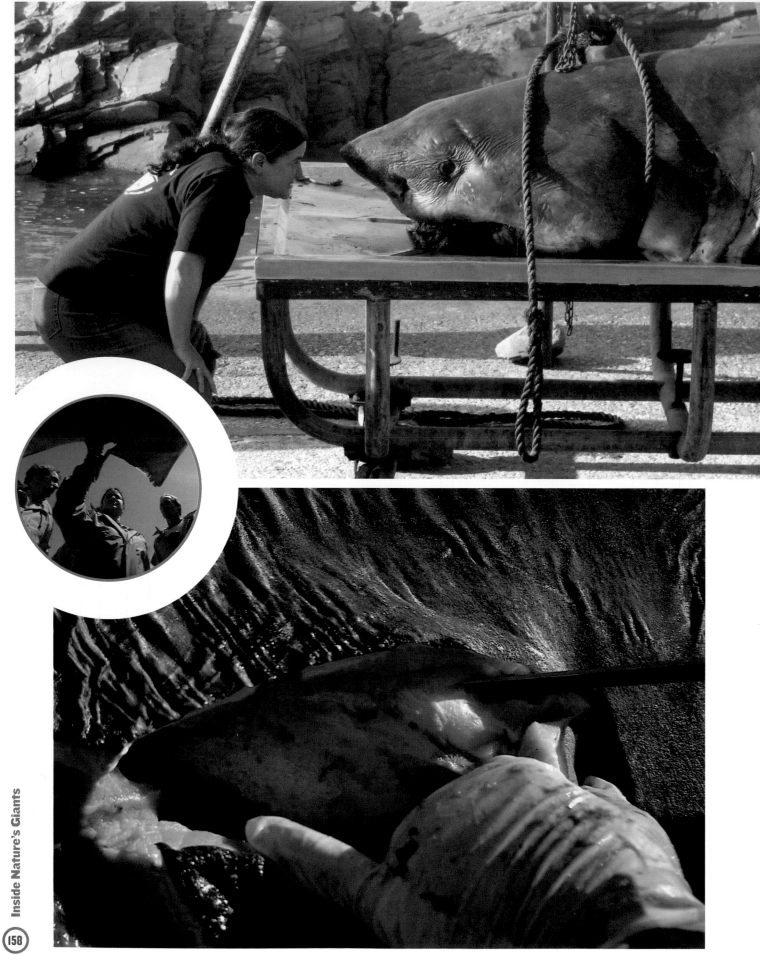

white caught in static nets since 2002, and this adolescent female was not even fully grown.

At dawn on the day of dissection, the refrigeration truck arrives from Durban with the 900kg (2,000lb) shark. Surfers and visitors speculate on the bloody mass inside its jaws. At first glance this looks like her last meal; in fact, it's her stomach. When sharks swallow something they don't like, they can invert their stomachs to eject the contents. In the case of our shark it was probably a response to the stress of being caught in nets.

Philip Zungu, the KwaZulu-Natal Sharks Board's most experienced dissector, begins cutting away the tissue around the jaw. Looking on, scalpel in hand, Joy Reidenberg is eager to start cutting too. She has dissected many whales, but this is her first great white shark. She soon discovers shark skin is much tougher than whale skin. It's like cutting through sandpaper.

Shark skin was once used as sandpaper and in some parts of Australia – it still is. Rub your hand along the side of a shark towards the tail and the surface feels quite smooth; but run it back towards the head and it feels rough. Closer examination of the skin under a microscope reveals millions of miniature teeth. They provide an extremely tough outer coating against bites from other sharks. During mating the male often holds on to the female with its jaws. Without that protective skin a love bite from a great white could be more than skin deep.

It may seem surprising that this large fish is covered in tiny teeth, instead of scales, especially as its jaws are equipped with enormous razor-sharp teeth. But what happened during evolution is that the micro teeth of the skin eventually turned into eating teeth.

Peering inside the jaws of the shark, Mark Evans touches one of the serrated but wobbly front teeth. The last thing you'd expect in a shark is wobbly teeth, yet they've turned an apparent weakness into an advantage. A land mammal predator, like a lion, is doomed if its adult teeth break, but the great white has a new set of teeth behind the front row for when the outer teeth need replacing. The teeth are not embedded in sockets like they are in our mouths, but are connected to a layer of tissue that grows continuously, very slowly, from the inside of the jaw out, so that when the front teeth fall out there's another row to replace them.

No jaws are more terrifying than the great white's mighty cavernous bite. But the reality is that great whites rarely attack humans, and most victims survive the ordeal. So why is that? The team dissects the jaw to investigate the mechanics of the shark bite. Huge sections of muscle sit either side of the jaw. It reminds Joy of the huge muscle attachments on the crocodile jaw. But as she soon discovers, there's a big difference. Whereas the upper jaw of the crocodile is embedded firmly in its skull, the jaws of the great white are floating free from the cranium. So what impact does this have on the power of its bite?

Enrico Gennari has a bite metre to measure the great white's bite and he takes us on an expedition to try it out. He persuades sharks to bite the metal jaws of his metre by surrounding it with fish heads. It's a precarious procedure. He removes the safety rail from the stern of the boat, lies down on a short wooden platform and thrusts the bite metre into the swell on the end of a long pole.

After an hour or so throwing chum into the sea, several great whites begin circling the boat. Enrico greets them like long-lost friends, recognizing individu-

Above: Mark Evans can't resist lowering a great white's jaw over Joy's head. Engulfed by rows of sharp, serrated teeth, she would be a bite-sized morsel to a shark of this size.

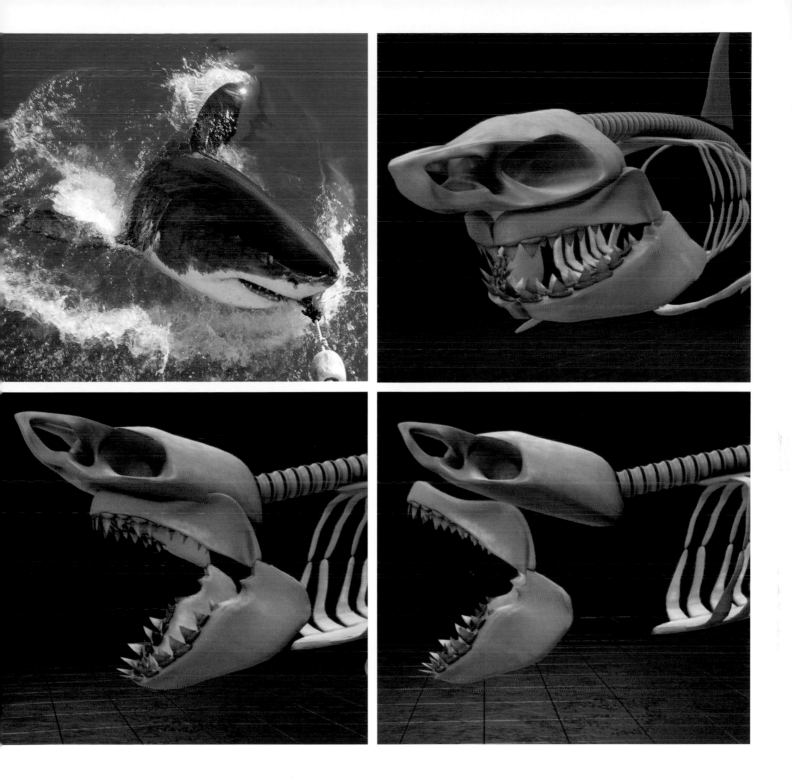

Above: The free-floating jaws of a great white are not attached to the skull. This means that when it attacks it can lunge forward – virtually dislocating its upper jaw in order to reach forward and widen the size of its bite.

als from the scars on their back. He goads them to bite his metre and they lunge. Their fist bite is little more than a caress to find out whether Enrico's bait is worth eating. But with teeth this sharp, a caress can do a lot of damage. This weak exploratory bite is the reason why most human shark attack victims escape with their lives. The shark prefers seal blubber to bony flesh and usually doesn't come back for the second, much stronger 'killer' bite.

One of the great whites circling that day is Pacella. She has a deep scar on her back and a feisty reputation. Enrico treats her with cautious respect. When she first appears, her big black eye surfaces above the water and watches us warily.

Enrico scoffs at people who think sharks' eyes are dead. 'They are dark and without any emotion, but when you interact daily with them, you see they are checking you out … not as bait, but because they are just interested in you.'

She makes her initial bite, then disappears. Lying on his front, Enrico leans out of the stern, his head only a foot above the water. He braces himself for the next challenge, but there is nothing.

Suddenly, with no warning, Pacella roars up from the deep, launching her jaws into the air to grab the fish heads on Enrico's bite metre. This time she bites hard and won't let go. An epic struggles ensues between man and shark. Enrico's not going to be beaten and appears to be hanging on by the tips of his wellies. We grab hold of his legs to help in this tug of war and eventually Pacella lets go.

So how strong was the shark bite? What had the metre recorded? The first exploratory bite was only 13kg (29lb), which is weaker than a modest human bite. Enrico explains that what they're doing is using their teeth like hands to touch and explore a strange object before they bite hard. When Pacella came back for

Above: As the shark swims, oxygen-rich water flows into its mouth and through the gills.

Above left: Joy exposes each layer of gills like the leaves of a book. The tightly folded tissue absorbs oxygen from the sea water.

Top: Joy attempts to cut through the eye of a great white which has a tough, fibrous coating to protect it from the flailing claw of its prey.

Great whites have a formidable reputation for tracking down prey and smelling the smallest traces of blood at great distances. The highly sensitive cells that line the nasal passages on either side of the nose enable the shark to pinpoint precisely which direction their potential prey is. But it's not just their sense of smell that's ultra-sensitive, they have many other finely tuned senses. Perhaps the most mysterious and least understood is the great white's ability to detect small changes in electric field through thousands of tiny electromagnetic receptors called Ampullae of Lorenzini.

the stronger bite, the metre recorded 40kg (90lb) which is still quite weak, but Enrico has recorded much higher readings. Nevertheless, pound for pound, the great white's killing bite is around four times weaker than a croc's.

It's hard to believe that such huge jaw muscles produce such an unimpressive bite, but as the dissection exposes more of the jaw, the reason becomes obvious. Joy is able to wiggle the entire structure. The jaw is not fused to the skull like it is in most animals. But the shark has turned this apparent disadvantage into an advantage. By almost dislocating its upper jaw it can thrust it forward to extend its reach and widen its bite. This allows the great white to catch larger prey like seals, penguins and dolphins or even take bites out of whales.

To show how the great white shark's jaws evolved the team continues its dissection along the gill arches. If you look into a shark's mouth you can see slits of daylight coming through the gill entrances. When a shark swims forward, water passes into the mouth, over the gills – which extract the dissolved oxygen into the bloodstream – and then exits through these slits. Like lungs, gills have a large corrugated surface area to enable maximum contact with oxygen in the water.

Joy carefully dissects each gill and folds it back. She is fascinated by this delicate, tightly-folded tissue. She likens the feathery structures to the leaves of a book with each page of gills and flap them back and forth to enable respiration.

Unfortunately the great white's method of breathing has one flaw: when it stops swimming, it stops breathing, because not enough water passes over its gills. This is probably what killed our shark when it became trapped in the beach protection nets. Many fish use their gill arches like bellows to pump water through, but the great white requires so much oxygen to power its muscles, it needs to be

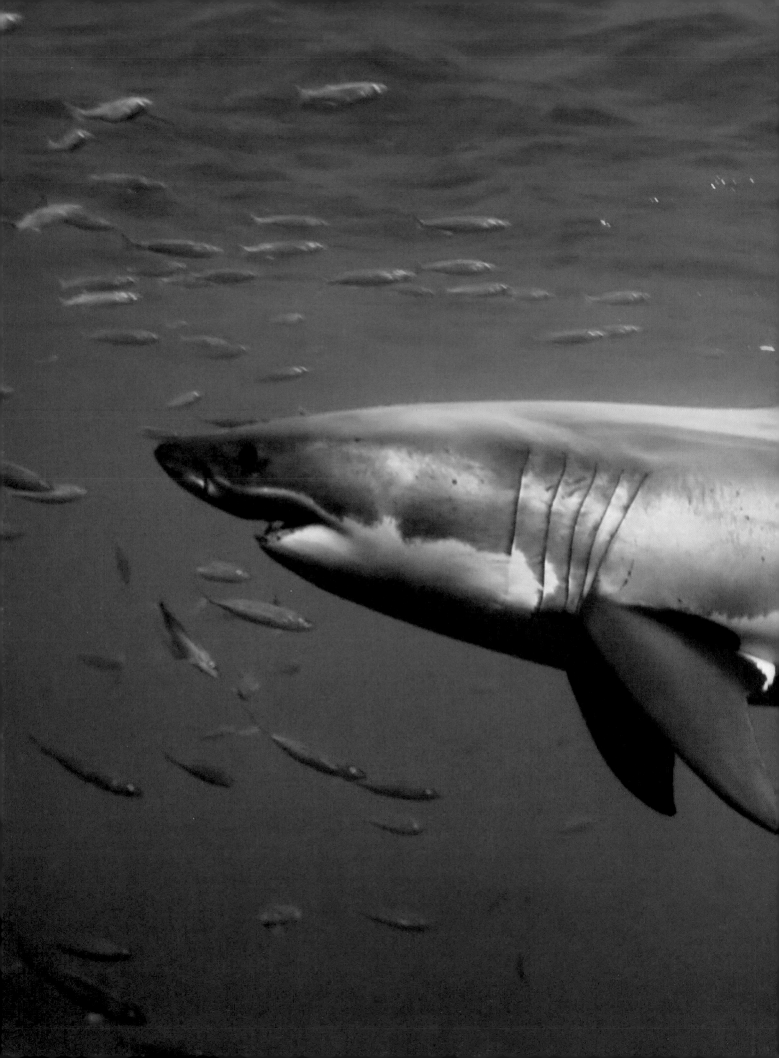

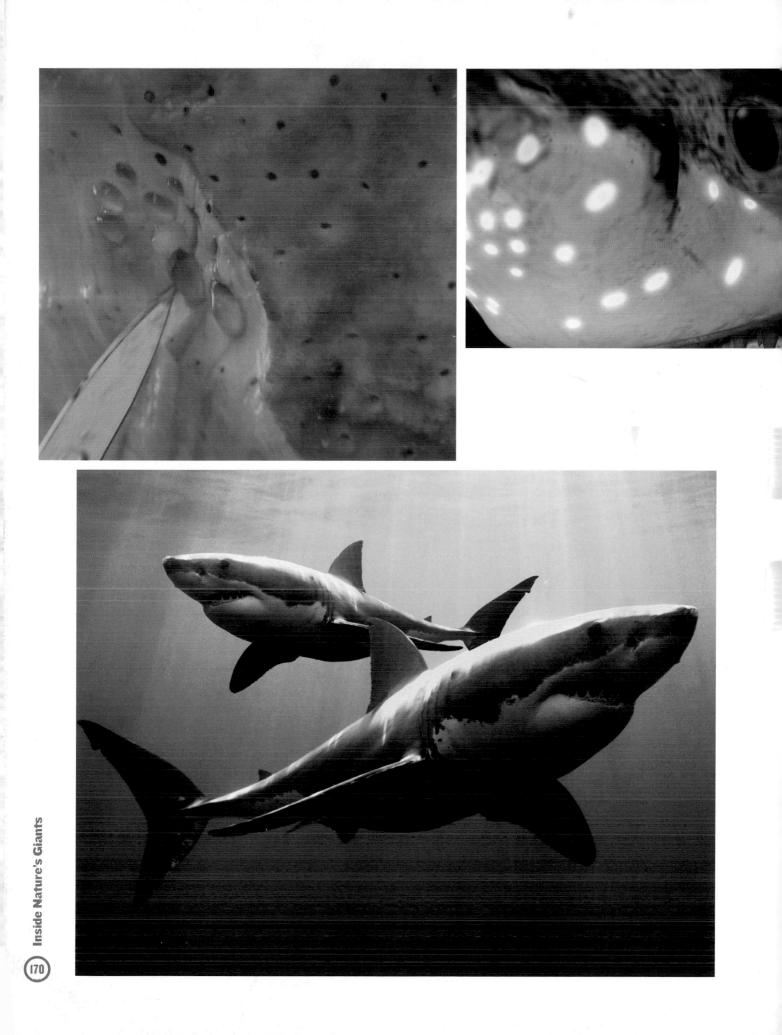

Metabolism

The great white is a warm-blooded animal and it can maintain a body temperature of 10-14 degrees warmer than the external water temperature. Sharks from this family (and tuna) have a special heat exchange mechanism that extracts heat from blood through a network of small blood vessels, before it returns to the gills. It does this in three places: near the brain, in the liver and in its muscle, enabling the shark to operate a higher rate of metabolism.

Gut

The great white has a compact torpedo-shaped organ that doesn't look like guts at all. It has evolved an incredibly compact way of absorbing nutrients by directing solids down a set of spiral grooves, maximising exposure to a large surface area of gut tissue. It's easy to see why sharks need to eject their stomachs when they've bitten off more than they can chew - these guts could not handle much more than blubber or flesh.

Skin

Shark skin is much tougher than whale skin and has actually been used as sandpaper. Rub your hand along the side of a shark towards the tail and the surface feels quite smooth; but run it backwards and it feels rough. It's made up of millions of miniature teeth, called dermal denticles, with three longitudinal ridges that improve the shark's performance when it swims. They also provide an extremely tough outer coating against shark bites. What happened during evolution is that the micro teeth of the skin eventually turned into eating teeth.

Great White Belly

The three lobes of the liver fill the belly of the shark and weigh almost 20 per cent of its body weight. Pale and fatty, it looks almost sickly. But in sharks the fat acts as a vital energy store. The liver also provides buoyancy in the place of a swim bladder. (Swim bladders are gas chambers that expand or contract to help fishes float or sink.) The shark liver is full of oils, which are less dense than water, so the liver acts as a giant buoyancy aid. Without its fatty liver, the shark would sink.

Shark:

Weight:
680–1,800kg (1,500–4,000lb)
Height:
N/A
Length male / female:
4–5.5m (14–18ft) (m)
Life Span:
30–35yrs
Top Speed:
40km/h (25mph)
Bite strength pound force:
4,000lbf

Tail

The muscles that power the mighty tail fin, which propels the great white through the water, are massive, but they are also arranged very differently to most fish. The red muscle (which is used for the continuous swimming) is situated in the centre; while the white muscle (which is used for sudden, brief bursts of acceleration) is on the outside next to the water. This means the red muscle is insulated from the cold, and through the network of blood vessels that makes the red muscle red, there is a counter flow of blood, so that even when the outer white muscle needs blood, there is still a flow back through the red muscle to maintain warmth.

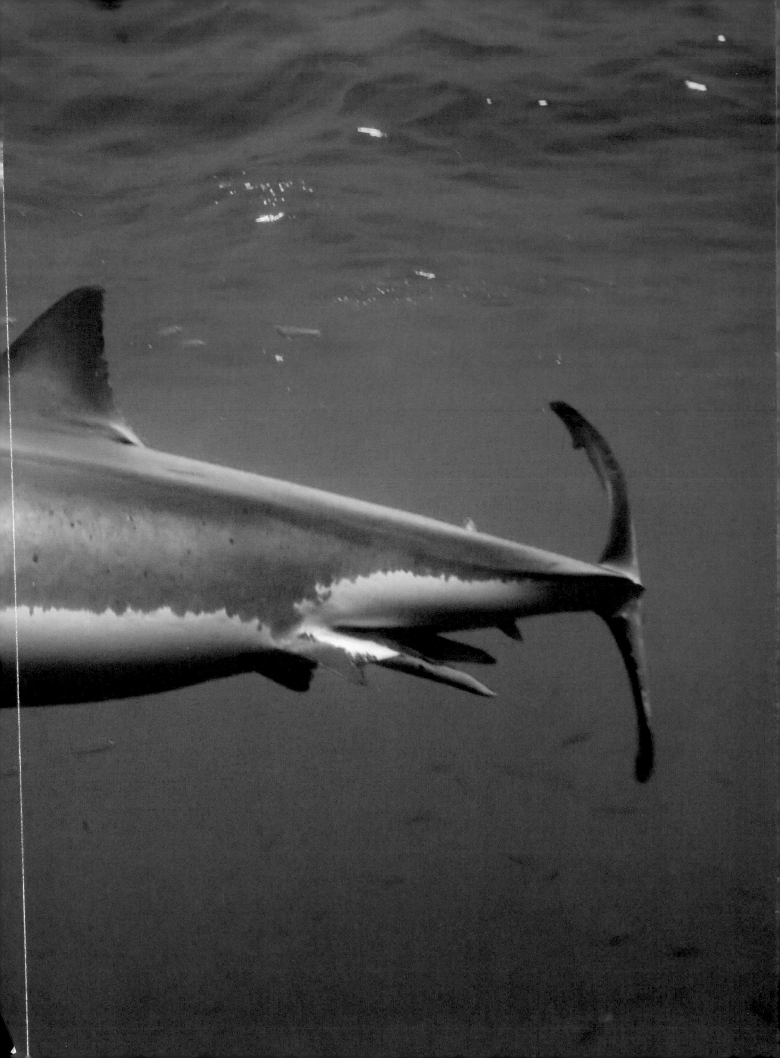

moving forwards for the gills to maintain sufficient water/oxygen flow.

As they explore the gill arches, they can see the similarity with the jaws. The muscles that open and close the jaws are similar to those that expand and contract the gill arches. The cartilaginous jaws and gill bars are both suspended from the braincase and both are jointed. Could one be derived from the other?

Feeding and breathing were closely linked in the earliest jawless fish ancestors. It's thought they used tiny hairs on the inside of their mouth to draw in water over their gills and deposit particles of food into their oral cavity, which then passed through to the gut. In later generations gill bars became hinged, working like a pair of bellows enabling more water (and food) to be pumped in. The hinged bars at the mouth entrance were now perfectly placed for a new role: to trap food. And so the jaw was born.

Great whites have a formidable reputation for tracking down prey and smelling smallest traces of blood at great distances. The highly sensitive cells that line the nasal passages on either side of the nose enable the shark to pinpoint precisely which direction their potential prey is. But it's not just their sense of smell that's ultra-sensitive, they have many other finely tuned senses.

From the outside it doesn't look like they can hear, but within the head they do have ears that are thought to be capable of hearing low frequency sounds over large distances. They also have a highly sensitive system for detecting the smallest vibrations in water called the Lateral Lines. Running down either side of the shark, from head to tail, this pair of long, thin canals is lined with tiny hairs that react to small amounts of water seeping through the pores of the skin. When the little hairs move, this alerts the shark that potential prey or predators are approaching from that side.

Vision is very important to great whites too. They are particularly well adapted to see in low light levels. Like cats, great whites have a shiny layer behind the retina, called a tapetum lucidum, that reflects light back on to the light-sensitive retinal cells enabling these predators to see, even when it's almost dark.

One slightly haunting aspect of great whites is their unblinking stare, because their eyes don't have eyelids. Some sharks, like hammerheads, have a nictating (or 'winking') membrane that flips down to protect the eye if it's battling with prey; but the great white lives up to its horror-film persona by rolling back the eye in its socket, just at the moment of attack. The sclerotic, fibrous coat of the back of the eye provides perfect protection from a flailing sea claw. When Joy attempts to cut into this tissue to dissect the eye she discovers how tough it is.

Perhaps the most mysterious and least understood sense is the great white's ability to detect small changes in electric field through thousands of tiny electromagnetic receptors called Ampullae of Lorenzini. When the great white rolls back its eyes it must rely on this sense for the final moments of the kill. The Ampullae of Lorenzini are concentrated around the snout. The small clusters of conductive jelly-filled tubes that lie just beneath the surface of the skin are able to detect minute fluctuations in electrical fields produced by muscle contractions of marine animals. These electro-sensitive cells were first discovered in a torpedo ray, in 1678 by Italian anatomist Stefano Lorenzini.

The Ampullae of Lorenzini are also thought to play an important role in navigation. Sharks can detect electrical fluctuations induced by the Earth's magnetic field acting on ocean currents, which help great whites navigate on epic journeys.

Opposite top: Clustered around the snout are jelly-filled pores called Ampullae of Lorenzini. Joy presses with her scalpel blade to squeeze out this conductive jelly. It's highly sensitive to any fluctuation in electric fields that might be caused by a muscle twitch of a fish.

Opposite bottom: Great white sharks swimming around the Neptune Islands in Australia.

When you look at this vast range of sensory inputs, it's easy to see why sharks have evolved and survived around 400 million years.

Inside the main body of the shark lies an organ that holds the key to why great whites became so big. After making a gigantic incision, Philip lifts back the skin to reveal an enormous three-lobed liver, the main lobe of which is bigger than Joy. Even in the biggest whales Joy has never seen a liver this size. There is a large gaping hole in the body cavity. Most of the internal body mass seems to be liver. The guts are barely visible. When they weigh the three lobes of the liver it's a staggering 170kg (375lb) – almost 20 per cent of its body weight. Mark Evans is surprised by how pale and fatty it looks. Enrico explains that in sharks the fat acts as a vital energy store: whales have blubber as an energy source, but sharks have no blubber, conserving fat in the liver instead.

It soon emerges that this enormous organ has another important role. Sharks have no swim bladders to control their buoyancy – swim bladders are gas chambers that expand or contract to help fishes float up or sink down. But the shark liver is full of oils, which are less dense than water, so the liver acts as a giant buoyancy aid. Without its fatty liver, the shark would sink.

There's another reason sharks stay afloat: they don't have a single bone in their body. Whereas most other vertebrates' skeletons are made of bone, shark skeletons are made entirely of cartilage which is much lighter than bone.

Richard Dawkins explains how this gives sharks many useful advantages as a marine predator: 'We have cartilage in our ears, in our noses. And in the embryo all our bones start off as cartilage. But a shark only has cartilage. And this gives them lightness, flexibility, and enables them to become the largest fish in the sea.'

Today the very largest shark is the whale shark, which can weigh up to 20 tonnes and reach lengths of up to 20m (66ft). These breathtakingly huge, slow giants are harmless filter feeders that suck in plankton and small fish. They are so docile they sometimes even allow swimmers to hitch a ride.

Returning to the almost hollow carcass of the great white, the team begins to investigate the digestive system. In an animal of this size with such a voracious appetite, you might expect large guts, but the great white has a compact torpedo-shaped organ that doesn't look like guts at all. Joy discovers thin layers of tissue, shaped in a spiral staircase. The shark has evolved an incredibly compact way of absorbing nutrients by directing solids down a set of spiral grooves, maximizing exposure to a large surface area of gut tissue. It's easy to see why sharks need to eject their stomachs when they've bitten off more than they can chew – these guts could not handle much more than blubber or flesh.

Mark is intrigued to find out that the great white's rate of metabolism is faster than most cold-blooded fish, and that it can maintain a body temperature of 10–14 degrees warmer than the water. It turns out that great whites have a special heat exchange mechanism that extracts heat from blood through a network of small blood vessels, before it returns to the gills. It does this in three crucial places: near the brain, in the liver and in its muscle, thus enabling the shark to operate at a higher rate of metabolism. This is particularly important in the muscle, given that great whites need to swim constantly.

While Enrico, Mark and Jeremy explore the shark's swimming muscles, Joy and Philip expose the brain. The great white's brain is small and highly spe-

Opposite top: A great white shark swims through a school of smaller fish in the Pacific Ocean.

Opposite bottom: The entire team is needed to turn the shark over on its side to expose the white under-belly that gives the great white its name. Here we see the first glimpse of the liver as that belly skin is cut away.

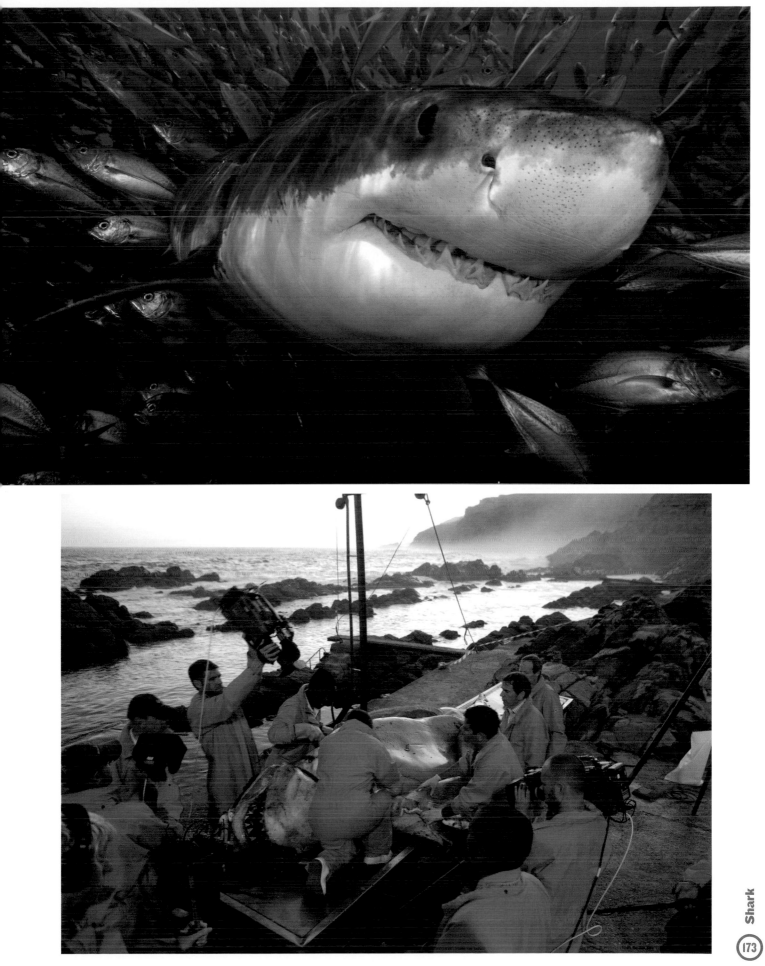

173

Jaws that Breathe, Gills that Grab
Joy Reidenberg

Jaws. They are so iconic for sharks that this one word readily conjures up an image of the infamous great white shark. Most people, upon looking at the jaw, see only shark's impressive teeth and are awed by the display of weaponry. As a comparative anatomist, I see the jaws as part of an incredible story of function and evolution. How a great white shark eats is ultimately related to how it breathes. If we look at very primitive fish that have no jaw support for their mouth, we see a pattern that likely existed in the shark's ancestors. Jaw percursors begin humbly as simple cartilage bars that hold the breathing apparatus: the gills. The gills are supported by a cartilage skeleton whose rod-like elements are arranged in series as pairs of arched bars along the left and right sides of the head. They are reminiscent of a rib cage, but occur just under the head. As fish species diversified, they evolved specialized feeding. Predatory fish species had a survival advantage if they had more flexibility in the mechanism for opening and closing the branchial basket, particularly if it became exaggerated near the mouth. This allowed the mouth to function in suction, grasping, scraping, crushing, biting, or tearing food, and marked the beginning of jaw evolution in fish. Larger prey, desirable because of their higher nutrition value, presented a special challenge for predatory fish such as sharks. Selection favoured those that could capture and retain struggling prey. An evolutionary trade-off thus occurred between the respiratory and digestive systems. The first gill arch was modified so that it was no longer used for breathing, but for capturing food and keeping it from escaping. The gill elements were lost and were replaced by armour derived from the skin called teeth. The evolution of the jaw is what makes the great white shark one of the top predators.

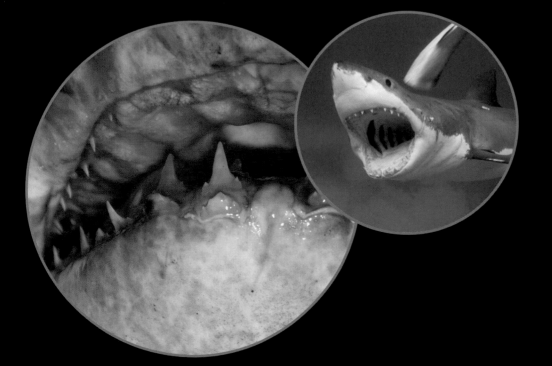

The Breathing Apparatus
The gill arches form a branchial basket that cradles the common passageway for food and water. Muscles attached to one side of each arch are used to open the entrance and widen the space inside. This action allows both food and water to be sucked into the oral cavity. Muscles on the opposite side of the bars are used to contract the basket. This helps keep food from escaping, pushes the food further down the throat, and also forces water out between the gill arches.

Gills

Fish use gills to extract oxygen from the water flowing between each gill slit. Gills are bright red because they are filled with blood vessels with very thin walls. The water is sieved through a mesh of fine feathery gill tissue that allows maximum surface contact with the thin walls of the blood vessels.

cialized. The most striking feature is its Y shape. At each end of the Y sit two orbs. These are the olfactory bulbs that give the shark its acute sense of smell. Joy pokes a finger through one of the two nasal channels and it emerges by the bulbs. The optic nerves linking the eyes to the central part of the brain are huge which is not surprising given its excellent vision. In fact it seems that most of the brain is devoted to sensory perception with further nerves linking the brain to the Lateral Line and the Ampullae of Lorenzini. This is clearly not an animal with much capacity for cognitive thought, but it has an astonishing capacity to react instinctively to a mass of sensory information. Enrico believes great white sharks are not mindless predators out to kill anything. He thinks the small number of attacks on humans has been blown up out of all proportion.

The great white's killer instinct has propelled it to the summit of the ocean's food chain, but humans are not part of that food chain. Individual incidents like the 2010 attacks in the Red Sea receive a huge amount of publicity, because they fulfil people's nightmare preconceptions. Hundreds of people are killed by kitchen toasters every year, compared to a handful of fatal shark attacks. Yet each year around 70 million sharks are killed for their fins and left to die. It's been estimated there are fewer great whites in the oceans than there are tigers in the forests. The truth is, it's sharks that should fear us.

Above: The great white's digestive system is incredibly compact. Instead of long intestines it has a small torpedo-shaped organ that breaks down the blubber it eats.

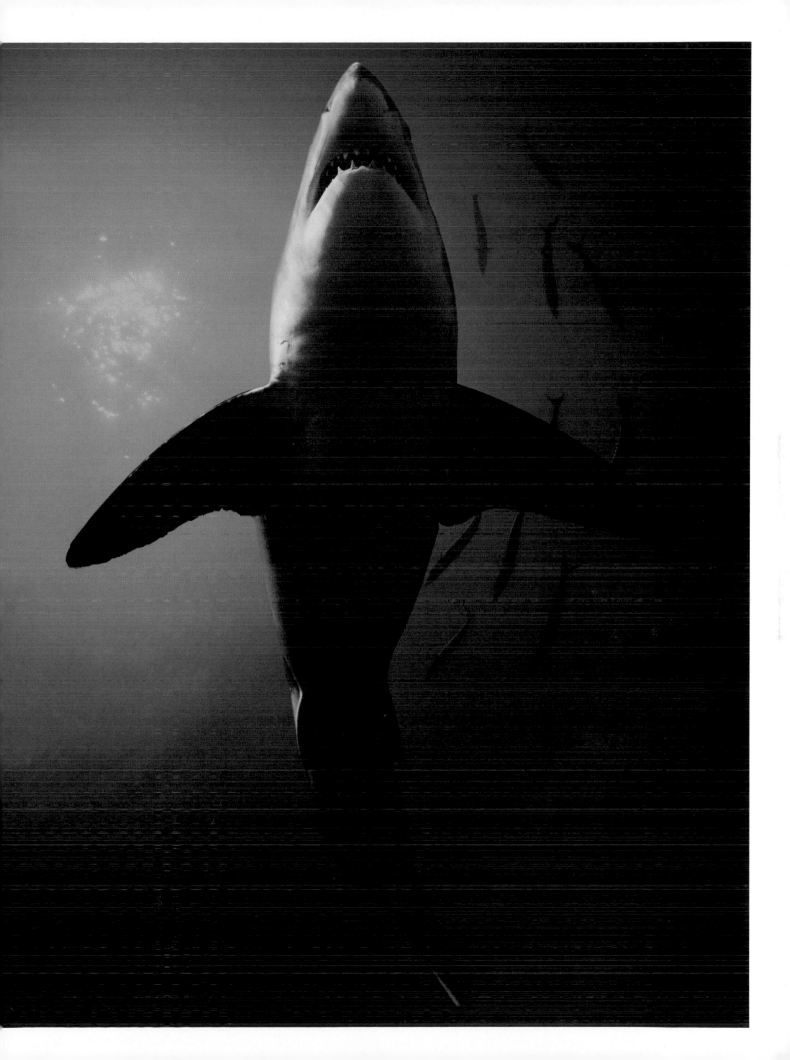

Cassowary

Casuarius casuarius

Peter Fison

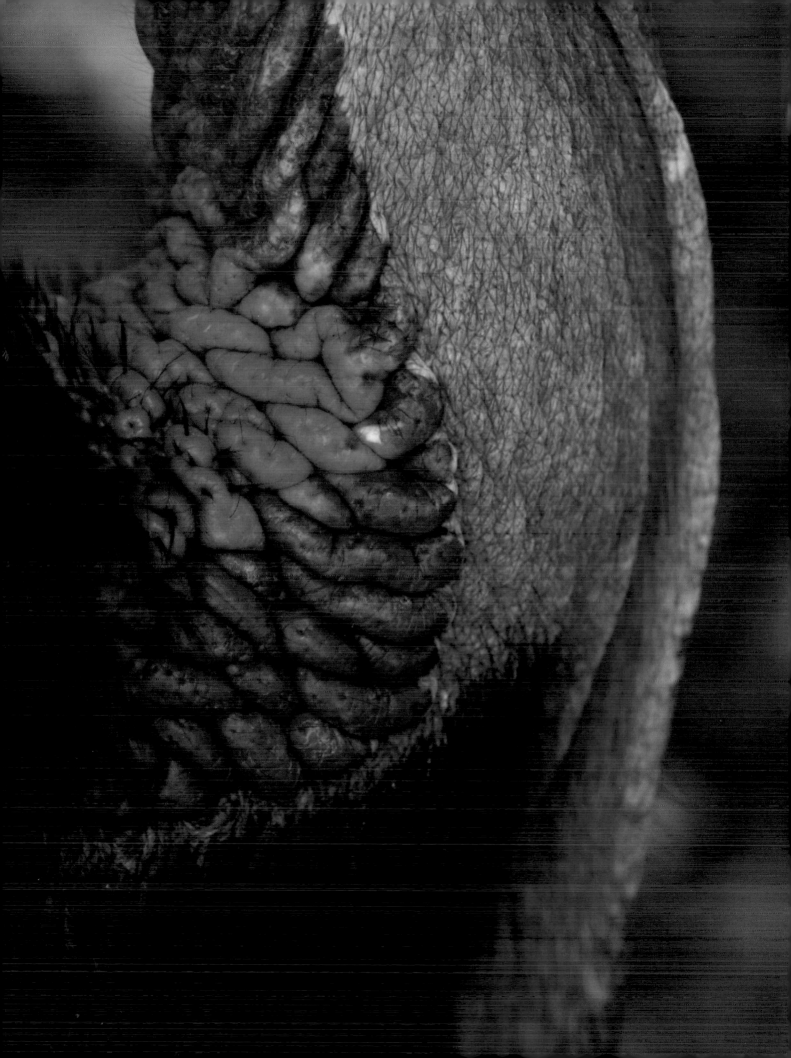

Suspended in a crane high above the rainforest canopy, we look out over a swathe of lush jungle on the northernmost tip of Queensland, Australia. It is one of the oldest rainforests in the world – older than the Amazon – older even than the Congo. This World Heritage site, covering 450km (280 miles) of coastline, is home to more than 370 bird species. From hummingbirds to parrots and eagles, the treetops bustle with birds. Yet the bird we seek lives on the forest floor and looks like something from _The Lost World_. It's the second heaviest bird on earth, as tall as a man, with the thick scaly legs of a dinosaur. Few people know about this bird and even fewer have seen it. This bizarre, elusive creature is the cassowary.

Three species of this ancient bird survive today. All three live in New Guinea, but the largest, the Southern cassowary, also lives in Australia. It's this species that we are investigating to trace its dinosaur roots. The Southern cassowary has the most extraordinary appearance. Its head is adorned with what appears to be a huge horn, its neck is a vivid blue with two blood red 'wattles' that hang from its throat, and a patch of bright red skin that looks like bubbling lava at the base of its neck. From a distance the feathers look like iridescent black fur, and only when examined closely are seen as feathers. The black coat covers a short stocky body and the stunted wings have quills like a porcupine's. The scales on its legs run down to a three-toed trident foot. On the end of each toe is a dagger up to 15cm (6in) long. These weapons give cassowaries their fearsome reputation. If they are scared, or attacked, they will use these blades with devastating effect.

Until recently cassowaries rarely emerged from the deep rainforest, but as urban sprawl and cyclones destroy their habitat, they wander out on to roads, looking for food. There are road signs warning drivers to watch out for these skittish birds, but half of all recorded cassowary deaths are caused by road accidents. The population of this threatened species is shrinking every year.

Shortly before we arrived a cassowary was hit by a car, breaking its leg. Sadly, it had to be euthanased. The Queensland Parks Wildlife Authority collected the

Opposite: Cassowaries are usually extremely shy birds that hide away in the deep rainforest. As their habitat continues to be destroyed, however, they increasingly venture out in search of food.

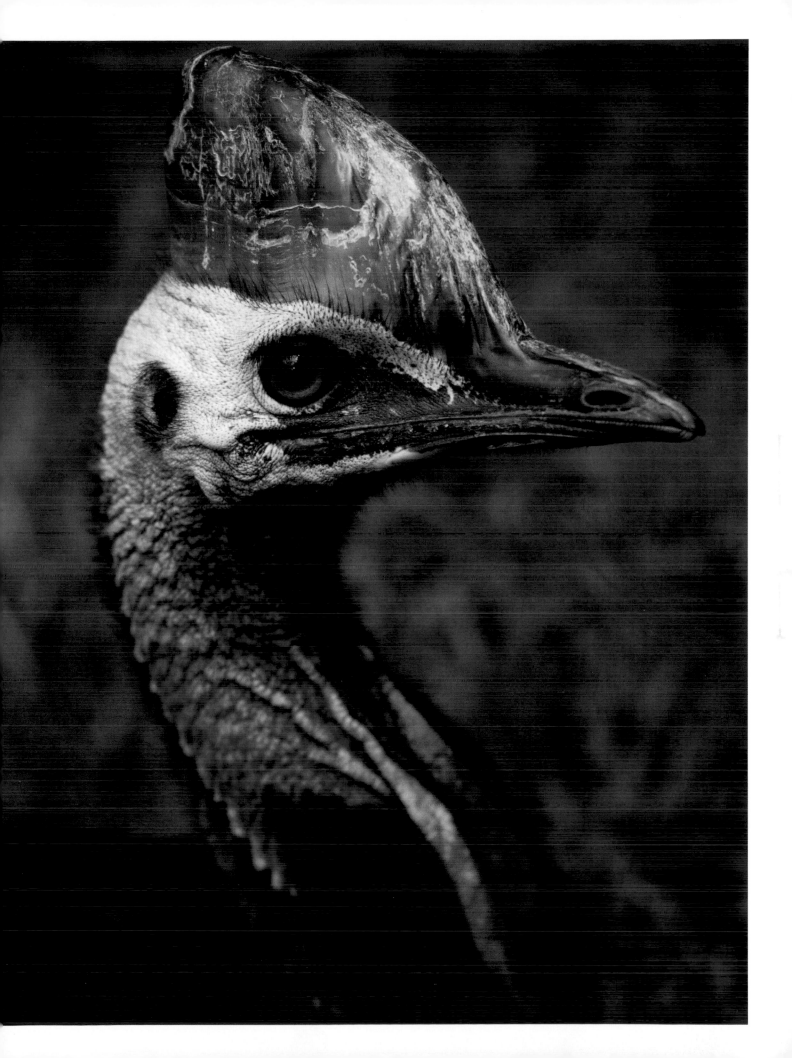

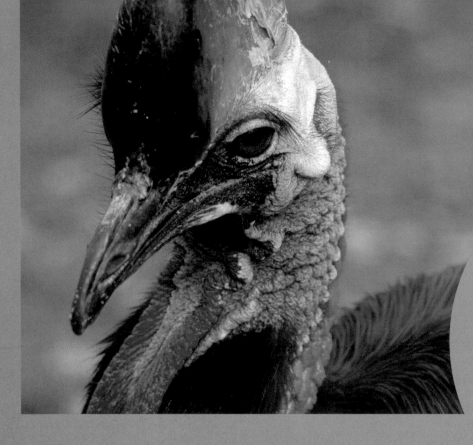

cassowary and kept it in a freezer for us, for further scientific investigation.

Mark Evans and Audrey Reilly, the ranger in charge at the Cassowary Rehabilitation Centre, carry the frozen body to a place it can defrost. The bird is three times the size of a Christmas turkey, so it takes two days in the sun to thaw.

Joy is the first to express her delight at the bird on the table. She has never seen anything like it. Joining Joy and Mark is Graham Lauridsen, a vet and cassowary expert, who has dissected and operated on more than 50 cassowaries. Alongside Graham, for the first time in our team, is a palaeontologist, Scott Hocknull, one of Australia's leading dinosaur experts. Using evidence from the dissection, Scott reckons he can persuade the team that the cassowary is a living dinosaur.

They begin by investigating the leg injury that caused this animal to be put down. What Scott sees transports him back to the time of the dinosaurs. The legs are massive chunks of muscle covered in scales, which lead down to the three-toed foot armed with dagger claws. Everyone agrees that these bear a remarkable resemblance to the velociraptors' legs in the film *Jurassic Park*.

In many ways the underlying anatomy of the cassowary leg is like ours. However, what looks like the knee is actually the ankle. The knee and thigh are much closer to the bird's body and, while a human foot lies flat on the floor, only the bird's toes touch the ground. When the leg strikes forward, ligaments and tendons pull the three toes rigid like a trident. You would not want to get in the way.

Back at the dissection, Joy strips back the skin and feathers of the leg to reveal a large drumstick covered in enormous muscles. These taper to a tendon that attaches under the ankle to the long foot. When this muscle contracts, it pulls the tendons, which stretch the leg out. These muscles allow the bird to walk miles

Above: Cassowaries have horn-like but soft and spongy crests called casques on their heads. Scientists are unresolved as to their use. They could be used as a weapon for dominance disputes and attracting a mate. But they could equally be used to help clear the underbrush they run through.

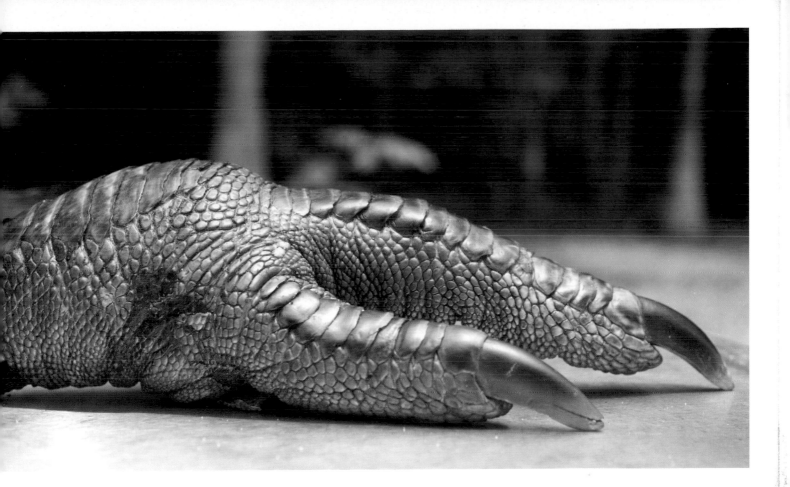

every day searching for fruit; but it can also generate huge power to kick.

Scott is even more struck by the similarity with the leg of meat-eating theropod dinosaurs. He thinks the cassowary is more closely related to Tyrannosaurus Rex and Velociraptor than any creature alive today.

If the cassowary's dinosaur-like leg is not proof enough, he suggests we take a look at its wing. Calling it a wing is laughable; it is more like Freddy Krueger's hand. It is tiny. The bones are about the same size as a chicken's, even though a mature cassowary is 20 times larger. Protruding from the wing is a set of jet-black quills with no obvious use. Graham speculates that they could act as shields to fend off thorny undergrowth. Graham has never seen a cassowary get stuck, even in the thickest rainforest. At the end of this shrunken wing is a claw. Perhaps this is the vestigial slashing talon that might once have protruded from an ancestral dinosaur's stubby arm – further evidence of its dinosaur past.

The genetic code shared between modern birds and extinct dinosaurs surfaces everywhere. Since the 1990s it's been known that non-avian dinosaurs had feathers. Now over 20 feathered dinosaur genera have been identified. Scott thinks the ragged feathers of the cassowary aren't dissimilar to the proto-feathers of dinosaurs. Even T-Rex baby fossils have been found covered in cute fluffy down. It's thought these proto-feathers were used for insulation.

Feathered dinosaurs evolved into the first birds around 150 million years ago. We know this thanks to a remarkable fossil found in 1861 called Archaeopteryx. It has serrated teeth like a dinosaur and a long bony tail like no modern bird. But the most striking feature is that feathers surround the fossilized skeleton. Archaeopteryx is half way between a modern bird and what we think of as the

more traditional dinosaurs. It is the missing link in bird evolution.

Even though we know the earliest birds had feathers, we don't know how they used them to fly. There are two main theories. The first is that they were tree-dwellers that leapt and glided between branches. The other is that they were ground-living species, which ran and then started to use their limbs to take off.

To understand how the cassowary evolved from its ancestor, Archaeopteryx, we need to dissect the anatomy of a modern flying bird. The Queensland Museum donated an Australian bustard that had been hit by a car. Bustards are over 1m (3ft) tall with a wingspan of more than 2m (7ft). They are the heaviest flying birds in Australia, and the heaviest recorded was 14.5kg (32lb). Yet cassowaries can weigh 80kg (176lb).

Joy removes the bustard wing. The first striking thing is the difference in size between the cassowary and bustard wings. Scott notices that the quills on the cassowary are like those of the flight feathers on the bustard. They even attach at the same points to the wing bone. This is important, because the quills are a leftover from the days when cassowary's ancestors used to fly.

But feathers alone cannot make a bird fly. To take off requires enormous power derived from muscles that flap the wings. Joy wants to examine the muscles that power flight. Somewhere in its recent ancestry the cassowary lost the ability to fly; so to find out what muscles a bird needs to fly, she cuts into the bustard chest to expose huge breast muscles. These are double the size of a chicken breast.

Joy returns to the cassowary to see how its muscles compare. The first thing she notices is how fat this bird is compared to the lean bustard. There's three inches of white lumpy fat covering the whole of the chest. Cassowaries can put

Above: Cassowaries' leg structures are strikingly similar to the bone structures of Tyrannosaurus Rex and Velociraptor.

Top: The quills on a cassowary are very similarly positioned to the flight feathers on a bustard, attaching at the same points to the wing bone. However, the cassowary does not have the powerful muscles that a bustard has which are required to be able to fly.

Opposite: The vestigial claw on the cassowary wing – a link to its dinosaur past.

Precisely how the cassowary lost its ability to fly is a mystery. But the muscles for flying require lots of energy, so are expensive to maintain. When conditions are right, birds will get rid of this anatomy. These conditions can occur on islands with few predators on the ground and abundant food. This is probably what happened to the cassowary. Eventually as the bird got bigger and the wings smaller, the ability to fly eventually disappeared, too.

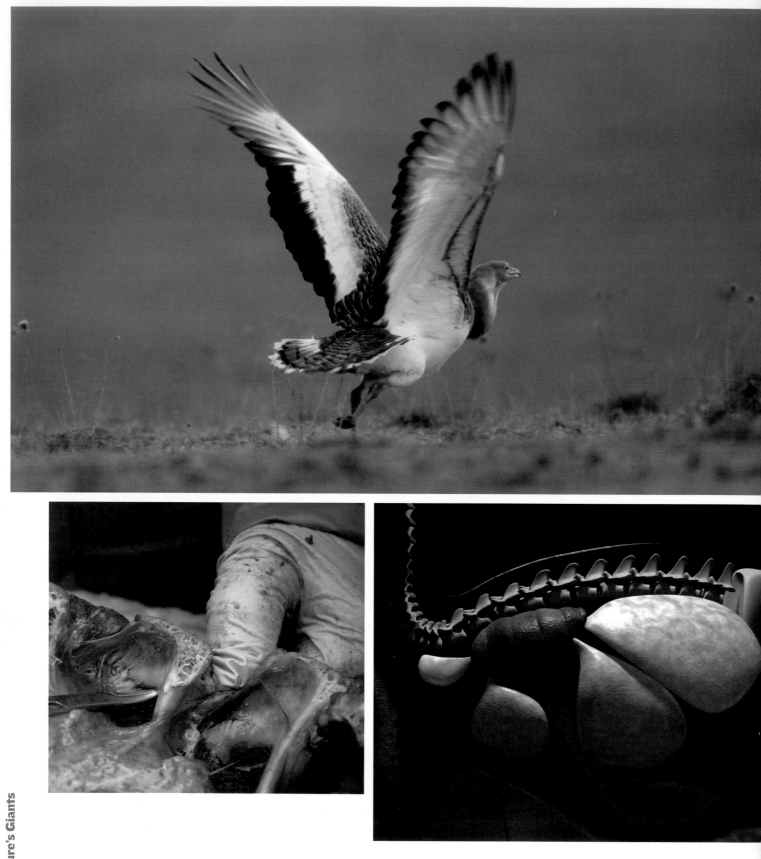

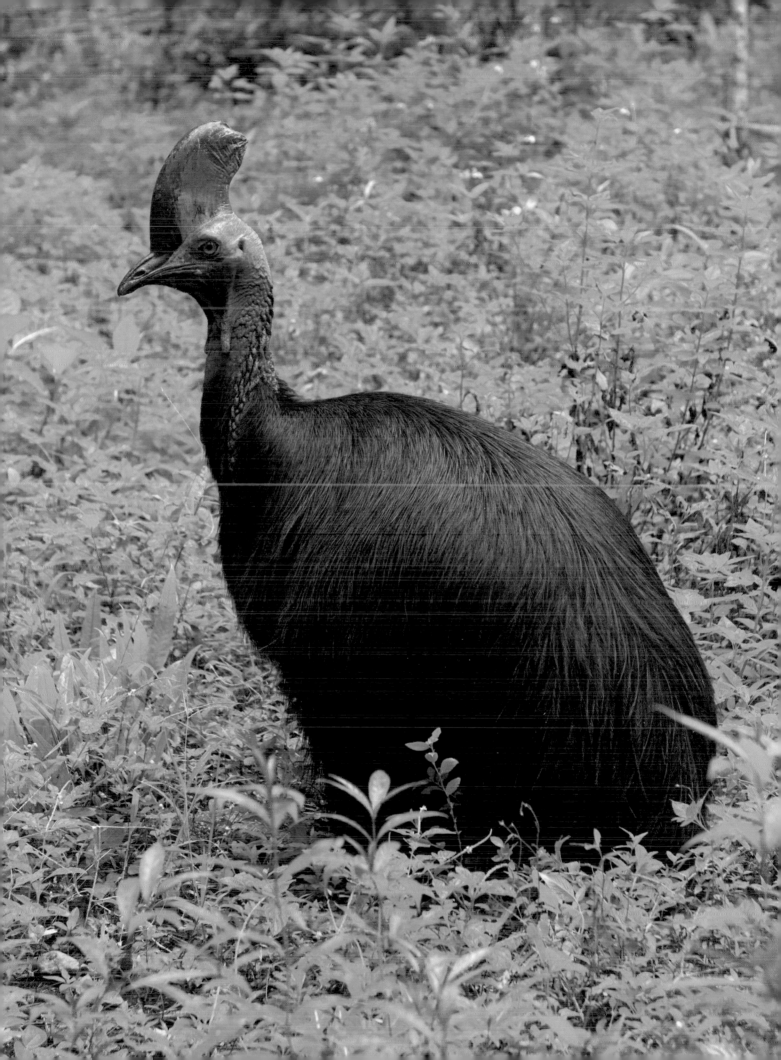

Crown and Wattles

The bird's most iconic feature is the strange conical crown that sits on its head: the casque. Its function is not understood: it looks like a helmet, but it's not hard; the casing is made of keratin. Inside is a fine mesh of capillaries and sponge-like material, and two holes lead from the casque into the skull. Are these holes used to project the booming birdcall more widely or for listening for a mate? The two bright red wattles, found in both sexes, that hang from the throat are also thought to be important in attracting a mate.

Windpipe

Cassowaries share other birds' dazzling ability to communicate using their voice. The cassowary call is particularly unusual like no other birdsong: it goes into a stooped posture as if gulping air and lets out a series of deep resonating booms that resonate all round the forest. These low-frequency calls can be heard for miles – probably to mark territory or to attract mates. The windpipe looks like a piece of pink hosepipe with a split at the lung end. At the branch there are two bits of tissue that look like drumheads positioned to hit against each other at the V of the windpipe.

Flight

Cassowaries are heavy birds (weighing up to 80kg) and have lost their flying muscles. Their bodies are literally fat, with three inches of white lumpy fat covering the whole of the chest. Instead of a large keel that protrudes in flying birds, the sternum is completely flat with only a meagre ridge down the centre line and no keel. At the bottom of the sternum is a tiny vestige of the flight muscle, which is as flat as a pancake and smaller than a bar of soap. Just why they lost their ability to fly is a mystery: but flying muscles require energy, are expensive to maintain and perhaps in a predator-free environment (such as an island with plentiful food) can be dispensed with.

Lungs

Though flightless, the cassowary retains certain adaptations for flight. In order to extract the maximum oxygen from each breath it has hundreds of front and rear air sacs (in addition to a pair of lungs). Each air sac is like a thin latex balloon and their combined capacity is 60 per cent of the body cavity. In fact the cassowary's bones are hollow, and the air sacs fill this space too. And instead of a simple (but less efficient) human breathing model (in which fresh air mixes with 'used' air already in the lungs) the cassowary like other birds uses a multi-stage process ensuring that only fresh air reaches the lungs. In the first stage of breathing, air comes down the windpipe and is held in the rear air sacs. In stage two, the rear air sacs push the fresh air into the bird lung where oxygen is extracted. In stage three, used air in the lung moves to the front air sacs. In the final stage the bird exhales used air from the front air sacs via the windpipe. So for one breath of fresh air to pass the bird takes two breaths in and two out and optimizes oxygen.

Wing

The cassowary's tiny wing provides clues to its dinosaur past. Protruding from the wing is a set of jet-black quills, a leftover from the days when the cassowary's ancestors used to fly. The cassowary's downy feathers are thought to be like the proto-feathers of dinosaurs. At the end of this shrunken wing is a claw that is perhaps the vestigial slashing talon from the creature's ancestral dinosaur's past. We know from fossil evidence of the Archaeopteryx that feathered dinosaurs evolved into the first birds around 150 million years ago.

on weight because they never need to fly. When Joy uncovers the sternum she finds it is completely flat with only a meagre ridge down the centre line, instead of the large keel that protrudes in flying birds for muscle attachment. Because there's no need to attach big flying muscles the keel has disappeared, too.

Joy searches further down the sternum until she finds a tiny vestige of the cassowary's flight muscle. It is as flat as a pancake and smaller than the palm of her hand. Mark compares one side of the bustard's pectoral muscle with the cassowary's. The bustard muscle is 10 times the size of the cassowary's. If the cassowary had wings that could fly, it would need huge muscles to become airborne.

In order to fly there's another vital adaptation needed, as well as feathers and large wing-flapping muscles: extra lung power. Flying muscles require huge amounts of oxygen to function. To become airborne, birds evolved an incredibly efficient way of turbo-charging their flight muscles. Joy hopes to find evidence of this adaptation in the cassowary, even though it's no longer able to fly. She begins a systematic search of its breathing mechanism. To expose the lungs the team must first remove the ribcage. Graham uses bolt croppers to crack the ribs.

Birds breathe in a very different way to humans. There is a right and a left lung, but there comparisons end. Flying requires an enormous amount of muscle strength. Muscles need oxygen to work efficiently. So birds need to extract as much oxygen as possible from each breath. They achieve this by having front and rear air sacs in addition to a pair of lungs, which allow an extraordinarily efficient exchange of oxygen into the blood supply. There are hundreds of these air sacs (each like a thin latex balloon) and they take up over 60 per cent of the body cavity. The result is a breathing system more efficient than ours.

When humans breathe it's a two-stage process: we breathe in and we breathe out. Inside the lungs is a mixture of newly inhaled air and used, carbon dioxide rich, air that's not been exhaled. Not very efficient. Birds use a multi-stage process to eliminate this problem. In birds, when they breathe in, air comes down the windpipe and fills the rear air sacs. During this first stage no oxygen is taken out of the air – the air sacs are merely holding chambers. The second stage occurs simultaneously: used air in the lung is moved into the front air sacs. In the third stage the bird breathes out and exhales the used air from the front air sacs via the windpipe. At the same time, in the final stage, the rear air sacs contract and push the fresh air into the bird lung where oxygen is extracted. So for a breath of air to pass through the respiratory system of a bird it takes two breaths in and two out. By breathing this way it means that only fresh air enters the bird's lung. It avoids the problem that mammals have each time they take a breath, of mixing fresh air with 'used' air already in their lungs.

Birds use every available space to accommodate air sacs. The cassowary's bones are hollow, so air sacs can use the space inside to fill with air. This is an adaptation seen in most flying birds; but as Scott points out, hollow bones are also seen in dinosaurs, and this happened before dinosaurs took to the sky.

Scott takes Simon Watt to the Australian Age of Dinosaurs laboratory and museum, where he introduces him to Banjo, a 100 million-year-old skeleton of a meat-eating dinosaur. Banjo stands 2m tall and is equipped with an arsenal of weapons: huge claws, cassowary-like daggers on its toes and razor-sharp teeth.

Scott starts to compare the cassowary's bones with Banjo's. The ribs are exactly the same shape, only the scale is different. He points to a small hole at one

Opposite top: A great bustard takes flight.

Opposite right: Birds breathe in a very different way to humans because they require an enormous amount of muscle strength to be able to fly. For this reason, birds have several air sacs in addition to a pair of lungs so that they avoid the problem that mammals have each time they take a breath, of mixing fresh air with 'used' air already in their lungs.

Opposite left: The air sacs extend into the hollow spaces of the ribs, penetrating the skeleton throughout the body. These hollow bones were also a major feature of dinosaurs.

General Body

The Southern cassowary is a flightless bird that lives in dense forest with the most extraordinary appearance. Its head is adorned with a huge horn-like crown; its neck is a vivid blue with and a patch of bright red skin that looks like bubbling lava at the base of its neck. From a distance the feathers look like an iridescent black fur coat, and only when examined closely are seen as feathers.

Cassowary:

Weight: ...
58–80kg (129–176lb)
Height: ...
1.5–1.8m (4.9–5.9ft)
Length male / female:
N/A
Life Span: ...
40yrs
Top Speed: ..
50km/h (31mph)
Bite strength pound force:
N/A

Ovaries

The ovaries can contain dozens of eggs at one time. Each egg is bright green and 14cm (6in) long, the third largest in the world. After mating with several different males, the female eventually lays a clutch of 3–5 eggs. The female abandons the eggs for the male to stand by when they hatch and look after the offspring. The father rears the chicks from stripy infants into dull-brown juveniles, until mature, when he finally leaves them.

Legs

The underlying anatomy of the cassowary leg is like ours but what looks like the knee is actually the ankle. The knee and thigh are much closer to the bird's body and, while a human foot lies flat on the floor, only the bird's toes touch the ground. The leg is a large drumstick covered in enormous muscles that taper to a tendon that attaches under the ankle to the long foot. When this muscle contracts, it pulls the tendons, which stretch the leg out. These muscles allow the bird to walk miles every day searching for fruit; but it can also generate huge power if it needs to kick.

Foot

The scales on its legs run down to a three-toed trident foot. On the end of each toe is a dagger up to 15cm (6in) long. These weapons are what give cassowaries such a fearsome reputation. If they are scared, or attacked, they will use these blades with devastating effect. The cassowary foot bears a remarkable resemblance to fossil evidence of a giant dinosaur print. There's an obvious difference in size, but the two prints are almost identical.

Kicking

The legs are massive chunks of muscle covered in scales, which lead down to the three-toed foot armed with dagger claws. When the cassowary kicks, ligaments and tendons pull its three toes rigid like a trident. When provoked, it leaps into the air, slashing and kicking. Not to be provoked, cassowaries can inflict serious damage: puncture wounds, lacerations and broken bones, and some injuries prove fatal.

end of Banjo's rib. The cassowary rib has a hole in exactly the same position. These holes are for the air sacs to enter. Scott next compares the three toe bones and claw of the cassowary with Banjo's. Again, they are almost identical in shape. If you scaled up the cassowary foot it would be just like Banjo's. When you see this, the conclusion is inescapable: cassowaries are dinosaurs.

230 million years ago the Dinosauria split from the reptiles. They flourished and split into myriad different species. One of these orders included the meat-eating dinosaurs, such as T-rex, Velociraptor and those feathered dinosaurs, the birds. Until 65 million years ago these dinosaurs ruled the land; then the famous mass extinction took place. Only two superorders of dinosaur survived – the Palaeognathae and Neognathae. Initially they were all flying birds, and then two superorders began to diverge further. The surviving Palaeognathae group is tiny and includes mostly flightless birds like the cassowary. The Neognathae group evolved into more than 10,000 living species, including nearly all the flying birds.

The flightless birds of the Palaeognathae superorder are: the cassowaries and emu in Australia; the kiwi in New Zealand; the ostrich in Africa; and the rheas of South America. But why, when it's so deep in their DNA, did most of these birds lose the ability to fly? As Richard Dawkins points out: 'Flying is expensive. It's a wonderful thing to do, but it costs an enormous amount in energy in huge breast muscles, so when you can do without flying, it can be better to do without it.'

Once birds no longer needed to fly, their wings could shrivel and they didn't need to stay light any more. Consequently, some grew very large indeed. The very biggest giant birds are now extinct. These included the elephant bird of Madagascar (3m tall and half a tonne); the moa of New Zealand (3.7m tall); and the meat-eating brontornis of South America (under 3m tall and 400kg).

Modern birds have spread all over the world and have adapted to suit a wide variety of niches. From cassowaries in dense forest to skylarks on open moorland, one characteristic they share is a dazzling ability to communicate: birdsong.

The cassowary has a particularly unusual call. It goes into a stooped posture as if gulping air, before letting out a series of deep low-frequency booms that resonate for miles, probably to mark territory or to attract mates.

Joy wants to find out how they make these sounds. At the dissection table she cuts into the neck of the cassowary and pulls out the windpipe. It looks like a piece of pink hosepipe with a split at the lung end. At the branch there are two bits of tissue that look like drumheads positioned to hit against each other at the V of the windpipe. Joy wonders if they resonate when air is pushed over them. Perhaps these are the source of the cassowary's deep booming call?

Another feature thought to be important in luring a mate are the bright-red wattles that hang from the throat. Males and females both have this turkey-like, wobbly adornment, so they can't be used to tell the sexes apart.

Inside the ovaries they find dozens of newly formed eggs. The bright-green cassowary egg is the third largest in the world at 14cm (5.5in) long. After mating with several different males, the female lays a clutch of 3–5 eggs which she abandons. It's the male who stands by when the eggs hatch to look after the offspring and who rears the chicks from stripy infants to dull-brown juveniles. Only when they finally become mature does he leave them to fend for themselves.

Cassowaries are not alone in this behaviour: other birds that lay a large volume of eggs also leave the male to rear the chicks, and this behaviour extends all

The Secret of Wing-Powered Flight

Unlike Cassowary feathers, which are useless for flying, Bustard feathers are perfect. Their feathers are asymmetrical; each one is like a miniature aeroplane wing. The feathers can be manipulated to form an unrivalled surface for lift. But even the best-kept feathers split apart when buffeted in strong wings or caught in a tree. Feathers have an ingenious quick repair mechanism. The individual hair-like components of a feather – the barbs – form a flat aerodynamic surface. Under a microscope you can see that each of the barbs has minuscule hooks, or barbules that join the barbs together like Velcro. When they are ripped apart, they readily knit back together to reform the surface. Joy splits apart the barbs and then zips them back together by simply pushing them with her thumb and forefinger, like a preening bird. Feathers alone are not enough to make a bird fly, however. To take off requires enormous power derived from muscles that flap the wings. Somewhere in its recent ancestry the Cassowary lost the ability to fly; so to find out what muscles a bird needs to fly, Joy cuts into the bustard chest to expose its huge breast muscles. These are at least double the size of a chicken breast. Two key muscles are involved in powering flight. The first is the breast muscle that provides the downward thrust of the wing beats. This muscle is so strong it can create enough lift to get the bird off the ground. These are the pectorals, equivalent to human pecs, or chest muscles, and there is a set for each wing. Positioned deeper in the chest is a second set of smaller muscles. This is the muscle for the upstroke that raises the wing back up, ready for the next down stroke. The breast plate consists of the sternum and keel which projects from the sternum like that of a boat. The sternum and keel provide the attachment for the upstroke and down stroke muscles to anchor to.

Below: The major muscles for the downstroke of the wing.

Bottom middle: Muscles for the upstroke.

Bottom right: The bones of the wings are hollow to reduce their weight for flying.

the way back to the dinosaurs. Some dinosaurs have large clutches of eggs too and there's fossil evidence from their nest sites to suggest males sat alongside their eggs. In Winton, Queensland there is a piece of preserved earth over 100 million years old. It is covered in literally hundreds of fossilized dinosaur footprints and provides a 15-second snapshot of an incident that happened by a billabong – a dried up riverbed today. Most of these footprints are small and heading in one direction, running away from danger. On the other side of the riverbed, the possible source of the panic can be seen: 11 huge footprints. These belong to a much larger meat-eating dinosaur. The huge footprints have three toes just like a cassowary's. Scott Hocknull places the cassowary foot from the dissection into the big dinosaur print. Apart from a difference in size, the two prints are almost identical. A dinosaur foot from today: a dinosaur footprint from 100 million years ago.

The progress of the cassowary from meat-eating dinosaur, to flying bird, to the large, flightless, jungle-dwelling loner it is today is an improbable evolutionary tale. The colourful creature that struts through the forest is one of natural selection's more exotic incarnations.

But as that most invasive of all species, Man, encroaches on the rainforest, the cassowary habitat shrinks. All that's left are small pockets of forest, where the last remaining cassowaries fight for survival. There may be only 1,500 left in Australia. No one knows for sure. Two weeks after our visit to the Cassowary coast, Cyclone Yasi blasted through prime breeding territory, causing widespread devastation. Let's hope the dinosaur DNA within every cassowary finds ways of adapting, so that once again it avoids the mass extinction of its ancestors.

Above: Amazingly, today's cassowary foot is nearly identical to a dinosaur's footprint from 100 million yerars ago.

Opposite: Cassowaries have evolved from a meat-eating dinosaur to the large, flightless, jungle-dwelling loner it is today, an improbable evolutionary tale which is one of natural selection's more exotic developments.

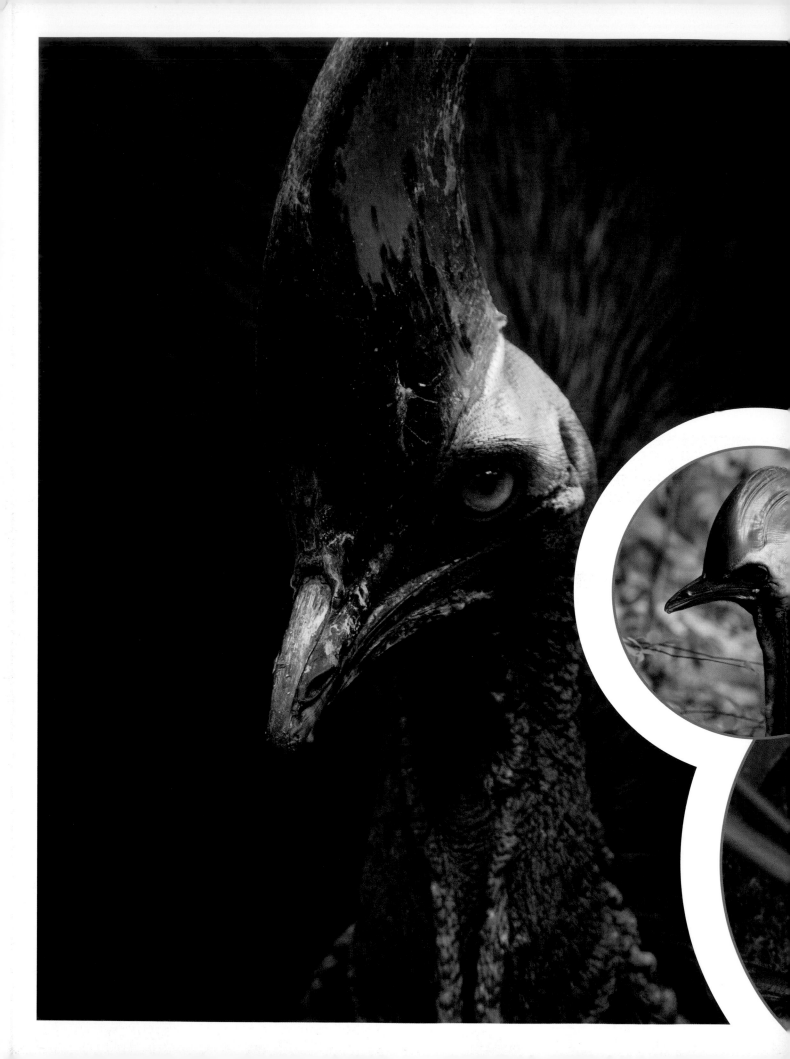

Mystery of the Cassowary's Crown

Another piece of anatomy that may have a role in projecting the booming sound is this bird's most iconic feature, the strange conical crown that sits on its head: the casque. It looks like a helmet, but it is not hard enough to offer much protection. The outer casing is made of keratin with a similar texture to fingernails. Very little work has been done on this odd anatomical structure. Inside is a fine mesh of capillaries and sponge-like material. As they probe further into the casque they reach the brain case. Joy is intrigued. She finds two holes heading from the casque into the skull. The team hopes that these might be a clue to its function. Graham fills a large syringe with water and pushes it into one of the holes. The water disappears down the hole. Joy looks in the ears, Mark in the mouth, Graham at the far end of the windpipe. But the water has vanished. They are completely baffled. Joy wonders if the water has gone into the brain. The light is beginning to fade, so they decide the mystery of the casque will have to be solved another day. Each member of the team has different theories. Scott thinks it might have something to do with thermoregulation – there are similar structures in dinosaurs. Graham thinks it is probably for attracting mates: the bigger your casque the sexier you are. The peacock has a marvellous tail – the cassowary has a top hat!

Elephant

Elephas maximus

Mark Evans

We're almost through. As each muscle sheet is sliced, the layer below bulges under the pressure of what lies beneath. Richard Prior is a man on a mission. After 22 years as a butcher and nine more as a pathology technician he has honed his knife-wielding skills to perfection. He's fast. He's very focused. But he's feeling the pressure. And not just under his knife. Behind him, more than 150 vet students and scientists watch his every move. Millions more will witness this event at home, on TV. Richard knows they'll never forget what they're about to see. He has one more cut to make. Too deep and he'll create a monumental mess. Just right and those watching will never look at an elephant in the same way again.

Elephants are extraordinary. As the largest living land animals they are impressive – particularly up close. Some are monstrously big, reaching 4m (13ft) tall and weighing 6 tonnes. An elephant with attitude should be given a wide berth. But why are they so big? And how, through 55 million years of evolution, has being big shaped their anatomy and behaviour? We're at the Royal Veterinary College in London to explore these questions from the inside out.

Professor Alun Williams, one of the world's leading veterinary pathologists, has invited us to a post mortem on a 40-year-old female Asian elephant. She has been euthanased after a brave fight against a chronic illness. Inevitably we feel conflicting emotions, as animal lovers, as scientists and as teachers. As filmmakers we're nervous about how viewers will react to seeing an elephant taken apart on primetime TV. It's a world first.

Richard's final cut is perfect. Turgid, gas-filled bowel spews intact from the abdominal captivity with dramatic effect. It's an extraordinary sight. Elephants have a truly massive digestive system. You'd expect it to be sizeable, but not on this scale. With the loops of bowel unravelled, a string of fleshy sacs and pipe work stretches right across the vast post-mortem room floor.

Huge guts need a big chassis to carry them. The elephant's skeleton is made up of more than 200 bones, each one perfectly shaped for a specific function.

Opposite: The team has been invited along to a post mortem on a 40-year-old female Asian elephant who sadly succumbed to a chronic illness.

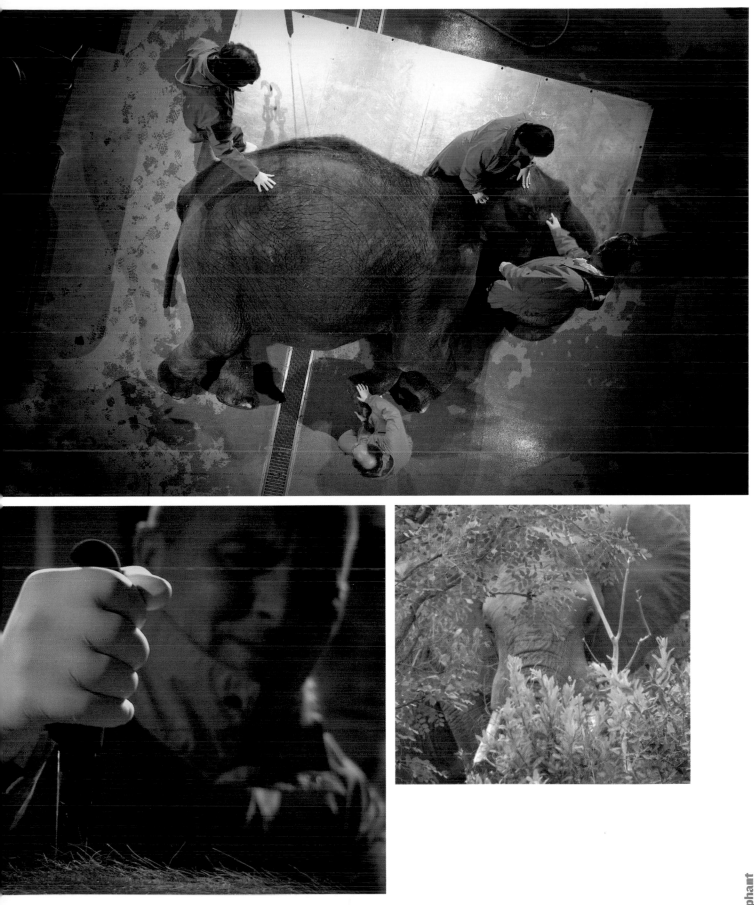

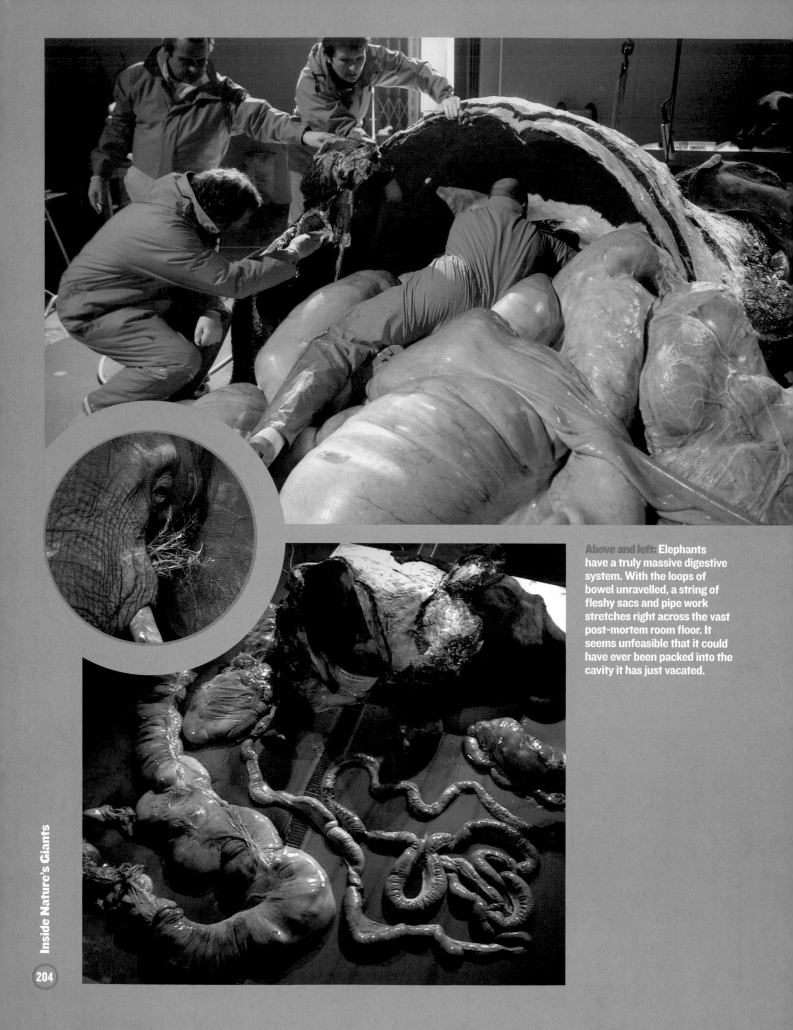

Above and left: Elephants have a truly massive digestive system. With the loops of bowel unravelled, a string of fleshy sacs and pipe work stretches right across the vast post-mortem room floor. It seems unfeasible that it could have ever been packed into the cavity it has just vacated.

Collectively, joined together by complex arrangements of ligaments, tendons and muscles, they form a mobile scaffold that supports the elephant's soft and squidgy bits. Perched at one end is the largest skull of any living land mammal.

Gerald Weissengruber has flown in from Vienna to join our dissection team. He's a professor of anatomy and has been working on elephants for 10 years. In his hands, he cradles a tooth the size of a house brick. It's an elephant molar, or cheek tooth, one of 24 (usually) that emerge during an elephant's life.

Despite their huge skulls, elephants have surprisingly small mouths that they can't open very wide. It's incredibly hard to see deep inside even at close quarters. But peel away the skin and muscles from the side of the face, and the massive molars dominate. On each side there are usually only four molar teeth in wear at any one time, two in the upper jaw and two below. That's a total of eight. The other 16 are either worn out and have been discarded, or haven't been made yet.

The first step in digesting coarse, tough plant food is to turn it into pulp. This makes it easier for the food to be attacked by the elephant's own digestive enzymes and the microbes waiting further down the gut. The molar teeth crush and grind while the tongue mixes in saliva. When the elephant chews, it moves its lower jaw backwards and forwards (not side to side), rasping hard ridges on the bottom teeth against those on the molars above. The ridges are made of enamel, the hardest material in the elephant's body.

Elephants may eat for up to 20 hours a day and, over time, this marathon munching wears the ridges down. An elephant with flat-topped teeth is doomed. There's not enough space in their skull to store replacement teeth, so they manufacture new ones on a dental conveyor belt. Each tooth is made from a number

Above: Elephants have surprisingly small mouths which they can't open very wide. Yet they have massive molars, usually two in the upper jaw and two down below. On each side usually only four molar teeth are in use at any given time.

of separate, narrow sections that are grown and then cemented together as the emerging and elongating tooth moves very slowly from the back of the mouth towards the front. As it goes, it pushes along the older tooth that is already wearing down. The worn-out sections of this tooth then break free when they reach the front of the jaw. It's mind-blowing biological engineering. The life cycle of an individual molar tooth may be many years, but there's a finite supply. If an elephant manages to live long enough to wear out its quota of 24, its days are numbered.

Elephants can live into their sixties, but sadly, some never get the opportunity to wear out all their molars. It's their other set of teeth – their tusks – that cause their premature demise. Tusks are incisor teeth. We have eight incisors (our front teeth). Elephants have two, both in the upper jaw. They are usually a prominent facial feature of mature African elephants (both bulls and cows), and also Asian bulls. But our Asian cow doesn't appear to have any.

For those elephants that have them, functional tusks are used for digging, foraging and as formidable weapons. For bulls, size is everything. Huge tusks can help intimidate less well-endowed adversaries and they can also win over a mate. Over generations, natural selection has produced so-called 'tuskers' – bulls with absolutely massive incisors. The largest tusk ever found weighed in at over 100 kilos and was almost 3.5m (11.5ft) long. That's one big tooth.

Over millennia, natural selection has led to larger tusks, but in recent times that trend has reversed through a form of unnatural selection. Richard Dawkins sees it as a spectacular example of evolution happening before our very eyes. Since poachers and hunters have targeted and killed the biggest tuskers for their ivory, they've exerted a massive selection pressure in favour of smaller tusks. Big tusks are no longer a survival advantage, so within living memory the average tusk size has gone down and down.

Elephants can breathe through their mouths as well as their trunks. Either way, given their size, they need to shift a lot of air in and out. We're joined at the RVC by elephant vet Jon Cracknell. Jon is clearly excited by elephant anatomy and physiology. The mechanics of breathing are fascinating. In our bodies the paired lungs are like a couple of fleshy, stretchy balloons dangling inside an airtight set of bellows formed by our ribcage and diaphragm – the sheet of muscle and tendon that separates our chest from our abdomen. When we breathe in deeply, our dome-shaped diaphragm flattens and our ribcage swings forward and up. As a result, the volume inside the bellows – inside our chest cavity – increases.

As far back as 1662, Irishman Robert Boyle worked out that in such a situation if volume goes up, pressure goes down. So, as we subconsciously set the mechanics in motion to breathe in, the pressure inside our chest drops compared to the pressure outside our body. Air doesn't have a mind of its own but, when it comes to pressure, it does like the status quo. It will always try to even out pressure differences by moving, en masse, from higher to lower pressure places. The chest cavity itself is sealed, of course, but the balloon-like lungs dangling inside are open to the atmosphere. What happens next is entirely predictable. Air rushes in to fill the lungs. And, it takes the path of least resistance. If your mouth is shut, air rushes in through your nose, unless it's stuffed full of snot. In which case, you'll die, if you don't drop your lower jaw.

Opposite top: African elephants are typically larger than Asian elephants and have much larger ears than their Asian counterparts. Both males and females have tusks, whereas only Asian males have tusks.

Opposite bottom left: As Joy dissects deep into the upper jaw of the female Asian elephant, she discovers a tooth buried there. Astonishingly, it's a very small tusk.

Opposite bottom right: The average tusk size has decreased in size within living memory, due to poachers and their hunt for ivory. This form of unnatural selection is a spectacular example of evolution happening before our very eyes.

Breathing works in essentially the same way in elephants, but there's an intriguing anatomical difference. John carefully peels off the last of the ribs on the elephant's right side. It's a tough job because the elephant's lungs are actually stuck to the inner surface of the ribcage (and to the diaphragm) by stretchy connective tissue. The space between them, the pleural space, has been obliterated. In any other mammal, this would be seen as dangerous pathology. In the elephant it is completely normal – an extraordinary and unique anatomical anomaly that has been known for centuries but until recently could not be explained.

Step forward another John – John West from the Department of Medicine at the University of California. In 2002, he proposed that the visible adhesions we are looking at could be the result of a unique adaptation in elephants that allows them to claim the title as the only animal that can snorkel, underwater, at depth. Elephants are capable of walking along river and lake beds, completely submerged, with just their trunk tips poking periscope-like above the surface. It's an amazing trick and incredible to see. An adaptation perhaps not so surprising given the elephant's ancient, pig-sized ancestors were semi-aquatic and lived like hippos.

To snorkel for extended periods, even just a couple of metres underwater, is a risky business. It makes tiny, delicate blood vessels in the membranes between the lungs and ribcage vulnerable to catastrophic failure. Evolution's solution in elephants has been to protect these blood vessels from the huge pressure differences by encasing them in much thicker, tougher membranes than are found in other animals. But there's a downside to this remarkable adaptation that may

Above: Unlike other mammals which have a pleural space between the lungs and the ribs, elephant lungs are attached to the ribcage with connective tissue. This may help them deal with the increased pressure when they snorkel underwater.

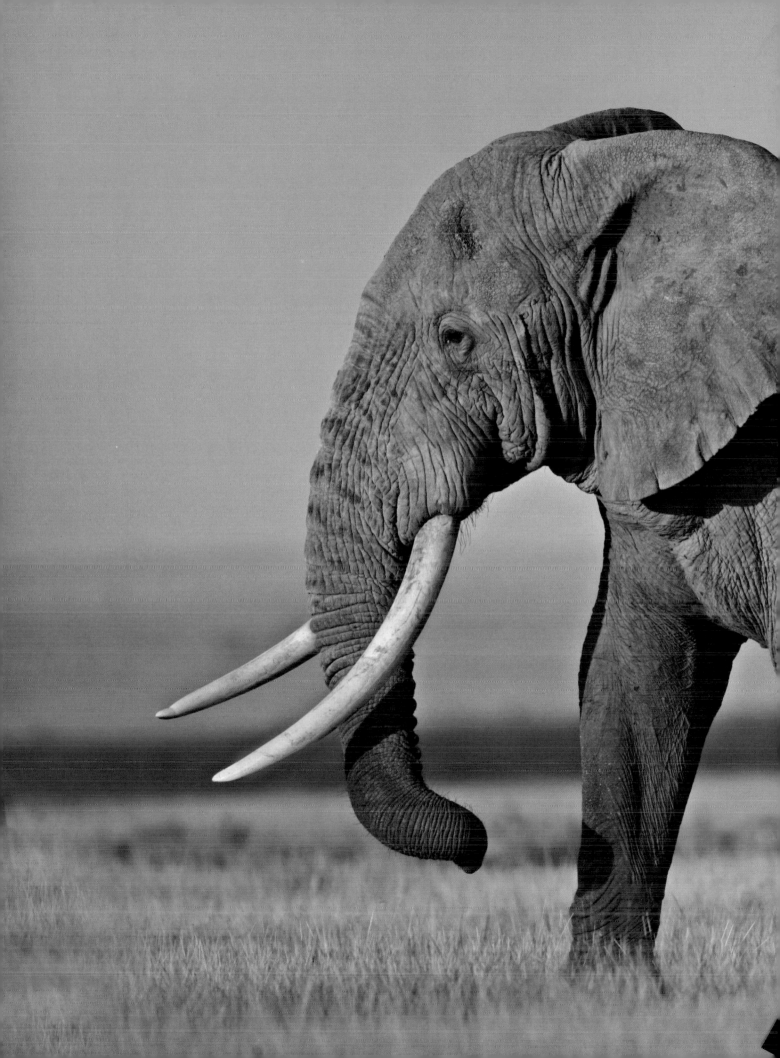

Ears

Elephant earflaps act as built-in, biological heat exchangers that do exactly the same job as a radiator. Always on auto, elephants unconsciously regulate the blood flow and fine-tune the flapping to help their bodies keep cool. Being so big, the elephant's ears provide a massive surface area from which heat can be dissipated. Inside the ear is a stunning network of blood vessels sandwiched between the two skin surfaces. It takes just 20 minutes for an elephant to flush all its blood through these thin tubes.

Trunk

The elephant's trunk is rarely idle: it's a multipurpose tool unique among living mammals: it can be used for feeding, drinking, showering, trumpeting, snorkelling, stroking, grasping, lifting, itching, shoving, sucking, manipulating and greeting – elephants entwine their trunks like a handshake. A trunk has around 150,000 micro-muscles producing enormous dexterity and fantastic versatility. Trunk sensitivity is most obvious at the tip, where thousands of nerve networks feed electrical signals to the elephant's brain.

Tusks

Elephants can live into their sixties provided their tusks endure. Tusks are incisor teeth (they have two, both in the upper jaw) while humans have eight incisors (our front teeth). Functional tusks are used for digging, foraging and as weapons. For bulls, size is everything. Huge tusks can help intimidate less well-endowed adversaries and help win over a mate, and so over generations, natural selection produced bulls with larger tusks. But since poachers and hunters have targeted and killed the biggest tuskers for their ivory, they've exerted a massive selection pressure in favour of smaller tusks. Big tusks are no longer a survival advantage, so the average tusk size has decreased.

Teeth

Inside the largest skull of any living land mammal are molars the size of house bricks. An elephant will have 24 cheek teeth emerge over the course of its life. There are usually only four molar teeth on each side at any time, two in the upper jaw and two below. The other 16 are either worn out and discarded, or not yet formed. They'll devour almost any kind of plant material they can get their trunks on – bark, wood, roots, even soil. Despite their huge skulls, elephants have surprisingly small mouths that they can't open very wide.

help explain why the elephant's lungs are stuck to its chest wall. The encased blood vessels are no longer able to produce (in the 'normal' way) the fluid that, in us and other mammals, lubricates the pleural space between the lungs and the lining of the ribcage. This allows their surfaces to slide against each other when the lungs inflate and deflate. Instead, in elephants, loose elastic tissue obliterates the pleural space but is stretchy enough to allow some sliding of the lungs against the inner rib cage. But, John West thinks this is unlikely to be much of a handicap to efficient respiration. Arguably, it's a small price to pay, not just to be able to snorkel but, perhaps, more importantly, to be able to drink and shower. When elephants suck water up their trunks, those tiny blood vessels in their chest are subjected to the same kind of strain, if briefly, as they are when the elephant snorkels. The physics is complex. John's hypothesis is fascinating.

On a sweltering afternoon in South Africa's North West province, a young zoologist rocks from one foot to the other as she shuffles herself into the perfect position. She's holding a running hosepipe in one hand and what looks like a large chocolate truffle in the other. Towering above her is Sapi, a 27-year-old bull elephant. She gently inserts the hose into the corner of his gaping mouth. He swallows. She lobs the truffle over his bottom lip and tongue and into the back of his throat. He swallows again. Job done.

Nadine Torrao is from the University of Witwatersrand in Johannesburg. She's in the Letsatsing Game Reserve as part of a year-long study into how elephants regulate their body temperature. The truffle-like projectile is a chocolate-covered 'Trojan horse', designed to carry a delicate bit of electronic gadgetry into the elephant's core. Hidden inside, embedded in wax, is a tiny thermometer. As

Above: Given that the elephant's ancient, pig-sized ancestors were semi-aquatic and lived like hippos, it is perhaps unsurprising that they are able to snorkel for extended periods of time.

Skeleton

As the largest living land animals, elephants are certainly impressive. Some are monstrously big, reaching 4m (13ft) tall and weighing over 6 tonnes. The elephant's skeleton is made up of more than 200 bones, each one perfectly formed and shaped for a specific function. Collectively, joined together by complex arrangements of ligaments, tendons and muscles, they form a mobile scaffold that supports the elephant's soft body.

Elephant:

Weight: ...
5,400kg (12,000lb) (m)
Height: ...
2.5–3.2m (8–10ft)
Length male / female:
N/A
Life Span: ..
45–60yrs
Top Speed: ...
25km/h (15mph)
Bite strength pound force:
N/A

Gut

Elephants have a truly massive digestive system. The major components of the elephant's digestive tract are the same as they are in us, but it's the size of the large intestine that defies belief. The elephant's large intestine is a colossal sac the size of a sleeping bag, containing millions of microscopic life forms that get to work on the huge quantities of coarse plant material squeezed down to them from the stomach and small bowel.

Toes

Elephants stand on tiptoe. Asian elephants usually have five toes up front and four behind. African elephants generally have one less in each foot. The toe bones are towards the front and sides of the foot. Between them and the horny sole, or slipper, is a great fibrous, fatty mass of squidgy tissue. It's this huge heel cushion that expands so dramatically under the elephant's weight. It absorbs energy under compression ready to help spring the giant leg off the ground as the foot rolls over onto its toenails and leaves the ground.

Legs

Elephants support their weight by having large muscles attached to very strong leg bones arranged in columns. But the bones have no central marrow cavity – they are rock solid, making them perfectly adapted to cope with compression. Hi-tech video analysis of elephant locomotion reveals that their feet work a bit like pogo sticks. When an elephant walks along, the base of the foot swells as it soaks up pressure. As this pressure is reduced, the foot rebounds back to its original shape with great force.

Breathing

Elephants can breathe through their trunks, and uniquely, use their trunk as a snorkel underwater. Breathing works in exactly the same way for humans as for elephants, but elephant's lungs are stuck to the inner surface of the ribcage (and to the diaphragm) by stretchy connective tissue. The space between them, the pleural space, has been obliterated. In any other mammal, this would be seen as dangerous pathology. It is believed that these visible adhesions allow them to snorkel, underwater, at depth. Elephants can walk along riverbeds, completely submerged, with just their trunk tips poking periscope-like above the surface.

Elephants are special in so many ways. As giants, they push biological engineering to the extreme. Intellectually and emotionally they are complex to say the least. The more we know about how their bodies are built, how they work and how they behave, the clearer it becomes that caring for zoo elephants – providing properly for their physical and behavioural needs – is a truly monumental challenge. I continue to struggle with two questions. Are we up to it? And, is it even possible?

the thermometer passes through Sapi's digestive system it records the temperature of its location every five minutes. When it reaches the end of the tunnel, his anus, its journey is over and it will be laid to rest in a steaming turd. All Nadine then has to do is find it. Sensibly, she attaches pink tell-tale ribbons to the truffle thermometers to make them easier to find.

A potentially dangerous consequence of being so big is that elephants generate and absorb vast amounts of heat. Nadine wants to find out how they prevent themselves from fatally over-heating. Day and night, while the internal thermometer is on its long journey through Sapi's digestive system, she films him with a thermal-imaging camera to check his surface temperature. Later, she'll compare his surface heat maps with simultaneous temperatures inside his body. Nadine discovers that during the hottest part of the day, on the outside, her elephants can reach 55ºC (131ºF). Yet, deep inside, they can be almost 20 degrees cooler.

As he wheels in a hefty hydraulic press, designed for use in an engineering workshop, I know instantly that John Hutchinson is my kind of scientist. John works in the Structural Motion Lab at the RVC and is a world authority on animal location. He has a special interest in how elephants get from A to B. He's a perfect guide as we dissect our elephant's limbs.

Elephants support their weight by having large muscles attached to very strong leg bones arranged in columns. John saws through one of the elephant's hindleg bones, the tibia. There's no central marrow cavity. It's not hollow – it's rock solid. That makes it perfectly adapted to cope with compression. And lots of it. Bone is an amazing material. Soak a bone in acid to remove its minerals and it becomes completely flexible, like rubber. Bake it at a high temperature to burn off the softer organic component and the bone becomes so brittle it snaps easily. It's the complex combination of hard minerals and soft organic stuff that gives bone its ability to cope with the stresses and strains of everyday life. And, in elephants, those forces are considerable, especially when they run at full speed.

Hi-tech video analysis of elephant locomotion reveals extraordinary insights into how they shift their bulk. For starters, their feet work a bit like pogo sticks. John puts one of our elephant's lower limbs into his hydraulic press. As he pumps up the pressure, the machine pushes down on the sawn-through leg bone replicating what happens when an elephant walks along. I'm focused on the bone itself, but John tells me to lower my gaze. The base of the foot is swelling as it soaks up the pressure. Not just a bit, but a lot. As John de-pressurizes the hydraulic ram, the stretched foot rebounds back to its original shape, forcing the ram back into its housing.

Another lower leg has been sawn in half, from top to bottom, so we can take a closer look at the anatomy that powers this pogo. It's the first time I've seen inside an elephant's foot. It's awesome. Elephants stand on tiptoe. Asian elephants usually have five toes up front and four behind. African elephants generally have one less in each foot. The toe bones are towards the front and sides of the foot. Between them and the horny sole, or slipper, is a great fibrous, fatty mass of squidgy tissue. It's this huge heal cushion that expands so dramatically under the elephant's weight. It absorbs energy under compression ready to help spring the giant leg off the ground as the foot rolls over onto its toenails and leaves the ground. An elephant's foot is a much more dynamic structure than I'd imagined. John describes elephants as having built-in, high-heeled running shoes.

Joy Reidenberg

Large size certainly has advantages, but unfortunately it's not an efficient shape for cooling off. Bigger and rounder means less surface area for radiating heat. Rotund elephants therefore seem out of place in hot environments compared with their skinny neighbours whose long and thin necks and extremities provide extra surface area for radiating heat. Elephants use a different strategy: large ears. While their solution for heat regulation is not unique (e.g., long ears are found in the desert fox and desert hare), it is the most extreme example.

Elephants have the largest ears in the animal world, particularly African elephants, whose ears are larger than their Asian cousins. Elephant ears act much like a Japanese folding hand fan. Muscles fan the ears forward and back, moving cooling air across the elephant's broad sides. Air currents also cool the ears' own surfaces. They function like a car's radiator. As the car moves forward, air currents strip heat off the radiator's thin surfaces, thereby cooling fluid in the pipes. Elephant ears do the same thing, but the hot pipes are blood vessels.

Several arteries carry hot blood from the elephant's core to the ear's surface. The arteries branch into smaller and smaller pipes that spread out to cover as much surface area as possible, using the many thin blood vessels to dissipate heat. The skin of the ear is much thinner than the tough hide covering the back and sides of the body. Heat is easily transferred across the skin and radiated to the air since blood vessels lie close to the surface, particularly on the back of the ear. When an elephant is cold, it simply presses the back sides of its ears against its body, shielding the thin skin from radiating heat to the air or recapturing any radiated heat directly back to the sides of its body.

Since elephants don't sweat, heat loss can be augmented by using the trunk to throw water or mud over their bodies. As the water evaporates, it cools the surface. Evaporative heat loss involves a transfer of heat from the hot blood through the skin and to the water, causing it to vaporize. Elephants aim water towards the back of the ear, as that is where the skin is thinnest and blood vessels are closest to the surface. This also keeps water from accidentally blocking their hearing by entering the auditory canal on the front side.

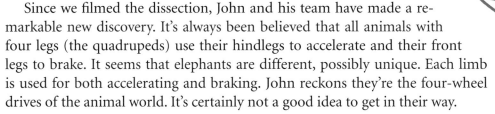

Since we filmed the dissection, John and his team have made a remarkable new discovery. It's always been believed that all animals with four legs (the quadrupeds) use their hindlegs to accelerate and their front legs to brake. It seems that elephants are different, possibly unique. Each limb is used for both accelerating and braking. John reckons they're the four-wheel drives of the animal world. It's certainly not a good idea to get in their way.

Our dissection ends on a sad note. As a critical part of the post mortem, Alun opens up one of the elephant's knees. He dips the tip of a syringe into the joint fluid that bathes and lubricates the cartilage-capped ends of the articulating bones. It should be quite oily and cling to the syringe tip as it's pulled away. It doesn't. It's too watery. A tell-tale sign of worse to come.

Alun extends the cut through the joint capsule to get a better view and reveals the cause of our elephant's demise. The boundary between the white cartilage and the creamy-coloured bone should be smooth. But it's badly roughened by abnormal bone growth and riddled with craters, some large and deep. We are staring at the site of her pain. It's the worst case of arthritis I've ever seen.

Arthritis is well known in captive elephants. It's a complex disease and very difficult, sometimes impossible to manage, especially in such heavy animals. It can be excruciating. With the help of her keepers and vets, this elephant had fought a long and brave battle. But, in the end, it got the better of her and them.

Alun's post mortem findings confirm that the difficult decision to end this elephant's life was absolutely the right call. Since the dissection I can't get what I've seen out of my mind. It leaves me thinking about all the other elephants in zoos, I worry about them.

Above: Elephants stand on tip-toe but are able to support their weight by having large muscles attached to very strong leg bones arranged in columns. They also have huge heal cushions made up of a fibrous, fatty mass of tissue which absorbs energy under compression and so helps spring the giant legs off the ground.

Top: Arthritis is common in captive elephants. This elephant's knees are riddled with the disease, a tell-tale sign of its sad demise.

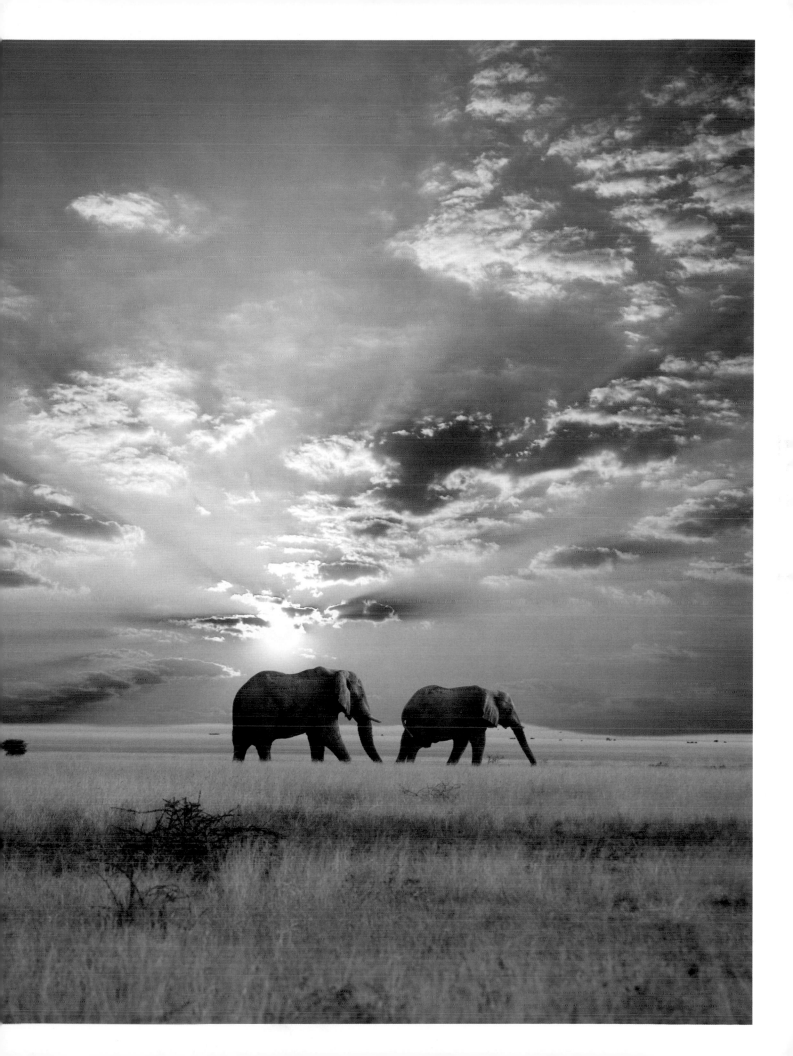

How the Elephant Got Its Trunk

The elephant's trunk is, without doubt, one of the most iconic anatomical wonders of the animal world. It's a multi-purpose marvel unique among living mammals that's so sensitive yet so strong: it can be used for feeding, drinking, trumpeting, snorkelling, touching, feeling, stroking, grasping, lifting, shoving, sucking, manipulating. Rarely is it idle. When elephants meet they may entwine their trunks as a friendly greeting, much like we shake hands. They can hold branches in their trunks and use them to scratch those hard-to-reach itches. But they also have a strong enough grip to lift logs weighing hundreds of kilos. They can use their trunks to give themselves a wet shower or a standing dust bath. An elephant's head is huge and heavy. It needs to be able to support its massive molars and tusks. If it were more giraffe-like, the elephant would never get its head off the ground. But having a stubby neck on a very tall animal leaves the mouth a long way up. This is a definite disadvantage for feeding off the ground and drinking. So how, did the elephant get its trunk? According to Kipling's *Just So Stories*, it was the result of a tug-of-war with a crocodile. But natural selection doesn't work like that. The elephant's extinct ancestors were thought to have been the size of modern-day pigs. They didn't have trunks, but some may have had a mobile upper lip or snout. Over millions of years, through natural selection, the ancients of the elephant family tree became bigger and taller, their jaws elongating to keep their mouths capable of reaching the ground to feed and drink. But as these animals became bigger still, their increasingly massive heads must have become a heavy handicap. It's thought possible that those with slightly shorter, lighter jaws and with longer upper lips that could grub for food would have had an advantage. Over many, many generations, animals evolved with shorter jaws and longer, muscular upper lips and nostrils fused into recognizable trunks. From the fossil and frozen record of life on Earth, it's clear that there have been animals on Earth with trunks similar in size to those adorning living elephants for around seven million years. Today, elephants are the only animals that still have trunks.

Hippo

Hippopotamus amphibius

Alex Tate

Snaking 800 km (500 miles) through the heart of Zambia, the great Luangwa River is the lifeblood to one of Africa's greatest wildlife sanctuaries, South Luangwa National Park. Here, a luscious emerald-green landscape entices large herds of grazers – antelope, zebra and elephant – which in turn attract predators – lion, leopard and hyena. The animal that benefits most from this wealthy supply of water is the hippopotamus. At no other place on earth does it congregate in such vast numbers. There may be as many as 50 of them in a single kilometre-stretch of the river.

Each year, a stark transformation takes place. By October, there's not been a single drop of rain for four months. The river, once 4m (13ft) deep, is barely knee high. A brown, dusty desert, littered with the carcasses of animals that have succumbed to soaring temperatures and drought, replaces the green vistas. Locals call it suicide month – and the hippo is one of the most vulnerable animals. So it is in late October that the *Inside Nature's Giants* team arrives in South Luangwa.

The hippo is an odd-looking animal. Perched upon short, stumpy legs is a huge, bulbous body, with a small tail at one end and a colossal head at the other. The ancient Greeks thought that its long face resembled a horse's, which is why they named it the hippopotamus, 'hippo' meaning horse and 'potamus' meaning river. Today we know that hippos are not that closely related to horses at all. Until the early 20th century scientists thought that hippos were most closely related to pigs because they have similar molar teeth. But by analysing their DNA we now know that their closest living relatives are whales. Hippos are more closely related to these giant marine mammals than they are to any land mammal.

So for whale expert Joy Reidenberg, this dissection offers a unique opportunity to search for anatomical similarities between the hippo and its ocean-bound cousins. She is especially interested to see the larynx or voicebox, to investigate whether hippos, like whales, may communicate underwater.

Opposite: Hippos sparring to establish territory in the Luangwa River in Zambia.

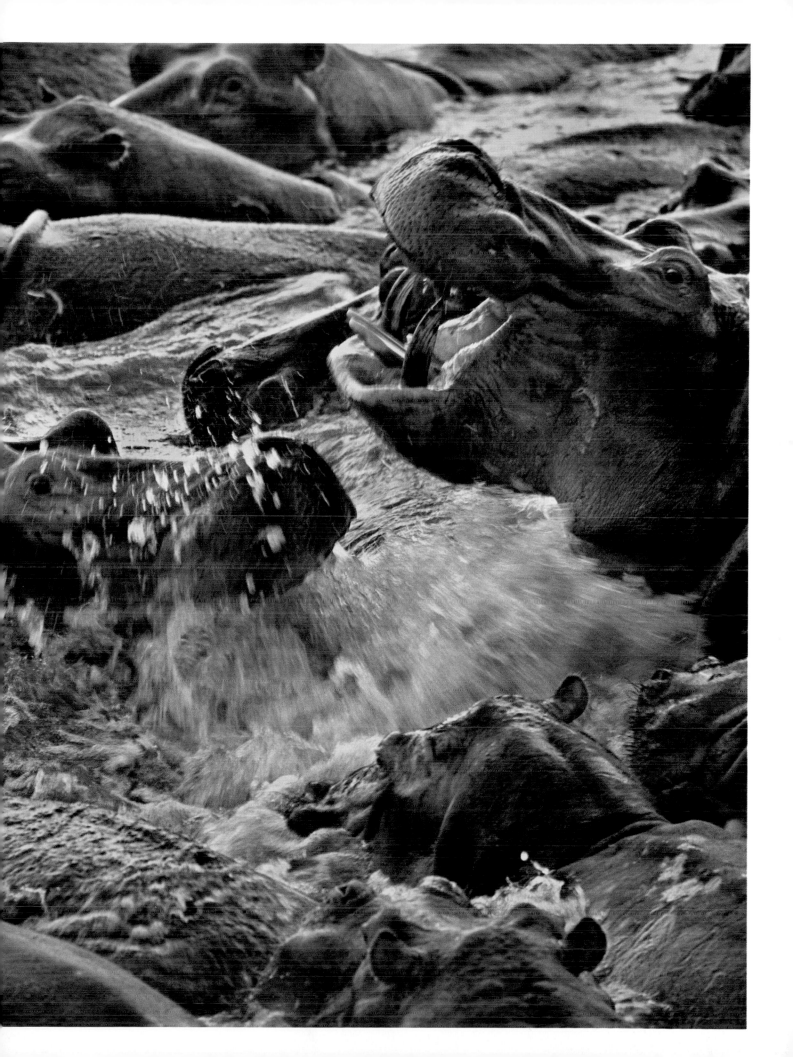

With so little water around at this time of year, all the hippos in the park tend to congregate in pods of 70 or so in the Luangwa River. Most of the river's smaller tributaries have dried up, although one or two hippos can be found alone in pools of mud. Invariably these are males ousted from a pod by a dominant bull that is keen to prevent rivals getting too close to his females. These lonely souls are the ones most likely to die during the dry season, although finding their carcasses in the mud can be quite difficult. In the river carcasses are much easier to spot. When hippos die, decomposition gases bloat their bodies and leave them floating upside down in the water, exposing their pink underbelly. However, we are not alone in trying to gain access to dead hippos. Crocodiles move in quickly, dismembering carcasses limb by limb.

At South Luangwa Park, the Zambian wildlife authorities have decided to control the hippo population to preserve the park and prevent Anthrax outbreaks, which may be due to overpopulation. Each year they cull around 200 hippos, and they have agreed to let us carry out a dissection of one of them.

On the day of dissection, we meet the man in charge of the culling operation, Kudu, and his team of 20 men. The hippo that we've been given is a female – although it's not that easy to tell the sexes apart, as the males keep their scrotum inside their body. While females appear to stop growing when they reach 25, males continue to grow until they die and can reach over 3 tonnes. This is comparable to a small elephant or a rhino. What's immediately striking is the size of her head. It's enormous. And yet, because a hippo's sensory assets – its eyes, ears and nostrils – are positioned on the top of the head (just like a crocodile), it can submerge the rest of its body underwater, hiding it from the sun.

Above: At South Luangwa Park, the Zambian wildlife authorities have taken the decision to control the expanding hippo population. The dissection team fly out to the area and are greeted by their guides.

Above left: The team are given permission to dissect one of the culled animals, a female hippopotamus.

Top: Like crocodiles, a hippo's sensory assets are positioned on the top of the head.

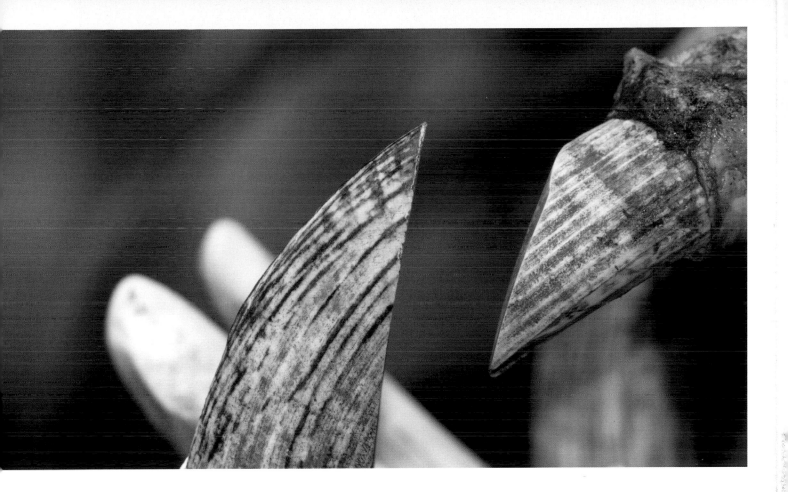

Kudu's men open up the mouth and place a wooden stake between the top and bottom jaw to keep it open. This allows Mark and Joy to peer inside and examine the giant tusks. Both the upper and lower incisors are large, but it is the canines that are particularly prominent. In males they can grow as long as half a metre. They never stop growing, but these canines are positioned in such a way that the upper and low sets grind against each other. This wears them down and keeps them sharp. If a hippo loses one of its canines, the other one keeps growing and can spiral wildly out of control. The powerful combination of large, sharp teeth in incredibly strong jaws means hippos are always treated with great respect. They can bite a crocodile – or even a canoe – in half!

These terrifying teeth are usually reserved for attacks on other hippos. They are fiercely territorial in water. Fights between male bulls are especially brutal, and often escalate into bloodbaths. When the dissection team examines the female's back, they notice her naked skin is covered in battle wounds, some deep. The amazing thing is that hippos rarely die from their wounds.

Although the surface of the hippo's skin seems rather delicate, underneath it is up to 3cm (1in) thick in places. It offers the hippo a protective shield against its rival's canines. But there is more to this skin than meets the eye. Joy takes the small square of skin and bends it to test its strength. She notices what seems to be a small speck of blood. This red fluid, which is normally secreted out of the skin, is often referred to as 'blood sweat', but in fact it is neither blood nor sweat. It's actually a colourless, viscous liquid, which happens to turn red on exposure to air. This is what gives hippos that slightly pink complexion.

The nature of this blood sweat puzzled scientists for generations. Recently a

Above: Hippos have prominent canine teeth, giant tusks which are mainly used for territorial fighting.

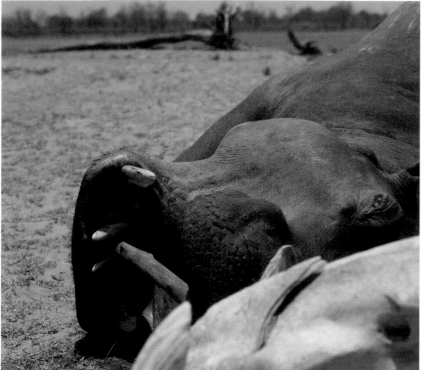

detailed chemical analysis revealed its remarkable properties. This magic potion prevents the growth of harmful bacteria (which grow particularly well in muddy water); it accelerates wound healing and it also absorbs harmful UV rays, protecting the hippo's skin from the sun.

The hippo's skin is very vulnerable to the harmful effects of the sun. Many mammals rely on fur to act as a sun shield, but hippos are naked. There's a good reason for this. A fur coat may offer protection from sun rays, but it can also cause large animals to overheat. Elephants and rhinos have also lost their fur, but the outer layer of their skins is very thick; whereas a hippo's is relatively thin. It loses water from its surface faster than most mammals. This works well when submerged in the river, because losing water from its body removes heat at the same time. The problem for hippos occurs when they spend long periods out of the water. Then their skin dries and cracks in the sun. They will dehydrate fast. Interestingly, when whales and dolphins strand on land, their skin dries and suffers from sunburn too. Sometimes what kills them is dehydration. So for hippos, whales and dolphins water is a life-saver – it's their sunshade.

By 11am our team, clad in protective orange suits, is starting to wilt under the African sun. The temperature is now above 45ºC (113ºF). Fortunately Kudu's men have fashioned together an ingenious shelter built from tree trunks. This is our refuge where we can retreat to rehydrate with foul-tasting isotonic drinks.

Out in the field we wanted to find out how hippos refuel their giant bodies. Sheltering from the sun during the day restricts their grazing time, because although they may live in the water, they don't feed there. At the end of each day, as the sun dips below the horizon, one by one, hippos begin to leave the water. They

Above left: The Zambian wildlife authorities open the hippo's mouth and use a wooden stake to keep the jaw open so that the team can examine its teeth and jaw.

Above: Mark takes a break in the shelter from the intense African heat.

Opposite: Hippos are able to submerge their bodies underwater, keeping them cool and avoiding sunburn. Unlike most other semi-aquatic animals, they have very little hair.

Apart from their nocturnal excursions when they leave the river to feed, hippos really are aquatic animals. The water is where they mate; where females give birth; where they socialise and also where they sleep. During sleep, hippos have a curious ability that allows their bodies to automatically rise to the surface when they need to breathe. Adults usually come up for air every five minutes or so and slip back below the water's surface again.

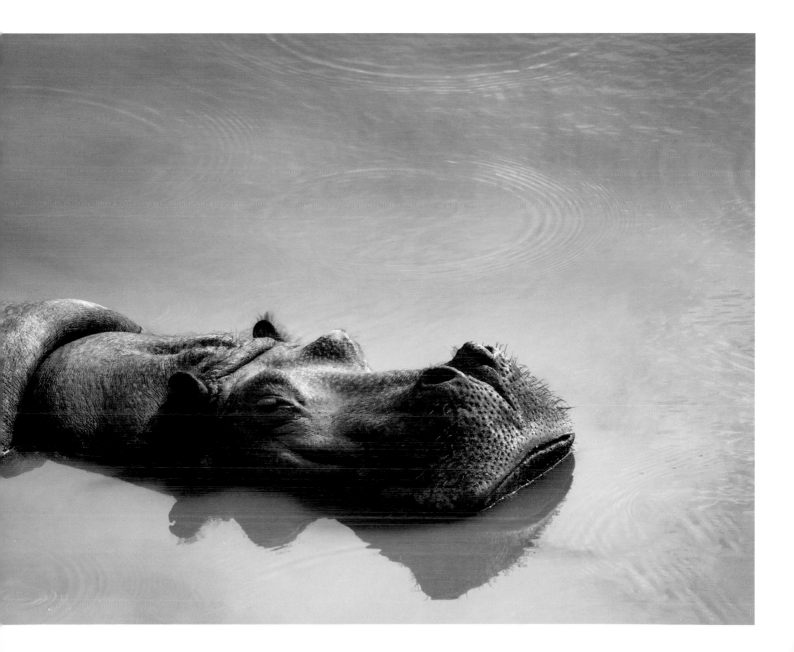

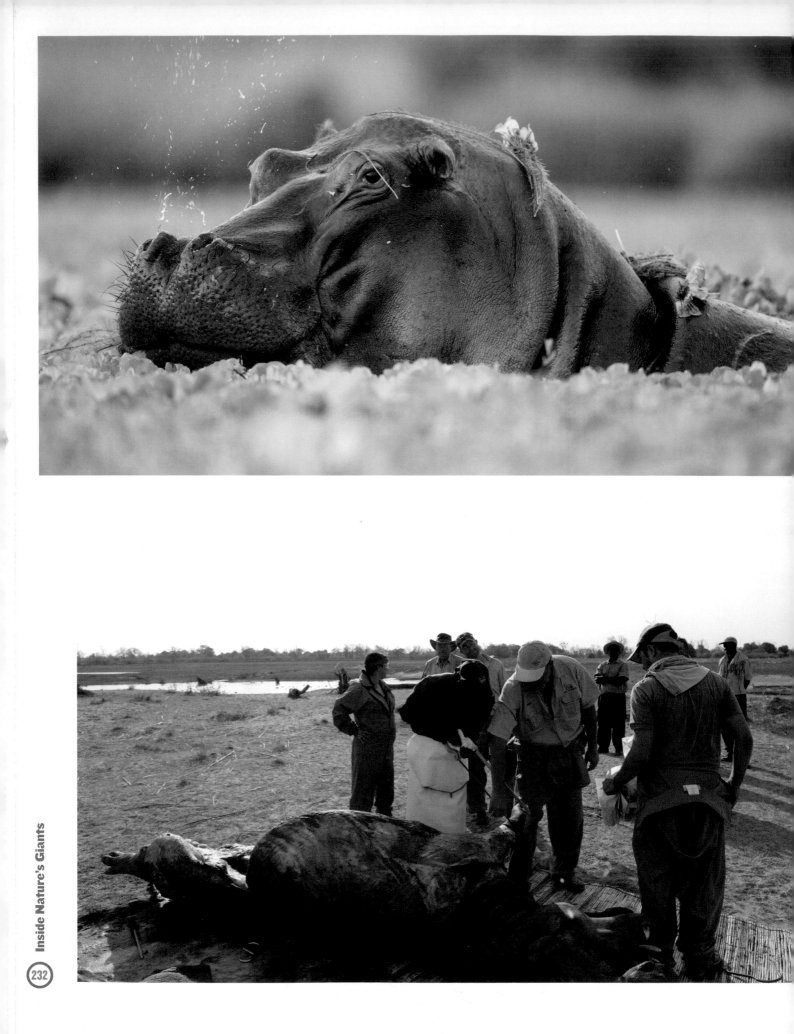

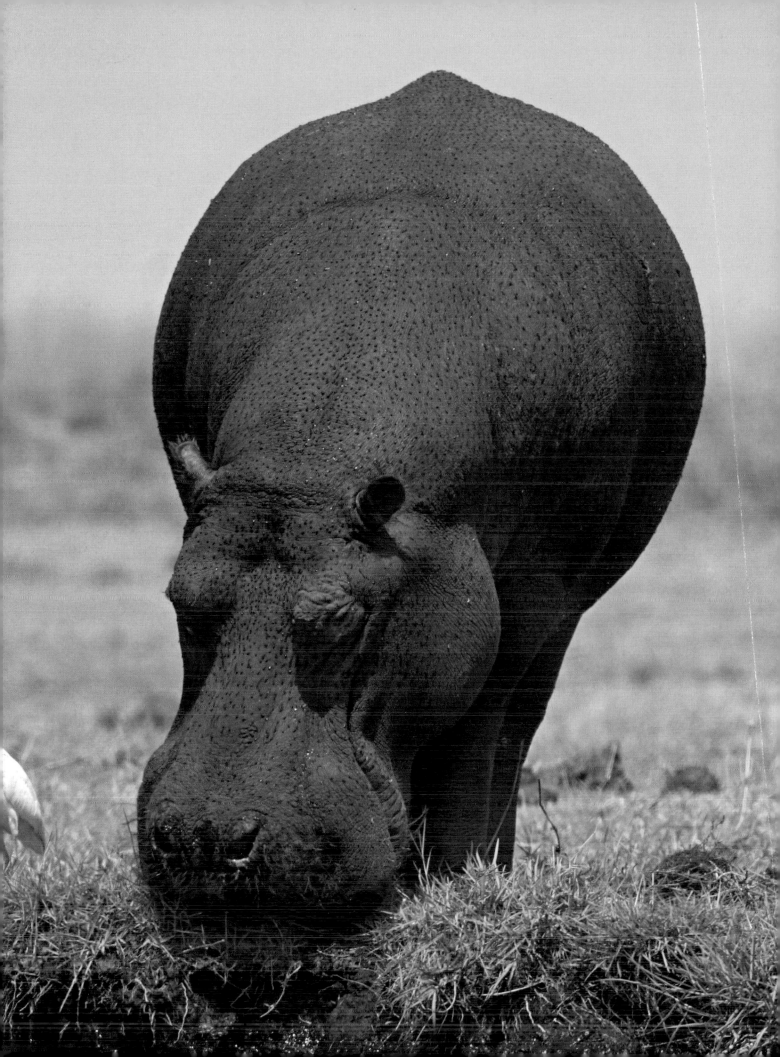

Big Head

The hippo has a huge head, with its sensory organs (eyes, ears and nostrils) positioned on top, just like a crocodile. This is so it can submerge the rest of its body underwater, hiding it from the sun. Its jaws can open to almost 180 degrees, exposing its huge tusks, which are used to battle with rivals. The ancient Greeks thought that its long face resembled a horse's, which is why they named it the hippopotamus, 'hippo' meaning horse and 'potamus' meaning river.

Long in the Teeth

Hippos have the powerful combination of large, sharp teeth in incredibly strong jaws. Both the upper and lower incisors are large, but it is the canines that grow up to 50cm (20in) in males. They don't stop growing as continual grinding wears and sharpens them. If a hippo loses one canine, the other one keeps growing and can spiral wildly out of control. Teeth are used to attack other hippos, and fights between bulls can be brutal. Skin wounds are frequent but rarely fatal.

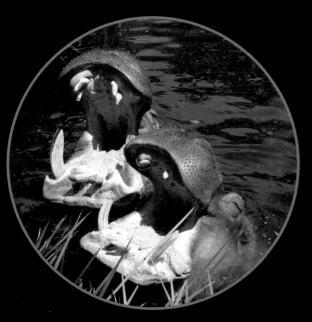

Nocturnal Herbivore

At the end of each day hippos leave the water to graze on grass for five or six hours. Unfortunately, the hippo's impressive front teeth are useless for biting grass so they use their nimble lips to grip the grass, and a swing of the head rips it from the ground. As dawn breaks, its huge belly full, the hippo follows its own trail of dung back to the water before the sun rises. Their lazy aquatic lifestyle means their energy needs are not so great as a similar-sized animal such as a white rhino. The hippo's stomach offers the chance to explore how hippos are related to whales. Both have multi-chambered stomachs, though in the case of the whale there's no real need for a specialized stomach to digest plants.

Whale Talk

As hippos prepare to leave the water for the night they emit a chorus of honks and snorts. Some experts believe that they also use their unusual larynx to communicate underwater like whales and dolphins. Sound travels about five times faster in water than it does in air, so this would allow them to spread their messages far and wide.

Aquatic Sleep

During sleep, hippos have a curious ability that allows their bodies to automatically rise to the surface when they need to breathe. Adults usually come up for air every five minutes or so and slip back below the water's surface again. They may be able to stay under for as long as 30 minutes.

haul themselves up steep banks to lead a secret life under the stars.

Driving in our jeep along the meandering game trails, our powerful torch beam scans the road ahead looking for hippos. After 15 minutes driving through thick bush, we come across a large open plain, and there we find a grazing hippopotamus. This animal almost looks out of place on land. The hippo has such a close association with water it's easy to forget that they are grazers just like zebras and antelope. And very efficient they are too. Their grassy feeding areas are so well tended they look like a well-trimmed putting green on a golf course. These are appropriately named 'hippo lawns'.

Unfortunately, the hippo's large front teeth, so effective for showing off to rivals, are useless for biting grass. So they've evolved an unusual feeding strategy. They use their nimble lips to grip the grass, and then a swing of the head to rip it out of the ground. For five or six hours during the night a hippo will walk its lawn, swinging its head back and forth until its huge belly is full. Then, as dawn breaks, it returns to its water refuge, as if it never left. Throughout this foraging the hippo vigorously wags its short tail, scattering dung like a muck spreader. This trail of dung marks the route so it can find its way back before sunrise.

We want to see how much grass a hippo can eat; so we turn the hippo onto its back and open up the abdomen to remove the stomach and intestines. What's immediately obvious is the tremendous capacity of the stomach which is crammed full of grass. We pile its contents into several bags and weigh them. The total weight is just under 160kg (353lb). Amazing! This is probably the result of more than one night's feeding. Their lazy aquatic lifestyle, hiding away from the sun, means their energy needs are not so great as a similar-sized animal such as a white rhino. In fact, hippos only eat about half as much as white rhino per day,

Above: At night, hippos leave the water, hauling themselves up steep banks to graze and feed on land.

Top: Upturned log covered in hippo dung sprayed along its trail.

Opposite: The team turn the half-skinned hippo onto its back to cut off and examine its leg.

Magical Skin

Although the hippo's skin seems delicate, underneath it is 3cm (1in) thick in places and protects against a rival's teeth. The hippo's skin secretes a viscous fluid that turns red on exposure to air and contains remarkable properties: it can prevent the growth of harmful bacteria; it accelerates wound healing; and also absorbs harmful UV rays. Many mammals rely on fur to act as a sun shield, but hippos are naked to avoid overheating. Apart from getting sunburn, their skin dries and cracks during long periods out of the water, causing dehydration.

Hippo:

Weight:
1.5–3 tonnes
Height:
1.5m (5ft)
Length male / female:
3–5m (11–17ft) (m)
Life Span:
40–50yrs
Top Speed:
30km/h (18mph)
Bite strength pound force:
1,820lbf

Heavy Legs

A hippo leg is heavier than expected. It is dense with bone all the way through, without the hollow marrow-filled cavity of other animals. Heavy bones act as ballast and counteract the buoyancy of the lungs, helping the hippo to sink. They do such a good job that a hippo can walk around easily on the river bed. It can even manage a slow gallop as its body weight is supported by the water.

Inflatable Lungs

Large lungs provide the hippo with oxygen-filled air sacs to breathe underwater, as well as additional buoyancy. Inflated lungs help it float whereas deflated lungs let it sink. This poses a dilemma for hippos. If they want to stay submerged and out of the sun for long periods, then having large lungs means they can hold their breath longer. But large lungs, full of air, also make them more buoyant, preventing them from sinking in the first place. The answer lies in the hippo's legs.

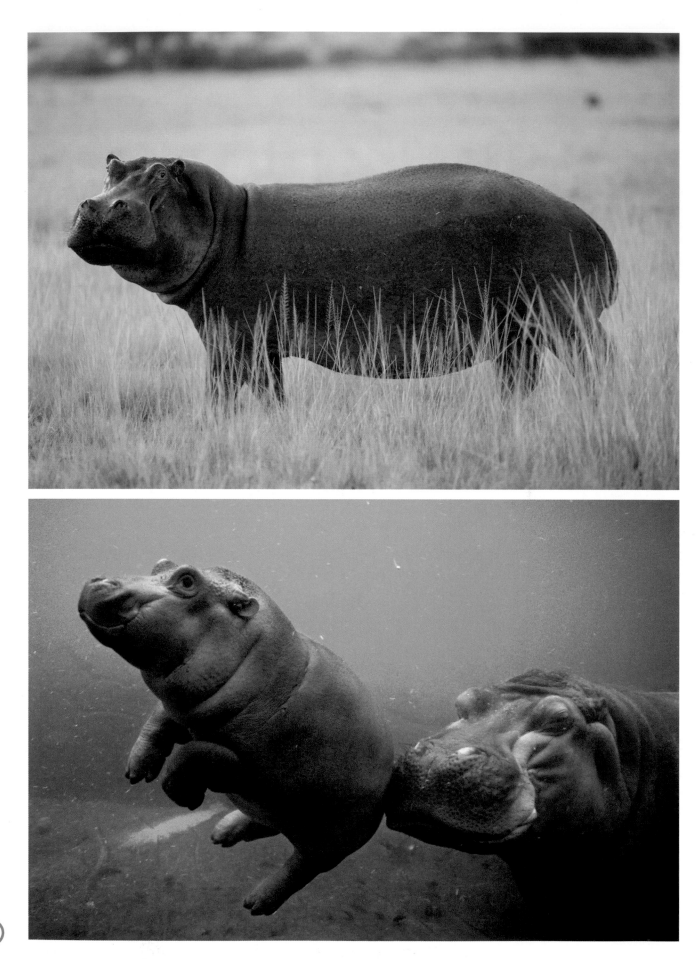

which allows them to restrict their feeding to the brief hours of the night.

For Joy, the fascination with the hippo's stomach goes beyond its size and contents. For her the anatomy of the stomach offers the chance to explore how hippos are related to whales. No mammal can digest grass without the help of gut bacteria. They produce enzymes that break down the tough cellulose wall of grass. In some mammals – like elephants and zebras – this fermentation process takes place in the hindgut (i.e. after the stomach). But in the majority of plant eaters, and this includes cows, camels, antelopes, pigs and hippos, fermentation takes place in the stomach itself. These animals are known as foregut ferment-ers. Their compartmentalized, multi-chambered stomachs help make digestion much more efficient. What's interesting for Joy is that if you look inside a whale surprisingly they have multi-chambered stomachs too. Whales are carnivores, so there's no real need for a specialized stomach to digest plants. But the ancestors of whales were plant eaters, and when they entered the water around 50 million years ago, they took their multi-chambered stomachs with them.

Once the stomach and intestines are removed, Joy wrestles to excavate the lungs. Stretching her arms beneath the ribcage she manages to cut the windpipe and pull the breathing apparatus out onto the ground. The lungs are large, but not larger than might be expected for an animal of this size. Diving mammals rely on their oxygen-filled air sacs to allow them to stay underwater, but they also have a secondary function: buoyancy. When lungs are inflated with air the den-sity of that animal's body decreases, helping it float in water. Conversely, when the volume of air in the lungs is reduced it enables the animal to sink. This poses a dilemma for hippos. If they want to stay submerged and out of the sun for long periods, then having large lungs means they can hold their breath longer. But large lungs, full of air, also make them more buoyant, preventing them from sinking in the first place. So what is a hippo to do?

The answer, curiously, lies in the legs. Joy picks up the leg bone and finds that it is much heavier than she expected. Unlike the long bones of most mam-mals, there's no hollow cavity filled with bone marrow. In a hippo limb there's no hollow channel. There's bone all the way through, and the middle section is peppered with tiny pockets containing bone marrow.

These heavy bones act as ballast – just like the weight belt of a diver. This counteracts the buoyancy of the air-filled lungs to help the hippo sink. They do such a good job that hippos can get about in water by walking on the riverbed.

Although they may look cumbersome on land, when underwater, hippos move with a spring in their step. Because the river water supports their body weight, it reduces the effect of gravity and changes the way they move. In the zero gravity of space humans walk with a slow run. In water, the same effect allows hippos to walk with a slow gallop. You could say that they spacewalk.

Interestingly, fossil evidence suggests that the four-legged ancestors of mod-ern whales also had thickened leg bones just like hippos. These 'proto whales', which lived around 50 million years ago, were wading animals, spending time both on land and in water. Eventually their descendants left the land altogether, perhaps because they switched from being herbivores to carnivores hunting fish and other aquatic animals. Fully committing to a life in the buoyant conditions of water allowed whales to balloon in size. As we've seen in the whale chapter, their forelegs modified into flippers and their hind limbs have been reduced to

Opposite top: Hippos spend most of their day in the water or mud to keep cool. They emerge at dusk to graze on grass. While hippopotamuses rest near each other in the water, grazing is a solitary activity and hippos are not territorial on land.

Opposite bottom: Reproduction and childbirth both occur in water, but the mother helps the newborn to the surface, later teaching it to swim. Young hippos can only stay underwater for about half a minute, unlike adults, who can stay submerged for up to six minutes.

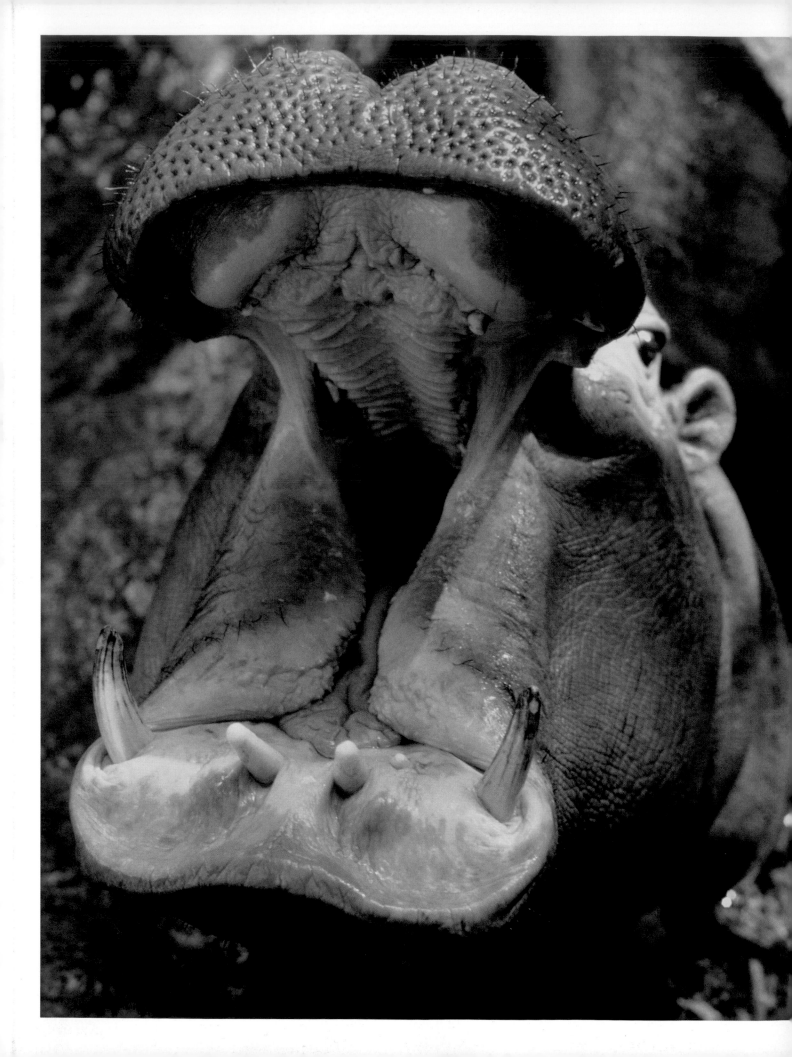

The In-Betweener

The hippopotamus, with its massive head, rotund body and stumpy legs, is one of the most awkward-looking animals I have ever seen, having neither the grace of a swimming whale nor the agility of a jumping gazelle. Nevertheless, hippos are the closest living relative between modern day whales and their gazelle-like artiodactyl ancestors. Evidence supporting this intermediate evolutionary position can be seen in their laryngeal anatomy.

The hippo's larynx is large, but looks very much like any artiodactyl's larynx from the outside, having the same arrangement of cartilages and muscles. Hippopotamus ancestors likely had the same anatomy, including valve-like vocal 'cords' (properly called vocal 'folds') that can close across the airway. Vocal folds oriented perpendicular to airflow can interrupt or bottleneck airflow, causing vibrations that generate sounds.

Perpendicular vocal folds are important for regulating intra-thoracic and intra-abdominal pressures. When a mammal tries to exhale against closed vocal folds, the air stays trapped in the lungs. This fixed lung volume immobilizes the diaphragm, which in turn stabilizes the ribs. Chest, shoulder, neck and back muscles pull more efficiently against this rigid thoracic frame, allowing running and climbing. A rigid diaphragm also assists contracting body wall muscles in elevating abdominal pressure. This 'bearing-down' (Valsalva manoeuvre) forces contents out through the only flexible boundary: the pelvic floor. Saying 'Push!' during childbirth encourages pregnant woman to stop screaming, and instead use shut vocal folds and body-wall contractions to increase abdominal pressure.

Whale vocal folds, however, are positioned parallel to airflow. Although they cannot control intra-abdominal pressure (one reason why whale faeces are liquid), their vibrations generate low-frequency sounds. Amazingly, we found that the hippo vocal folds are also aligned parallel to airflow! It is likely that they cannot use them to seal off the airway – perhaps explaining why they need to discharge dung while it is still soft. The vocal folds are also long, indicating hippos can make low-frequency vocalizations that propagate underwater, just like whales. These laryngeal features support the hippo as an evolutionary 'in-betweener'.

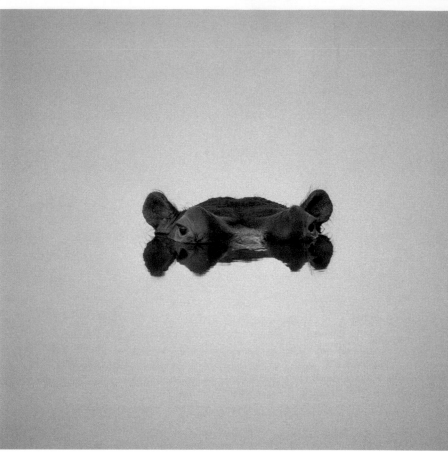

vestigial stumps buried inside their bodies. Living underwater also led to other developments, such as echolocation. We know dolphins and some whales use high-frequency clicks to hunt, navigate and communicate underwater. However, some researchers believe that hippos make similar sounds to talk to each other.

Joy teams up with Derek Solomon, a wildlife expert, who has been recording the underwater sounds of hippos in South Luangwa for several years. In the early evening, we creep gingerly down a steep riverbank to where a large pod of hippos congregates. Derek hangs a waterproofed microphone off the end of a long pole and lowers it into the water. Then, we wait until the hippos break silence.

This is the time of day when hippos prepare to leave the water to graze. They are usually quite boisterous, emitting a chorus of honks and snorts. Once they become accustomed to our presence, it doesn't take long for them to start, and our underwater microphone picks up the commotion. Although we don't detect any high-pitched dolphin-like clicks, we do pick up some low-frequency sounds. Derek is convinced that hippos are using these sounds to communicate underwater. It would make sense if they were. Sound travels about five times faster in water than it does in air, so that helps spread their messages far and wide. Joy is not totally convinced. The evidence she seeks lies inside the hippo's throat.

Watching the hippos floating beneath the surface with only their eyes, ears and nostrils visible, it's not hard to imagine the ancestor of this aquatic giant making the transition to a whale. Yet this animal is beautifully adapted to life on the Luangwa River. Its tough skin protects it from rivals and the sun; its multichambered stomach enables it to be a nocturnal herbivore; its heavy legs act as ballast; and its unusual larynx helps it communicate underwater. Each remarkable feature is a piece in the puzzle of the hippo's evolutionary link to the whale.

Above: A submerged hippopotamus, its eyes and ears just above the water, in Kruger National Park, South Africa.

Above left: Joy and Francois the camera man see a hippo just by the boat.

Opposite: A hippo in Luangwa river at sunrise, South Luangwa National Park, Zambia.

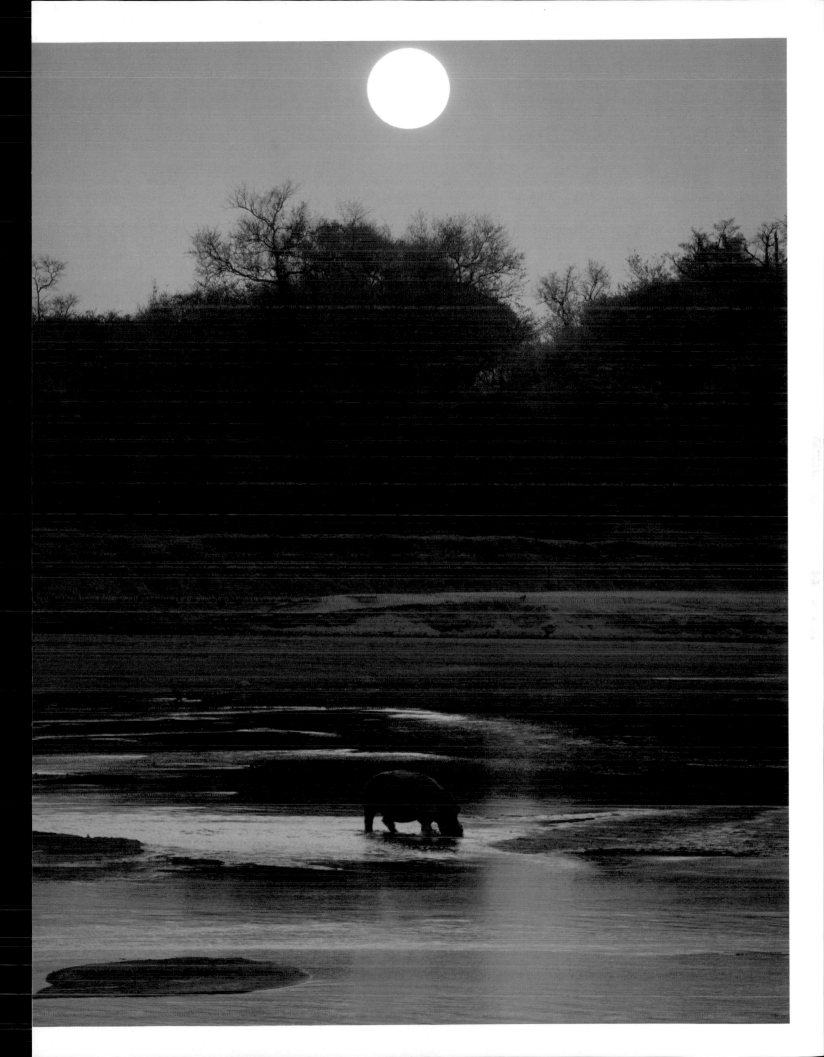

A new Superorder

The DNA evidence that reveals whales and dolphins are the closest living cousins of hippos has forced scientists to redraw the tree of life for these animals. Hippos belong in a group called the artiodactyla, the even-toed ungulates, which includes giraffes, sheep, goats and cattle. What these animals have in common is that they bear their weight equally on their third and fourth toes. Whales and dolphins are grouped in the order cetacea, and were not originally linked to the artiodactyls. But now that scientists think that the cetacea evolved from within the artiodactyla, they have combined the groups into one new superorder; the cetartiodactyla.

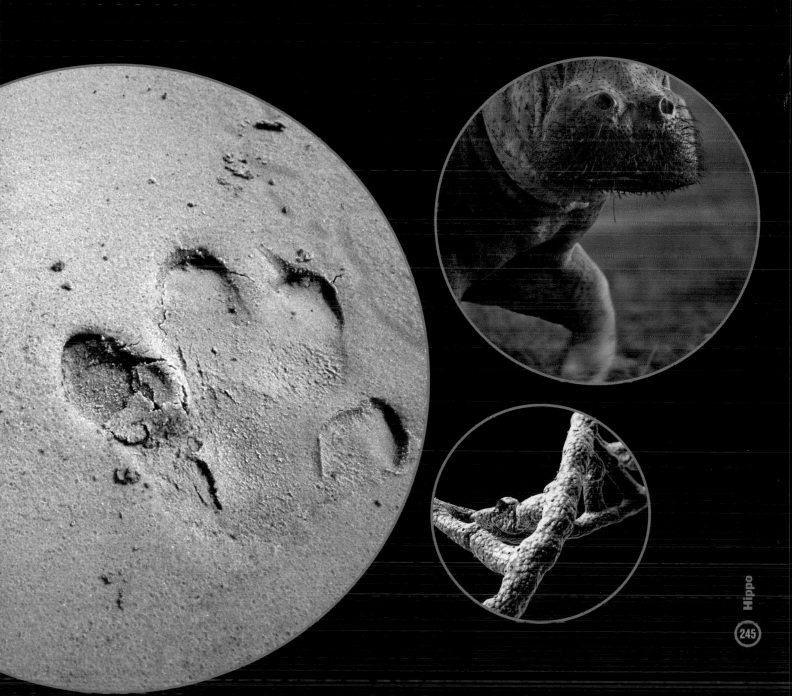

Big Cats

Panthera leo & Panthera tigris

Mark Evans

Alex, our producer, can hardly breathe. He's in charge of a lighting rig hooked up to our truck battery. His sole task is to ensure that four aircraft landing lights illuminate the carcass of a dead wildebeest lying beneath a tree, 50m away. It's pitch black. He grits his teeth to keep a cloud of insects out of his mouth. In the back of the truck, Joy and I sit motionless alongside Dr Paul Funston, a bush-hardened zoologist. We're conducting an experiment to see how lions react to a recording of an intruder's roar. We wait patiently, listening for an iconic sound of Africa we've travelled more than 8,000km to hear. Suddenly, after two hours, the silence is broken. We can't believe it. It's not a lion – it's Radio Botswana.

Welgevonden Game Reserve lies in South Africa's Waterberg Plateau, north of Johannesburg and south of the border with Botswana. It's a stunning wilderness of rocky hills and grassy plains that's home to more than 50 kinds of mammal, including rhinoceros, elephant and giraffe. We're here to learn about its lions.

Paul Funston is an expert in lion communication. He's recorded the varied vocalizations of lions and the animals they like to lunch on. We want to see how the Reserve's resident male lions respond to some of the sounds on Paul's unusual playlist. Just before dusk, we hook up Paul's iPod to an amplifier and a pair of speaker-horns mounted on a makeshift tripod. Necessarily lion-proof, it's a simple set-up that's worked many times for Paul on field studies. Only, tonight, for its TV debut, Paul's transmitter has become a receiver. For a few seconds, what sounds like the news is broadcast far and wide. There are two lions nearby and our aim was to bring them closer, not to inform them of world events.

It's a priceless memory, but nothing compared to what happens next. Paul grabs the radio and instructs the iPod controller in the other truck to do three things: scroll down to the bottom of the list, turn up the volume and press 'play'. There's a deafening high-pitched beep and then nothing. Within a heartbeat, the speakers burst with life, or rather death. They bellow out the haunting, gut-wrenching call of a buffalo calf in distress. It's so loud it sounds as if the poor

Opposite: The team fly out to South Africa to investigate lion behaviour and communication in one of the country's many game reserves, north of Johannesburg.

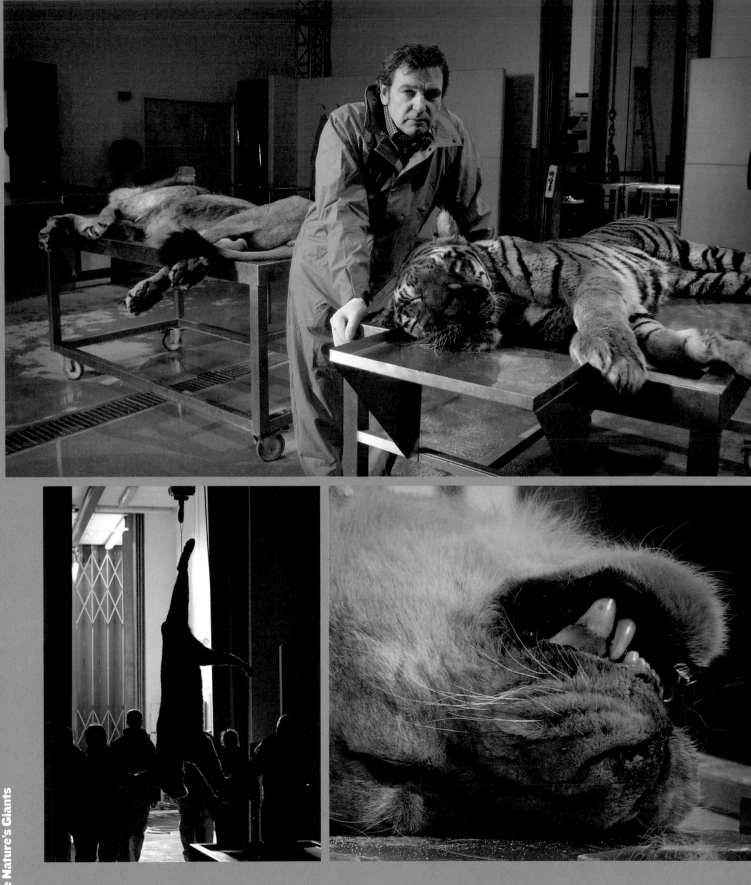

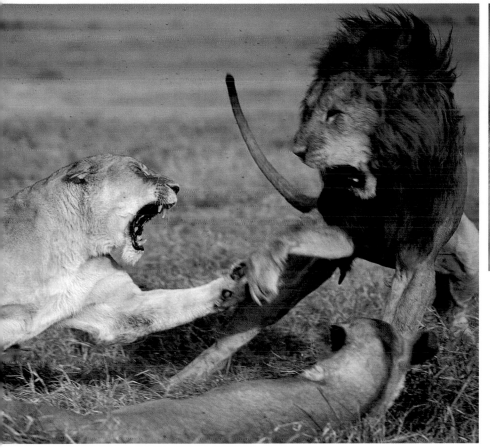

animal is right behind me. The playback continues for about 30 seconds, and then silence. Paul puts his finger to his mouth, his instruction is clear. We wait again in silence. Still nothing. As I begin to doubt the sanity of this experiment, I'm brought up sharp by a deafening roar so loud and so deep that I can feel my chest vibrate. I turn towards Paul's speakers, but this is no recording. Standing just 5m (16ft) away, and staring right back at me is a massive male lion. In the darkness I can make out a magnificent mane and a head jewelled with the reflections from the back of his eyes. Without us noticing, this 200kg (441lb) big cat has crept quietly through the undergrowth. He could kill any one of us in an instant. But he turns and slowly walks away with a lazy arrogance. He leaves us all shaken. I've never been so scared in my life.

Animals make noise to communicate information. The shaking of a rattle snake's tail, a cricket rasping its wings, us clicking our fingers and rabbits drumming their big back feet on the ground are familiar examples. But mammals have also evolved a specific organ that's able to generate complex vocal sounds.

The larynx is a stunning piece of anatomy. A key part of the mammalian respiratory system, you can feel yours as a hard lump at the front of your neck, especially when it moves as you swallow. It's usually referred to as our voice box. In our ancient ancestors, it most likely developed as a way to prevent the collapse of the entrance to a primitive air breathing system. But it has evolved to do much more. Today, in us, it may be involved in as many as 50 functions.

At the Royal Veterinary College in London, the body of a male lion that died in a UK zoo awaits post mortem. In preparation for dissection we gather together a few essential tools. As well as the usual scalpels, forceps, scissors and bone

Above left: An African lion mating pair quarreling in Serengeti National Park, Tanzania.

Opposite: A unique opportunity has arisen, enabling the team to compare the anatomy of two of the most iconic big cats on Earth.

cutters, we need a short length of corrugated plastic tubing, a selection of metal hose clamps and a portable air compressor. Unusual items, but specially requested by Tecumseh Fitch, a biology professor from the University of Vienna who joins the team. Tecumseh is fascinated by how lions roar. He's keen for us to help him run an experiment that he's never tried before. With the lion on its back, an incision is made from its chin to its chest. We need to be careful as the organ that makes the roar is close to the surface.

The larynx is attached to the end of the trachea, or windpipe. Anatomically and functionally it's a complex structure, but, in essence, it's simply a cartilage and muscle tube with a valve inside and a lid at one end. The lid is the epiglottis, a leaf-shaped piece of cartilage that shuts off the entrance to the larynx during swallowing to prevent food and drink going down the wrong way. The valve within is formed from two soft tissue membranes that can be pulled together or apart to change the size of the aperture between them through which air flows in and out of the lungs. They are the vocal folds, sometimes referred to as vocal cords. You can visualize them as a pair of small, thin lips inside the larynx that lie at right angles to the real ones on the front of the face. They're held apart to allow breathing and can be pulled wide open when the animal needs to shift a lot of air during hard exercise. They close tightly when swallowing and are held together more loosely when the animal vocalizes. In this position and under the right amount of tension the vocal folds vibrate and generate sound.

Rather than open up the larynx to take a look inside, Tecumseh wants to keep it intact. For now, his focus is further down the lion's neck. Cutting the ligament between two of its C-shaped cartilages, he severs the trachea. Steps two and three

Above: The lion's larynx is an amazing piece of anatomy. It has adapted to allow the animal to roar. Anatomically and functionally it is a complex structure, but essentially, it's simply a cartilage and muscle tube with a valve and lid at one end.

Above left: A lion's roar is hugely impressive. The vocal folds, or cords, located inside the larynx, vibrate and emit sound. Unsurprisingly, the frequency depends on a number of factors, including their size and structure.

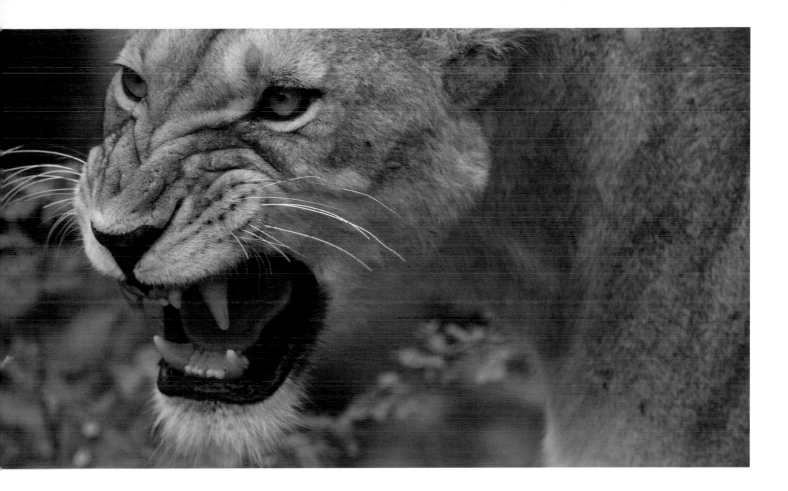

of this extraordinary experiment requires basic plumbing skills. Tecumseh feeds the corrugated plastic tube a few centimetres into the cut end of the windpipe, towards the head, and then seals the two together using one of the metal hose clamps. It's important the joint is airtight. We'll soon find out if it is. Tecumseh reckons there's only a 5 per cent chance this test will work, but he keeps smiling.

The noisy compressor is banished outside, where it pumps and packs air into its steel cylinder. Tecumseh holds the pistol-grip pressure release valve in his left hand. Very gently, he squeezes the trigger to test his connections. A blast of compressed air rushes into the windpipe and towards the lion's head. The soft tissues in its throat billow and then collapse. Tecumseh grins, now more confident of success. Over 150 students and scientists have assembled to witness this dissection. All eyes are on Tecumseh. It'll be a neat trick if he can pull it off.

As in Africa, I find myself doubting the sanity of those much more learned than me – the lion is lifeless, so how can it possibly work? Tecumseh squeezes the trigger again, this time all the way. I choke on my thoughts. Incredible as it sounds, and it does sound incredible, the dead lion roars.

As the compressed air flows through the larynx, it speeds up passing through the narrow gap formed by the lion's vocal folds, reducing the pressure between them. It's a predictable scientific effect named after an Italian physicist, Giovanni Battista Venturi. He died almost 200 years ago, but the 'Venturi Effect' lives on in all of us and it would seem, this dead lion. The drop in pressure causes the vocal folds to be sucked together momentarily before being forced apart again by the air pressure building up behind. A repeating cycle is set up and the vocal folds vibrate. The lion roars. It's not the full, rich, thunderous sound that scared me

The ancestry of today's cats, including lions and tigers, is complex and controversial. Experts believe it can be traced back around 60 million years when a new group of mammals emerged – the Carnivora, animals with specialised, meat-shearing molar teeth, called carnassials. This branch split into dog-like and cat-like animals. Today, from Siberia to the African savannah, the cat body plan is almost the same. It's a source of endless fascination for evolutionary biologists, including Richard Dawkins. He loves the fact that, amongst modern felines, there are small ones like domestic cats, medium-sized ones like lynx, and large ones like lions. All sizes but one basic shape. We set out to explore the anatomy of a feline, meat-eating machine.

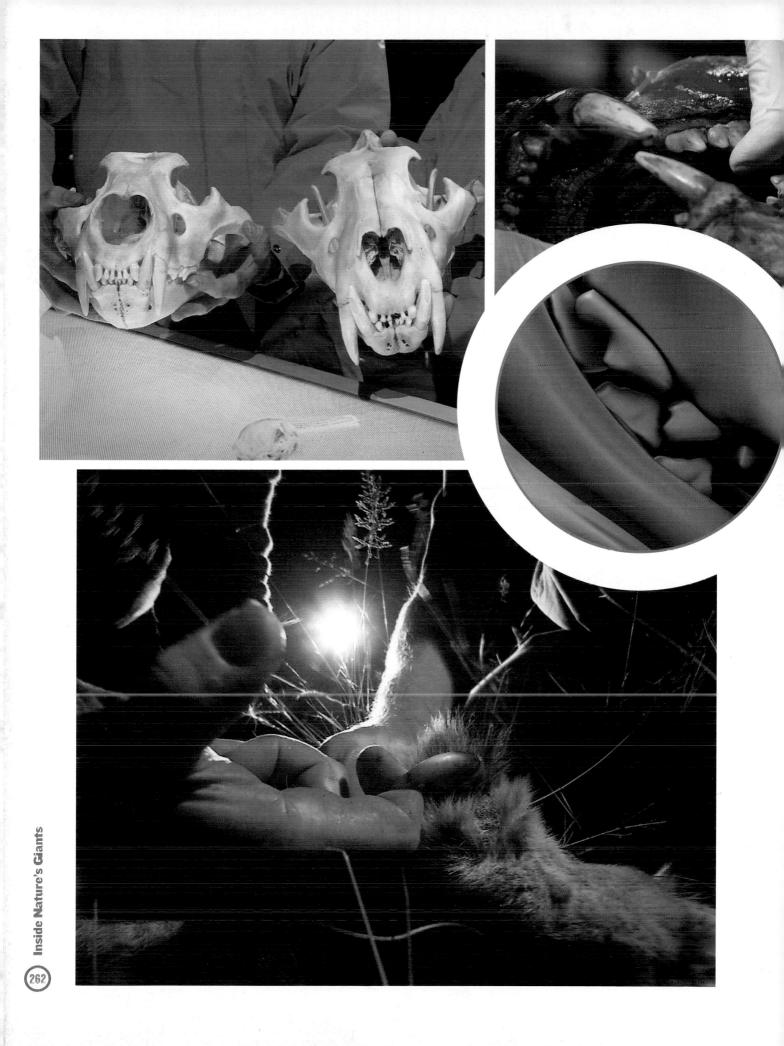

Feline Canines

For any cat, the final act when despatching its dinner is the killing bite delivered by its long canine teeth. Cats usually kill by a bite to the nape of the neck that severs the victim's spinal cord or they grab it by the throat, clamping down hard until the animal suffocates. Its canines are incredibly strong and have long curving roots that anchor them deep into the skull. A relatively short jaw maximises the power of the bite – it's all about levers.

The Larynx

A lion's roar can be heard for miles. It's used to broadcast ownership of territory, to retain contact with a group and to attract a mate. A deep roar is critical to an individual male's survival and reproductive success. The voice box or larynx is a cartilage and muscle tube with a valve inside and a lid on one end. The lid is the epiglottis, cartilage that seals the entrance to the mouth during eating and drinking. The valve within is formed from two soft tissue membranes (vocal folds) that pull together or separate to change the size of the opening. They close tightly when swallowing, and loosen when the animal roars, vibrating to generate sound. Muscles control their tension and position. Lions, tigers, jaguars and leopards all have large vocal folds and are the only cats to roar.

Big Cats (Lion):

Weight: ..
250kg (550lb)
Height: ...
123cm (4ft) (m)
Length male / female:
250cm (8ft 2in) / 175cm (5ft 9in)
Life Span: ...
16yrs
Top Speed: ..
58km/h (36mph)
Bite strength pound force:
1,400 lbf

Night Vision

Good night vision is an essential adaptation for successful nocturnal lions. The reason cats' eyes are so easy to identify in the dark is thanks to built-in, biological, eyeball mirrors. Behind each retina is a thin layer of tissue called the tepetum lucidum, which reflects light back on to the photoreceptors that line the retina, enabling cats to see in the dark. The visible effect of the tepetum lucidum inspired an invention that is familiar to drivers. 'Catseyes' reflect back car headlight beams to enable people driving at night to see every bend in the road.

View to a Kill

Night vision is not their only optical advantage. The way the sensitive light cells are laid out in the feline retina makes cats super-sensitive to the movement of prey in a horizontal plane - very handy for scanning the horizon for prey. The position of their eyes on their heads gives all cats great binocular vision, crucial for judging distance accurately when they're closer to the kill.

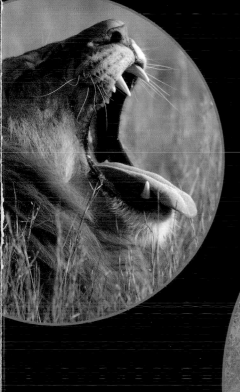

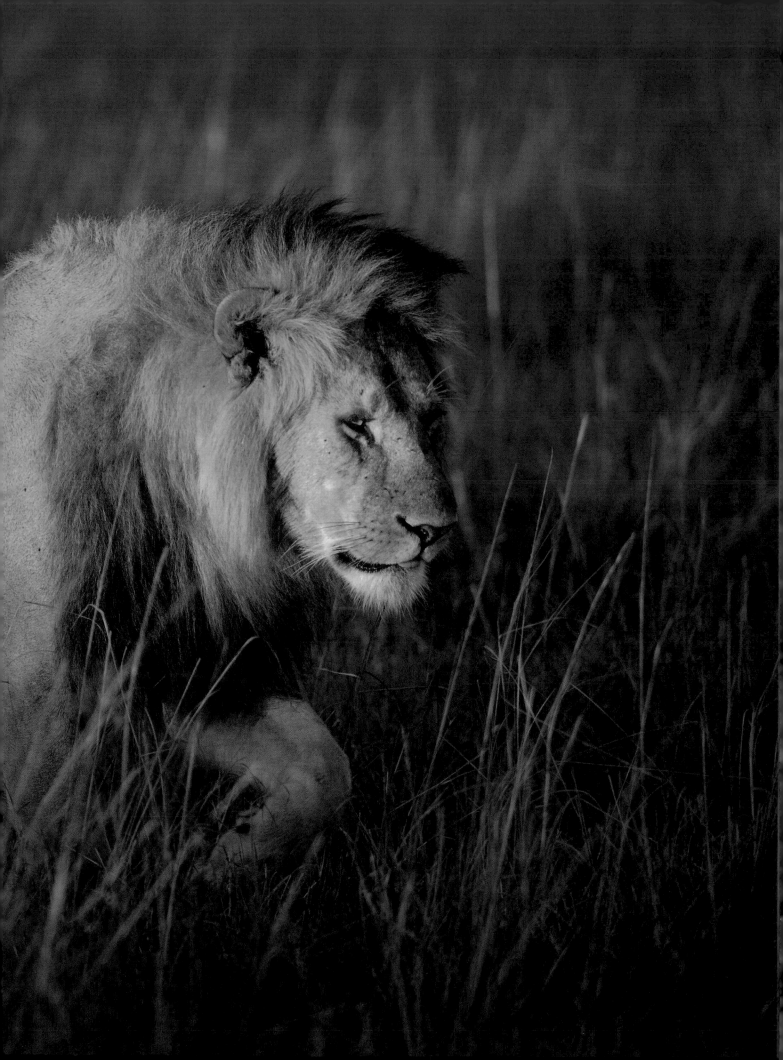

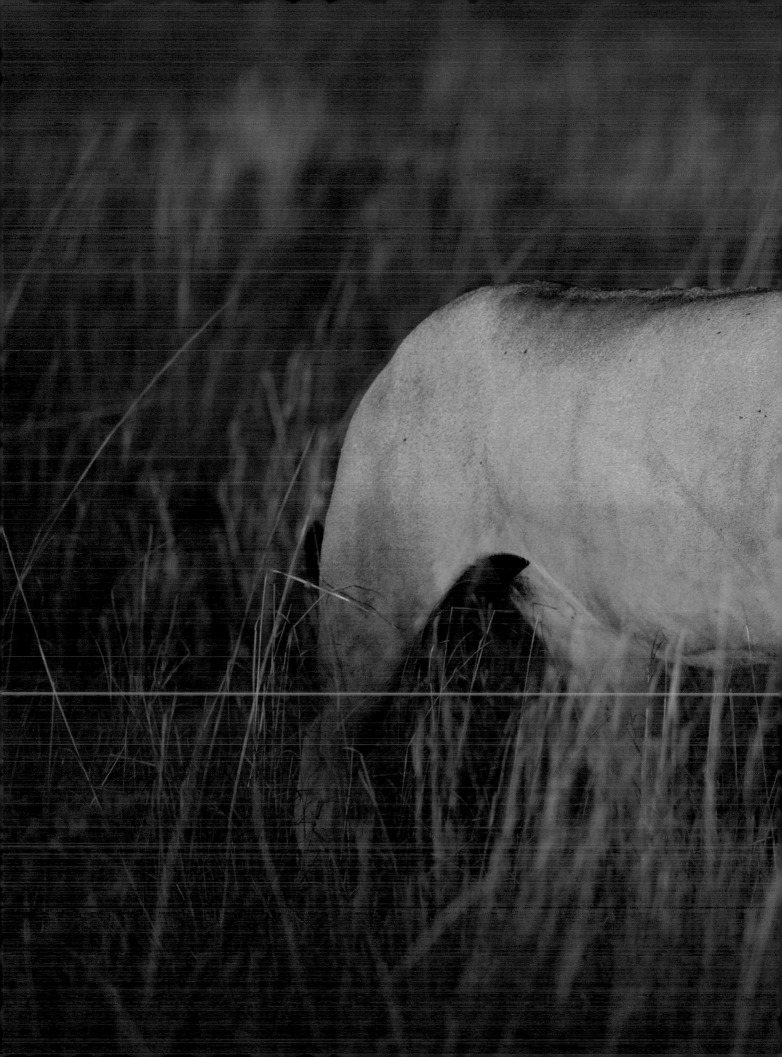

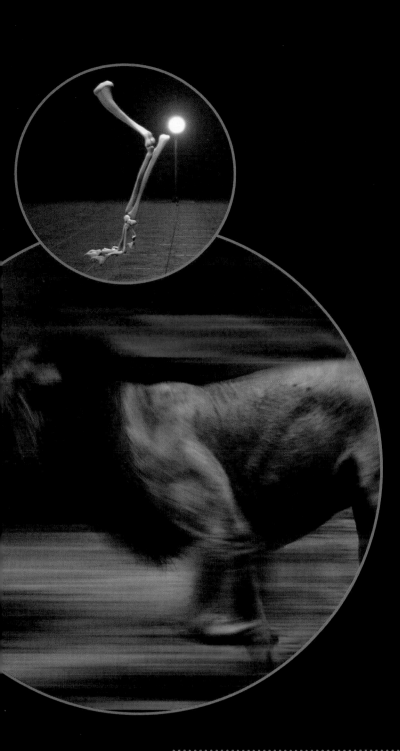

Camouflage

Effective camouflage is absolutely essential for a lion on the prowl, day or night. A lion's fawn-coloured coat easily disappears in the long dry grass making them tricky animals to spot. Perfect for creeping up on prey.

Legs

Cats are awesome athletes. But there's a downside to having such fearsome front limbs. To make the most of the muscle power, their lower leg levers – their bones – need to be relatively short. Cats have evolved a clever compromise to achieve the best of both worlds – powerful enough front legs to bring down prey – but a body that can catch up with it in the first place. They noticeably flex and extend their spines when running to increase their stride length.

Claws

A swipe from a big cat's paw would send you flying, but, it's the cat's claw that really damages. All cats (except cheetahs) keep their curved claws fully retracted, off the ground, and out of harm's way when unused. Cheetahs' claws are always on show and they're thought to use them like running spikes. When a lion goes in for the kill, the leg muscles that flex and extend the toes pull against each other to flick out its switchblades from inside their protective skin sheaths. It slams the sharply pointed, curved claws into its terrified quarry to anchor itself on board allowing its bodyweight and momentum to bring the prey down.

Shoulders

Cats have incredibly mobile shoulder blades that can move backwards and forwards over the ribcage because they are only attached by muscles. In cats there are no bony connections between the front legs and the rest of the body. That's why a cat's shoulder blades protrude so visibly when they're stalking prey. This both extends their reach and gives them energy-absorbing dampers that help reduce the shock to their bones when they put the brakes on or land after jumping.

half to death in Africa, but this lion is dead. That one definitely wasn't.

In life, the vocal folds are dynamic. Muscles control their tension and position. The frequency of the sound they produce when they vibrate depends on a number of factors including, not surprisingly, their size and structure. Men have longer, thicker vocal folds than women and that's one of the reasons why men normally have deeper voices. Amongst cats, lions, tigers, jaguars and leopards have, relatively, very large vocal folds and they are the only felines that roar. Interestingly, they don't purr. Even if they wanted to, it seems likely that the anatomy of their vocal folds would make it incredibly difficult, if not impossible, for them to do so. In those smaller cats that can, the purring sound is generated through super-fast twitching of a muscle within each of their finer vocal folds, co-ordinated by a special control centre in the brain. Why big cats roar but don't purr is a conundrum that has puzzled zoologists for at least 200 years. Some scientists reckon that the chunky vocal fold anatomy thought to give the four big cats the ability to roar would tend to damp down the twitching necessary to purr.

Long, heavy vocal folds are only part of the roaring story. What we actually hear when any animal with a larynx vocalizes is the noise of the vibrating vocal folds amplified and altered by the acoustic properties of the rest of its vocal tract – essentially the air-filled spaces between its larynx and lips. In essence, the longer the vocal tract, the deeper the delivery. The lion's larynx is lower down the neck than it is in smaller cats that don't roar. But, it's not fixed and can be pulled even further down the neck to extend the vocal tract and lower the tone. But how far can it go? Tecumseh is desperate to find out.

He dissects out the flat, strap-like muscles in the lion's neck responsible for pulling its larynx towards its chest. In theory, they should attach to the end of the sternum but they don't. He delves deeper, cracks open the ribcage and discovers that the muscles go further down than he's ever seen in any other animal. Further down than he had thought possible. 'I can't believe this. We're making a scientific discovery on TV,' he says. He's very excited and it's infectious.

Both male and female lions roar in order to broadcast ownership of a territory, to stay in contact with other members of their social group and, under some circumstances, to attract mates. They can be heard for miles. A really effective, deep roar is critical to an individual male lion's survival and reproductive success. Could this muscle adaptation be evidence of evolution at work? Tecumseh is wary about drawing too many conclusions from this one dissection, but he reckons that, in theory, it's possible. It's certainly worth a test. He quickly fires up the compressor once more. On the other side of the glass, 300 ears prick up. The lion roars again. Mid-roar, Tecumseh moves the larynx towards the lion's broken ribcage to mimic the pull of the strap muscles he's just dissected. The further it is from the lion's mouth, the lower the pitch. Tecumseh plays the lion's windpipe like a trombone. I shut my eyes, think about that roaring lion in Africa and wonder what position its larynx must have been to shake my bones. Far too close to me, that's for sure.

I've not been lucky enough to see a tiger in the wild. It's on my list of things to do before I die . . . or they do. I find it ironic that a coat that has evolved to help keep them concealed is one of the reasons why so many of them have been killed.

The tragic death of a young zoo tiger offers a unique opportunity for us to compare the anatomy of two of the most iconic big cats on Earth. Dr Andrew

Kitchener supervises the removal of their skins. Andrew is a world authority on the natural history of wild felines. I ask him about the evolution of the tiger's stripy coat. He thinks it probably developed from a spotted pattern but no one really knows because we don't have skins from hundreds of thousands of years ago. That's why he and his colleagues are so keen to keep the skins from these animals. Their coats make the lion and tiger look very different, and for good reason. An orange, black and white tiger roaming the sun-baked African plains would stick out like a clown on a cricket pitch. But, with their coats removed, it's hard to tell these cats apart.

All cats, big and small, are built to kill. They all share a similar strategy – stalk and surprise – and their bodies are beautifully adapted to help them despatch and devour their prey. When they're not hunting, they chill out to save precious energy. Few animals sleep as much, as any pet cat owner will testify. The ancestry of today's cats, including lions and tigers, is complex and controversial. Experts believe it can be traced back around 60 million years when a new group of mammals emerged on the tree of life – the Carnivora, animals with specialized, meat-shearing molar teeth, called carnassials. This branch split again into dog-like animals (including bears, seals and true dogs), and cat-like animals (including meerkats, hyenas and true cats). The tiger parted company from the ancestral big cats around four million years ago. Today, from Siberia to the African savannah the cat body plan is almost the same. It's a source of endless fascination for evolutionary biologists like Professor Richard Dawkins. He loves the fact that, among modern felines, there are small ones like domestic cats that hunt mice and birds; medium-sized ones, like lynx, that hunt hares; and large ones like lions that hunt antelopes and wildebeest. All sizes: but one basic shape.

Back in Welgevonden, conservation manager David Powrie issues clear instructions. He wants us to stay absolutely still and silent to give his vet a fighting chance of hitting the target – a lioness with a well-known attitude problem. It's getting dark. David scans the bush with the beam of his torch and it's soon clear that we're being watched. We see the reflections from the back of lots of eyes. It seems the whole pride is here.

With the drug-laden dart embedded in her back leg, it only takes a few minutes for the anaesthetic to take effect. We move closer. The other lions in her pride are tempted away by a free meal offered by the rangers. We remain vigilant, all our senses on full alert. They could return at any time. The lioness will be out for the count for about an hour, more than enough time for David to change her radio collar and for me to get my hands on a live, wild, big cat for the first time. Instinctively, I stroke her. There's no spare fat on this cat – she is solid muscle.

The lioness gives me a fright when I open her mouth to take a look at her teeth. She growls in her sleep. For any cat, the final act when despatching its dinner is the killing bite. Cats usually kill by either a well-directed bite to the nape of the neck that severs the victim's spinal cord or they grab it by the throat, clamping down hard until the animal suffocates. Either way, the long canine teeth are critical. They are incredibly strong and have long curving roots that anchor them deep into the skull. A relatively short jaw maximizes the power of the bite – it's all about levers again. This lioness has great teeth, but I could tell this just by looking at her body condition. She's eating well. We inject her with an antidote to the anaesthetic to bring her round and

Cryptic Claws
Joy Reidenberg

All cat claws are like sheathed swords that are only unsheathed when used as weapons. The anatomical story behind this amazing property begins with an understanding of the skeleton. A cat's toe contains three bones. Compared to a human toe, the joint between the two closest to the body is bent down, and the joint between the two furthest from the body is hyper-extended. Imagine taking the tip of your finger and pulling it up backwards at the last joint! Humans can't do it. Cats, however, are 'double-jointed'. Their last toe bone is kept pointed in this hyper-extended position by tight elastic ligaments acting like rubber bands. This keeps the claw, which is attached to that last bone, retracted. Exposing the claws for an attack, however, requires active muscular contraction. The anatomy behind claw protrusion is paradoxical, involving contractions of opposing muscle groups. Muscles running to the top of the toes (extensors) insert on the middle toe bones and lift them up. The muscles running under the paw (flexors) attach to the middle and tip of the most distant toe bones and curl them down. In order to protrude the claw, the most distant toe bone must be pulled down (flexion). However, this does not protrude the claw far enough from within the paw's skin sheath and fur. The entire toe must be straightened for the claw to fully protrude. This involves pulling up (extending) the joint between the two toe bones closest to the body while simultaneously pulling down (flexing) the joint between the two bones furthest from the body. Therefore, both extensor and flexor muscle groups need to contract at once to allow the toe to straighten. The ability to unsheath claws only when they are needed keeps them from wearing down when cats walk and run. Front claws are strongly curved making them useful for grasping and climbing, while hind claws are straighter and useful for raking and pushing off during leaping. Interestingly, cheetah paws are more dog-like, having lost the sheath of skin and fur. Their semi-retractable claws are always visible. This means cheetahs cannot climb trees, but they have extra grip while running on hard ground (similar to wearing football cleats).

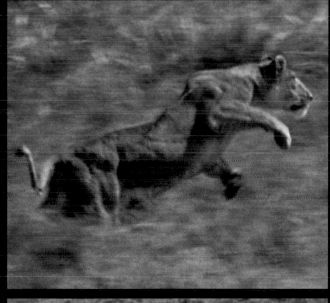

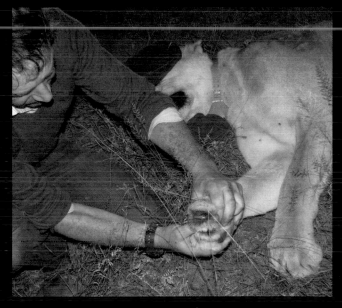

Curved Claws

One swipe from a big cat's mighty paw would send you or I flying. But it's the hidden armoury at the end of each digit that really does the damage.

retreat to a safe distance until she wakes up. Anaesthetized or even groggy, she could fall victim to a cocky hyena that's prepared to chance its luck.

As we wait in the darkness, I think about the hundreds of pet cats I've known as friends and patients. Domestic cats may be small, but their bodies are no less impressive than those of lions and tigers. Because they're so familiar, it's easy to take them for granted. Biologically and biomechanically they are brilliant. Underneath their skins they share the same basic body plan as lions and tigers.

Within a few minutes the lioness is back on her feet and she heads off to rejoin her family. We wait for the pride to move away so that we can collect a hidden camera. Before dark, we had set it on a rock in the hope of getting some close-up shots of the younger lions feeding and at play. One of the cubs became curious, picked up the camera in her mouth and carried it off. After a fruitless search in the long grass at night, we return the following day to continue looking. En route we pass the pride resting on a rocky outcrop in the shade of a tree. Sporting her swanky new radio collar, the lioness looks like she's nursing a hangover but David says she always looks like that! We tune in the receiver and it picks up a strong, steady beep. It should keep working for another 18 months or so. We continue to where we'd been the night before and comb the area on our hands and knees. Eventually, we find the camcorder about 100m (over 300ft) from where we'd left it. It's been chewed, but not fatally. Everyone gathers round to see what, if anything, it recorded. The screen's a bit damaged but the pictures are awesome. It's clear the kids had quite a party while mum was out of the way.

Above: Radio tracking collars provide rangers and scientists with invaluable information about the movements and whereabouts of lions. They keep working for around 18 months.

Opposite: The adult male lion's mane is unique amongst cats and is one of the most distinctive characteristics of the species. It makes the lion appear larger and is useful for intimidating competitors and impressing mating partners.

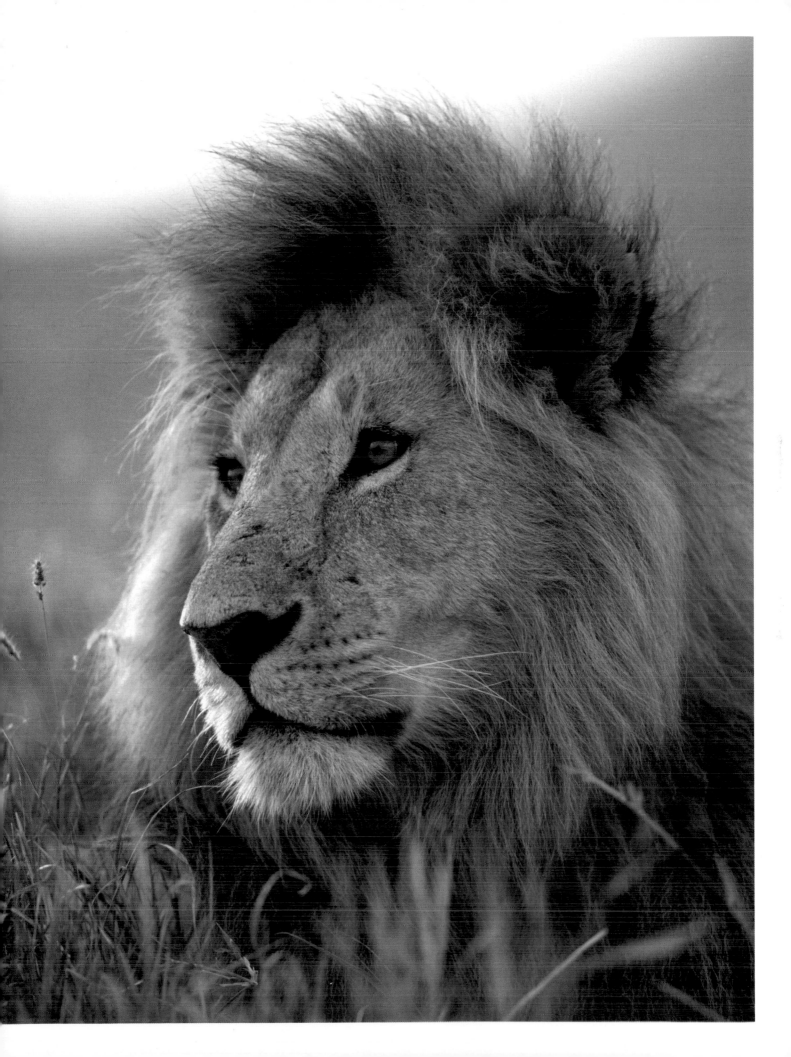

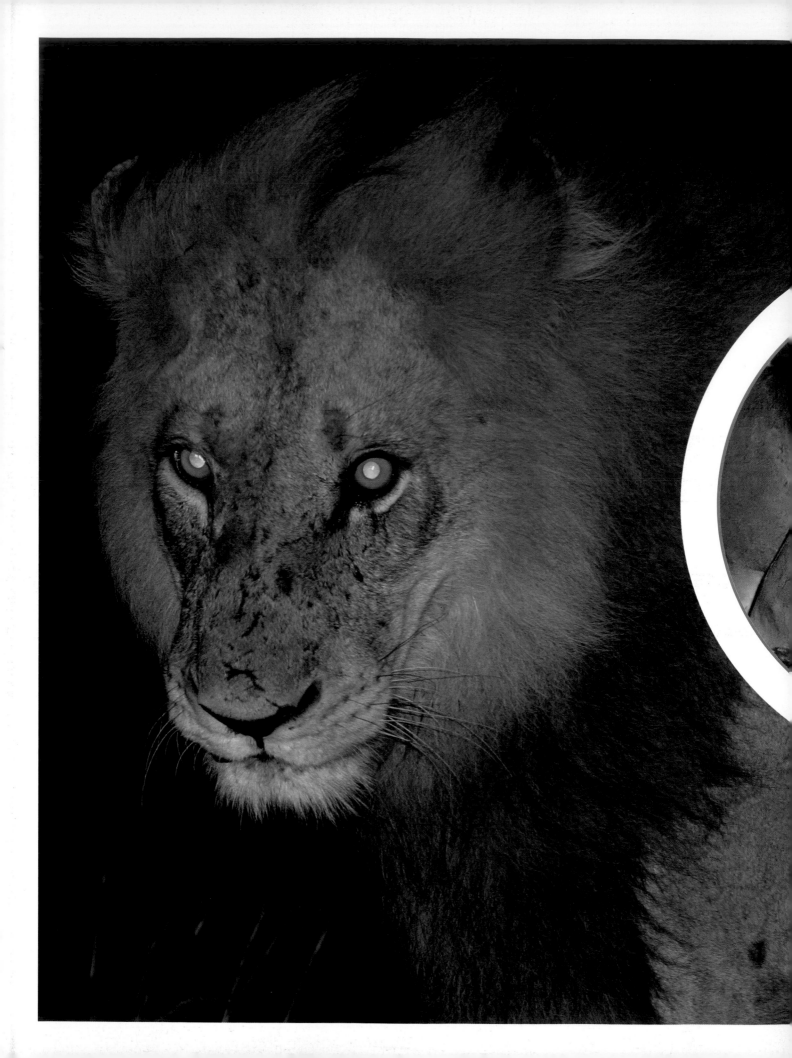

How Cats See in the Dark

The reason their eyes, and those of other cats, are so easy to identify in the dark is thanks to built-in, biological, eyeball mirrors. Behind each retina is a thin layer of tissue called the tepetum lucidum, which reflects light back on to the photoreceptors that line the retina, enabling cats to see when we're groping about in the dark. Good night vision is an essential adaptation for successful nocturnal killers. But that's not their only optical advantage. The way the sensitive light cells are laid out in the feline retina makes cats super-sensitive to the movement of prey in a horizontal plane – very handy for scanning the horizon for prey. It's an adaptation that's especially well developed in cheetahs. The position of their eyes on their heads gives all cats great binocular vision, crucial for judging distance accurately when they're closer to the kill.

The principle of eyeshine in cats – the visible effect of the tepetum lucidum – inspired an invention that is familiar to drivers. 'Cat-seyes' reflect back car headlight beams to enable people driving at night to see every bend in the road.

Left: Good night vision is an essential adaptation for lions; it allows them to be successful nocturnal killers. Females do most of the hunting, and they often work in teams to stalk and ambush prey.

Below: The team sedate a female lion to be able to give her a new radio collar in order to track and investigate her behaviour.

Snake

Python molurus bivittatus

Simon Watt

'The worst that can happen is that you'll bleed a lot.' This was not what I had hoped to hear. Tom Crutchfield was poised above the black cooler, ready to remove the lid. In my mind I repeated his advice: do **NOT** hesitate. Tom snapped off the lid and in one motion I thrust my hand into the box, seizing the snake behind the head. Its jaws flashed as it hissed at me, displaying three rows of fangs. Hoisting itself up, it threw coils around my arm. Within seconds my hand grew plum-coloured, its grip tightened, and I begged Tom and his assistant for help. Together they wrestled the iron-like body off me and a tingling announced the return of blood to my arm. I had just had my first encounter with a Burmese python.

The Burmese python is the largest of the Indian pythons and one of the biggest snakes in the world. In its native South East Asia habitat it's considered threatened; but its popularity as a pet has allowed it to spread across the planet. This is what led our team to the US.

In Florida, the Burmese python is a dangerous pest that spells disaster for local wildlife. No one knows for certain how the snake managed to stake such a strong foothold in the Everglades. It is thought that many may have escaped from reptile houses and exotic pet shops when Hurricane Andrew flattened much of Florida in 1992. However, it's more likely that they are the descendants of pet snakes released into the wild when they grew too big for their owners. Whatever the case, they are here to stay; the subtropical climate is perfect for them. Their population is exploding and they are posing a serious threat to the native wildlife of the Everglades. Over its lifetime a python consumes hundreds of prey animals.

The Floridian authorities have had to resort to drastic measures and in 2010 declared open season on these giant pythons, training locals to catch and kill any seen. This cull gave our team a unique opportunity to join forces with scientists desperately trying to work out the impact this incredible predator was having on the fragile local ecosystem. Together we could peer inside the snakes themselves and learn about the anatomy that has facilitated its invasion and allowed the

Opposite top: Burmese pythons are dark-coloured snakes with many brown blotches bordered in black down the back.

Opposite bottom: The team travelled to the Florida Everglades, where the introduced Burmese python is posing a serious threat to the native wildlife.

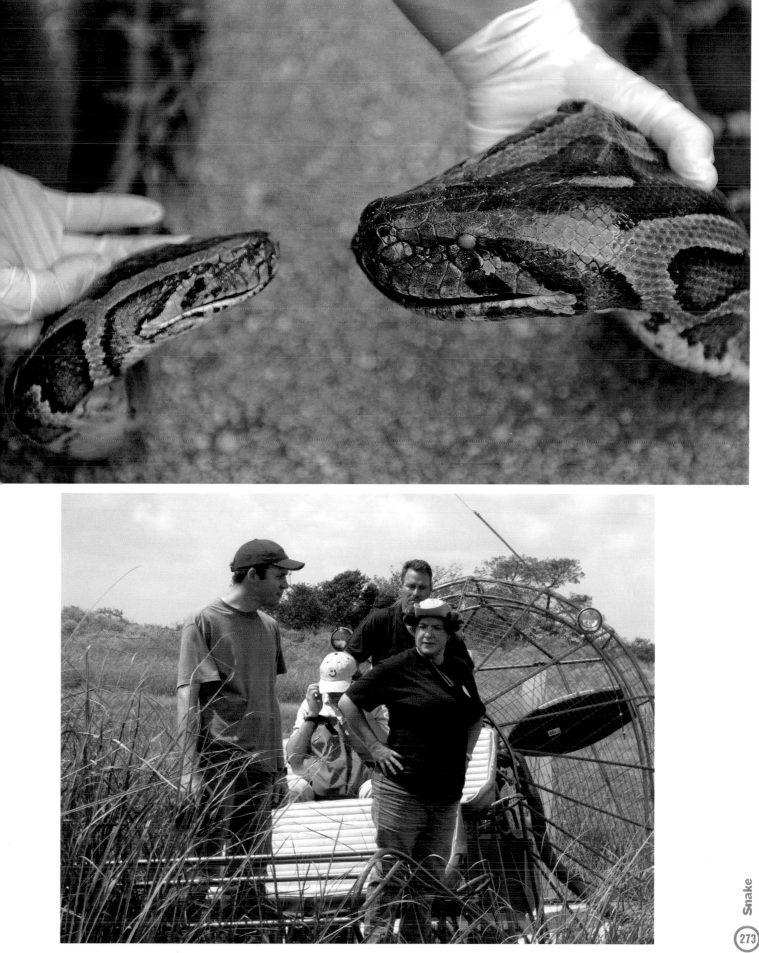

Burmese python to become so successful.

Our crew arrived in Florida and headed, at speed on some fan boats, straight into the heart of the Everglades. To maximize our chances of finding a good subject for our dissection, the team split up. As torrential rain began to fall, Mark Evans teamed up with local snake expert and former marine Jeff Fobb. Together they trudged through some of the swampier regions of the Everglades, searching not just in the water, but also in the trees. Mark was hopeful; Jeff had previously come across 4m (14ft)-long pythons on his forays into the Everglades. Unfortunately, on this trip, after hours of wading through muddy waters, they came back with nothing.

Joy Reidenberg joined Joe Wasilewski, a veteran snake hunter attempting to curb the damage the snakes are wreaking in Florida. He took her to one of his favourite and most fruitful hunting territories: a long, straight and desolate road through the salt marsh where the snakes would sometimes come to sun themselves. Suddenly, out of the corner of his eye, Joe spotted something. We barely managed to start our cameras rolling quickly enough to capture his frantic, stumbling chase through the undergrowth. He pounced, and pinned down the python's tail. Joy scrambled to his assistance and together they slowly dragged two metres of camouflaged reptilian tubing through the tall grass before Joe swiftly seized its head. Joy had her snake in the bag.

I tried an altogether different ploy heading into the urban jungle of Miami to meet with Lieutenant Lisa Wood at the fire department. She works for the Miami-Dade venom response unit, America's leading snake-bite response team. They are primarily on call to deal with venomous snakes. Their offices are lined

Above: Joy holds on to the python she has managed to apprehend on a long, straight and desolate road where snakes are known to sun themselves.

Above left: Pythons are found across Africa, Asia and Australia. The Burmese python is an invasive species which is now widespread across South Florida and the Everglades.

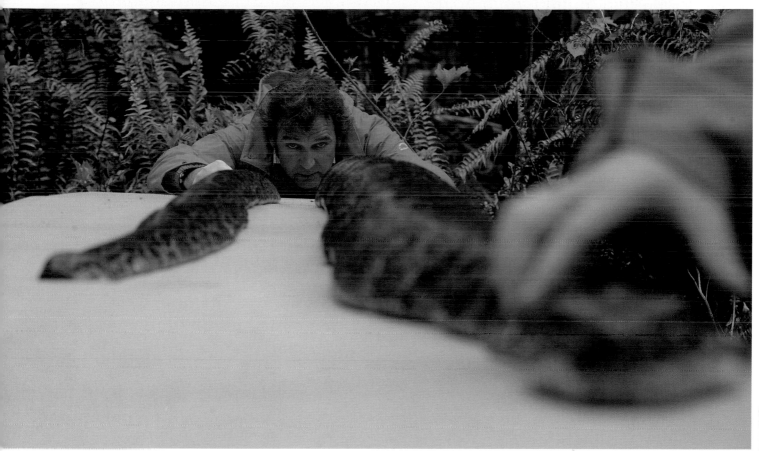

with fridges filled with anti-venom ready to be dispatched to anyone who has had a snake-bite. But in recent years she's had to deal with a growing number of Burmese pythons. She explained that three years ago they caught 20, two years ago 40 and last year they were up to 89. Evidently the problem is worsening.

In spite of this proliferation we waited all day, but there were no reports of pythons. I had one more chance to track down a Burmese python. Lt Wood directed me to one of her colleagues who had been called out to a fire at a warehouse back in 2007. Fire-fighters have to be brave at the best of times. One can hardly imagine how they felt, knocking down the door of a burning building, only to see 100 snakes fleeing the flames. The warehouse was owned by a snake-breeder who lost a great many snakes in the fire. Fortunately for us, to prove his losses to his insurers, he had been forced to keep all his dead snakes frozen since then. I went to have a look at his biggest snake, a giant female that was coiled up inside a chest freezer. It took the two of us, struggling to hold onto its frosty and slippery body, to haul it out and into our car. It looked ideal. Surely no one would find a bigger one than this.

The team regrouped for our dissection at a murky swamp camp at the heart of the Everglades. We unpacked our specimens and wondered where to begin. We were joined by reptile anatomist Professor Jeanette Wyneken, who gave our snakes a look over and confirmed that Joe's snake was a male and in prime condition for us to study. However, the snake from the fire was another matter. She lifted it up and remarked on the lumpiness of the tissue, which indicated that it was likely to be badly decayed inside. Now that it had thawed, the stench alone told us that this snake was unsuitable. Fortunately, Jeanette had brought another female python

with her, giving us something to compare with the male, and this one was huge. Hastily we fastened together two tables to make a work surface long enough to hold these massive animals, and our dissection began.

We started by considering the unusual way that snakes move around. The Bible might say that snakes were condemned to lose their limbs and crawl on their bellies, but the snakes seem to be managing just fine with their particular choice of locomotion. In fact, they can choose between several modes of movement. One method is known as rectilinear locomotion. This is favoured by larger, heavier-bodied snakes and allows them to move forward in a straight line, undulating ever so slightly. It may be slow but it is almost silent, making it ideal for stalking prey and manoeuvring into a perfect position for an ambush.

Jeanette flipped a section of the python over, displaying a pattern of scales on its underbelly akin to the treads on a tyre. These scales enhance the snake's grip on the ground and each scale has a set of muscles attached to the ribs. Together Joy and Jeanette stripped a section of skin from the python to reveal the complicated system of criss-crossing muscles that facilitate this motion. When moving, a section of the belly muscle relaxes and rib muscles pull it forwards. The scales then anchor and a contraction drags the belly along while a second set of rib muscles bring the rest of the body with it. The pattern is repeated throughout the body to produce a steady forward motion.

When it comes to moving, snakes have another option called sinusoidal locomotion. This is the winding movement so stereotypical of snakes. The snake twists its body into S-shaped curves, anchoring with one part while pushing the body forward with another. This sigmoidal slaloming movement might be, in

Above: Snakes display several different types of movement. One option, sinusoidal locomotion, enables the snake to twist its body into S-shaped curves, creating the familiar winding movement so stereotypical of snakes.

Top: The pattern of scales on a python's underbelly look like the treads on a tyre and work in a similar way. These scales enhance the snake's grip on the ground as it moves along.

Below: Jeanette and Joy examine the python's underbelly, stripping a section of skin from the snake to reveal the complicated structure of criss-crossing muscles that facilitate the snakes ability to move.

A snake swallowing its prey is both a repellent and mesmerizing sight. Given the opportunity it will attempt to gulp down prey items as big as its own body. Its mouth splays to what seems an impossible width and angle, hooking its teeth into the flesh of its victim before patiently and persistently engulfing its food.

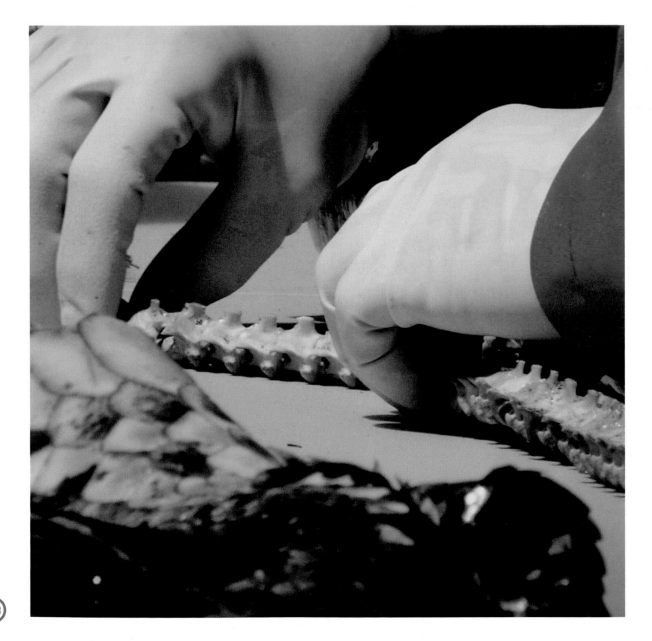

Vestigial Legs

We know that the ancestors of snakes walked around on legs just as their lizard cousins do today. The body of the male python provides a tantalising glimpse into their evolutionary past. Near the tail end there are two small, thorn-like protrusions bracketing the vent, the opening used for both passage of waste and mating. The dissection team use tweezers to pull out the tiny vestigial remnants of what were once legs: a tiny femur and behind that a small lump of cartilage, the equivalent of a pelvis. These tiny bones floated untethered in the muscle layer.

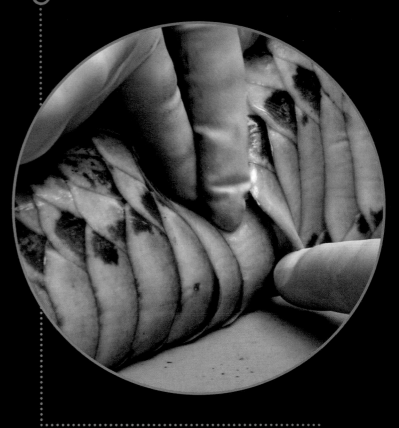

Ground Gripping

A pattern of scales on the python's underbelly enhances its grip on the ground, and each scale has a set of muscles attached to the ribs. There is a complicated system of crisscrossing muscles that facilitate motion. When moving, a section of the belly muscle relaxes and rib muscles pull it forwards. The scales then anchor and a contraction drags the belly along while a second set of rib muscles bring the rest of the body with it. The pattern is repeated throughout the body to produce a steady forward motion.

Movement

Snakes can choose between several modes of movement. Rectilinear locomotion is favoured by larger, heavier snakes and allows them to move forward in a straight line, undulating slightly. It is slow but silent, ideal for stalking prey. Sinusoidal locomotion is the familiar winding movement when the snake twists its body into S shaped curves, anchoring with one part while pushing the body forward with another. This sigmoidal slaloming movement makes them as adept in water as they are on land.

Internal Organs

The efficient packing inside the snake's tubular body is incredible in its simplicity. The backbone, ribs and muscles form a gulley into which all the inner workings were asymmetrically squeezed. The heart, like all the organs, is slender and elongated while the lungs, kidneys and ovaries are staggered one behind the other as though in an orderly queue.

Vertebrae

The supple movement of a snake is attributed to its 300 vertebrae (humans have just 33). When the snake contorts its body, the angle is spread between so many vertebrae that the bend is not as sharp as it may appear. It also gives a clue to how the snake became so elongated and lost its legs. It seems that the number of chest vertebrae increased again and again creating a greater distance between the fore and hind limbs. They needed these extra vertebrae for added flexibility before dispensing with legs.

part, key to their success in the Everglades. It makes them as adept in the water as they are on land. In some parts of Florida they have been tracked travelling up to 70km (43 miles) during the wet season.

To show us how snakes achieve such suppleness in their twisting movements, Jeanette had prepared the spinal column of another large python with about 300 vertebrae. To put that in context, you have to remember that we humans have only 33. When the snake contorts its body, the angle is spread between so many vertebrae that the bend is not as sharp as it may appear. It also gives a clue to how the snake became so elongated in the first place. It seems that the number of thoracic (chest) vertebrae increased again and again creating a greater distance between the fore and hind limbs. They needed these extra vertebrae for added flexibility before dispensing with legs.

We know that the ancestors of snakes walked around on legs just as their lizard cousins still do today. The body of the male python gives us a tantalizing glimpse into their evolutionary past. Near the tail end of their bodies they have two small, thorn-like protrusions called 'spurs' bracketing the vent, the opening used for both passage of waste and mating. The dissection team circled the tissue of this nail-like appendage with a scalpel and then used tweezers to pull out the tiny vestigial remnants of what were once legs. There was a tiny femur and be-hind that a small lump of cartilage, the equivalent of a pelvis. These diminutive bones were not even attached to the spine and instead floated untethered in the muscle layer. Both sexes have spurs, even the female – although they are smaller and harder to find. In the males they have remained slightly bigger because they play a role in courtship and reproduction. Not only do these small spurs provide us with clues to the evolutionary origins of the snakes but, like all vestigial or-gans, they provide further evidence for the theory of evolution.

To get to grips with the lethal capabilities of snakes, I met with Florida-based snake breeder Tom Crutchfield. Tom is a giant in snake-breeding circles and his collection of rare and exotic species is world-renowned. It was here that I first felt the awesome strength of the python. A trip to his 'Venomous Room' is not for the faint-hearted. Inside, stacked to the rafters, were small plastic boxes, each home to some form of deadly snake. Though many were small, most were capa-ble of killing me many times over with a single bite. Tom took a monocle cobra from its cage and set it down on the table before me, adding almost proudly, 'This snake probably causes more deaths in South East Asia than any other'. It flattened its head and stood up seething, looking straight at me. Now, I am not afraid of snakes but there was something about the hiss and the defiant posture of that cobra, as it flared its hood and rose up to meet my eye, that truly started my adrenalin pumping. It tapped into some primal fear. Science suggests that there might be something to this sensation, that the snake really may have been subverting my instincts. Some say that horses that have never seen snakes know to be afraid. It is better to frighten a threat away than to risk a fight. Terror is an important weapon for the cobra. In that instant I understood why snakes are so maligned and often seen as the embodiment of evil. 'It's angry,' I commented, taking a small step backward before Tom corrected me, 'No. It's afraid.'

Snakes use two very different tactics to kill their prey. The venomous snakes come armed with chemical weapons that kill within seconds. They are like snip-ers who take out their adversaries with a single hit. The constrictors employ a

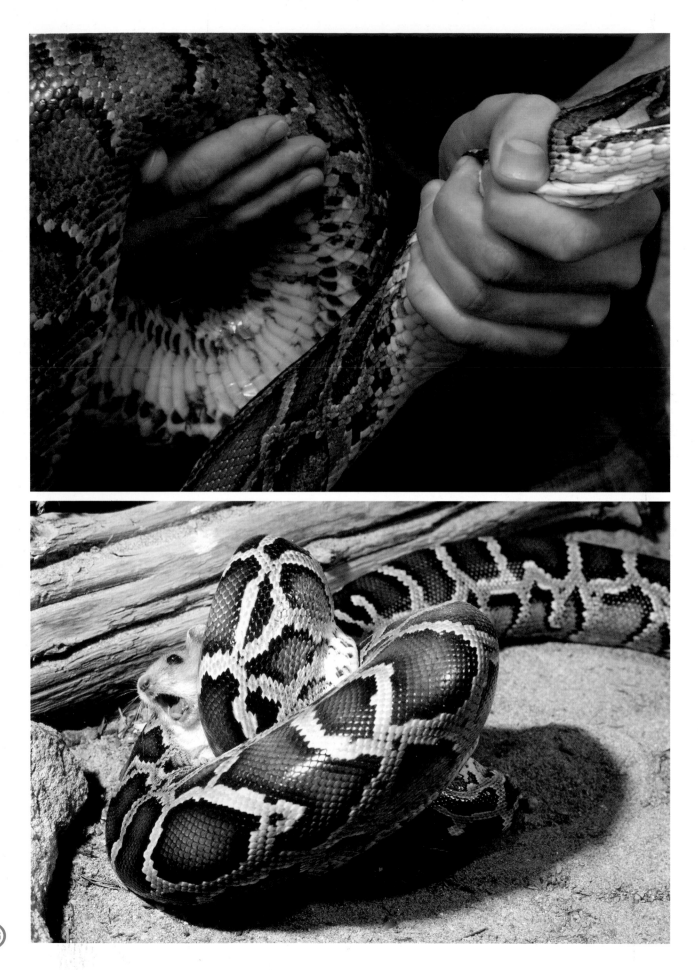

much more brutal and thuggish approach, using raw power to crush the life out of their prey. The snake fastens onto its victim with a vicious bite and then wraps tight coils around its body. Studies suggest the constriction kills by restricting the flow of blood to the heart. Usually it takes less than a minute and sometimes the pressure is so great that the eyes of the prey actually pop out from their sockets. Smaller victims often perish more quickly, dying from suffocation or having their backbone snapped. There is an economy of scale and, in general, the larger the snake, the more lethal its grip. Having impressed me with his Burmese pythons, Tom had a bigger constrictor to show me. The reticulated python is the world's longest snake; the largest measured was 8.7m (28.5ft). Though he described the one he had as 'only medium-sized', at over 5m (16ft), it still seemed enormous as we took it from its cage. It was so big and strong that it took five of us to hold it steady. Between takes, Tom repeatedly offered me the chance to hold it by the head and eventually our Director, Jamie Lochhead, nervously agreed. I worked my way up its slowly writhing body and, using both hands, I firmly gripped its head, struggling under its weight. At that moment the snake's enormous body kinked sharply, nearly knocking me over. I had thought we had it under control, but now knew that we were only holding it by its grace alone. Some of Tom's assistants jumped in to help hold on to it as we urgently wrestled it back to its cage. As soon as it knew it was home it slithered, almost calmly, out of our grasp and disappeared into the undergrowth at the back of the enclosure. It had only wanted to be free of us.

After feeding, a snake's mobility is seriously compromised. It's hard for them to move their laden bodies with such a gutful. When startled they have been known to forsake their food and vomit forth entire intact bodies to lighten their load and allow for a quick getaway. If nothing else, their partly digested meal might provide sufficient distraction for would-be predators. Claiming all the prey for oneself by swallowing is a greedy but fantastic idea. Nothing is wasted and not a morsel is lost to scavengers. Stomach acids and secretions potent enough to break down muscle, fat and even bone mean the snake makes the most of its meals. But the snake does more than this. Such an effective digestive system is expensive to maintain, so when digestion is complete, the intestines shut down until they are next needed. The python's body is preparing for the worst, and doesn't want to waste its energy on inessential organs. As soon as it feeds again, it is all systems go and the intestines swell to their optimal working size once more. This is a creature as perfectly adapted to coping with famine as it is to demolishing a feast. Its remarkable ability to control its body's energy expenditure affords it a lethal patience. Some have been known to lie, waiting for months, permanently poised for the perfect opportunity to strike. They are surely the ultimate assassins.

To examine the route taken by food, Joy and Jeanette made an extended incision along the body of the female, bringing most of the internal organs into view. The efficient packing inside the snake's tubular body was incredible in its simplicity and suitability. It was as though the backbone, ribs and muscles formed a gulley into which all the inner workings were asymmetrically squeezed. The heart, like all the organs, was slender and elongated while the lungs, kidneys and ovaries were staggered one behind the other as though in an orderly queue.

From the fat deposits lining the body we could tell that this female had been

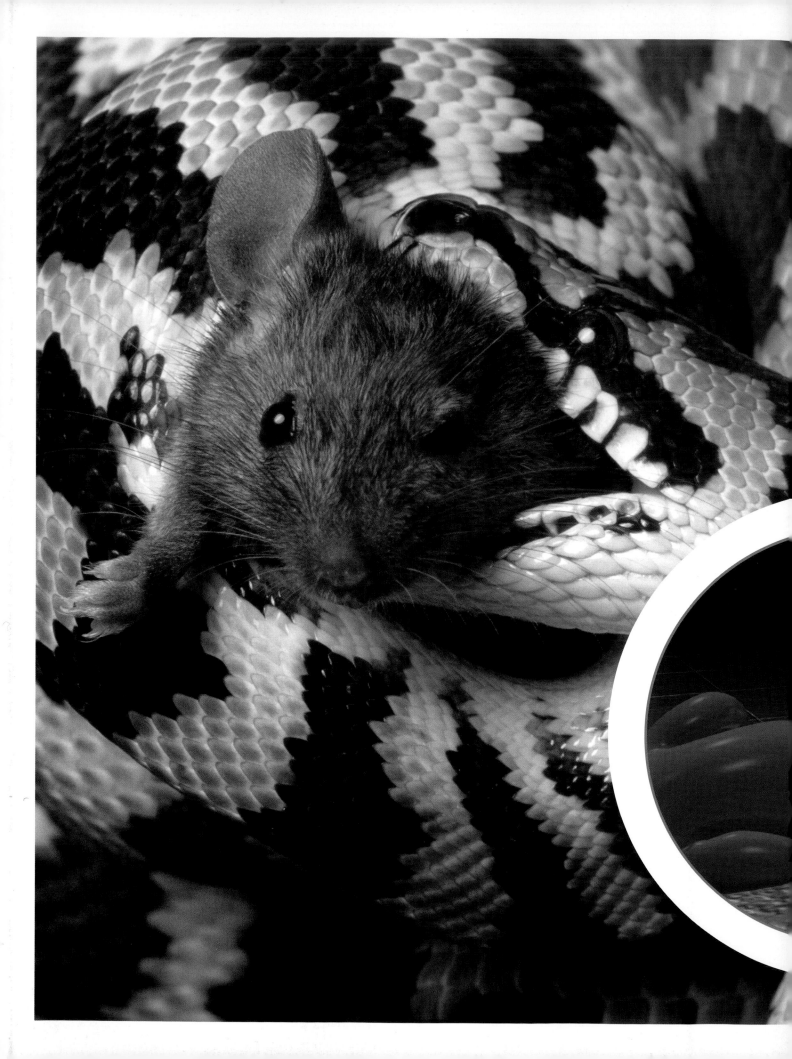

Breathing Between Bites
Joy Reidenberg

The vertebrate body plan is fairly straightforward: bilateral symmetry (two eyes, two ears, two nostrils, two arms, two legs) flanking a midline spine. The organ plan on the inside is also fairly predictable: two lungs, two gonads, two kidneys, but a midline heart and digestive tract. The elongated body of the snake, however, presents an interesting packing problem when it comes to fitting in all the same organs that you would find in a typical vertebrate. Predictably, all of the organs are elongated. Unpaired organs lie easily along the midline, while the paired organs are stacked one behind the other in the narrow body cavity.

The snake's lungs are particularly intriguing in their anatomy because they have different lengths, and instead of the complex branching tree of bronchi and clusters of alveoli, the snake has one very large central cavity in each lung. The front part is lined with a corrugated surface for air exchange, while the back part is simply an air sac with a thin membrane. During the dissection, we filled the lung with water. When the lung was partially 'inflated', we were able to squeeze the water back and forth between the respiratory and the air sac portions. In life, the snake can probably shunt air back and forth in a similar manner, thus mixing the 'unused' air in the air sac and in the core with the 'used' air lying against the respiratory membranes. This mixing could allow the snake to increase the amount of gas exchange that occurs with each breath, thereby allowing the snake to take fewer breaths or breath-hold for a longer period.

The staggered positions, uneven lengths and unusual air sac of the lungs may seem puzzling at first, but on closer examination it becomes clear that this unique arrangement actually solves more than just a packing problem. This crucial adaptation allows the snake to carry on breathing even when it is swallowing a large item of prey. If the swallowed prey is so large and heavy that it compresses the trachea (windpipe), then air shunting between the air sac and the respiratory membranes would enable respiratory gas exchange to continue during the breath-holding. As the prey moves further down, the distended oesophagus presses on the left lung. However, the right lung is still available to continue respiration. As the prey is pushed even further down, the left lung is now free to resume breathing while the right lung is compressed. This is an amazing solution to maintaining the essential function of respiration throughout the tediously slow process of swallowing and digesting prey.

in good shape and, judging from the appearance of ovaries, was gearing up to breed. About 20 custard-coloured yolk sacs were lined up in each ovary, ready to be swallowed by the oviduct and begin their journey toward becoming fully formed eggs. A closer look at an ovary revealed scar structures from previous matings, known as corpora albicans. A quick count of these gives a rough indication of how many eggs a snake has laid in its lifetime. It was enough to suggest that this female was already prolific. In their native habitat many python hatchlings never reach maturity, being eaten by birds and jackals, but in Florida they have very few predators to keep the population in check. Though alligators will sometimes eat them, pythons do not form a natural part of their diet and, as we've seen, sometimes snakes turn the tables and attack the alligator. It is no wonder then that pythons are having such a devastating effect on an unaccustomed ecosystem. In an attempt to catalogue the damage, Jeanette needed to gather samples from each snake's stomach and intestines. Picking through the digestive goo, Joy teased out some sticks, which were probably the stomach contents of some herbivore that the snake had consumed. She found some small teeth that would require further analysis. Then Mark spotted a small, brown stub. It was the hoof of what was once a rare, Key deer.

The harsh winter of 2010 brought some of the coldest weather that Florida had seen in decades. Pythons do not do well in the cold and it seems likely that many were wiped out over those months. Mother Nature may have been more effective at killing snakes than human hunters but we've not seen the back of this invader. This survivor of a species is in Florida to stay.

Above: Usually, a python's diet consists primarily of appropriately-sized birds and mammals. However, exceptionally large pythons may require larger prey such as pigs, goats or deer. Burmese pythons are also known to have attacked and eaten small alligators in Florida.

Top: The team make an incision along the body of the snake, bringing most of the internal organs into view, including custard-coloured yolk sacs lined up in each ovary, ready to begin their journey toward becoming fully formed eggs.

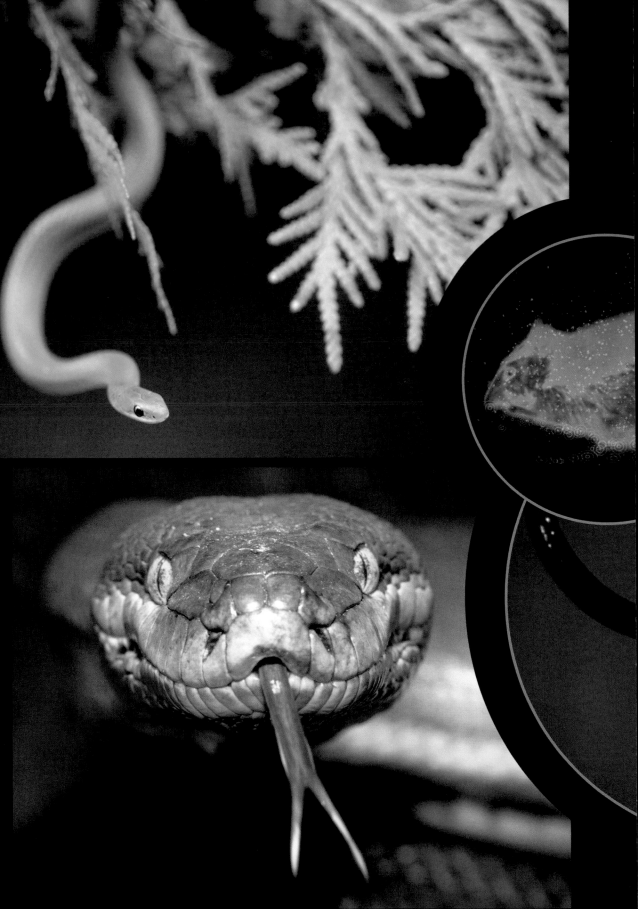

How Snakes Hunt

The team investigated the creature's head to explore how its senses are hard-wired for the hunt. Reptile anatomist Jeanette Wyneken stared deep into the fearsome predator's eyes. Surprisingly, though snakes can see, their eyelids are permanently closed. These eyelids, aptly known as the spectacles, are clear, and are discarded with the rest of the snake's skin when it is shed. Still, their vision is poor and their hearing is worse. They have no external ears and so cannot hear in the way that we can, but they do use the same internal apparatus to help detect tiny vibrations through the ground. Through their undersides, they can feel the footfalls of approaching food. Snakes, therefore, must rely more on other senses. They pick up chemical cues using a method that is a sort of hybrid of tasting and smelling. Though they have a nose they seem to smell with their tongue. They flick their forked tongue out of their mouth on chemical reconnaissance missions into the environment. Scent molecules in the air stick to the tongue, which the snakes then dock into a chemosensory area on the roof of their mouth known as the Jacobson's organ. This, in turn, relays sensory information to the brain. The pronged shape of the tongue allows them to compare and contrast the density of chemicals on their left and right sides and so deduce where the strongest scent of prey is coming from so that they can track it down. Studies suggest that even blinded snakes can still hunt effectively for warm prey like rats, and some snakes in Australia have been known to pluck bats from the air in the depths of night.

A Trick Up Their Limbless Sleeves

Near their nostrils, snakes have pits with which they can detect the infrared radiation emitted by warm bodies. It is as though they have an in built thermal imaging camera, which allows even nocturnal snakes to strike with near perfect accuracy in complete darkness.

Camel

Camelus dromedarius
Tom Mustill

Glenda Sutton crouches low on her mount, urging him on as he hurtles down the track. His four legs softly thump the dry grass as he gathers speed. Glenda's a record-breaking jockey; she's won her last 18 consecutive races. Her racing-camp lies just outside Wedderburn, a sleepy village in South-Eastern Australia. But Glenda isn't your average jockey – she races camels.

She has caught every one of her racers herself, from where they roam wild, thousands of kilometres away in the outback. She rounds up feral herds using helicopters and 4x4s; then she picks potential racers and gradually breaks them in, training them to accept a saddle and a rider.

It may come as a surprise that in the land of the platypus, koala and kangaroo, there are so many camels. In fact, there are estimated to be over a million living wild across an area of central Australia the size of India. It's one of the few places in the world where you can find wild camels. The one-humped camel or dromedary, which has spread from North Africa through the Middle East to India, is now almost completely domesticated everywhere else. The same goes for the two-humped species, the bactrian camel, which lives in Central Asia. There are a few hundred wild ones living in the Gobi Desert where they eke out an existence braving fierce temperatures and high background radiation in a nuclear testing range. The population of one-humped camels roaming wild in the outback is thought to double every nine years. Unlike most other large mammals, camels thrive in the desert. In small numbers their impact is minimal. Their soft feet don't disturb the delicate soil and when they browse, they select a few choice bits from each plant before moving on. The native species can tolerate this. But when the population rises and there's a drought, the camel's ability to eat almost anything, no matter how dry it gets, causes extreme and permanent impacts. The damage extends beyond the plants they eat. It deprives native animals of scarce food and leaves their water holes fouled. Australians are painfully aware of the damage invasive species can cause – foxes, mice, rabbits, cats, sheep, horses, don-

Opposite: Unlike most other large mammals, camels thrive in the desert. As the team will discover, they have evolved to be able to withstand changes in body temperature and water consumption that would kill most other animals.

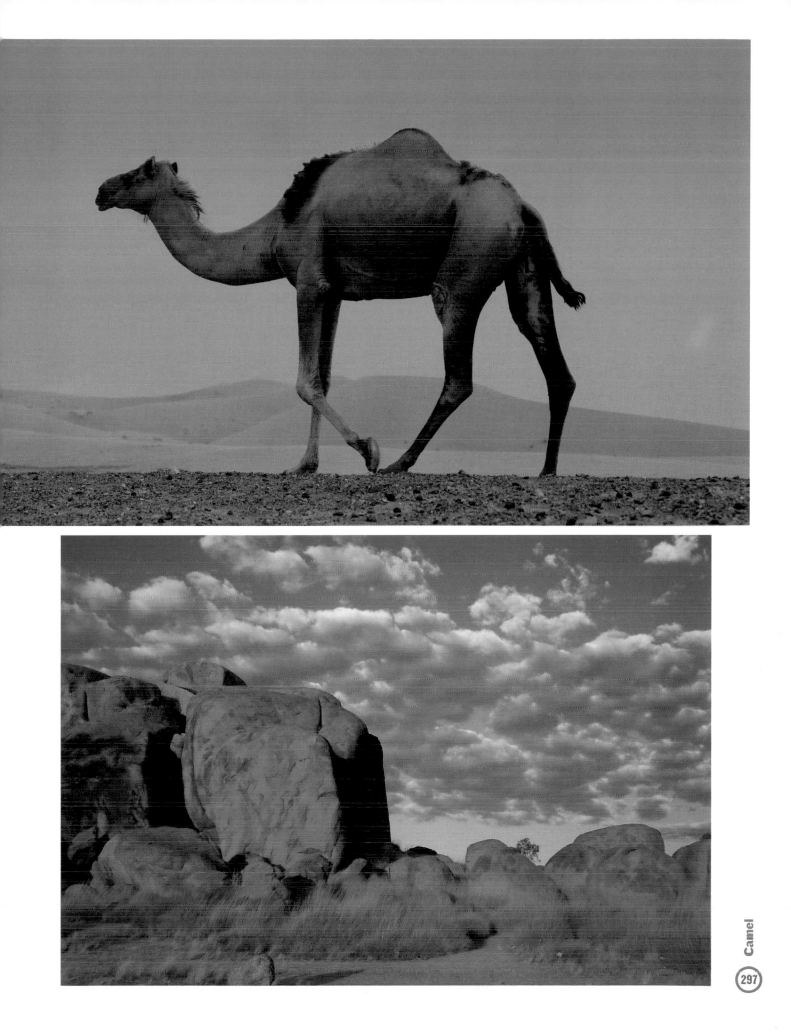

keys, pigs, goats, dogs, pretty much a complete English farmyard, have all been introduced by European settlers. These invaders found a land with few predators and lots of food species totally unprepared for them. The result has been genocide. In the last two centuries species after species, that have evolved and lived in Australia for millions of years, have disappeared forever. The camel numbers have to be controlled somehow, and the Government has decided that the best way to do this is to cull them. This is a controversial policy. There are other options such as neutering, capturing the animals for export to the Middle East, or slaughtering them for meat. But culling is seen by many as the only viable short-term control measure to prevent further destruction. Nearly two thousand kilometres from Glenda's racetrack, in the dead centre of this enormous continent, lies Lambina Station, a cattle farm the size of Cornwall. We arrive in the middle of summer, when temperatures in the mid-forties (centigrade) are common. So little rain falls here that the land is categorized as a desert. But for Alan Fennell his farm is his life and working this land is in his blood. Alan is a cattleman, or drover, of the old school. He has a voice like sandpaper, a car-crusher handshake and a healthy scepticism for pommy film crews. We meet him by a large dusty barn, surrounded by farm machinery, a cluster of houses, an airstrip and some intimidating-looking dogs.

Inside the barn lie the carcasses of four freshly-culled camels. He's planning to cull another and this is why we're here. Culling an animal is always a desperate last resort, but it provides an opportunity to explore the anatomy of the camel and to find out why it has done so well here. Our guide will be Geoff Manefield, a tough 84-year-old vet and camel specialist. There's little Geoff doesn't know

Above: The team travel to a cattle farm, where they meet Alan Fennell, a cattleman of the old school.

Top: Camels have a two-toed foot with toenails and a soft footpad, thought to have emerged as an adaptation for less steady ground, such as that found in deserts.

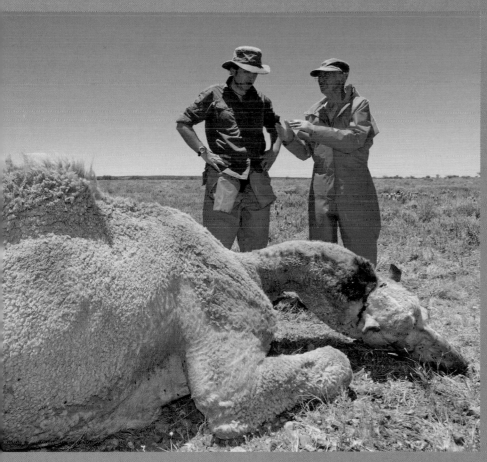

about camels – he's worked with them in Australia and the Middle East. He started a research institute in Abu Dhabi to study the health and physiology of the Crown Prince's racing camels. Mark, Geoff and Joy quickly go over Alan's plan. He'll find the camels from his microlite – the only way of covering the terrain when you're farming an enormous desert – and radio to his colleague Jon Crombie in a 4x4 vehicle below. Jon has culled hundreds if not thousands of camels and other feral species in the outback. He is unsentimental about the culling, but he is serious about it being a clean, painless kill. Once the camel is down and confirmed dead we'll have to work quickly. In the heat the carcass will cook fast. We'll also have an audience – the flies in central Australia are horrific, with no sense of decency, and crawl into your ears and up your nose. Alan tells us that the local solution is to cut a hole in the seat of your trousers to lure them away from your face. We're not sure, but we think he's joking. Minutes later Alan's tiny aircraft is airborne, and our small convoy of 4x4s sets off raising a plume of red dust. This land normally gets just a fraction more rain than the Sahara, but right now the desert is strangely green. Central Australia has received more rainfall than anyone can remember and the flora, much of which will wait years for such conditions, is in full bloom – scraggly flowers create hazy purple fields between the clumps of stubby mulga trees.

When Alan locates a group of camels, he radios Jon who drives over to the herd. When he's close enough Jon makes a low, grunting sound mimicking a camel. The bull pauses long enough for Jon to take aim and fire. It's a clean shot through the back of the skull. As we gather around the dead camel it strikes us how strange it is that this animal is here, on an enormous island, so far from the

Above: The team is joined by Geoff Manefield, a vet and camel specialist who has worked with camels in Australia and the Middle East

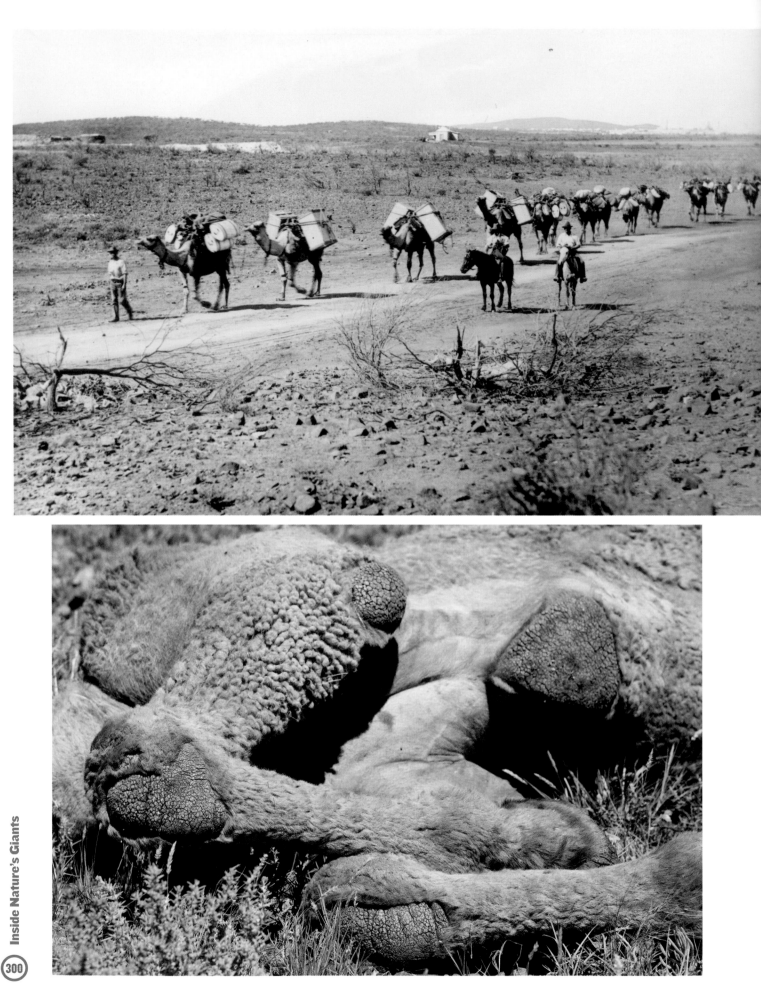

deserts where humans first tamed them over 4,000 years ago. Camels were first brought to Australia in the 1840s. Without the camel it would have been impossible to penetrate the interior. They carried the earliest explorers and hauled supplies – from hatpins to entire houses – to the frontier towns in the outback. They also laid the great north–south railway that is still named the 'Ghan', after the cameleers who came with their animals from Afghanistan, India and Pakistan. Once the roads and railroads were complete, the camels were no longer needed and their owners were ordered to destroy them. But rather than kill them, many were turned loose into the outback, where instead of dying, they thrived. Over the last century thousands of feral camels have multiplied to over a million. Looking at our dead camel it seems almost unfair that this animal should be punished for being so very, very good at living in such a hellish place.

After donning our protective suits, we begin work on the dissection. There's one obvious place to start. The most distinctive part of the camel is perhaps the most mysterious: the hump. To access the hump we move the animal into an unusual position, impossible for most four-legged animals. This is called sternal recumbency – when the camel lies down with all four limbs tucked neatly under its body. This is the position that Arab butchers use to remove the skin from camels, and it gives good access for Geoff to cut through the hide to open up the hump. Everyone helps to push the camel into this upright position. Once it's there Mark is quick to notice something amazing. Each part of the camel that touches the ground is covered in a callous of thick skin – on each of the four limbs and, most significantly, on the chest. Above the sternum, where the ribs

Above: Camels eat the best juicy parts of plants: they are browsers. But when conditions are tough they can eat dry lower quality food.

Opposite top: Camels were first brought to Australia in the 1840s to provide transport throughout the country. Many different types and breeds were imported, but most were from India.

Opposite bottom: Camels are outfitted with natural shin guards and knee pads. The tough skin protects the legs when the camel rests on the blistering sand.

Camel

meet together, there's a large and very tough pad that keeps the ribs three or four inches away from the desert sand. Geoff says that this is called the pedestal – and the name suggests its function. It holds the middle of the camel's body high enough above the sand to allow air to circulate freely underneath, keeping it cool. Mark demonstrates this by sticking his hand under the gap from one side to the other. This wouldn't be possible with a cow or horse. Meanwhile, Geoff and Joy are cutting through the skin above the hump. They stop every so often to sharpen their knives which are quickly blunted on the camel's tough hide. Finally, enough of the skin has been pared back to see the hump. It's a large glistening pale pink mass, fitting neatly above the vertebrae. Where the knife has cut into it we can see that it looks uniformly blubbery throughout – there's no complex structure – and definitely no hidden water source. Joy removes the hump entirely and holds it up. It's a huge lump of almost pure fat!

But how can the camel turn such dry, unpromising desert plants into a great ball of fat? Simon attaches a tiny camera to the nose of one of Glenda's camels to get a camel's-eye view of its feeding habits. The footage is revealing. The soundtrack is constant chewing as the camel breaks down its food for better digestion. The camel-cam footage shows how it uses its great neck to reach up or down to pluck the most tender buds and shoots. Its upper lip is split into two large flaps. These are muscular and act almost like fingers, reaching out past vicious thorns to grab the choicest morsels.

Back in the dissection, it's time to look inside the mouth to follow the path of the food into the camel's immense digestive system. Geoff makes an incision up the cheek of the camel and Mark and Joy gasp as the inside surface of the mouth is revealed. It's covered in hundreds of strange stubby bits of tissue, like tiny fingers. Geoff explains that these papillae are thought to help direct food on to the teeth and down the throat whether it's being chewed for the first time or has been regurgitated for further chewing. They're also thought to protect the mouth from thorns and tough vegetation. Geoff notices the front teeth are missing and he thinks this is why the camel is so skinny. It turns out the hump we've just examined is on the small side, only 10 per cent of the size of the biggest he's seen. Given the desert is currently so lush with vegetation, this is strange, and Geoff thinks this camel may not have lasted much longer without its front teeth because they're vital for pruning bushes.

Looking at the mouth, Mark's keen to know how the camel gets such dry food down its throat. Geoff explains that when well watered the camel will produce up to 80 litres of saliva. Mark is astonished. That's 17.4 gallons of fluid coursing through the camel. Where does it all go? And how can it afford to use so much fluid for digestion in such a dry environment?

There's only one way to find out. The team shifts the camel onto its side to gain access to the guts. They then make a deep incision taking great care to avoid puncturing the digestive tract. It's getting very hot and the bacteria in the camel's stomach have continued to ferment. Normally the camel would belch copiously to release the resultant gas, but now with nowhere to go, the camel is starting to bloat visibly. To release some pressure Geoff chooses a particularly swollen part of the digestive tract and lances it. The hot fetid air rushes out and we all take a moment to hold onto our lunch. There's not much respite, however, as after a bit of a struggle Joy and Geoff heave the stomachs (all three of them), along with

Opposite top: The inside surface of the camel's mouth is covered in hundreds of stubbly bits of tissue. These papillae are thought to direct food on to the teeth and down the throat whether it's being chewed for the first time or has been regurgitated for further chewing.

Opposite bottom: Looking further into one of the stomachs, the team uncover a strange set of pouches. This mass of pockets has a honeycomb structure. As well as secreting digestive juices, these pouches have a large surface area that's extremely good at sucking water out of the digestive system into the bloodstream.

Knee Pads

The camel habitually lies down in the unusual position of sternal recumbency, where all four limbs are tucked neatly under the body. In this position, each part of the camel that touches the ground is covered in a protective callous of thick skin – on each of the four limbs, and most significantly, on the chest. The position the camel sits in is impossible for most other four-legged animals, but by resting on this skin when it tucks its legs in and rests on the pedestal, the camel can make a cool, shady gap underneath its body.

Toes

The foot of a camel is perhaps, after the hump, its most distinctive feature – two huge toes, with large toenails. But why are toes better than hooves? At the base of each of the camel's two toe bones is a large squishy elastic pad, like a jelly insole. When the bone presses down on this, the pad expands out. It acts like a shock absorber and spreads the weight of the camel over a larger area. This steadies the camel on uneven ground and prevents the foot from slipping deep into sand dunes. The toes also hold glands that secrete a cooling substance – like air-conditioning in the camel's feet – vital when walking on a surface that could fry an egg.

Pedestal

Above the sternum, where the ribs meet together, there's a large and very tough pad on the camel's skin that is called the pedestal. This pad keeps the ribs three or four inches away from the desert sand when the camel is sitting in its position of sternal recumbency. The name suggests its function: the pedestal holds the middle of the camel's body high enough above the sand to allow air to circulate freely underneath, keeping it cool.

Achilles Tendon

In the camel the Achilles tendon is enormous – a great thick tube of elastic tissue connected to powerful muscles at the top of the leg. The camel has swapped a lot of its leg muscles for long tendons. Some of the muscles are just millimetres long at the end of immense tendons stretching across the limbs. It's thought that with every step the camel takes, it stores some energy in its great tendons, and when it shifts its weight from one leg to another, the tendon pushes back – saving the camel vital energy and water. When it's pacing, the camel's long leg tendons have been estimated to save half the muscle work needed if it did not have elastic band legs!

Mouth and Lip

The camel's upper lip is split into two large muscular flaps that act almost like fingers, reaching out past vicious thorns to grab the choicest food. The surface of the mouth is covered in hundreds of strange stubby bits of tissue, like tiny fingers. These papillae are thought to help direct food on to the teeth and down the throat whether it's being chewed for the first time or has been regurgitated. They're also thought to protect the mouth from thorns and tough vegetation.

Du'laa

In the back of the mouth of most mammals is a curtain of flesh called the soft palate that hangs down from the edge of the hard palate. Male camels have developed an enlarged version of this that looks like an empty, fleshy beanbag the size of a small grapefruit. It is inflatable and when puffed up hangs outside the mouth. Called a du'laa, it is apparently very attractive to female camels, as well as being intimidating to other males. Continued flow of air into and out of the du'laa causes it to shake and change volume, making this a dramatic visual display.

Camel:

Weight: ...
400–600kg (880–1,320lb)
Height: ..
2m (7ft)
Length male / female:
N/A
Life Span: ..
40–50yrs
Top Speed:
55km/h (35mph)
Bite strength pound force:
N/A

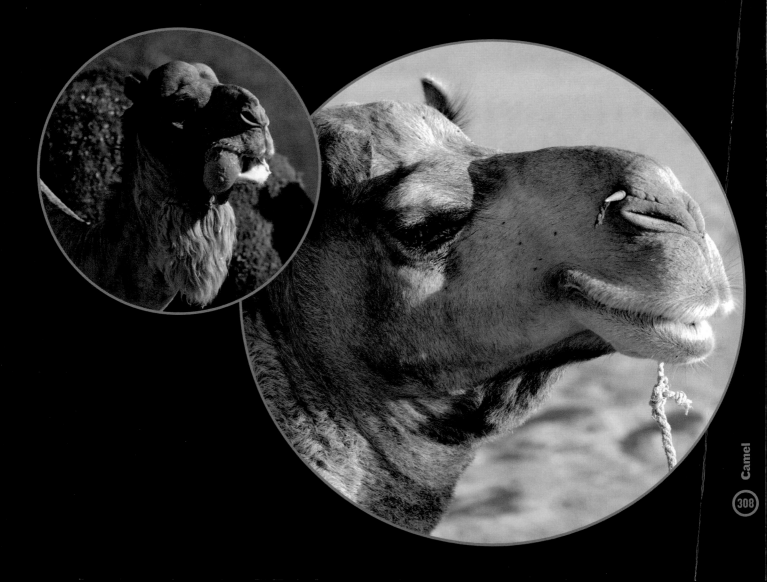

Head

When the temperature gets too hot for the camel, it allows itself to overheat. Much like running a fever, it stops using water to produce sweat and its body temperature rises by up to six degrees. The sensitive brain tissue avoids overheating (and brain damage) by using a localised cooling system. Huge delicate nasal turbinates within the skull provide as much as two square metres of surface area in the nasal cavity. Covered in blood vessels, these bring hot blood close to the surface of the nose, where the camel breathes in air. The water on the damp inner surface of the nose evaporates, cooling the nasal cavity and the blood in the vessels. This then specifically cools the blood on its way to the brain.

Stomach

One key to the camel's survival without water in the desert is found inside the stomachs. These have a variety of structures with large surface areas, for sucking water out of the digestive system into the bloodstream. When the camel is hot and low on water, it quickly pulls in water from the digestive system into the bloodstream. By redistributing water to its life-support systems when stocks are low, the camel can last for months without a drink.

Legs

Camels have three gaits. The slowest is a walk. Then, instead of a trot, it paces – with both legs on each side moving in synchrony. This allows it to extend each leg further, without crashing into the other leg on the same side. Finally, there is the gallop which has been recorded at over 55kph - not bad going for an animal that can weigh over half a ton.

Below: As Joy cuts open the base of the foot and peels it back, the team discover the large squishy elastic pads at the base of each of the camel's two-boned toes which look like jelly insoles. When the bones press down on these, the pads expand out. They act like shock absorbers and spread the weight of the camel over a larger area.

Below top right: Tendons, such as the huge Achilles tendon (pictured), absorb and release energy as the camel moves – vital efficiency in a land where no energy can be wasted.

the large and small intestines, out of the animal for a closer look. Inside the first stomach chamber is a thick slushy green paste – re-chewed desert plants watered down with copious saliva and digestive juices. By frequently regurgitating this soup and chewing it more (ruminating) the camel is able to break the tough plants down enough to digest a greater variety of the outback flora than sheep, goats or cattle. In some parts of the outback the camel has been found to eat 80 per cent of the plant species available. This re-chewing is where the camel gets its reputation for spitting. If a camel vocalizes while re chewing its lunch, the sludgy mass of saliva and plant can be expelled at great speed, with unpleasant consequences for anyone unlucky enough to be standing in its path.

It's also not clear at which stage the hooves changed gradually into soft toes, but they're thought to have emerged as an adaptation for less steady ground, such as that found in deserts. But why are toes better than hooves? Joy has cut open the base of the foot and is peeling it back. What's inside is rather extraordinary. At the base of each of the camel's two toe bones is a large squishy elastic pad, like a jelly insole. When the bone presses down on this, the pad expands out. It acts like a shock absorber and also spreads the weight of the camel over a larger area. This steadies the camel on uneven ground and prevents the foot from slipping deep into sand dunes. The toes also hold glands which secrete a cooling substance – like air-conditioning in the camel's feet – vital when walking on a surface that could fry an egg.

As Joy cuts further up from the foot she exposes the Achilles tendon. In the camel it is enormous – a great thick tube of elastic tissue connected to powerful muscles at the top of the leg. The camel has swapped a lot of its leg muscles for long tendons. Some of the muscles are just millimetres long at the end of immense tendons stretching across the limbs. Mark holds the leg while Joy bends it at the knee. The tendon becomes stretched and very hard. When Joy lets go, the leg flies out, releasing all the built up tension. It's thought that with every step the camel takes, it stores some energy in its great tendons, and when it shifts its weight from one leg to another, the tendon pushes back – saving the camel vital energy and water. When it's pacing, the camel's long leg tendons have been estimated to save half the muscle work needed if it did not have elastic band legs! At the end of a long and very tough day, Joy and Mark are impressed by the formidable range of adaptations that has enabled this animal to survive in such harsh desert conditions. Every bit of anatomy is honed to save as much energy and water as it can to allow these great beasts to conquer desert after desert. Looking at the story of the camel's runaway success in Australia you can't help but feel sorry for an animal that's evolved to thrive in a furnace and is now the victim of its own success.

How the Camel Got Its Hump

The popular myth that the hump is a giant water jug has been dispelled. But why carry around so much fat in a backpack? Joy has a theory. When she cuts into a seal or whale, it's completely covered in a thick layer of fat that is vital for keeping it insulated in the cold sea. The camel needs emergency supplies of fat too – in a drought it must last weeks in the parched desert. But the last thing it needs is a thick coat of fat that will trap heat. In these hot conditions it needs to lose as much heat as possible. So the camel's solution makes good sense – it has moved its entire fat supply and it uses it as a sun shield. Instead of keeping heat in, it blocks it out. The hump sits right above the camel's vital organs, protecting them from the heat of the sun.

Back at Glenda's ranch, Simon Watt fixes a herd of camels in the sights of a thermal imaging camera. The hump glows bright white, the hottest colour on the scale. At some points the surface is over 60 degrees centigrade. As well as a fat store, the hump is a parasol.

Pure Fat
The camel's hump is made up almost entirely of fat. It is a large glistening pale pink mass which fits neatly above the vertebrae, with no water reserves in sight.

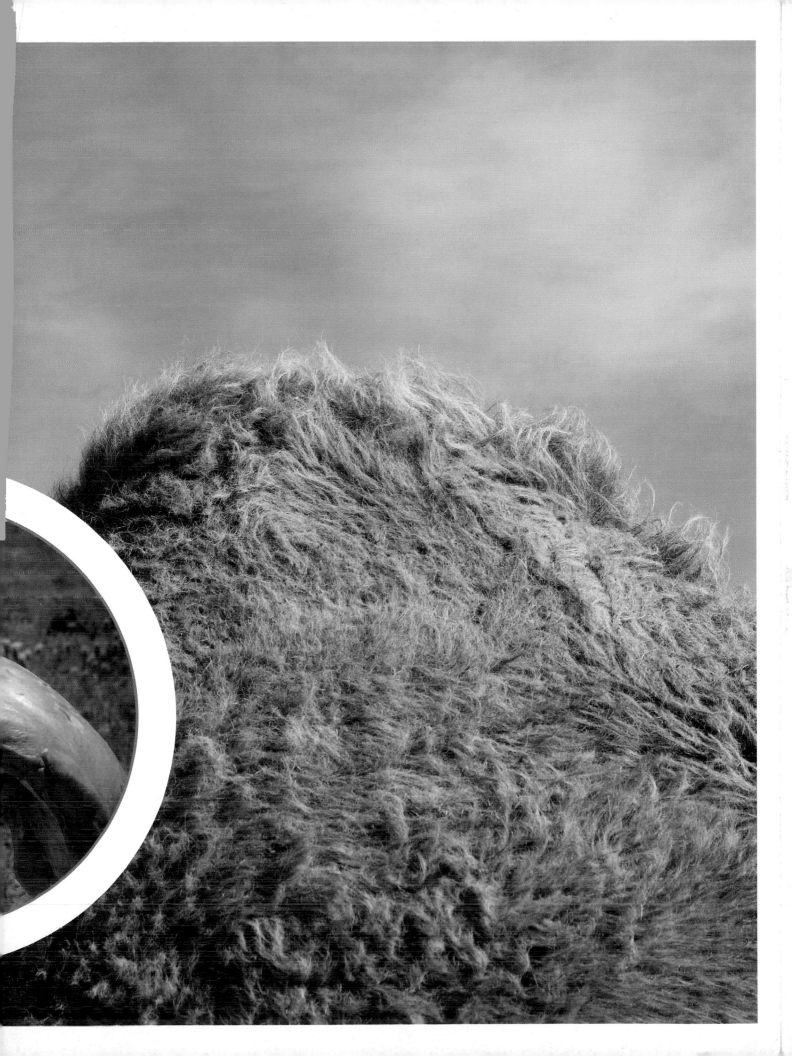

Index

Picture Credits

top=t; middle=m; bottom=b; left=l; right=r

Also available on the App Store

Download the *Inside Nature's Giants* App and explore the animals as you've never seen them before — from the inside out.

Autopsies, gestural dissections, fact files, videos and more.

Acknowledgements

When HarperCollins first approached us to write a book about *Inside Nature's Giants*, I was keen it should reflect the awe we'd all felt during filming as we looked inside each animal, so each chapter is written by a member of the team who experienced the adventure first-hand. The book, like the television series, has been a collaborative effort from an incredibly enthusiastic and dedicated team. Mark Evans, Peter Fison, Jamie Lochhead, Tom Mustill, Alex Tate and Simon Watt each contributed chapters on different animals. Joy Reidenberg provided anatomy highlights for each one and kept a watchful eye on the anatomical descriptions.

We'd like to thank our excellent HarperCollins editorial and design team, especially Julia Koppitz, who has been encouraging and supportive throughout the process, and Taylor Wallace, Myfanwy Vernon-Hunt and Helen Griffin. We'd also like to thank Dave Throssell and the Fluid Pictures team who adapted the series' distinctive CGI for the book. At Windfall Films Kristina Obradovic, Cherry Brewer and Eva Johnsson all helped coordinate the complex planning of this book.

The book and the series has benefited from a wide range of experts including: Alun Williams, Andrew Kitchener, Tecumseh Fitch, Gerald Weissengruber, Jon Cracknell, Graham Mitchell, Greg Erickson, Samuel Martin, Jeanette Wyneken, Nancy Mettee, Enrico Genarri, Geremy Cliff, Steve O'Shea, Ian Gleadall, Derek Solomon, Geoffrey Manefield, Adam Munn, Chris Darwin, Graham Laurisden, Scott Hocknull, Rune Dietz and Christian Sonne.

The first television series started filming in 2009. We'd like to thank Emily Roe, who helped develop the project in its infancy; Yvonne Bainton, who as line producer overcame some seriously big hurdles and got everyone into orange boiler suits; Julian Thomas and Jamie Lochhead, the producers on the first series; Alex Tate and Tom Mustill, who proved themselves in the edit room and have become producers on the current series. We have a fantastic production team on this series, which includes: our amazingly energetic line producer, Cherry Brewer, production manager, Eva Johnsson, producer, Anna Evans-Freke and edit producer, Peter Fison. A special thank you to our composer, Max De Wardener, whose music contributed so much to the films. And a final word to the unsung heroes of all documentary films, the editors: Justin Badger, Paul Shepherd, Martin Sage, Garry Crystal, John Moratiel.

At Channel Four Ralph Lee and David Glover backed the idea from the outset. David's demands in the edit room have made us squeeze the last bit of potential out of each film. At National Geographic Channels Janet Han Vissering, Madeleine Carter, Sydney Suissa and Michael Welsh were always strong advocates of the series.

We are indebted to the Wellcome Trust, who came to the rescue of the second series when our US co-producers pulled out. In particular we'd like to thank Clare Matterson, Rachael Hillman and Dan Glaser.

David Dugan
Series Producer
Inside Nature's Giants